D0848169

CROWN AND VEIL

# Crown and Veil

FEMALE MONASTICISM FROM THE FIFTH
TO THE FIFTEENTH CENTURIES

EDITED BY

Jeffrey F. Hamburger and Susan Marti

*Translated by Dietlinde Hamburger*
*Foreword by Caroline Walker Bynum*

Columbia University Press
*New York*

Columbia University Press
*Publishers Since 1893*
New York    Chichester, West Sussex
English text and translation copyright © 2008 Columbia University Press
Original copyright © 2005 *Krone und Schleier. Kunst aus mittelalterlichen
Frauenklöstern*; hrsg. von der Kunst- und Ausstellungshalle der Bundesrepublik
Deutschland, Bonn, und dem Ruhrlandmuseum Essen. Munich: Hirmer, 2005.

Library of Congress Cataloging-in-Publication Data
Krone und Schleier. English.
Crown and veil : female monasticism from the fifth to the fifteenth centuries /
edited by Jeffrey F. Hamburger and Susan Marti ; translated by Dietlinde Hamburger.
p.   cm.
Essays originally commissioned for the exhibition Krone und Schleier:
Kunst aus mittelalterlichen Frauenklöstern.
Includes bibliographical references (p.   ) and index.
ISBN 978-0-231-13980-9 (cloth : alk. paper)
1. Christian art and symbolism—Germany—Medieval, 500–1500.
2. Monasticism and religious orders for women—Germany—History.
3. Convents—Germany—History.   4. Art, Medieval—Germany.
5. Nuns in art.   I. Hamburger, Jeffrey F., 1957–
II. Marti, Susan.   III. Hamburger, Dietlinde.   IV. Frings, Jutta.
V. Gerchow, Jan.   VI. Ruhrlandmuseum Essen.
VII. Kunst- und Ausstellungshalle der Bundesrepublik Deutschland.
VIII. NRW-Forum Kultur und Wirtschaft Düsseldorf.   IX. Title.

N7850.K76213   2008
704'.08827190043—dc22        2007044186

*Jacket Illustration:* Coronation of St. Clare, part of a winged altarpiece,
probably from the Poor Clares of Nuremburg, Nuremburg, ca. 1350/1360.
Private collection, Great Britain.

# Contents

# Illustrations

# Foreword

The exhibit "Krone und Schleier" opened in two venues, Bonn and Essen, in the spring of 2005. Many of those who attended the Bonn portion of the exhibit were an overflow crowd from the Egyptian exhibit next door. I listened to their comments as they walked from case to case, clutching tickets stamped with the waiting time until they could be admitted to see Egyptian gold. As I listened, I realized that they found the title puzzling: "Crown and Veil." Surely it must be an exhibit on the art of court and cloister in the Middle Ages—that is, on female patronage, both ecclesiastical and secular, and on women's art from aquamaniles and jewelry cases to prayer books and ivory triptychs. As viewers realized that the exhibit concerned female monasticism, they expressed at first disappointment. "Crown" and "veil" were, they learned, ornaments taken on by nuns as they espoused Christ. The veil was a symbol of betrothal but also of enclosure away from the world. The crown had nothing to do with worldly power; it was an emblem not only of heavenly glory but also of the wounding of Christ. I overheard more than one viewer say: "Oh dear, it's nuns." But then, as attendees went from room to room, something happened. There was increasing excitement in the comments. For the items exhibited there—many of them gorgeous, many very strange—all opened the way into a fascinating world. Moreover, they raised fundamental questions about issues as basic as the nature of what we mean by "art," the place of the visual in culture, and the role of gender in religion. Not only a

resounding "yes" to the question whether there were female artists before the Italian Renaissance—a question that, oddly enough, is sometimes still asked—the exhibits at Bonn and Essen also raised the question whether medieval religious culture associated women especially with visuality and hence with what we still call the "visual arts." The essays that follow focus in many cases on the technical background necessary to understand the female monasticism (and other forms of organized women's religious life such as houses of canonesses and beguines) that was the setting for the objects displayed in both parts of the exhibit "Krone und Schleier." But in reading this book one should not lose sight of the large theoretical questions that lie behind. It is the adumbration of these issues—however much scholars may, in some cases, be at an early stage in posing them—that makes the translation of this volume into English so important.

The focus of the exhibit on female monasticism means that some comparative questions about European religious life are not raised. This may at first seem surprising. Recent work in both English and German on the topic of women and religion has progressed far beyond the concern of the earlier twentieth century simply to find women artists and writers; it now involves an understanding that all history of women must be in some way embedded in gender history. To take gender as a context means that one can describe what women did, painted, commissioned, and wrote and how their institutions were structured, but one cannot say anything about these activities or institutions as characteristically "female" without comparison to male institutions. It also means that both male and female roles—that is, expectations of behavior appropriate to individuals of one or the other biological sex—are understood to be imagined and prescribed (the word usually employed is "constructed") by both men and women as they act, write, educate others, and wield power. This understanding of gender, which began to emerge in the 1970s, implies that, for many descriptive statements about women's piety and/or cloistered life, comparison needs to be made with the monastic life of men, with the lives of secular (and even dissident) women, and with contemporary writing by both men and women about what women's values and lives ought to be.

In most of the essays in this volume, such comparison is only hinted at. This is in part because the scarcity of medieval sources makes statistical comparison in many cases impossible. It is in part because historians are only beginning to undertake the complex task of drawing comparisons. The wealth of recent scholarship on women's institutions, such as (to

give only two examples) that of Walter Simons on the beguines and Franz Felten on nuns, has provided us with so much new information that we need time to absorb it before we can restructure our history of organized religious life in the Middle Ages to include women more centrally in it or draw more explicit comparisons between male and female institutions.[1] Furthermore, much of the detail given here is intrinsically interesting and stands without comparison. We learn about the material conditions of women's lives (what they owned, what they ate, what work they did, and so forth), about regional variations in their architecture, and about the social and class composition of various houses and how it changed over time. Such information is necessary if we are to understand both how a relatively small number of women's houses in medieval Germany could produce such a large number of manuscripts, panel paintings, devotional objects, reliquaries, liturgical vessels, and embroideries and how so many of the products of this wealth and talent have managed to survive to the present.

Moreover, there is much in what follows that does bear on the question of gender. A number of essays point out the fundamental difference enclosure made in cloistered female lives and the connection of the radical separation from the world prescribed by the bull *Periculoso* (1298) with medieval conceptions of women's bodies as dangerously porous and women's spirituality as especially receptive to visual stimulation. The chapters by Jan Gerchow and Susan Marti, Carola Jäggi and Uwe Lobbedey, and Gabriela Signori also show us that, despite the stress on enclosure, women's cloistered lives were closely connected to those of the clergy who supervised and celebrated mass for them (or refused to do so); they were connected as well to the bustle of surrounding urban life or the splendor of courts and hence to the needs of relatives who wanted to place their daughters and sisters in monasteries as religious specialists to say prayers for their souls. If one reads carefully, there is considerable comparative material in these essays, both comparisons between men and women and comparisons between cloister and world.

The objects so beautifully set out in the exhibit "Krone und Schleier" raise questions not only about monasticism and gender but also about art. As Jan Gerchow and Susan Marti point out, the phrase "nun's work" was often used ambiguously in the last century to designate works small either in size or in artistic merit. Recent study by Jeffrey Hamburger has thoroughly banished from our vocabulary such easy judgments about quality; it has moreover rendered deeply problematic any implication that either

devotional objects used in women's houses, such as Christ dolls, or stylistic characteristics that can be associated with illuminations from particular scriptoria, such as round faces and pink cheeks, are to be described as unsophisticated and childish or as, in any simple sense, feminine or maternal. Indeed, this observation participates in important current discussions about the nature of art itself in what Hans Belting has called "the era before art."[2] For the papier-mâché prayer cards that enabled the pious to feel with their fingers embossed images of the instruments of Christ's torture as they prayed, like the large and beautiful statues rightly valued by connoisseurs (such as the Katharinenthal Christ and St. John group), were not created for the often dispassionate viewing suggested by our modern museums with their boutique lighting and didactic labels identifying primarily the "artist" and the nature of the materials employed. The objects in the "Krone und Schleier" exhibit were made to be used—handled, dressed and undressed, censed with smoke and spices, kissed. Their power was often lodged not in a naturalism or realism that reflected the world or even in a beauty that conjured visions of heaven but rather in a sacrality conveyed either by the fact that they actually contained bits of holy bodies or by the way they enabled users to transcend human experience by going through it (sometimes in pain and ugliness) to an incarnate God. As Jeffrey Hamburger and Robert Suckale put it, works of art do not just document religious and social relations; they establish and secure them. Such a generalization is true in a special sense of the objects described in this volume. For they are not so much "art" in the modern sense of decoration or representation (and even nonrepresentational modern art explores the issue of representation) as they are the very stuff of religious practice.

This brings me to the major theoretical issue raised by these essays: the issue of women and the visual. As a number of the authors stress, a disproportionate amount of both visual material and material encouraging visualization can be associated with women's houses. A surprisingly large number of early antependia, altarpieces, and panel paintings come from female monasteries. Books of hours and books of revelations are almost female genres—that is, created either by or for women. Figures such as Angela of Foligno, Julian of Norwich, and Gertrude the Great found in physical crucifixes both doctrinal instruction and devotional inspiration. The art they saw fed the content of their prayers and visions.

The association of women with images and with techniques of visualization was, as both Barbara Newman and I point out below, owing in part

to St. Paul's warning against female speech, in part to the association of woman with body often made by both women themselves and their male advisers. Whether or not the objects in the "Krone und Schleier" exhibit were made by women (and indeed "made by" in the case of medieval devotional objects often better describes the activity of the patron who commissioned the work than that of the sculptor or illuminator who formed it), many clearly reflect the emphasis, found in both sermons for nuns and books by them, on visualizing the experiences of Christ and his mother, saints and martyrs, heaven and hell.[3]

The nexus between women and the visual suggested here needs exploration and refining. It is one of the virtues of this book to put it squarely on the table for further discussion. But we should also note that these essays, explicitly and implicitly, suggest several important caveats. First, visualization and the visual are not the same thing. Much of the emphasis on the visual in late medieval women's piety is textual—that is, women are urged by men and by each other to go from verbal description to interior imagining. Such visualization can actually bypass visual objects or even contain implicit criticism of them as external or material.

Second, and connected to this, the stress both on the visual and on visualization in writing for and about women is often suspicious of it, partly of course because the female bodies it was associated with were themselves suspect in a misogynist culture. As Hamburger, Newman, and I indicate, the bodily and visual quality of much female piety was also rejected by some women themselves, who preferred to stress the interior and imageless approach to God or even the dangers of visions. Deep and denigrating ambiguity about both the female and the visual is underlined in recent work by Dyan Elliott and Nancy Caciola that demonstrates how preachers and inquisitors persecuted exactly the visualizing they also encouraged.[4]

Third, the visuality associated with women was often more tactile than visual. It may indeed be a limitation of modern notions of art to separate sharply touching (even tasting) from seeing. As these essays point out, religious women kissed choir seats, drank the wash water of priests and saints, nursed and dressed and cradled Christ dolls. Among the most characteristic artistic products of female monasteries were textiles, and some of these Lenten (or hunger) cloths made by nuns and canonesses were white on white—a medium in which the art is as much felt with the fingers as seen with the eyes.

Visitors in the summer of 2005 who saw the gorgeous illuminated manuscripts and the Golden Madonna at Essen or puzzled over the devotional sculpture and panel paintings at Bonn had an experience that cannot be reproduced by translating the catalog essays from "Krone und Schleier." But thanks to Columbia University Press, a number of these objects are here made available in reproduction to an audience that could not travel to the Rhineland. That audience will find in these articles a rich background necessary to understand not only the objects displayed in summer 2005 but many others as well. Moreover, the essays provide glimpses of the everyday world of medieval nuns that go well beyond what these particular objects conjure up, and they raise theoretical questions about visuality, art, and gender that medievalists and art historians generally will do well to explore further.

—*Caroline Walker Bynum*

## Notes

1. Simons 2001b; Felten 1992, 2000a, 2000b, 2001.

2. Belting 1994. On the Belting thesis, see Thunø and Wolf 2004 and J.-Cl. Schmitt 2002:50–53.

3. Kessler 2004:45–46.

4. Elliott 2004; Caciola 2003.

# Acknowledgments

This collection of essays, like a medieval monastery, represents the result of a far more complex collaboration than a glance at the table of contents alone could possibly indicate. As in a monastery, behind those who fill the roster of prominent offices, be it as editor, translator, or contributor, stands a whole series of sponsors and donors, not to mention the labor of collaborators too numerous to be named here.

The book originated in the catalog prepared to accompany the international loan exhibition Krone und Schleier: Kunst aus mittelalterlichen Frauenklöstern.* Yet it does not simply reproduce that catalog. Although most of the contributions from the essay section of the catalog appear here, with no more than modest editorial adjustments to accommodate English-speaking readers, two introductory essays in this volume—one by Jan Gerchow, with collaborators, and the other by Jeffrey F. Hamburger, Petra Marx, and Susan Marti—represent revised conflations of material that originally was spread over various sections of the catalog. The

* Krone und Schleier: Kunst aus mittelalterlichen Frauenklöstern. Ruhrlandmuseum: Die frühen Klöster und Stifte, 500–1200. Kunst- und Ausstellungshalle der Bundesrepublik Deutschland: Die Zeit der Orden, 1200–1500. Eine Ausstellung der Kunst- und Ausstellungshalle der Bundesrepublik Deutschland, Bonn, in Kooperation mit dem Ruhrlandmuseum Essen ermöglicht durch die Kunststiftung NRW, 19. März bis 3. Juli 2005. See www.krone-und-schleier.de/and Cat. Bonn/Essen 2005.

two essays originally written in English—by Caroline Walker Bynum and Barbara Newman—which had to be shortened to fit in the catalog, have been restored to their original length, although, alas, some of the pictorial material that accompanied them has had to be cut. Added to all this is a new, general introduction, addressing issues of method and historiography, by Jeffrey F. Hamburger, a representative selection of images with explanatory captions, and a bibliography based on that in the exhibition catalog but enhanced with references to English-language scholarship and free of items that were specific to entries on individual works, which are not included here. In short, this book is designed to serve as a much-needed introduction to a long-neglected topic by an array of international scholars from both sides of the Atlantic, bringing together (without necessarily seeking to harmonize) various disciplines and approaches. As with any such introduction, the book hardly seeks to say the last word; rather, it is the hope of all the contributors that it, like the exhibition from which it derives, will help galvanize further research, scholarly collaboration, and, not least, interest on the part of students and the general public alike.

Objects of course are at the heart of any exhibition. Of the approximately six hundred loans that were obtained for the exhibition at the Kunst- und Ausstellungshalle der Bundesrepublik Deutschland (Art and Exhibition Hall of the Federal Republic of Germany) in Bonn and the Ruhrland-museum in Essen in summer 2005, only a handful can be reproduced here. Readers interested in taking in the splendid conspectus provided by the color illustrations in the catalog are encouraged to consult it. This book, however, serves a different, independent function and is addressed to a different audience. Like the essays in the catalog, this volume provides the first attempt to tackle the topic of female monasticism as a whole, from a variety of historical perspectives and employing different methods. The focus is on the German Empire but also incorporates, at least for the early Middle Ages, a broader European perspective including Frankish Gaul, Langobard Italy, and Anglo-Saxon England, which is required to understand the development of this distinctive form of religious life in the Christian West. In the absence of the catalog entries describing the art objects gathered for the exhibition, the emphasis in this book, in contrast to the catalog, is no longer on works of art, hence the slight change in the subtitle.

We wish to express our thanks to our original collaborators and contributors, without whose cooperation and efforts over many years this book, like the exhibition and catalog that preceded it, would never have seen the light

of day. Together with Jeffrey F. Hamburger (Harvard University), the exhibition was originally conceived by Jan Gerchow (formerly Ruhrlandmuseum, Essen, now Historisches Museum, Frankfurt) and Robert Suckale (Technische Universität, Berlin). They were joined as curators by Lothar Altringer, Carola Jäggi, Susan Marti, Petra Marx, and Hedwig Röckelein. Ulrich Borsdorf, director of the Ruhrlandmuseum in Essen, and Wenzel Jacob, director of the Kunst- und Ausstellungshalle in Bonn, were instrumental in making it possible for us to realize our ambitious plans, as was the Domschatz in Essen, home to an early medieval female monastery and probably the most important treasury of these artifacts in the world today preserved in situ. No less important was the generous financial support of the Kunststiftung NRW (Nordrhein-Westfalen), among other foundations and enterprises. A grant from the Ruhr Museum (the former Ruhrlandmuseum) and the Alfried Krupp von Bohlen und Halbach-Stiftung in turn made it possible to publish this book. To all these sponsors and those who direct them, we offer our repeated, heartfelt thanks. We would also like to express our gratitude to all the libraries, museums, and ecclesiastical institutions that once again granted us permission to reproduce works in their collections.

We owe a final word of thanks to several others without whose help and support this book could not have been published. Although the tide is turning, one reason the art of the German Middle Ages has for so long been neglected in English-speaking countries is quite simply the fact that so much scholarship on the subject is available exclusively in German, a language that unfortunately is no longer as widely taught as it once was. The translations in this volume, provided by Dietlinde Hamburger, represent one attempt to bridge this communication gap. Sarah St. Onge carried out the copyediting in a most meticulous manner. Our thanks also to our editor at Columbia University Press, Wendy Lochner, for responding enthusiastically to our proposal to publish this volume, and, not least, to Caroline Walker Bynum, not only for her essay and foreword but also for the passion and scholarly commitment that she has brought to the study of female monasticism, which have repeatedly reminded others of its enduring significance in our world as well as that of the past.

Note to Readers

Readers will observe that we have employed a short form for all citations. Books and articles are indicated by name of author or editor or, in

a few instances, title, followed by the date and, if necessary, page numbers. Catalogs of exhibitions are indicated by the place where they were held, followed by the date. All are listed alphabetically in the bibliography, which also includes additional references.

German and Latin terms have been translated systematically, except where no exact English equivalent exists, in which case definitions are provided. One, however—*Frauenstift* (literally, a foundation for women)—resists felicitous translation, so we have simply left it unaltered. The fact that there is no adequate English equivalent is telling in itself.

*Jeffrey F. Hamburger and Susan Marti*

CROWN AND VEIL

# Introduction

## *Histories of Female Monasticism*

JEFFREY F. HAMBURGER

Medievalists are accustomed to working with sources that are as scarce as they are intractable. The most formidable obstacles to furthering knowledge of virtually any aspect of medieval history and culture, however, are quite simply neglect and lack of interest, not to mention prejudice. As far as female monasticism is concerned, the historical record, for the early Middle Ages but also for later periods, right up to the Reformation, remains thinner than for male monasticism. The reasons for this paucity of information are manifold. They extend, however, beyond the vagaries of survival. It is ironic, to say the least, that in parts of Germany, it was only due to the Reformation that certain female monasteries of the Middle Ages, for example, the so-called Heideklöster clustered on the Lüneburg Heath, survived virtually intact to modern times. In areas where Catholicism prevailed, female monasteries were sometimes suppressed, abandoned, or, if they survived, transformed under the pressures of modernization.

The sources, however, are not nearly as scarce as is often maintained. Imagine a single book that, in addition to providing virtually complete documentation of the liturgical life of a Benedictine convent, permitted a detailed reconstruction of the ways and means by which it was reformed. Imagine further that this book provided a vivid account from the hand of the prioress recounting her role in the process of reform, her struggles with various ecclesiastical officials, and, not least, her day-to-day dealings

with craftsmen and artists of all kinds. As if that were not already too much to ask, imagine yet further that this same book not only documented the deeds of this enterprising prioress but, in addition, provided extensive first-person accounts in her own hand as to why she did what she did. For social historians, a book such as this would be a gold mine of information about daily life in a late medieval convent, right down to the conflicts and tensions that made life in some monasteries anything but paradisiacal. For the historian of institutions, it would offer not simply a list of monastic offices but a detailed picture of just what the execution of those various duties actually entailed. For economic historians, it would offer the kind of information—including inventories and accounts documenting the origins of various materials, rates of inflation, and even the names of the craftsmen employed and the number and cost of every nail used to renovate the abbess's apartment—that in most cases they could only dream of. For art historians, it would provide detailed descriptions of images and the spaces in which they were installed, in short, much of the data required to reconstruct a plausible history of their patronage, function, and, to a certain extent, their appearance. The same book would even include something for historians of literature and music, be it the equivalent of a *Liber ordinarius*, a plan for the performance of chant throughout the liturgical calendar, material for the history of liturgical drama, or, what remains quite rare, even in late medieval sources, a diarylike account of personal experience, not only an autobiography of sorts but also in this case an autograph written in the first person.

There is no need to imagine such a source; it exists. It is the *Buch im Chor* of Anna von Buchwald (1484–1508), prioress of the Benedictine convent at Preetz in Schleswig-Holstein, and it represents but one of many such sources that have yet to be fully exploited for a comprehensive, wide-ranging history of female monasticism.[1] One would have thought that a book of this kind would have long since become a steady, standard point of reference in the ever-growing literature on female monasticism. Yet it remains unedited and, effectively, unknown. The only real way of accessing its riches, apart from consulting the manuscript itself or a microfilm of it, is to go back to a fine, thorough article by an economic historian, Friedrich Berthau, published in 1917 in a relatively obscure journal, the *Zeitschrift der Gesellschaft für Schleswig-Holsteinische Geschichte*, an essay that, by its nature, rather than taking the book whole, for all that it can tell us about female monasticism and the manifold ways in which it intersected with the sur-

rounding society, focuses to the virtual exclusion of all else on whatever information the *Buch im Chor* can contribute to the economic history of this particular part of Germany in the mid- to late fifteenth century.[2] In short, rather than considering the rich material of female monasticism as part of the much more complex fabric of medieval history in all its variety, the author, in keeping with his expertise, pulled a single thread and followed it as far as he could within the boundaries imposed, in part, by the state of the historical art as it was practiced in his day.

Today, we are, or ought to be, in a position to do better, not because we are necessarily better historians but because we are more inclined to collaborate and have vastly greater resources at our disposal. This does not mean, however, that we should scoff at the accomplishments of earlier generations of scholars. Quite the contrary: they may have been hampered by what we today might regard as outdated methodologies and outworn prejudices, but they also had at their command formidable training in the requisite languages, not to mention technical skills such as paleography and, in some cases, the sheer ambition to undertake what, from the present perspective, confronted by the vast accumulation of specialized scholarship, seems almost impossible or perhaps even presumptuous, namely, a comprehensive, at times "universal," history of their subject.

In this respect, it is both instructive and humbling to return to one of the early monuments and continuing classics in the historiography not only of female monasticism but also of medieval history *tout court*: Eileen Power's *Medieval English Nunneries, c. 1275 to 1535*, first published in 1922.[3] A simple résumé of its table of contents gives a small suggestion of its impressive, almost implausible, range, a coverage and reach that no subsequent study has ever rivaled. After two introductory chapters in which Power discussed novices and abbesses, including their social background and their characteristic way of life, her book went on to discuss female monasticism, not in terms of mysticism—one of the contexts in which the subject is most often treated today—but rather in terms of its situation in the world: the property holdings of female monastic institutions, their sources of income and expenses, their methods of administration. She then discussed at considerable length the internal administration of such communities, including the whole hierarchy of officeholders beneath the abbess or prioress, and their integration into the daily life of the towns and villages in which these monastic houses were embedded. Far from painting an idealized picture of female monasticism, Power devoted a subsequent chapter

to documenting the financial difficulties, mismanagement, and inadequate endowments that plagued most female communities. Following this detailed consideration of economic and administrative issues, she then turned her attention to the education of nuns from the Anglo-Saxon period until the late Middle Ages, including their role not only as students but also as teachers of novices and secular children. Subsections of this chapter provide an agenda for subsequent scholarship, be it on female literacy and libraries or women's contribution to the history of medicine. Daily life in the cloister, including dancing and the keeping of pets, the relationship of private life and private property to monastic ideals, the enforcement of enclosure, the conduct of visitations, the range of exchanges between inhabitants and outsiders, attempts at reform, reports of scandal, and, not least, the representation of nuns in medieval literature, whether sermons or *fabliaux* all find their place in Power's astonishing book.

The present volume does not attempt to provide for the history of female monasticism on the Continent what Power, all subsequent revisions and refinements aside, so precociously provided for England. Its origins lie in an exhibition catalog, the primary focus of which was the art of female monasticism. As in the exhibition catalog, however, the essays seek to provide an interdisciplinary set of introductions, written by a wide range of specialists but addressed to students as well as scholars, on many, if not all, of the topics that Power touched on in her magisterial book almost a full century ago, at least as they relate to female monasticism predominantly in the German-speaking lands of the Holy Roman Empire.[4]

What, one might ask, has changed since Power wrote her book, and why has it taken so long for a study that focuses for the most part on Germany to appear? In contemplating an answer, one must keep in mind the distinction between feminist scholarship and the history of women per se, which in its various forms—witness Power's work—predates feminism and the pressures it puts on traditional scholarship. Some essays in this volume represent first forays, others, a synthesis of work previously accomplished. As noted by Caroline Bynum in her foreword to this volume, the comparative perspective required by the study of gender, as opposed to the study of women per se, is sometimes lacking. Nonetheless, much of the work represented here could not have been undertaken without the first wave of feminist scholarship on the Middle Ages, which began around 1980 and provided much of the impetus for a revival of interest in all aspects of female monasticism, lending the topic new legitimacy, even urgency.

Feminism stands in a special relationship to scholarship on the German Middle Ages. As a scholarly movement, it had its origins primarily in France and the United States, where traditionally, at least since World War I, interest in German language, culture, and history has (with the exception of the Carolingian material, which is often construed as pan-European in character) consistently taken second (or even third) place to other regions of Europe. One mundane reason for this neglect, despite the richness of the German sources, is, quite simply, the steady decline of interest in German as a foreign language. Another is, or was, until no more than several decades ago, the continuing focus of German medieval scholarship on economic, political, and institutional history, often to the exclusion of female monastic institutions. To this must be added what certain German scholars themselves characterize as continuing skepticism concerning the legitimacy or value of women's history, let alone feminist approaches that have a much broader purview than the study of women alone.[5]

The relative lack of interest, at least until recently, in the history of female monasticism in Germany is that much more unfortunate given not just the extraordinary wealth of the German material but also its extraordinary interest. Why, despite the ravages of so many wars—not only two world wars, but also the Thirty Years' War in the seventeenth century—so much more material survives in German-speaking regions than from any other region of northern Europe is a complex question that would itself be worthy of study. One contributing factor is certainly the general cultural conservatism that prevailed in German lands, which slowed the forces of modernism that, because of changing tastes, in other regions often brought destruction in their wake. Another factor is the political fragmentation and regionalism of the regions known collectively as the empire, that, despite that imposing title, remained fractious and fragmentary. Regionalism prevented or at least hindered the imposition of sweeping centralization and encouraged the proud preservation of local traditions and the institutions that lent them life.

Yet another consideration, at least as far as the history of art is concerned, is the irregular impact of iconoclasm, despite the Reformation, in contrast to the despoiling and destruction of monastic communities in, for example, the Netherlands. Patterns of appropriation and secularization also play a role. Whereas in England the monasteries were dissolved before the establishment of national, let alone local, institutions that might systematically preserve their property, libraries included, in Germany, secularization

only took place in the early nineteenth century, precisely at that time when, in the context of nascent romanticism, national self-consciousness was on the rise. As a result, monastic collections, although dispersed and displaced, were not destroyed, or at least not to the same extent.[6] In some respects, too, more evidence survives in Germany in part because, in comparison to other regions north of the Alps, more was created in the first place. In this regard, the distinctive character of *Frauenstifte*—foundations for canonesses for which there is no adequate English term—offer a case apart. Although similar institutions can be found in other parts of Europe, nowhere outside of German-speaking regions were they as widely or deeply entrenched as in the lands of the empire, in part because they played such an important role within its political as well as its religious structures.[7] All this, however, is, at least in part, to compare apples and oranges. Our picture of female monasticism and religiosity in medieval France would be vastly different had simply the library of Metz, which housed incalculable treasures from the city's numerous monasteries and beguinages, not been largely obliterated in 1944 by a fire set off by grenades tossed into the storage chambers where the manuscripts were housed.[8] The same could be said of Strasbourg's library, destroyed in the Franco-Prussian war, which once housed Herrad of Hohenburg's *Hortus deliciarum*, among the most elaborately illuminated manuscripts of the entire Middle Ages. It should nonetheless be noted that in the Middle Ages, both cities belonged as much, if not more, to the empire's sphere of influence as they did to the kingdom of France.

No consideration of female monasticism in the Middle Ages would be complete without some consideration not only of the degree to which female monasticism was in fact distinctive, and in what respects, but also of how and to what extent its study should be integrated into the study of medieval monasticism in general or, more broadly still, medieval culture as a whole. At issue is not simply the question of how female monasticism in all its various forms differed from male monasticism (which was no less varied) but also the ways in which modern scholarship should structure, define, and discuss such differences, to the extent it acknowledges them at all. In schematic terms, one might say that scholarship on the subject can have two goals, which are not always easily reconciled: on the one hand, to integrate the history of female monasticism—its institutions, literature, religiosity, liturgy, art, architecture, or music—into a larger, more inclusive history of medieval society and monasticism and, on the other hand, to emphasize those respects in which female monasticism was in fact distinc-

tive. There is no need to choose between these two alternatives, and attentive readers of this volume will notice that different contributors choose different points of emphasis in handling this complex and delicate subject.

One thing, however, is clear: regardless of where one comes down on the issue of difference, a proper history of female monasticism can only be written in comparative terms. Comparison of categories (not to mention their dismantling) is a precondition of research on gender. Those critics of women's history who call for a comparative approach, however, would do well to recall that the same holds true, perhaps with even greater emphasis, for the history of male monasticism, let alone of the medieval church and society in their entirety, fields of scholarly investigation that long found it unnecessary to pay much attention at all to the history of female monasticism. This is but one more reason why more research on female monasteries, which still lags behind that on male monasticism, remains an ongoing desideratum.

Just how to integrate the history of female monasticism without denying its distinctive character will differ from one area of research to another. One purpose of a volume such as this, however, is to insist on the necessity of seeing the subject whole. For example, without understanding the reasons why many female monasteries in the later Middle Ages had much smaller endowments than did many of their male counterparts, one cannot understand the character of their artistic patronage. The same holds true of the liturgical requirements of strict enclosure, which in turn necessitates a careful plotting and reconstruction of architectural settings. By the same measure, without understanding the challenge posed by the efflorescence of female piety in the High and later Middle Ages, it would be impossible to write a history of the male monastic orders that were entrusted, often very much against their will, with the pastoral care of nuns.

Take the example of literacy. Despite the emergence of the history of reading as an important area of historical research, until recently, women did not figure prominently in accounts of early medieval libraries or literary transmission, in part because it was assumed their literacy and learning were so limited. More recently, however, the work of scholars such as Rosamond McKitterick and Katrinette Bodarwé, building on contributions by Bernhard Bischoff, Peter Dronke, and others, has shown that many more women were far more literate in Latin than was previously held to be the case.[9] In this instance, even if female literacy operated within limitations that themselves form an important part of this history, the distance between male and female monasticism has narrowed. The later Middle

Ages offer a different picture. Beginning in the twelfth century, then accelerating in the thirteenth, female literacy increasingly meant vernacular, not Latin, literacy. To this extent, female spirituality was, by definition, different, insofar as most enclosed women had only limited and, even then, only indirect access to Latin learning as it was conducted and disseminated at the universities. This is not to say that there were not complex conduits of interconnection; witness the example of Meister Eckhart (1260–1328), who not only preached in the vernacular, for the most part, to women but whose theology responded to the spirituality of women as he encountered it in enclosure.

As this and other examples make clear, it is difficult to generalize about the Middle Ages as a whole. The same holds true for many of the specific areas of investigation treated by the essays in this volume. Whereas in the early Middle Ages, small numbers of aristocratic women affiliated with religious houses could wield enormous spiritual and temporal powers, in the later Middle Ages, their possibilities for action in the world diminished considerably. Looking at the history of female monasticism within such a *longue durée* permits reconsideration of other questions—such as that famously posed by Joan Kelly-Gadol in 1977: "Did women have a Renaissance?"—in that much of the diminution of women's scope for action in the world had set in long before the Reformation.[10] To this extent, it should be recognized that the price of separation was new forms of inequality. The history of female monasticism, however, is not simply one of subjugation, although that aspect should never be ignored. With separation came the need, born out of a combination of compensation and creativity, to which should be added sheer acts of will, to develop alternative ways of life, communication, prayer, and devotion. To recognize or even to emphasize this aspect of female monasticism is not to romanticize the subject, let alone to make of medieval nuns proto-feminists; it is simply to give them their due.

In this context, one question that remains very much open is to what degree female spirituality differed from that of the laity at large. Whereas Anglo-American scholarship has tended to emphasize the distinctive character of female piety and practice, German scholarship has, on the whole, been more reluctant to admit any distinction. This may in part have to do with different points of emphasis. Although it is difficult to generalize, and numerous distinguished exceptions could be cited, whereas until quite recently German historians tended to focus on institutional issues, whether the history of a single monastic house or the history of monastic

orders, much, although by no means all, American scholarship has tended to focus on individuals or specific bodies of literature, with special, perhaps at times inordinate, emphasis on mysticism to the exclusion of more mundane matters. Although by no means all-inclusive, this book was designed to bring together and, to a certain extent, confront American and Continental approaches to a subject that in its importance and interest transcends any one set of approaches or any single historiographic tradition. For a host of reasons that extend well beyond linguistic barriers or the impediments posed by trans-Atlantic travel, there remains far too little scholarly exchange between German and American medievalists. We hope that this book represents a contribution to increasing collaboration.

Whatever the differences in approach between various areas of investigation and different scholarly traditions, in some areas it is difficult to deny not only that differences between male and female monasticism existed but also that they had a significant impact on women's lives. One such area quite literally involves the enforcement of enclosure. The fact that for women claustration was often so much more strict than for monks, let alone male mendicants, brings in its wake a host of defining differences, the ramifications of which are profound and wide-ranging. These include, but are by no means limited to, such topics and issues as the economic underpinnings of female monastic communities, the character of their liturgies, their patronage, the range of their contacts with outsiders, their view of the world, their visual culture (which includes but extends well beyond the types of images that were available to them to include such matters as the nature, forms, and function of visionary experience), and, not least, the architecture of their communities, which provided the principal means of enforcing enclosure in the first place. All these topics, among others, are discussed in the essays gathered here.

A word should be said about the origins of this book. All the essays, in one form or another, were originally commissioned for the exhibition *Krone und Schleier: Kunst aus mittelalterlichen Frauenklöstern* (Crown and Veil: Art from Female Monasteries of the Middle Ages), held simultaneously at two venues, the Kunst- und Ausstellungshalle der Bundesrepublik Deutschland in Bonn and the Ruhrlandmuseum in Essen, in the spring of 2005. The exhibition, the first of its kind, aimed to provide an overview of the development not simply of female monasticism in Europe, with emphasis on the Holy Roman Empire, but, more particularly, on the history of its visual culture and character. As indicated by the title, the emphasis

of the exhibition was on those works of art that in many respects provide the most complete and most vivid testimony to the legacy and impact of female monasticism over the course of the period—almost an entire millennium—that the exhibition took as its span. In Essen, the focus was on the early Middle Ages, from late antiquity until the late twelfth century; in Bonn, the emphasis was on what we called the "Time of the Orders," the period following the establishment of the mendicant orders, whose growth and continuing influence dominated developments right up until the time of the Reformation. Over six hundred objects from approximately 150 lenders gave the culture and character of female monasticism in its varied forms vivid visual presence.

This book is not, and cannot be, a re-creation of the irreplaceable and unrepeatable experience offered by the exhibition. Readers wishing to get some sense of the full range of objects displayed are encouraged to consult the catalog, in which virtually all of them are reproduced, along with a broad range of comparative material. The illustrative material provided here is, out of necessity, much more restricted, although it should still suffice to give some sense of the extraordinary and, it must be added, distinctive character of the visual culture of female monasticism. Especially in the later Middle Ages, this distinctiveness emerges with special clarity, but it can also be observed in the earlier period as well, be it in the choice of subject matter or the combination of techniques employed in the creation of these eloquent objects. All but two of the chapters offered here in translation are essays from the catalog stripped of its entries. They nonetheless can stand on their own. The remaining two essays—one by Jeffrey Hamburger and Petra Marx and the other by Jan Gerchow and Susan Marti—represent reworked amalgamations of introductory materials that, in the exhibition catalog, were employed to open various sections. They have been recast here to provide an appropriate initiation to the broad range of historical materials covered by this book, which, like the exhibition that stands behind it, is intended, above all, as a stimulus to further and much needed research.

## Notes

1. Faust 1984:498–511; Hamburger 1998b:67–71.

2. Buchwald 1897; Bertheau 1917; Kelm 1974, 1974/1975.

3. Much the same could be said of another classic and a milestone in the historiography of the Middle Ages: Eckenstein 1896/1963. For Power's contributions and

place in medieval studies, see Berg 1996 and McCallum Chibnal 2005, which points out that Power remained first and foremost an economic and social historian, not a historian of women.

4. A comparable, if less coordinated, collection of essays that has a pan-European focus and covers a period extending from late antiquity to the present is *Les religieuses* 1994.

5. A glance at the bibliographies in Goetz 1995 and 1999:318–29 ("Mittelalterliche Frauen- und Geschlechtergeschichte"), both of which provide excellent, if hardly comprehensive, overviews of scholarship, confirms that, despite numerous noteworthy contributions from German scholars, this is an area in which Anglo-American scholarship undoubtedly took the lead. Goetz himself notes the "coolness" of German medievalists not only toward feminist approaches but also more generally toward women's history, observing that "eine solche Skepsis der etablierten Mediävistik ist bis heute keineswegs überwunden [this skepticism on the part of established medieval studies has to this day hardly been overcome]" (321). Other obstacles remain as well: aside from a handful of references under the rubric of nonverbal forms of communication, the history of medieval art and the scholarship of historians of medieval art find no place whatsoever in Goetz's otherwise comprehensive survey of all corners of the discipline.

6. See cat. Schussenried 2003.

7. See Lorenz and Zotz 2005.

8. See Louis 2004 and *Metz enluminée* 1989.

9. McKitterick 1994/2004:1–35; Bodarwé 2004.

10. Kelly-Gadol 1977/1984. See also Herlihy 1985.

# Early Monasteries and Foundations (500–1200)

## *An Introduction*

JAN GERCHOW WITH KATRINETTE BODARWÉ,

SUSAN MARTI, AND HEDWIG RÖCKELEIN

From the beginnings of monastic life in the West, veil and crown have served as signs and symbols of women leading a religious life. Taking the veil was and remains the most important element in the changing of clothes that virgins perform on taking their vow of chastity. The veil functions as a bridal veil that symbolizes the betrothal of the virgin to Christ. The act of coronation, which from the tenth century was often added to the veiling, also has a bridal connotation. In this ritual, actual crowns were employed. From the late Middle Ages, crowns made of white strips of cloth decorated with red crosses symbolic of the wounds of Christ are documented.[1] Crown and veil thus represent both the outer requirements and the spiritual significance of the life of religious women in the Middle Ages.

This religious symbolism, however, itself serves to veil the ambivalent attitude of church fathers and theologians toward religious women. Women are by nature closer to Christ than is possible for men. At least this is what Pope Gregory the Great (in office 590–604) maintained at the beginning of the Middle Ages, basing his argument on, among other things, the fact that after the Resurrection Christ first appeared to a woman, Mary Magdalene. Because of this tradition, throughout the Middle Ages, the prayers of women were thought to be especially efficacious. In the twelfth century, the French theologian Peter Abelard (1079–1142) expressed a similarly high estimation of the dignity and spiritual standing of women in his

letters to Heloise, the abbess of the Paraclete (in office 1135–1164). None-theless, one can also find in Abelard's writings positions that point to the opposite extreme: No nun may touch "the relics, the sacramental vessels or the altar cloths, even if they were given to them for cleaning."[2] From the time of Dionysius of Alexandria (d. 265), women were regarded as "culti-cally unclean." As a result, they were considered unable to assume spiritual offices. In the few instances in which women were able to define the rules of their own religious lives—as in, for example, the case of Heloise's own monastic rule or that of the abbess Hildegard of Bingen (1098–1179)—one does not find such restrictions or deprecatory statements regarding women's capabilities. In any case, despite such ambivalence, throughout the Middle Ages, participation in a religious community remained an at-tractive and highly admired way of life.

For the early Middle Ages, it makes sense to adopt a broad, European perspective, not simply because of the relative scarcity of sources and ma-terials relating to the later Middle Ages but also because of the close con-nections and intensive exchanges that took place at this time between the dominant Frankish culture at the center and its wide-ranging ties that extended well beyond its boundaries without the restrictions imposed by nation-states. These networks were established and cultivated not only by missionaries, pilgrims, and scholars but also by *sanctimoniales* (literally, fe-male servants of the holy), as women pursuing a spiritual life had been called from the time of late antiquity.

Historical Overview

Until the sixth century, the religious life of women usually played itself out in the houses of their parents, in the cities where they had grown up, under the protection and with the support of relatives, overseen by the local bishop. We know of numerous women "dedicated to God," both virgins and widows. in the cities of Italy and Gaul from the fourth to the sixth centuries and in smaller numbers at a later date. Beginning in the fifth century, however, these veiled women were placed in newly founded monasteries, in keeping with the rulings of councils such as that held at Saint Jean de Losne between 673 and 675. Why was it only at this time that the first female monasteries came into being?

It is certain that the fundamental transformation of civic culture of late

antiquity into a new social structure based on gentile dynasties encouraged the establishment of monasteries. Religious women were dependent on protected spaces and functioning institutions that the weakened cities of late antiquity (such as Marseille, Arles, Tours, Poitiers, Laon, and Autun) were increasingly unable to provide. Many women may have sought the protection of monasteries in order to pursue a religious life against the will of their parents or husbands. The lives of the Merovingian saints Radegunde of Poitiers, Austreberta of Pavilly, and Burgundofara of Faremoutiers-en-Brie testify to this trend. In addition, by the seventh century, the Church had abolished the only ecclesiastical office that had been open to women, that of the deacon. Female deacons had previously helped with the baptism of women and had taken care of women who were ill. This downgrading of women leading a religious life may have contributed to the rise of female monasteries, which offered women new ecclesiastical roles, even if their scope remained limited to the monastic community.

The first female monastery in the West of which we have any knowledge is the one of John Cassian (ca. 360–430/435) in Marseille (ca. 410), followed by female monasteries in Rome, about which, however, we know very little. The number of foundations only increases from the beginning of the sixth century, the most important being the monastery of Saint-Jean in Arles, founded by Bishop Caesarius of Arles (in office 502–542) and his sister, Caesaria, around 503. Caesarius also wrote the first known rule specifically for a female monastery, the Regula sanctarum virginum (rule of holy virgins). Put to the test by Caesaria in her capacity as abbess and further elaborated by her and her brother, the Regula sanctarum virginum represented for its time a completely new notion of what a monastery should be. In addition to binding admittance for life, obedience to the abbess, the renunciation of private property, and the *vita communis* (common way of life), the rule stresses, above all, strict enclosure. Unbroken enclosure was designed to make of the cloister, which was, for reasons of security, located in the middle of the city, an island of safety. It also served to guarantee the chastity and virginity of the women and their undisturbed dedication to prayer on behalf of the outside world. The holy women were never to forsake the protection of their walls, and neither was anyone to disturb them by entering the monastery.

Toward the end of the sixth century, Columban, the Irish abbot of Iona, settled in France, where, by virtue of having founded the monastery of Luxeuil in the Vosges, he exercised considerable influence on subsequent

developments. He cultivated contacts with women of the ruling class, as a result of which the number of monastic foundations increased considerably. From then on, monasteries were no longer established only in the immediate vicinity of old Gallo-Roman cities but also in rural regions. The rules that far and away were the most widely followed in the Merovingian period (ca. 500–750) derive from the new monasticism of Columban. Far more common than the older rule of Caesarius and its reworking by Aurelian are the rules written by Abbot Waldeberts of Luxeuil (d. 670) and the student of Columban Donatus, the bishop of Besançon (ca. 625/626–660). The Benedictine rule appears only to have acquired increased influence in the eighth century. This development is important insofar as the rule of Columban only prescribed passive enclosure (the prohibition against outsiders entering the cloister), whereas Caesarius and Aurelian added to this strict active enclosure (the absolute prohibition against leaving the cloister).[3]

The preference for passive enclosure might possibly be attributed to the fact that only after the arrival of Irish itinerant monks does one find any mention made of double monasteries, institutions in which monks and nuns lived together or near one another, for the most part ruled by abbesses. Among other places, paired institutions of this kind existed in Gaul at Faremoutiers, Jouarre, Remiremont, Nivelles, Laon, and Chelles. Given that Irish monasteries were characterized by their great openness and lack of enclosed precincts, it seems likely that the wandering Irish monks, who were known as *peregrini*, introduced their native customs to France. At the monastery of St. Brigit of Kildare (ca. 455–525), monks and nuns lived together without strict separation. In addition, at least in rural areas, double monasteries permitted the monks to carry out the spiritual care (the performance of Mass and parish functions) and also, to a degree, to protect the women. In the early period, however, clerics or monks who had taken vows as priests were not required to carry out such functions as the daily performance of the Office or the taking of confession and the absolution of sins, as abbesses were able to perform these duties themselves, as were their fellow nuns.

In the Frankish kingdom of the Merovingians, that is, from 500 until the middle of the eighth century, a total of around 115 female or double monasteries were founded. Many of them, however, suffered destruction at the hands of the Normans or Saracens in the course of the seventh and eighth centuries; in the following Carolingian period, only sixteen of these institutions can still be documented.[4]

Given that, in the British Isles, the female monasteries of Hartlepool and Whitby were only founded in the middle of the seventh century, Anglo-Saxon girls went to Faremoutiers, Chelles, and Andelys-sur-Seine to receive a religious education and lead a religious life. The following two centuries, however, witnessed the founding of no fewer than sixty-five female monasteries in Britain of which nineteen are attested with certainty as double monasteries. As a rule, they were governed by abbesses, often from royal households. Important imperial synods were held at the Northumbrian royal monastery of Whitby, whose monastic school trained bishops, to which kings retired and which also served as their place of burial. Aldhelm (ca. 640–709), the bishop of Sherborne, wrote his treatise on virginity for the nuns of Barking, which, by praising the cloistered life as a better alternative to marriage or widowhood, contributed to its popularity in England.[5]

Anglo-Saxon missionaries and church reformers introduced the period of Franco-Irish dominance in the Frankish kingdom. They were in fact dependent on the support of the female and double monasteries in their homeland. It was above all the two archbishops of Mainz, Winfrid-Bonifatius (672/675–754) and Lul (ca. 710–786), who corresponded with abbesses and nuns in their native land, requested books from them, and recruited them for the development of monasteries in the Frankish kingdom. Their female companions (among them, Tecla and St. Lioba) founded the first female monasteries to the east of the Rhine (including Tauberbischofsheim, Kitzingen, Schornsheim, and Würzburg). St. Walburga, the sister of the two missionaries Willibald and Wunnibald, led the double monastery of Heidenheim near Eichstätt.

Like that of the Anglo-Saxons, the influence of the Irish can be traced all the way to Italy. In Rome as in the Langobard kingdom, there had been numerous female monasteries from the early fifth century. Among the wealthiest and largest of these convents was that of San Salvatore/Santa Giulia, founded in Brescia around 754 by the royal Langobard couple Desiderius and Ansa (fig. 1.1). As in England and the early Frankish period, royal women played a notable role as founders and abbesses, dedicating a significant part of their lives and their wealth to the foundation of female houses.[6]

From the middle of the eighth century (Synod of Ver, 755), the Frankish church underwent reforms that repeatedly addressed the common life of monks and canons and, in this context, that of nuns and women living

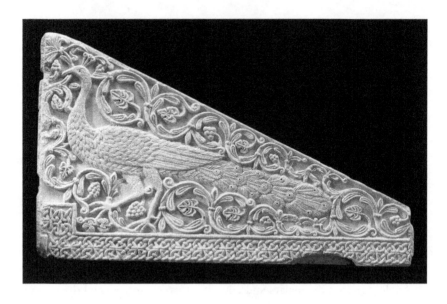

*Figure 1.1* Fragment of ambo with peacock from the abbey of San Salvatore/Santa Giulia, Brescia, northern Italy, mid-eighth century, marble, h. 73 cm. (Musei Civici d'Arte e Storia, Santa Giulia, Brescia, inv. MR 5829.)

a canonical life (*canonicae*) as well. This process culminated in 816 at the imperial synod convened in Aachen under the direction of Emperor Louis the Pious. For the first time, binding forms of life were prescribed for all religious communities in the empire of the Franks, that is, modern-day Germany, France, Switzerland, and northern Italy. These included the rule of St. Benedict for monks and a newly written rule for canons for the clergy. For women, the Institutio sanctimonialium, for which the authors had frequent recourse to the rule of Caesarius, was compiled.[7] Contrary to what is sometimes maintained, however, this rule did not establish either a conceptual or a normative distinction between a monastery and a *Stift*. It would be more accurate to say that the text's twenty-eight chapters established no more than a "framework of possibilities for acting" when it came to the formation of ways of life for female religious communities.[8] Although the regulations governing enclosure are in fact formulated in terms stricter than those found in the rule of Benedict, in other decisive matters, for example, the election of the abbess, the opposite obtains. Thus, for example, contrary to the Benedictine rule, no provision is made for a binding vow. At the same time, however, no provision is made for the

possibility of returning to the world. In the highly important matter of whether private property would be permitted, the Institutio actually envisages three alternatives: its renunciation or consignment to the community, the right to enjoy its use as long as one remained alive, and its free use through the intermediary of a worldly administrator. The basic provision of equality contradicts the possibility of maintaining one's own dwellings and servants.

In the wake of the synod, the Institutio, along with the rules for canons and the Benedictine rule, was widely disseminated. Yet we do not know of a single community that expressly adopted these institutions or put them into practice.[9] The terminology in the sources remains very vague. Only rarely is the distinction drawn between those religious women who are nuns (*monachae*) and those who are canonesses (*canonicae*). Rather, they are generally referred to as *sanctimoniales*. In like fashion, only one community is known to have adopted the Benedictine rule: the monastery of Remiremont in the Vosges, founded in 817, and even there hardly fifty years had gone by before the convent had returned to its previous way of life. In light of the unsettled course of developments in the ninth and tenth centuries, there is little point in insisting on a set of oppositional terms.

The eastern kingdom of the Franks in the region between the Lower Rhine and the Elbe, which was first conquered in the Saxon wars shortly before 800, witnessed a regular groundswell of foundations of religious institutions for women. In this region, over sixty new convents can be documented between the ninth and the middle of the eleventh century.[10] The only other regions with a significant number of *Frauenstifte* are Lothringen, with fifteen; Alsace, with seven; and the area around the Bodensee, also with seven.[11] As their rules, we can assume that all these convents modeled themselves on the wide range of possibilities represented by the Institutio.

Among these new foundations could be found such rich and long-lived institutions as Essen and Gandersheim (both founded in 852) and Quedlinburg (founded in 936), which enjoyed very close relationships with the ruling Liudolfing-Ottonian family (fig. 1.2). Gandersheim and Quedlinburg were named eleven times and Essen six times as the model for other female communities, suggesting that, by the end of the eleventh century, conditions had developed that were accepted and adopted elsewhere as normative. The circumstances in Saxony, however, are deceptive, insofar as these three female convents were both unusually well endowed and close

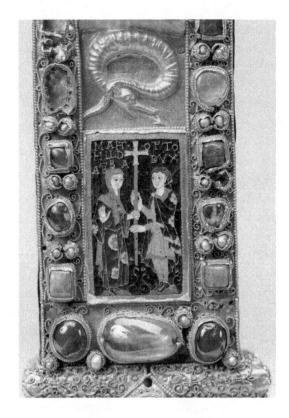

*Figure 1.2* Donor image with Abbess Mathilda II and Duke Otto of Swabia from the Otto-Mathilda Cross from Stift Essen, after 982. (Domschatz Essen, inv. 3.)

to the royal house and therefore by definition, at least in these respects, could not be taken as exemplary. In 987 an abbess such as Sophia of Gandersheim and Essen (in office 1001/1012–1039), a sister of Emperor Otto III, was in a powerful enough position to refuse to receive the veil from the local bishop, Osdag of Hildesheim, and insist that the archbishop, Willigis of Mainz, serve in his place. She thereby triggered the so-called Gandersheim conflict over who was in fact responsible for Gandersheim, a struggle that was only settled after armed conflict.[12] It is striking to what extent abbesses in this period felt free to act independently, just as their predecessors in the Merovingian period, such as Radegunde and Balthilde, had done. The documentary record reveals them acting less as religious leaders than as powerful female rulers conscious of their dominion within the boundaries of their monasteries.

In the ninth and tenth centuries, only one monastery besides Remire-
mont can be shown to have followed the Benedictine rule: the monastery
of St. Margaret in Waldkirch, founded around 910. In typical fashion, the
document of Emperor Otto III that touches on the matter, dated 994,
names two male monasteries as models. Only toward the end of the tenth
and in the course of the eleventh centuries did there emerge a clear defi-
nition and differentiation of the basic forms of life for female commu-
nities, which in their aims presented a clear choice: female Benedictine
monastery or *Frauenstift*. The forged foundation document for the *Stift* in
Essen, attributed to Bishop Altfrid of Hildesheim but in fact dated around
1090, testifies to this process: in anticipation of the *curia* (houses of the ca-
nonesses) that would later be in possession of the *sanctimoniales*, it speaks of
benefices and households.[13] From other documents, it can also be deduced
that, already in the tenth century, the property of the community was
divided among the abbess, the prioress, and the convent, to which now
were added canons. Essen was on the way to becoming a *Frauenstift*. Only
in 1246, however, was its new status made explicit: "secularis ecclesia de
Asnida," the secular (female) *Stift* of Essen.

*Frauenstifte* are generally referred to, in scholarship as well in everyday
speech, as foundations of canonesses, female foundations, or even as "in-
dependent, secular, and high aristocratic" ("freiweltlich-hochadelig"). All
these terms, however, characterize a way of life that could be found only
from the thirteenth and fourteenth centuries onward and then only in a
small number of foundations, such as Essen, Quedlinburg, and Gander-
sheim, to which could be added Herford, Freckenhorst, Vreden, St. Maria
im Kapitol and St. Ursula in Cologne, Niedermünster and Obermün-
ster in Regensburg, the Fraumünster in Zurich, St. Stephan in Strasbourg,
Remiremont, and Nivelles in modern-day Belgium, as well as Buchau
am Federsee. From this time until the secularization, these foundations
were in fact reserved for the high aristocracy. Yet, as has recently been
shown, the same cannot be said of the early and High Middle Ages.[14]
Early evidence of entry payments (from 779 onward) makes it clear that
dependents or those without means hardly ever found a place in such in-
stitutions. Rather, until the middle of the twelfth century, it was the entire
spectrum of the "free" that both disposed over landed property and could
afford a monastic life.

The aristocracy and royalty were, however, the indispensable pillars of
female religious institutions, without whose enormous endowments for

the establishing and outfitting of monasteries and *Stifte* none could have been created, let alone have survived. The practice of commemorative prayer permitted a female convent to become the focal point of a family and contributed to the formation of rulership, as did, at a later date, castles, and manors. Over and above the interest of families in whatever spiritual services "their" nuns could perform, the motivation of the women to lead a religious life and to contribute to their own sanctification through ascetic exercises should not be underestimated. Moreover, female monastic communities were the only places where, in the early and High Middle Ages, women could acquire a thorough education and, what is more, employ it, be it as authors, scribes, painters, makers of textiles, or, not least, as patrons and directors of building projects. In the world, as opposed to the cloister, all these activities were matters for men. Female monasteries hardly represented dead ends off the beaten track and leading nowhere. Until the twelfth and thirteenth centuries—the period witnessing the foundation of cities—monasteries remained focal points in western and central Europe, surrounded by large territorial holdings and endowed with numerous rights. The material endowment of a monastery exceeded that of nearly all lay households; as a result, it offered a very attractive standard of living. Thus life in a monastery was certainly healthier and for that reason alone for most women lasted longer than a life in the world.

From the tenth century onward, the growing number of priests (canons) increasingly compromised the relative independence and areas of competence that women had enjoyed in monastic services in the Merovingian period. The value of the prayer of virgins, which had been so highly prized in the early Middle Ages, was diminished in the face of private masses, which could only be celebrated by priests. The development culminated in the ecclesiastical and monastic reforms of the late eleventh and twelfth centuries, a period of great social, economic, intellectual, and religious transformation. Reforms of the church that were vehemently supported by popes as well as by various monastic congregations also had a dramatic impact on previously accepted ways of life within female monasticism. New concepts of reform were tried out, alternative ways of life proposed, and stronger sets of norms enforced, a process that ultimately led to the formation of various different orders. As always, criticism of received traditions provided the reformers with their point of departure and legitimation. At the Lateran Synod of 1059, the Roman cleric Hildebrand (later Pope Gregory VII, in office 1073–1085) condemned the Aachen Institutio

as uncanonical because it violated the principle of apostolic poverty. Several councils, culminating in the council of Vienna in 1311, repeated the prohibition of this rule and required the adoption of either the Benedictine rule or the still stricter Augustinian rule for canons and canonesses. In this, they were successful. In greater Saxony alone, twenty-three such convents were converted into Benedictine communities, foundations of Augustinian canonesses (*Chorfrauenstifte*), or male monasteries. In France and England, not one monastery of the early medieval period became an aristocratic *Damenstift* during the later Middle Ages. Those sources that accuse canonesses of immorality and lack of discipline requiring reform were, for the most part, written from a clerical perspective that often masks the political motivations of male reformers.[15] To this day, modern scholarship often uncritically repeats such prejudiced judgments of this religious way of life.

From the twelfth century onward, however, it was the reformers who set the tone. Benedictine reform congregations, such as Hirsau and Siegburg, among others, reformed canons (both male and female Augustinians), and new orders such as the Cistercians and Premonstratensians were henceforth responsible for the majority of new monastic foundations. Although no numbers are available for the German Empire, those for France and England give a good impression of the dynamic of religious change: between 1080 and 1170 the number of female monasteries in these regions increased by a factor of four, from around one hundred to four hundred.[16]

Double monasteries of the Benedictine or Augustinian order, consisting of a convent of women and another of men in close physical proximity forming a legal and organizational unity under the direction of the abbot of the male community, constitute part of the transformation. These double monasteries, which spread from the reform center of Hirsau into the southwestern region of the Empire and modern-day Austria, took as their model the apostolic ideal of women and men living together in service of Christ. Many of them, however, survived for only a short period, and only a few left behind substantial material traces.[17] Double monasteries offered a fruitful ground for the development and transmission of early forms of vernacular literature. Rules were translated for women, who were not always literate in Latin,[18] prayers were glossed and elaborated with instructions in the vernacular, and original religious poetry was composed.[19] It is possible that the author of the *Speculum virginum* (Mirror of virgins), whose name is not

known, came from the reform circle of Hirsau. His unusual work was created around 1140 to serve in the pastoral care of the many newly founded female communities.[20] It was cast in the form of a dialogue and embellished with numerous illustrations, all of which served an ideal founded on the virtues of humility, love, and obedience,

Closely related to the *Speculum virginum* in its use of text and image as didactic media, although very different in terms of its content and conception, is a work written about forty years later, the encyclopedic *Hortus deliciarum* (Garden of delights) of the abbess Herrad of Hohenburg in Alsace (in office ca. 1176–after 1196). Studying the most modern theological texts from contemporary circles at the university of Paris, Herrad wrote a book covering the entire history of Christian salvation and held that theological and encyclopedic knowledge of this kind, which was otherwise hardly available to women, was appropriate for her nuns. Only a single fragmentary piece of manuscript evidence testifies to the style of the miniatures of the *Hortus deliciarum*, which was destroyed by fire in 1870 and is known only from drawings after the original (fig. 1.3).[21]

No less different from the *Speculum virginum* are the ideas of the charismatic visionary Hildegard of Bingen (1098–1179) concerning the best way of achieving salvation. Her distinctive point of view emerges in exemplary fashion from the celebrated controversy in which she engaged with Tenxwind of Andernach (d. after 1152), the head of a community of Augustinian canonesses. Tenxwind, in conformity with the content of the *Speculum virginum*, bitterly opposed the manner in which Hildegard's nuns conducted themselves during the celebration of the Divine Office, with unbound hair, white silk garments, and crowns embroidered with gold. In contrast, Hildegard regarded this festive way of celebrating the liturgy as a kind of foretaste of heavenly glory.[22]

The way of life represented by *Frauenstifte*, without binding vows and enforced enclosure, appears to have remained attractive to many women well into the later Middle Ages. In the fourteenth and early fifteenth centuries, private households, close relations with family members, and a relaxed approach to enclosure could frequently be observed in monastic communities that previously were strictly enclosed and that would become so once again in the second half of the fifteenth century. For example, Elsa von Reichenstein (ca. 1408–1486), abbess of St. Caecilia in Cologne, patron of Stefan Lochner's famous *Madonna of the Violets* (Diocesan Museum, Cologne) and the initiator of a new program of stained

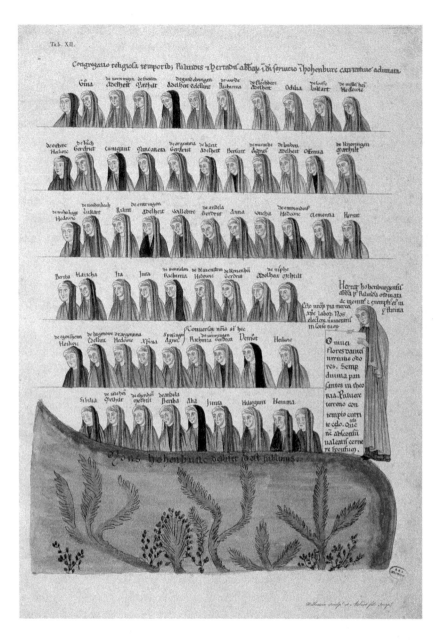

*Figure 1.3* The nuns of Hohenburg in the *Hortus deliciarum* of the abbess Herrad of Hohenburg, late twelfth century, engraving after the edition of Christian Moritz Engelhardt, Strasbourg, 1818, pl. XII. (Bibliothèque Nationale et Universitaire, Strasbourg [France].)

glass in the cloister that originally included 119 panels,[23] strongly, albeit vainly, opposed the transformation of her *Stift* into a monastery of Augustinian nuns.

When one takes into account the various religious activities of late medieval canonesses, which included the performance of the Divine Office, participation at Mass, other religious services, and any number of processions and liturgical practices, there is little to support the widely held notion that religious life in such institutions reached a nadir in the fifteenth century.[24] That said, only a few outstanding, economically well-endowed, and, from the fourteenth and fifteenth centuries, exclusively aristocratic institutions with the closest of ties to regional nobility were able to maintain their exceptional status during and beyond the reforms of the fifteenth and the Reformation of the sixteenth century.

## Persons and Rules

Among the thousands of nuns from the period spanning the sixth through twelfth centuries, it is almost exclusively abbesses of whom images were made and passed down. They represented their monasteries and *Stifte* to the outside world, not only in legal matters but also as the only individuals who were allowed such contact in the context of strict active enclosure (cf. fig. 3.1). Beginning in the eleventh century, abbesses minted their own coins, and from the twelfth century they possessed their own seals on which they were both named and portrayed.[25] Their special status quickly resulted in special spaces being set aside for them apart from the convent. There is evidence of private apartments and burial places for abbesses from as early as the eleventh century and of residences with private chapels and chancelleries from the twelfth century onward. In keeping with such arrangements, abbesses' endowments and upkeep were kept separate from those of the convent. Both parties maintained separate seals and administrative structures.

The convent owed the abbess unconditional obedience, although the abbess was supposed to seek the advice of her sisters in all decisions. The Benedictine rule prescribed the free election of the abbess from the convent's members, but until the twelfth century every known instance points to their having been nominated (followed by confirmation by the convent) by influential donors, benefactors, or even the monarch. Formal

electoral processes, which of course were not free of outside interference, are only known from a later period.

In contrast to abbesses, very few representations of nuns have survived. The first, few exceptions, such as the famous image of the community in the *Hortus deliciarum* of Herrad of Hohenburg (see fig. 1.3)[26] or those in the necrology from Obermünster in Regensburg (see fig. 3.6), appear only in the twelfth century. In most cases, we only know the nuns' names. Even written testimonies of nuns before the eleventh century remain a rarity. Convents could include anywhere from three to three hundred nuns. A woman became a member of the community after a period of probation—as a rule, a novitiate of one year—at the end of which she made her profession (from the Latin *professio*), the binding vow on the rule, after which she assumed a place among the ranks of the nuns in keeping with her age at entry. Girls were offered to the patron saint of the monastery at the high altar at ages as young as six or seven, usually in conjunction with a gift of material goods. They attended the monastic school and made their profession when they reached their majority at the age of sixteen to seventeen.

Monastic offices were already foreseen in the earliest rules. Among them, that of the prioress (or deaconess) as leader of the convent stands out most clearly. From the eleventh century, she often emerges as the counterpart of the abbess of the monastery or *Stift* and was often a candidate to succeed her. Other high-ranking positions that could also serve as stepping-stones to the position of abbess were the cellarer (responsible for the economic administration of the convent's properties), the *magistra* or *scholastica* (the teacher responsible for the training and upbringing of oblates and novices), and the *thesauraria* (the keeper of the treasury, where liturgical implements and furnishings were housed).

From the very beginning, men also had a place in female monastic communities. Priests and deacons were required for what was at first the only sporadic celebration of Mass. Bishops entered enclosure on the occasion of the consecration of virgins and abbesses. Clerics also played a role in the administration and the library. With the massive increase in the number of masses celebrated beginning in the eighth century, the need for clerics grew accordingly. At the Saxon *Frauenstift* in Essen, the monks of the nearby monastery of Werden originally provided the service, but beginning in the tenth century, canons affiliated with the *Stift* had taken over the task. These canons increased in number until the thirteenth century, when they

organized themselves into a convent with its own statutes, property, and benefices that had the same rights as the women's convent when it came to the election of the abbess. Parish churches that belonged to venerable, well-endowed abbeys were cared for by their own affiliated clergy. Priors, who in many monasteries and *Stifte* rose to the position of directors, were introduced as a result of ecclesiastical reform.

The way in which a monastic community brought together many people of disparate social origins always required clear guidelines and rules. As a result, even the earliest communities of hermit saints required regulations that could govern their Christian communities. These were transmitted and elaborated by means of stories, saints' lives, and moral treatises as well as by rules per se. The determination of whichever way of life was to be adopted by a given community as well as its programmatic formulation were the responsibility of the founders. Regulations of this kind were often passed on orally and continuously adapted to changing requirements. In most cases, they were only written down in moments of crisis.

As previously mentioned, the oldest rule for a female monastic community was compiled by Bishop Caesarius of Arles (in office 502–542) together with his sister, Caesaria, for the foundation Saint-Jean in Arles. Put to the test of practice by Caesaria in her capacity as abbess and further elaborated together with her brother, the *Regula sanctarum virginum* represented for its time a completely new notion of what a monastery should be. Despite the fact that its radical conception of enclosure rarely was implemented, it repeatedly offered inspiration to reformers of later periods. For example, in addition to having provided Carolingian reform synods with a model, the rule of Caesarius also served the abbess Uta during the reform of Niedermünster in Regensburg in the tenth century (Staatsbibliothek Bamberg, Msc. Lit. 142).

With the increased use of the Benedictine rule from the tenth century onward, however, the problems in applying a rule conceived for a male community to convents of women became clear. Various attempts were made to adapt the rule for womens' use. These ranged from the addition of simple notations[27] to complete adaptations and translations. At this point, given that the only accepted rule could no longer, as previously had been the case, be adapted to changing conditions and individual requirements, it was instead, beginning in the tenth century, supplemented with collections belonging to a new genre known as *consuetudines*, or customs, that collated the specific usages of a particular community. In this way, it proved pos-

sible for monastic life to continue to evolve, even as the normative priority of the Benedictine rule was acknowledged. *Consuetudines* have one thing in common with rules, however, and that is that they can only convey an idealized conception of monastic life. In spite of the many normative texts that have come down to us, we can only have an approximate impression of what life in an early medieval monastery was really like.

## Education, Writing, and the Production of Textiles

When monasteries are described as guardians of culture and education, reference is usually made to male monastic communities only. New research, however, has been able to demonstrate that the extent to which female communities participated in the learned culture of the early and High Middle Ages has long been underestimated. For women as for men, learning was an indispensable precondition for the proper performance of prayer services and for understanding the most important texts pertaining to matters of faith. Only when they had mastered Latin could the *sanctimoniales* acquire standing within the church. As a result, learning this ecclesiastical language was among the very first responsibilities of young girls in the monastery. By memorizing biblical texts, they learned the Latin language as they learned to read: the Psalms, the Gospels, prayers such as the paternoster, hymns, and, later, other books of the Bible. Translations and commentaries in the form of glosses served as aids to understanding, since schoolbooks in the modern sense did not exist (fig. 1.4). Although the early convents in the Frankish kingdom had self-consciously rejected classical learning, the *sanctimoniales* of the tenth through twelfth centuries required advanced training in the Latin language based on grammatical and classical texts in order to understand the full range of meanings informing the most important doctrinal texts. The writings of the church fathers and biblical commentaries were used to strengthen their understanding of Scripture. For example, the abbess Gisela of Chelles asked that Alcuin send her the commentary on the Gospel according to John that is preserved in a manuscript from the *Stift* in Essen.[28] Her exchange of letters with Alcuin, like other comparable correspondence, demonstrates the degree to which religious women maintained close intellectual contact with contemporary scholars and centers of learning.[29]

Acknowledging this intellectual context places the limited number of female authors of whom we have any knowledge into proper perspective.

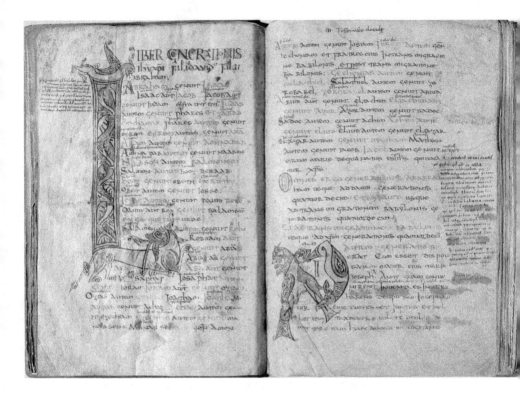

*Figure 1.4* Beginning of Genesis in the glossed Carolingian Gospel Book from Stift Essen, northeastern France or northwestern Germany, ca. 800, with Anglo-Saxon glosses from the tenth century. (Domschatz Essen, ms. 1, pp. 29–30.)

In addition to Roswitha of Gandersheim, who composed Christian dramas in the style of Terence, there were numerous religious women who wrote saints' lives, monastic annals, and chronicles. Many of their works, however, are either lost or have been attributed to male authorship. Baudonivia, a confidante of the Merovingian queen Radegunde, the founder of the monastery of Sainte-Croix in Poitiers, wrote a life of the queen at the request of the convent's nuns. An author portrait serves as a frontispiece in a copy illuminated in Poitiers in the eleventh century and shows her as a divinely inspired author holding a wax tablet and stylus; it is one of the earliest representations of a woman as an author (fig. 1.5).

Contrary to what we are accustomed to today, in the Middle Ages writing was a skill unto itself, independent of the ability to read. Numerous styluses testify that the application of writing, whether in administration

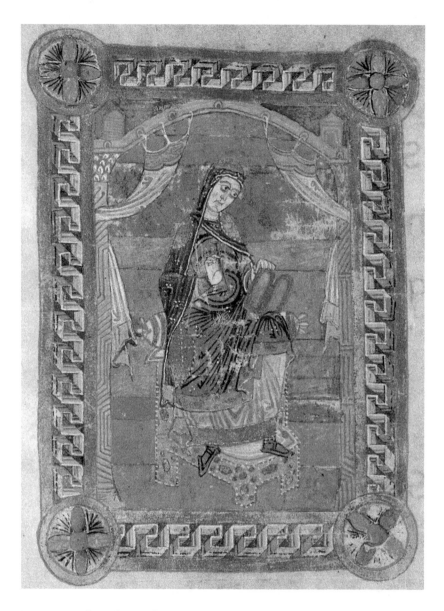

*Figure 1.5* Radegunde as author, miniature in the *Vita* of St. Radegunde from Sainte-Croix, Poitiers, late eleventh century. (Bibliothèque municipale/La médiathèque François Mitterand, Poitiers, ms. 250, f. 43v.)

or the practice of prayer, was an everyday affair. Some communities, moreover, had their own trained scriptoria for the production of books. Occasionally, women, such as the nuns at the convent of Chelles in the ninth century or the nun Diemut at the double monastery of Wessobrun in the twelfth century, also wrote on behalf of male communities or cathedral chapters. In other cases, newly produced books helped make possible the foundation of additional monasteries. Like other forms of craft and artistic activity carried out by *sanctimoniales*, writing itself constituted a way of praising God.

From time immemorial, the production of textiles, be it the weaving of simple fabrics for garments or the production of elaborate embroideries employing expensive materials, was of great importance in female monastic communities. Numerous archaeological finds from the seventh and eighth centuries testify to this fact, for example, spindles and weights for weaving from the Anglo-Saxon double monastery at Whitby. In addition, various early medieval saints' lives speak of the exquisite textiles made by their protagonists. The so-called veil of St. Harlindis,[30] the abbess of the female monastery at Aldeneik in the Maas region (Belgium), is an outstanding example of a way of handling textiles that is much more widely attested. The precious cloth, very often of Byzantine origins, was employed in the most varied fashion and reused again and again, enlarged, and then linked to personalities who according to legend played an important role in the monastery's history.

Pieces of jewelry in new settings, imitations of precious stones, and fragments of glass from Whitby and Barking, both large Anglo-Saxon women's abbeys, indicate that in the early Middle Ages the production of textiles was by no means the only craft carried out at a very high level of proficiency within the precincts of female monasteries.[31] Just how widely these traditions were practiced and how long they were maintained into following centuries has not yet been determined with certainty.

Patrons, Properties, and Treasuries

Kings, together with the aristocracy, funded and supported female monasteries and *Frauenstifte* as residences, as centers of rule, as places of retirement, as mausolea, as ways of securing the salvation of their souls, and, not least, as schools in which their daughters (and occasionally also their sons) could be

brought up and educated. Queens, who passed the later stages of their lives as widows in monasteries, often left them a portion of their personal possessions. In return, royal monasteries tended to the reputation of the ruling dynasty and the liturgical commemoration (*memoria*) of their family.

The monastery of Sainte-Croix in Poitiers, founded in the middle of the sixth century by King Chlothar I and his wife, Radegunde (520–587), provides an example. Radegunde retired to the monastery together with her adopted daughter, Agnes, after she had left her husband on account of his having murdered her brother. Radegunde not only selected the monastery's rule (that of Caesarius of Arles), she also appointed Agnes as the first abbess and, using her contacts with the Byzantine emperor Justinus II, acquired a precious relic of the Holy Cross for her monastery.

The women's abbey of Chelles to the east of Paris was founded in 658–659 by Queen Balthilde (d. before 680), the wife of King Chlodwig II. After her husband's death in 657, she ruled the portion of the kingdom known as Neustria, but after her fall from power in 665, she retired to her foundation at Chelles, where she not only left many treasures and her tomb but also several garments, which were preserved and revered as relics (see fig. 9.1).[32]

Remarkable examples of foundations established by female benefactors from royal houses can also be found in Italy. In addition to the royal Langobard monastery of San Salvatore/Santa Giulia in Brescia, mention can be made of the women's abbey of San Sisto in Piacenza, to which Angilberga (d. after 889), the widow of Emperor Louis II, left her possessions. Female rulers of the Ottonian dynasty cultivated this tradition further.

The monarch granted religious women certain rights, such as the free election of the abbess and the ecclesiastical advocate, protection by the king, and market, minting, and customs privileges, as well as immunities. In return, he expected the convent not only to pray on his behalf but also to provide hospitality to him and his court on his peregrinations as well as to provide either mounted soldiers or their equipment in support of his military undertakings (*servitium regis*). In addition, grants and privileges to aristocratic monastic foundations were presented as gifts to aristocrats in return for loyalty to the monarch.

In the course of centuries, many female monasteries and *Stifte* acquired considerable holdings of property. Nonetheless, the transfer of possessions to female monasteries from freemen and aristocrats (so-called private charters) are less well documented and researched than those made to male

monasteries. Hardly any original documents from the early period have survived. What we have are copies from the later Middle Ages (fourteenth and fifteenth centuries) in collections of charters, copial books, and rolls of revenues, as well as lists of contributions and interest payments. From the High Middle Ages survive a few inventories of property recorded in a mixture of Latin and the vernacular. These documents, which include the earliest witnesses to Old Saxon, give us a glimpse into administrative practice.[33]

Whereas in female monasteries secular duties involving the administration of property and legal matters were exercised by a prior, abbesses assumed responsibility for these functions in *Frauenstifte*. They administered justice at courts on progresses through their territories, controlled the manorial officer, who administered the offices, and gave dependent serfs the opportunity to protest abuses of office perpetrated by their officials.[34] They had the right to use a seal, mint coins, present fiefs, and exercise the rights pertaining to the assembly of territorial estates. Whether involving conversions, pastoral care in a parish context, or internal governance of the convent, the abbesses of Mons, Nivelles, and Herford assumed responsibilities that differed little from those of bishops.

All monasteries stood under the protection of one or more saints, who were selected at the time of their foundation by the bishop, the lords to whom the church belonged (*Eigenkirchenherr*), or the mother monastery and whose bodily remains, known as relics, were transferred to the new foundation. The saints were understood to be the representatives and actual owners of the religious community's property. They protected the inhabitants from dangers, provided them with internal unity, and represented them to the outside world. For these reasons, patron saints were frequently portrayed on the seals and coins of the convent (fig. 1.6). Offerings of goods were handed over to them, and oaths were sworn on their relics.

The saints and their relics, along with liturgical furnishings and service books, constituted the most valuable spiritual and material treasure of the convent. Written inventories of the relics and liturgical treasures (books and vestments) that were made from time to time give us an impression of the former wealth of female communities of which often no more than a fraction survives. Religious women went to great lengths to increase their holdings of treasure through exchanges, gifts, and purchases and thereby to increase the status of their communities (fig. 1.7). Among those with significant treasuries were Chelles, Säckingen, Essen, and Gandersheim. The bones of the saints were wrapped in pieces of cloth that ranged in

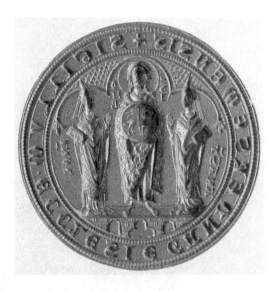

*Figure 1.6* Matrix of the great seal of the Stift Gandersheim, Gandersheim (?), mid-thirteenth century, brass, dm. 8.3 cm. (Niedersächsisches Staatsarchiv Wolfenbüttel, 2 Slg. Gr. 1 C K2.)

quality from simple strips of white linen to richly decorated pieces of silk imported from Persia, Byzantium, and Egypt and tagged with notes written on small pieces of parchment (so-called *authenticae*) that recorded the name of the saint. The wrapped relics were then either placed in lead boxes that were interred in the altar table and thereby hidden from the eye or placed in expensive gilded shrines studded with precious stones that were placed prominently on the altar or exhibited in the sacristy (fig. 1.8).[35] From the twelfth century onward, proper treasuries—raised, vaulted, windowless chambers—were built in or adjoining the church (fig. 1.9).[36] The supervision of these rooms, as well as power over their keys, lay in the hands of one of the canonesses, who was known as the *custrix* or sometimes as the *thesauraria*.

An astonishingly large number of masterpieces of early and high medieval art were either commissioned by or for female monastic communities. Among them are works such as the famous *Golden Madonna* from the *Frauenstift* in Essen (see fig. 9.6) made around 980 and hence the oldest extant sculptural representation of the Virgin Mary in the round. The sculpture, which is carved from wood and completely covered with beaten

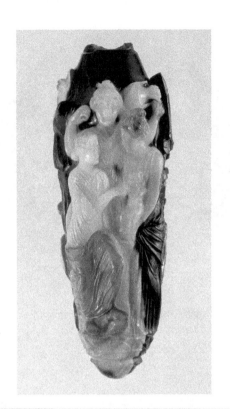

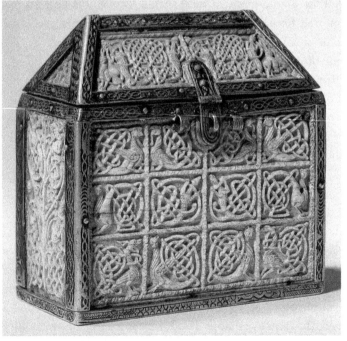

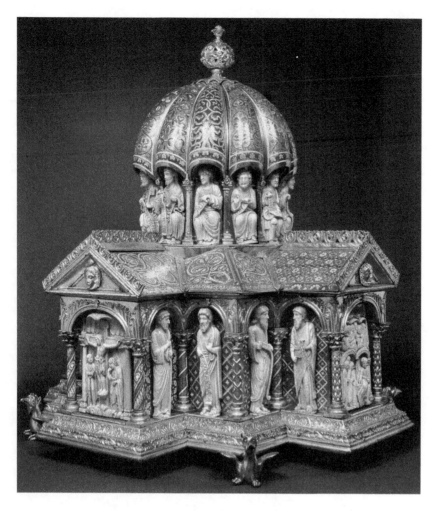

*Figure 1.7* (top, opposite page) Onyx-Alabastron from Stift Nottuln, Roman, ca. 50–30
B.C., sardonyx, h. 9 cm. (Staatliche Museen zu Berlin, Antikensammlung, inv. FG 11362.)
*Figure 1.8* (bottom, opposite page) Rune casket from Stift Gandersheim, Anglo-Saxon,
late eighth century, walrus horn (?), h. 12.6 cm. (Herzog Anton Ulrich Museum, Braun-
schweig, inv. MA 58.)
*Figure 1.9* (above) Dome reliquary from Stift Elten, Cologne, ca. 1185 and middle of the
nineteenth century, h. 54.5 cm. The form of this reliquary resembles that of a medieval
treasury. (Victoria and Albert Museum, London, inv. 7650–1861.)

gold, played an important role in the liturgy and piety of the *Frauenstift*, of which Mary was the principal patron. The monumental wooden doors of St. Maria im Kapitol in Cologne, which hark back to early Christian models, are the most important work of sculpture to have survived from the eleventh century in all of northern Germany. The oldest surviving panel painting north of the Alps, the antependium from Soest (see fig. 9.3), like the vast majority of the earliest painted retables and antependia, also comes from a female community, the monastery of St. Walpurgis in Soest. This short list of works of extraordinary importance for the history of art could easily be extended.[37] Although most of these works have received their fair share of scholarly attention, they have never been considered together as works made for or in female monasteries.

## Notes

1. Reproduced, for example, in the initial for Christmas in the Codex Gisle, Bistumsarchiv Osnabrück, Inv. Ma 101, p. 25; cf. fig. 5.2.

2. T. P. McLaughlin 1956:260.

3. Muschiol 1994.

4. Bodarwé 1997.

5. Aldhelm, *De Virginitate*, recorded in Lambeth Palace Library, London, Ms. 200 (part 2).

6. Wemple 1981; Veronese 1987.

7. A ninth-century copy can be found in Munich, Bayerische Staatsbibliothek, Clm 14431.

8. Schilp 2005.

9. Schilp 1998.

10. Ehlers 2003.

11. Parisse 1991.

12. Ehlers 2001:280–286.

13. Landesarchiv Nordrhein-Westfalen, Hauptstaatsarchiv Düsseldorf, Stift Essen Urk. 1.

14. See, most recently, Felten 2003.

15. Andermann 1996.

16. Venarde 1997.

17. Exceptions are the two Benedictine monasteries of Admont in Steiermark (Austria) and Engelberg (Switzerland) as well as the double Augustinian house in Seckau (Austria).

18. For example, see bilingual copies of the Benedictine rule, Engelberg, Stifts-bibliothek, Cod. 72, and Stuttgart, Württembergische Landesbibliothek, Cod. theol. et phil. 4° 230. See also cat. Bonn/Essen 2005: nos. 220–221.

19. Examples include the St. *Trudperter Hohelied*, Vienna, Österreichische Nation-albibliothek, Cod. 2719 (Theol. 593), and the Millstätt interlinear gloss on the psalter and hymnal from Admont, Vienna, Österreichische Nationalbibliothek, Cod. 2682. See cat. Bonn/Essen 2005: nos. 208–209.

20. Among the numerous manuscripts are London, the British Library, Ms. Arun-del 44, and Historisches Archiv der Stadt Köln, Best. 7010 (W) 276 A. See cat. Bonn/Essen 2005: nos. 205–206.

21. "Scenes from the Life of John the Baptist," London, the British Library, Ms. Add. 42497. See cat. Bonn/Essen 2005: no. 204.

22. Mews 2000:237–238.

23. Much of the cycle of stained glass is now in the treasury of the Cathedral of Cologne; see Rode 1974:149–162.

24. Klueting 2001:331–332.

25. For example, Adelheid von Sommerschenburg, abbess of Quedlinburg and Gandersheim (Niedersächsisches Staatsarchiv Wolfenbüttel, 23 Urk. [June 10, 1167]); bracteate with Abbess Adelheid III. (in office 1161–1184) from Quedlinburg (Nu-mismatic Collection, Staatliche Museen zu Berlin, part of the hoard from Freckle-ben, Inv. 1860/464 [ID 1659]); bracteate with Abbess Berta (in office ca. 1160–ca. 1180) from Nordhausen (Numismatic Collection, Staatliche Museen zu Berlin, Inv. alter Bestand); bracteate from Eschwege, around 1200 (Numismatic Collection, Sta-atliche Museen zu Berlin, from the Löbbecke Collection, Inv. 1925/1053). See also Bedos-Rezak 1988:61–82.

26. Tinted engraving after the original destroyed in the fire of 1870 in the library of the Grand Séminaire in Strasbourg.

27. Fragment of the Benedictine rule from Stift Obermünster, Regensburg, Bischöfliche Zentralbibliothek Regensburg, Fragment I.1.5 Nr. 6. See cat. Bonn/Essen 2005: no. 28.

28. Universitäts- und Landesbibliothek Düsseldorf, Ms. B 4.

29. Letter of a student in the school of the *Stift* Essen, Universitäts- und Landes-bibliothek Düsseldorf, Ms. B 3; "Regensburger Liebesbriefe," Munich, Bayerische Staatsbibliothek, Clm 17142. See cat. Bonn/Essen 2005: no. 102.

30. Treasury of the church of St. Catharine, Maaseik (Belgien), Inv. 102. See cat. Bonn/Essen 2005: no. 119.

31. Collection of finds from Whitby: Whitby Literary and Philosophical Society/Whitby Museum, Yorkshire; from Barking: Valence House Museum, Dagenham, Essex.

32. All in the Musée Alfred Bonno, Chelles.

33. Gospel Book with "Archive" from Freckenhorst, Münster, Landesarchiv Nordrhein-Westfalen, Staatsarchiv, Mscr. VII Nr. 1315; *Heberegister* of Freckenhorst, Landesarchiv Nordrhein-Westfalen, Staatsarchiv Münster, Mscr. VII Nr. 1316a; Old Saxon sermon for All Saints' Day, in Universitäts- und Landesbibliothek Düsseldorf, Ms. B 80 (Leihgabe der Stadt Düsseldorf). See cat. Bonn/Essen 2005: nos. 192–194.

34. Visitation report of Abbess Irmgard of Herford, Münster, Landesarchiv Nordrhein-Westfalen, Staatsarchiv, Fürstabtei Herford Urk. 88. See cat. Bonn/Essen 2005: no. 195.

35. Reliquary flasks from altars in the church of the Stift in Essen, Domschatz Essen, Inv. r1–3.

36. In Frauenstift Essen, the treasury adjoined the south transept; in the church of St. Servatius in Quedlinburg, it was located in the raised choir.

37. The following essays, above all, that by Hamburger and Suckale, refer to a great many of these. Further examples can be found in cat. Bonn/Essen 2005.

# The Time of the Orders, 1200–1500

## *An Introduction*

JEFFREY F. HAMBURGER, PETRA MARX, AND SUSAN MARTI

In Europe, the twelfth century was a time of thoroughgoing economic, social, and religious transformation. Numerous new, hierarchically organized orders, which also exercised considerable attraction for women, took the place of the various older, rather freely regulated forms of monastic life. Over the course of the twelfth and thirteenth centuries, the way in which these groups, founded and formed by men, dealt with women gradually changed: openness gave way to strict regimentation and equality to patriarchal monastic structures.

The Cistercians, whose founder, Robert of Molesme (ca. 1028–1111), insisted on strict adherence to the original principles of Benedictine monasticism, participated most extensively in the religious women's movement. In 1125 Robert's successor, Stephen Harding (d. 1134) established the first female Cistercian convent at Le Tart. Beginning around 1190, the order began to incorporate female communities that had either been founded previously or were in the course of formation, a process that involved recognizing these houses as members of the order with equal privileges and obligations. In German-speaking regions, this development led in the first third of the thirteenth century to a new wave of foundations for female Cistercian houses: in the wake of a mere fifteen foundations in the previous period, there followed approximately three hundred new ones. In many regions, the number of female Cistercians far exceeded that of their male counterparts.[1]

The General Chapter, the annual gathering of the heads of the Cistercian order, reacted to this dramatic growth from the 1220s onward by radically curtailing new foundations and incorporations. The acceptance of new houses was henceforward made dependent on the existence of a monastic complex and sufficient material means of support, so that the maintenance of enclosure would not be threatened either by begging or by working outside the monastery's walls. The order's restrictive manner of dealing with female houses meant that their status remained uncertain: whereas some were fully incorporated, others followed the Cistercian rule without having been fully incorporated, not to mention independent, unauthorized declarations of affiliation. From a modern perspective, it is often quite difficult to determine the status of a convent's designation as Cistercian according to the order's legislation.

The *fratres minores*, the lesser (or humble) friars, who gathered around Francis of Assisi (1181–1226) aimed to overcome the increasing gap in the cities between the rich and the poor by means of active Christian charity and self-imposed poverty. Two principal aspects of the Franciscan movement nonetheless remained forbidden to women, who, led by the aristocratic Clara (1193/1195–1253), enthusiastically attached themselves to the movement: public preaching and charitable work. As a result, the requirement to go without property fell on them more heavily. Clara, having taken the habit and founded a female community in San Damiano, became in 1212/1213 the first woman known by name to have written a rule of her own, whose papal approval in 1253 led to the official foundation of the Franciscan order. Of the later foundations (of which, by the end of the fourteenth century there were 450 in the whole of Europe), only a few followed Clara's call for the strictest poverty. The possibility to dispose of landed property and private servants was in part what contributed to the considerable popularity of the great Franciscan convents, especially among the urban nobility and patriciate.

The female branch of the second large mendicant order, the Dominicans, whose founder, Dominic Guzmán (ca. 1170–1221), had preached against heresy in southern France, also established itself in the first half of the thirteenth century. The rule for Dominican nuns, written in 1259, took as its point of departure the constitutions of the women's convent of San Sisto in the city of Rome, which stood under Dominic's personal jurisdiction. Dedicated, like the Poor Clares, to the ideals of chastity, poverty, and charity, the female branch of the Dominican order spread

much more slowly. The greatest concentration of female Dominican convents was found in the province of Teutonia, which included southern Germany, Alsace, and the northern part of Switzerland. Of the fifty-eight convents founded before 1277 in all of Europe, forty were located in this region alone.

The success of the mendicant orders among the urban population led to the formation of so-called third orders, consisting of men and women who did not belong to the religious class, did not take vows, and did not live enclosed lives but nonetheless chose to be active in their immediate context in the spirit of the *vita apostolica*, caring for the poor, the old, and the sick and taking responsibility for the burial of the dead. Active above all in Italy, male and female tertiaries found their equivalent, for the most part among women, north of the Alps in the lay movement of the beguines. The refusal and inability of the orders to approve the desired number of female religious communities or administer to their spiritual needs may well have contributed to the success of this experimental way of life. Celibacy, poverty, and works of mercy were, as among the mendicants, the principal rules for women of any age, who lived communally in beguinages, which took the form of either enclosed groups of dwellings or individual houses. The first such foundations occur in Flanders in the twelfth century, followed in the thirteenth century by their rapid spread eastward, where the beguines found considerable acceptance in the cities along the Rhine and in the northwestern regions of the empire.

Following the fourteenth century, which was racked by social and religious crises such as the black death and the Great Schism, the fifteenth century was a period of wide-ranging reform movements. The term "*reformatio*" always indicated the revival and transformation of an "original" state of things, the return to strict observance (hence, the name "observant movement") of an order's rules and statutes and the founding principles of Benedictine monasticism: humility, chastity, and obedience. The central demand of all reformers active in female monastic houses—be it the Dominican prior Johannes Meyer (1422–1484), who was active in southern Germany; the abbot Johann Dederoth (d. 1439), the leader of the reform movement disseminated from the Lower Saxon monastery of Bursfelde; or the representatives of the so-called Windesheim Congregation in northern Germany—was the return to strict enclosure. In connection with female monastic houses, reform and enclosure were effectively synonyms.

To sum up, institutionally, three different groups of religious women in the late Middle Ages can be identified. To the largest group, the female monastic communities (in German territories, in addition to the older Benedictine and Augustinian foundations, the new monastic orders such as the Cistercians, Dominicans, and Franciscans) belonged several smaller orders as well. These included the female (as well as male) Birgittines, founded by Birgitta of Sweden (1302/1303–1373); an attempt to reactivate the model of the double monastery; and the mendicant Penitents (Reuerinnen), founded in 1224 to save "fallen" women but by the end of the century a more traditional order. A second group consisted of unincorporated female monastic communities, which understood themselves to be Cistercians, lived in enclosure and according to a rule, and submitted themselves to the local bishop. The third group of women, who lived a religious life outside of enclosure, consisted primarily of beguines, tertiaries, and, in southern Germany, so-called *Sammlungen* (literally, assemblages). To these can be added the late medieval *Frauenstifte*, usually aristocratic in character, whose members were not bound by enclosure or vows but who nonetheless maintained a common religious life. The city of Strasbourg gives an impression of how such different communities coexisted: as of 1400, in addition to the old *Stift* of St. Stephen's, the city boasted seven female Dominican houses, two communities of Poor Clares, eighty-five beguinages, and a house of Penitents.

For women in the late Middle Ages, entry into a convent or attachment to another type of female monastic community brought with it new spiritual liberty and, with the assumption of offices within the community's hierarchy, some possibility of advancement. Nonetheless, in many respects, they shared the disadvantaged status of their worldly counterparts, who remained under the charge and control of men. In many cases, one has the impression that rules and statutes were adopted or adapted arbitrarily or resulted from the coincidental proximity of a nearby male monastery. This in part explains why female monasteries belonging to different orders can resemble one another quite closely in structural terms.

The maintenance of the strongest possible standards of enclosure can be considered a constitutive element of all female monasteries. This ideal did not only have consequences for the inner life of the convent; it also had a negative impact on the community's economic life. Nuns frequently had to rely on hired laborers and were seldom able to achieve financial independence, which meant that, more than their male counterparts, they

remained perpetually dependent on the support of their founders and patrons. "For monks and nuns, the point of departure and basic religious concept were the same: the striving for a life detached from the world, in willing poverty and in prayer. In reality, however, the ways in which men and women pursued these monastic ideals were fundamentally different."[2] It is one of the fundamental goals of this book to demonstrate how such differences affected the world of images with which the nuns were enclosed.

## Enclosure and Cloister: An Ideal Monastic Plan

In the view of most medieval theologians, women were more threatened than men by fleshly desires and foolish curiosity. They thus were estimated to be the weaker sex. To protect them (and men!), it was essential that they should live behind walls that were as impassable as possible. The papal bull *Periculoso*, promulgated in 1298 by Boniface VIII (reigned 1294–1303), required that nuns submit themselves to strict active as well as passive enclosure: with few exceptions, the monastery precinct could neither be left by the nuns nor entered by outsiders. In many instances, the form and structure of late medieval monastic complexes responded to these normative requirements. This book seeks to make clear the connections between an enclosed life and the world of images collected within the walls.

In the twelfth century, the strictly organized Cistercian order developed a model for a monastic complex that depended in part on older models, such as the ideal monastic plan developed at St. Gall around 825–830 and adopted in many of its essential features by a good number of female monasteries. In plans of this type, the conventual buildings were located to the south or north of the monastery church in four wings arranged around a square cloister with an interior courtyard. The cloister served to connect the church with all the other rooms and thus, in addition to establishing a central spatial nexus, lent itself to the performance of numerous liturgical rites that formed part of the daily monastic routine: inter alia, processions took place in this space, as did readings, commemorations of the dead, and burials. Given that the sanctuary and the liturgical choir for the performance of the Divine Office were located in the eastern part of the church, the adjacent eastern wing of the cloister incorporated the

most important spaces: on the ground floor, the sacristy for the safekeeping of liturgical utensils and textiles, sometimes with the treasury located immediately above it, and the chapter house for daily gatherings, the reading of the rule, and the election of abbots or abbesses. The common dormitory, connected directly with the choir, sometimes replaced by cells, was located in the upper story. The east wing also often included a multifunctional room equipped with heating that could, for example, function as a place where speaking was permitted or where common work, including crafts, was performed. The south wing sheltered the kitchen, refectory, and a warming room. The cloister gate, guest quarters, rooms for novices or lay sisters, and an apartment for the abbess were usually located in the west wing.

Using this normative scheme as a point of departure, one can identify variations specific to female monastic communities. These have most recently been researched with regard to the female houses of the Cistercian order but cannot be described here in detail.[3] Most important, on account of the nuns' exclusion from the celebration of Mass at the high altar, was the separation of the nuns' choir, that is, the partition of the place where the nuns gathered to perform the Divine Office from those portions of the church accessible to the laity. The nuns' choir thus formed part of enclosure. This place of prayer and devotion was often located in the western portion of the church or in a gallery to the side. Arrangements such as this could lead to a rearrangement of the spaces adjoining the women's choir. The sacristy, which in men's cloisters was usually located next to the presbytery because of its function as the place for the preparation for the celebration of Mass, in female houses was at times located within enclosure, an indication that the provision and care of liturgical implements and textiles lay under the supervision of the female sacristan, or *Küsterin* (the officer responsible for supervising liturgical ceremonies; fig. 2.1).

The remainder of this essay follows an imaginary itinerary through an idealized cloister, based on the principle of ever-increasing intensification of enclosure as one progresses from west to east or, better, from outside to inside. Our path will take us from the outer church, which remained open to the laity, through the various rooms of the cloister, to the inner church, the nuns' choir, which, as rule, was only accessible to women. The purpose of following such an imaginary itinerary is to pose the questions: Which works of art were typical of a late medieval female monastic community?

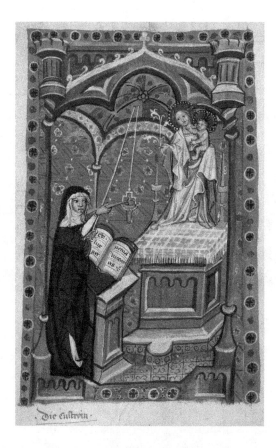

*Figure 2.1* Female sacristan at a mass for the dead, single leaf from a liturgical manuscript, south Germany, ca. 1420/1430. (Staatliche Museen zu Berlin, Kupferstichkabinett, inv. 36–1928.)

How were they distributed across different spaces with varying functions? How, then, did the form and content of a given image, book, wall hanging, sculpture, or piece of metalwork fit in with its original spatial and functional context? In pursuing such questions, it is of course crucial to keep in mind that both works of art and the spaces they adorned underwent changes and served multiple functions. Any space within a cloister could serve as a place of prayer and devotion. Works of art were mobile and often moved temporarily to other locations and hence were placed in novel contexts. Religious themes and motifs permeated all aspects of monastic life, from the high altar in the church to the forms used for baking in the kitchen. It should also be borne in mind that enclosure was enforced with

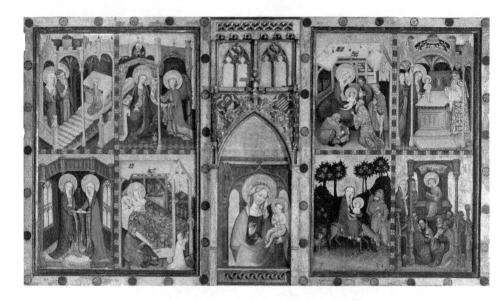

*Figure 2.2* Middle section of the Marian altarpiece from the Cistercian convent of Frön-denberg, Master of the Fröndenberg Altarpiece, ca. 1410/1420, painting on oak, h. 77 cm. (Stiftskirche Fröndenberg [Westphalia].)

varying degrees of strictness during different historical periods. Moreover, at different times during the liturgical calendar, especially at high feasts and on special occasions, enclosure was often relaxed, so contact with outsiders could take place, not only at the gate but in areas such as the guesthouse and the abbess's apartment.

Very often the original location of an individual work of art remains subject to speculation, even scholarly controversy. For example, at the Cistercian convent of Fröndenberg (Westphalia), the original location of the Marian altarpiece, which includes representations of two female donors, remains uncertain (fig. 2.2). According to Stefan Kemperdick, there is much to be said for its having been not the altarpiece in the nuns' choir but rather that for the high altar in the lay church, where it would have been seen by a wider public.[4] Similar problems beset the study of the well-preserved ensemble of sculptures from the Dominican convent of St. Katharinenthal (Switzerland; fig. 2.3). Whereas for some pieces, such as the famous group of Christ and St. John (fig. 2.4), a location in the nuns' choir is secure, for others, no such conclusion can be drawn.[5] In terms of their artistic quality, however, as well as in their content, they belong to a coherent ensemble (fig. 2.5).

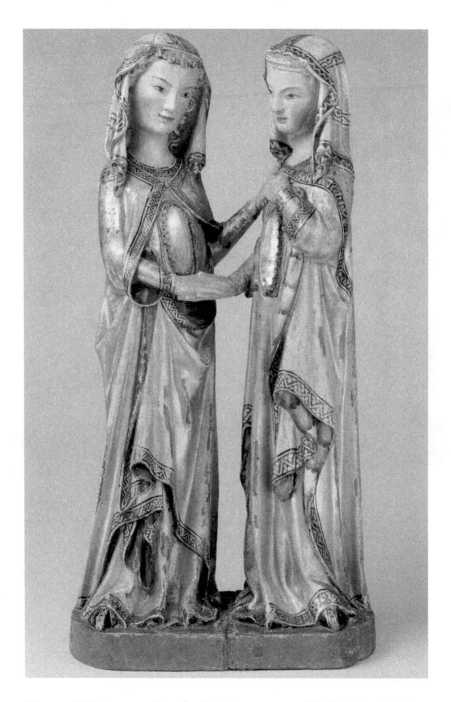

*Figure 2.3* Visitation group from the Dominican convent of St. Katharinenthal, Constance, ca. 1320, walnut wood, h. 59 cm. (Metropolitan Museum of Art, New York, inv. 17.190.724.)

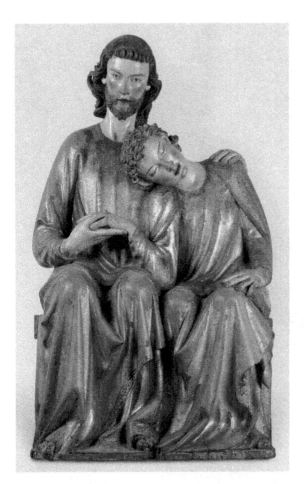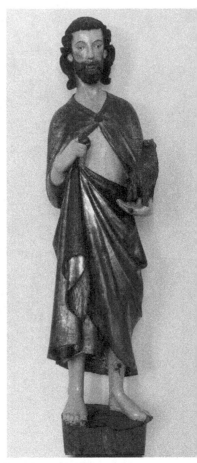

*Figure 2.4* (left) Group of Christ and St. John from the Dominican convent of St. Katharinenthal, Master Heinrich of Constance, ca. 1280/1290, walnut wood, h. 141 cm. (Museum Mayer van den Bergh, Antwerp, inv. 2094.)

*Figure 2.5* (right) St. John the Baptist from St. Katharinenthal, Master Heinrich of Constance, ca. 1280/1290, walnut wood, h. 179 cm. (Badisches Landesmuseum Karlsruhe, inv. L10.)

The *werkhus* (literally, workhouse or, better, place of work) is often difficult to locate. It should not be thought of simply as the place where common craft activities were carried out. Rather, it is the space in which reform and the production of works of art went hand in hand. In the wake of reforms in the fifteenth century, the return to the Benedictine ideal of *ora et labora* (prayer and work) resulted in a more intensive cultivation of artistic and craft activities. Handiwork was thought to encourage and entrench the reform process because it contributed to the regulation and stabilization of a regular routine within the monastery. It was thus accorded a fixed place in the course of every day, just like readings and the celebration of Mass.[6]

In the lower Saxon convents of Lüne, Wienhausen, Ebstorf, Medingen, and Isenhagen, an unusually large number of textiles were produced in the framework of monastic reform. The Dominican convent of St. Katharina in Nuremberg, which was reformed in 1428, produced tapestries both for itself and for sale. There was a comparably accomplished textile workshop at the Dominican convent of the Holy Cross in Bamberg, which was reformed in 1450 by a group of nuns from St. Katharina in Nuremberg. An enormous tapestry with Passion scenes, produced at the convent of Holy Cross around 1500, testifies to the long-lasting impact of the reform. Unique in its apparent fidelity to the daily life of the nuns who made it is the portrait in the lower border representing two nuns at their loom (fig. 2.6). The image, however, is to be understood less as an indication of the nuns' pride in their work than as a humble expression of their efforts to serve God through their industry and hard work. Standing before this tapestry in prayer or devotion with the example of their sisters before their eyes, fellow nuns would have been called to *imitatio* in the double sense of the term. *Imitatio*, understood as the lived imitation of the life of Christ, constitutes the pictorial program of the tapestry. The emphasis on the carrying of the cross, rather than the Crucifixion, can be taken as a reference to an expression of the Dominican preacher Henry Suso (1295/1297–1366): "The beloved Christ spoke thus: take my cross upon you, he said, every person should take upon himself his own cross."[7]

The essay concludes before the onset of the Reformation, the moment at which female monastic communities experienced a steep decline, in that many were dissolved or entirely destroyed, their precious inventories removed from their buildings and scattered throughout the world. This was true even for the especially well endowed and richly decorated com-

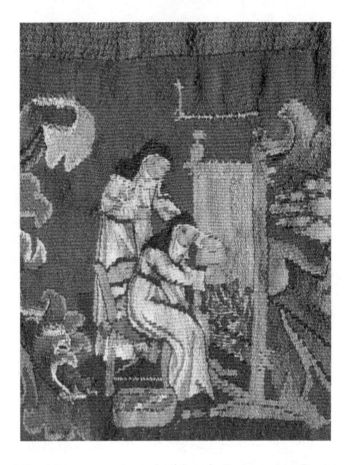

*Figure 2.6* Dominican nuns at a loom, detail from the Passion tapestry, Dominican convent of Heilig Grab in Bamberg, ca. 1495. (Diözesanmuseum Bamberg.)

munity at St. Katharinenthal, whence various works have found their way since the secularization as far as Antwerp and New York (see fig. 2.5).

## The Outer Church and Its Decoration

Church architecture is predicated on a hierarchy of spaces. The architecture of female monastic houses is made still more complicated by the need to separate clergy, laity, and convent, even while regulating their interaction. All monastic churches distinguished between an inner and an outer

church, the former for the monastic community, the latter for the laity. The outer church had its own high altar in the sanctuary and, in some cases, a choir to accommodate the celebration of the Divine Office by canons or monks. If the nuns' choir was located in a gallery or raised choir, the space beneath it could serve as a cemetery or chapel. Several points of passage, for example, the gate of the date (*Totenpforte*), allowed for communication and contact among the laity, enclosed women, and the men entrusted with their pastoral care.

The outer church can also be read as a visible projection of the holiness embodied by the enclosed women who remained invisible (but not un-heard), whether out of sight in an elevated gallery or behind the barrier of the choir screen. The outer church also served as a showplace for works of art that commemorated donations from founders and the families whose daughters inhabited the monastery, where their primary function was to pray for the salvation of family members' souls.

When it came to the decoration of altars, donors spared no expense, decking them out with retables, textiles, liturgical furnishings, and effigies of the saints. Winged altarpieces also served as shrines for relics and the Sacrament, providing a changeable backdrop throughout the church cal-endar that enhanced the dramatic presentation of the liturgy. Exhibited in prominent places, all these works of art further served to incorporate their donors visually into the framework of sacred history, a process reinforced by the prayers of the nuns. Votive reliefs, statues, and stained glass windows, a medium as expensive as it was striking, regularly portray nuns and their patrons in attitudes of prayer.

Indulgences such as those for the church of the Cistercian convent of Fröndenberg governed the forms of gift exchange within this economy of salvation. In Fröndenberg, whose decoration survives virtually intact, a statue of the Virgin Mary stood at the center of the high altar (see fig. 2.3). The statue was eventually replaced with a panel painting contained a sliver of wood that, according to legend, came from an icon brought back from the Holy Land (Museum für Kunst- und Kulturgeschichte der Stadt Dort-mund, Inv. C 4978). Drawings in the *Liber miraculorum* from the Dominican convent of Unterlinden (Colmar, Bibliothèque de la Ville, Ms. 495) illus-trate in unrivaled detail the role of images in the orchestration of the cult around just such a Marian image (fig. 2.7). For visitors to the church, im-ages were not just a backdrop but focal points and protagonists of ritualized performance in the ceremonies that punctuated the liturgical calendar, most

*Figure 2.7* The Marian icon in the convent of Unterlinden, tinted pen drawing from the *Liber miraculorum* (Book of miracles) of the Dominican convent of Unterlinden in Colmar, Colmar, third quarter of the fifteenth century. (Bibliothèque de la ville, Colmar [Alsace], ms. 495, f. 1r.)

notably, Christmas and Easter. The movable props that accompanied such rites—be it a Palm Sunday donkey, a Holy Sepulcher Christ with movable arms, or an ascending Christ—made the mysteries of Christian faith palpable for nuns and laity alike. Cult images formed part of a continuum with smaller sculptures conventionally called devotional images and established a further point of contact, not only between nuns in enclosure and their lay patrons but also, and much more important, between both groups and their saintly patrons in the world beyond.

Contemporary female saints from the aristocracy such as Elisabeth of Thüringia (1207–1231), Hedwig of Silesia (ca. 1174–1243), and Agnes of Bohemia (1205–1282) founded or lavishly funded female monasteries. All these women were associated with images that became part of their legends, but they themselves also became the subject of pictorial representation. In the piety of female patrons, the emphasis was on the humble imitation of Christ, and, in keeping with this pattern, many such women first adopted a religious life as widows or following a vow to live a chaste marriage. They are often represented on the model of Mary or Mary Magdalene (fig. 2.8). Their exemplary piety blurred the boundary between saints and their supplicants, and their patronage itself constituted an important part of their piety. In their persons, they united the figure of patron and petitioner, and, by their example, they provided a model for subsequent generations of female patrons.

## The Sacristy and Treasury

The sacristy and treasury housed the most precious material possessions of the monastic community. In addition to liturgical implements such as the chalices, patens, vessels, corporal boxes, and priestly vestments required for the celebration of Mass, they also sheltered numerous reliquaries housing the relics of the saints in whose honor liturgical feasts were celebrated. A French miniature of the late thirteenth century reflects the lavishness with which liturgical processions unfolded in wealthy female monasteries: the abbess carries a processional cross in her hand as she follows the clerics to the altar, and the sacristan rings the bell (see fig. 8.1).

Female monastic communities varied in wealth, but at well-endowed communities such as the Poor Clares of Königsfelden or Cologne, the accumulated splendor on display belied any ostensible allegiance to an order whose founder had espoused Lady Poverty. Surviving treasures from

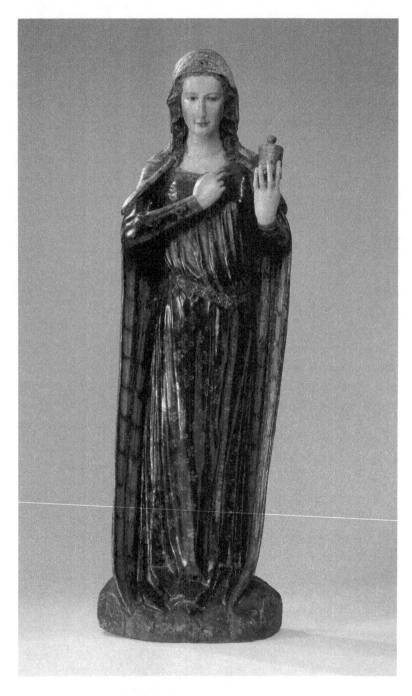

*Figure 2.8* Mary Magdalene from Freiburg, Freiburg or Strasbourg, ca. 1250, wood, h. 140 cm. (Augustinermuseum Freiburg, inv. A 1103/[11441].)

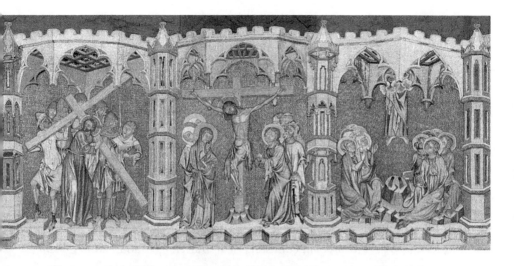

*Figure 2.9* Passion of Christ, detail from the antependium with the life of Christ from the convent of Poor Clares at Königsfelden, Vienna, ca. 1340/1350, silk embroidery. (Historisches Museum Bern, inv. 27.)

Königsfelden, including a pair of splendid antependia (fig. 2.9), represent no more than a fraction of almost two hundred items, royal insignia included, listed in an inventory of 1357 that was sealed by Agnes of Hungary (1280–1364), whose father, Duke Albrecht I of Austria (1248–1308), was buried in the nave, which doubled as a Habsburg mausoleum.

Regardless of their splendor, sacred vessels were of secondary importance in comparison to the relics of the monastery's patrons and the sacrament of the Eucharist. In the course of the late thirteenth and early fourteenth centuries, the feast of Corpus Christi, whose success was due in large part to women, assumed a place of unrivaled importance in the spirituality of nuns, not simply because of a new emphasis on Christ's humanity, of which it was the ultimate embodiment and expression, but also because of the increasingly strict enforcement of enclosure, which systematically denied women steady access to the high altar as a focal point of holy power and redemption (see fig. 7.4). Distance and desire stood in inverse relation to one another. In this context, holy vessels mediated between absence and presence and provided a concrete focal point for spiritual sight. The mystic Christina von Retters (ca. 1269–1291) is said to have seen right through the gleaming vessel holding the host.[8] Reliquaries and monstrances incorporating rock crystal containers enabled the spiritual

desires enacted in visionary accounts of this kind, even as they lent them living embodiment.

Abbesses and prioresses took a leading role in endowing their communities with liturgical vessels. The handling of these *vasa sacra* was carefully governed and documented. Female communities often insisted on retaining control of the treasury, a duty that fell to the *Küsterin* (see fig. 2.1). The *Vie de Ste. Benoîte* (Staatliche Museen zu Berlin—Preußischer Kulturbesitz, Kupferstichkabinett, Inv. 78 B 16), a *libellus*, or collection of liturgical texts in honor of the saintly patron, reports that the abbess, Heilius d'Escoufflans, renovated the church and commissioned the statues of Sts. Nichasius and Catherine for the high altar.[9] In the wake of the reform at Ebstorf in 1469, the abbess commissioned and had placed in the sacristy a precious object (*clenodium*) consisting of an ostrich egg mounted in gilded silver fabricated from jewelry confiscated from the nuns. Such was the quantity of gold and silver, however, that the greater part was stored in a chest.[10] A reliquary from the Reuerinnen in Freiburg, fashioned not from an ostrich egg but rather a coconut, adorned with a bust-length image of Mary Magdalene, ironically recalls the luxury that she had rejected.[11] In such cases, the sacristy came to resemble a *Wunderkammer*, or cabinet of marvels, as much a place of ostentation as veneration. A report of the fire that in 1410 destroyed virtually the entire community of Adelhausen in Freiburg gives some idea of the riches accumulated since its foundation in 1234. Among the losses, besides the buildings themselves, are all the relics, reliquaries, and monstrances, most of the chalices, all the books and common books (*gemeyne büchere*)—the distinction is probably between prayer books and service books—and, not least, "what each woman had especially, all her precious household items."[12] The nuns of Unterlinden and St. Margaretha's in Strasbourg gave their destitute sisters four *guldin* in gold and in books.[13] At Klingental in Basel, precious metal confiscated from the nuns was fashioned into a head reliquary.[14] At Stift Göß in Austria, sometime after 1474, silver sacrificed by the canonesses was used for a large silver Madonna commissioned by the abbess, Ursula Silberbergin. When the emperor tried to confiscate the image, along with a fourth of all the convent's precious metal, the Madonna balked; the cows couldn't pull the cart![15] Expensive jewelry did not always have to be melted down in order to be rededicated; it often was used to adorn statues of saints, above all, images of the Madonna. The difference between sacred and secular was often merely a matter of context, not content.

## The Cloister: An Enclosed World

The *hortus conclusus* (enclosed garden) is the archetypal symbol of enclosure. The cloister, the central space in the life of a nun, represents its physical embodiment: a convenient connection linking the nuns' choir, the chapter house, and the dormitory. In contrast to Romanesque cloisters, those of the late Middle Ages were often decorated with extensive cycles of mural paintings, although north of the Alps hardly anything of such decorative schemes survives. They often involved elaborate pictorial programs that included extensive sequences of stained glass windows with didactic and pious subject matter better suited to stationary meditation, not fleeting observation in passing during processions.

Claustration was far more than just an architectural imperative. It also represented an ideal that manifested itself in all forms of art made by and for nuns. The *Besloten Hofjes*, or enclosed gardens, in Netherlandish convents and beguinages—for which there are parallels in northwestern Germany—may strike the modern eye as curiosity items, but in their combination of crafts—ranging from sculpture and textiles to relics and metalwork appliqué—they represent communally crafted images of paradisiacal perfection (fig. 2.10).

The chronicle of Ebstorf (Lower Saxony) compares the prior's orchard, in which the nuns were permitted to perambulate three days a year, to a terrestrial paradise. Such rhetoric cannot be accepted at face value, but it need not be dismissed. Within strict limitations, enclosure could empower as well as disenfranchise its female inhabitants. Within the context of pastoral care, however, there was always tension between the idealizing rhetoric of reformers and everyday reality. To the nuns of St. Lambert (Rhineland-Pfalz), Hermann von Minden, prior provincial of the Dominicans in Teutonia in the late thirteenth century, denied what the nuns at Ebstorf were allowed, namely, their "foolish" request that they might "eat in the meadow near the infirmary":

> In the beginning even Jesus planted a garden of delights, in which he placed the people he had created, and we also read that he often met his beloved disciples there. The bridegroom in the Song of Songs climbs up into the sweet-smelling garden to pluck lilies (Song of Songs 2:1). We should contemplate the lilies of the field no less earnestly, how they neither labor nor sew, yet are dressed in greater splendor than Solomon. . . . But see! The indication is already at hand

*Figure 2.10* Paradise garden with relics from the Benedictine convent of Ebstorf, before 1487, h. 52 cm. (Ev. Damenstift Kloster Ebstorf [Lower Saxony].)

that all this, even when not forbidden, is not so beneficial. The first Adam disregarded the means of salvation and therefore was tempted in the garden; the second Adam [Christ] was betrayed in a garden. . . . Who would protect you from the fiery ants, from the crawling spiders, from the biting fleas?

Adelheid of Strasbourg would cry: "You're getting your clothes dirty on the ground, and the prioress would condemn your idleness with words

and punishments [*verbis et verberibus*]. . . . Stay in your crannies in the rocks and behind your walls like the turtledoves (Song of Songs 2:14), who don't know the bed of sin, and seek out dry ground rather than the green!"[16] Images present only one part of the picture: even within the "paradise" of the cloister, nuns chafed under and contested the limits of enclosure.

For a nun, her profession and, perhaps still more, her consecration as a virgin represented the irrevocable moment of entry into another world. From a modern perspective, a cloister from which a nun could only communicate with the outside world through a grille might appear to be a prison. From the standpoint of its inhabitants, however, at least according to a monastic commonplace, it was the world that was the true prison. The cloister was a paradisiacal space of idealized interiority that provided a foretaste of the world to come.

## Chapter House and Refectory: Instruction and Intercession

The functions of cloister, chapter house, and refectory were all closely connected, communal, and, to a degree, interchangeable. Unfortunately, all too little is known about the decoration of these communal spaces, in part because hardly anything, apart from stained glass, survives. A sermon by Johannes Tauler, delivered in 1339 to the Dominicans of St. Gertrude in Cologne, offers a tantalizing glimpse of what has been lost: the sermon comments at length on a close copy of the illustration to the first vision in Hildegard of Bingen's *Liber Scivias* that once adorned the convent's refectory but of which no trace survives.[17] Writing to her relative Hans Imhoff in Nuremberg, Katharina Lemmel, daughter of Paulus Imhoff and a nun at the Birgittine convent of Maria Maihingen in the early sixteenth century, makes the case for larger windows in the cloister, complaining that the existing ones are too small: a renovation would not only admit more light, so that the processing nuns could better read their books, it would also allow them, as they passed by, to take notice of the coats-of-arms that commemorated the donor. The windows, she hastens to add, should not, however, be too costly or elegant; better that each should present "a medium-sized representation of our dear Lord's suffering."[18]

The *officium capituli*, the gathering of monks or nuns that in summer took place following the office of Prime, in winter after terce, takes its

name from the section or chapter of the rule to be read on a given day before the entire community. In addition to prayers and readings from the martyrology for the following day, blessings would be read for the day's work. Also intoned were lessons, including sermons, and, above all, readings from the rule (hence the many translations made for female monasteries). Early rules do not stipulate a particular place for this all-important expression of community; on occasion, the refectory served as the communal gathering place, as could the south side of the cloister flanking the church. By the High Middle Ages, however, most monasteries had a chapter house per se, usually opening off the east wing of the cloister. The chapter house was the place where the community's important business, for example, the election of an abbess, was conducted. If it was heated, it also often doubled as a space where all forms of handiwork, including the copying of manuscripts, was carried out.

Among the most important duties of the community would have been the offering up of prayers for the larger community, including abbesses and benefactors, both living and dead, some of whose tombs would have been located either in the chapter house itself or in close proximity in the cloister. The admission of priests to conduct last rites and funerals was carefully legislated.[19] The texts governing all such ceremonies were gathered in the *liber capituli* or chapter office book.

A miniature of Clare of Assisi instructing her community in the copy of the *Klarenbuch* from the Klarenkloster in Nuremberg (Bayerisches Nationalmuseum, Munich, Ms. 3603, f. 1v) could be read as both an image and a product of the communal activities that took place in the chapter house. The Lower Saxon convent of Ebstorf is one of several from which there survives a rich collection of didactic manuscripts that give a lively impression of convent schooling, in which grammar, elementary theology, and singing (including the singing of secular songs) formed part of the curriculum (fig. 2.11).

The concept of *capitulum* (a short reading) was closely linked with that of *culpa* (guilt): perhaps the most important ceremony conducted in the chapter house involved the communal rites of penance, for example, ritual flagellation, enforced by the abbess and the *circatrices* (literally, those who circulated, looking for infringements of the rule). In 1264 the Dominicans of Teutonia instructed *circatrices*, inter alia, to see to it that nuns made no gifts of elaborate embroidery, be it of vestments, belts, or other tokens (*signa cum serico*), to their male confessors.[20] In most cases,

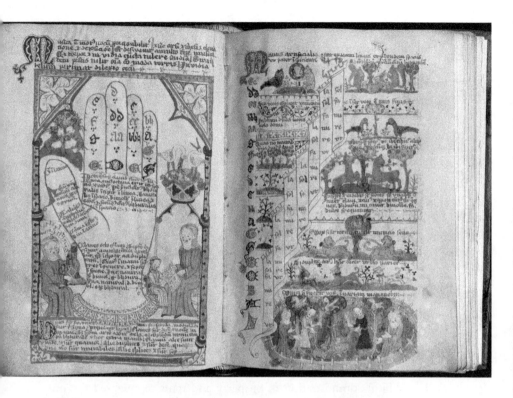

*Figure 2.11* "Guidonian Hand" from a manuscript for musical instruction at the convent of Ebstorf, late fifteenth century. (Ev. Damenstift Kloster Ebstorf [Lower Saxony].)

the only decoration required for ceremonial purposes was an image of Christ on the cross.

The rules enforced involved all aspects of daily routine. The comings and goings of individual members of the community and their conduct in groups, for example, while working, were often singled out for special scrutiny. A vision reported in the chronicle from the Dominican convent at Weiler near Esslingen (Black Forest) internalizes this form of supervision, even as it underscores the function of images: required to serve at the gate, the nun Margaretha von Helbeünen reluctantly leaves the procession in which the cross is being carried around the cloister, only to meet a man entering from outside, whose wounds reveal him to be Christ.[21] The primary lesson is obedience and subservience to the rule, the same lesson reinforced by didactic panels such as those that survive from Unterlinden in Colmar and the Katharinenconvent in Nuremberg. The cycle of monumental paintings from St. Catherine's in Augsburg

featuring the seven stational churches of Rome represents a particularly ambitious attempt to allow for proxy pilgrimage of a kind vividly described in the chronicle of the Bickenkloster in Villingen (Black Forest), in which the abbess, Ursula Haider, is characterized as a "*gaistliche baumaisterin*," or "spiritual architect."[22]

## The Guesthouse and the Apartments of the Abbess: An Opening to the World

Despite the fact that enclosure remained the predominant determinant of nuns' lives, there were still many points of contact with the outside world. This contact was concentrated in and around certain spaces, in addition to the outer church, above all the cloister gate, the abbess's apartments, and the guesthouse. Contact with outsiders also occurred as a result of certain activities, such as the administration of the monastery's landed possessions or the performance of certain ceremonies. Works of art played an important role as a medium of exchange and communication with the world beyond the cloister walls.

The skillful administration of property and rents represented the precondition and material basis for a secure monastic life. For women's monasteries, which were, for the most part, excluded from other forms of service or remuneration, these forms of income assumed greater importance than they did for male monastic communities. Whereas in the early and High Middle Ages, the convent and abbess enjoyed considerable independence and self-governance, beginning in the twelfth century, men increasingly came to assume responsibility for these aspects of administration. Either priors, who assumed responsibility for the monastery's economy, were appointed, or, as in the case of Cistercian convents, these tasks were taken over by the father abbot of the incorporated house. Male administrators had a decisive influence on a monastery's economic affairs insofar as they advised abbesses or themselves took action. On occasion, abbesses had to take action to protect the convent's interests from priors who sought to enrich themselves in the short term.

A throne and an abbess's crosier constituted the representative insignia of the abbess, both in internal and external affairs. Symbols of the power of her office and her claim to legitimate leadership, they were perpetually present, not only in the chapter house, where the election

of the abbess took place.[23] The hanging from Isenhagen (Lower Saxony), which is richly decorated with aristocratic coats-of-arms, could well have served to adorn the abbess's throne in the nuns' choir (Kloster Isenhagen, Hankensbüttel, Inv. IS Hb 6). At the Cistercian convent of Medingen, St. Maurice, the monastery's patron saint, together with the Virgin Mary, decorated the highly ornate crosier of the abbess (fig. 2.12). To this day, the crosier continues to serve the abbess of Medingen, who performs her role as head of the convent in St. Maurice's name and under his protection.

The patron saints of monasteries also provide a beloved motif on seals. The seal of Caritas Pirckheimer, abbess of the convent of St. Clare in Nuremberg, offers an example.[24] The various seals employed by the convent, the abbess, and the prior demarcated their various areas of responsibility and were attached side by side in instances of the greatest legal import.

The guesthouses lay to the west of the monastic complex, in most instances near the gatehouse and the abbess's apartments. They offered accommodation for secular as well as spiritual visitors, all of whom would be received by the abbess. The guesthouse also served to lodge the families of the nuns who, despite prohibitions to the contrary, were unwilling to give up contact with their sisters or daughters.

Family members of nuns, who often came from the circle of the community's founder or other donors, often presented gifts or endowments to the monastery. For example, Duke Albert II of Austria gave the Poor Clares of Königsfelden in northern Switzerland an exquisite antependium that had been made by artists at the court in Vienna (see fig. 2.9). Depending on the social origins of the novice, the entry of a girl or young woman into a convent was marked by a ceremony: a wedding in the sense of a spiritual union with Christ, the heavenly bridegroom. Family members were present at such occasions. It was at moments such as these that various items—not only those needed for daily life but also luxuries like expensive tapestries and objects made of rare materials (alabaster, ivory, mother-of-pearl, and gold), even items of jewelry—came into the possession of nuns. They were employed either to adorn commonly used rooms or as props in private prayer.

Figural tapestries with courtly themes, like the hangings for the stalls decorated with aristocratic couples from the Benedictine convent of Ebstorf (Kestner Museum, Hanover, Inv. WM XXII, 18) or the Malterer

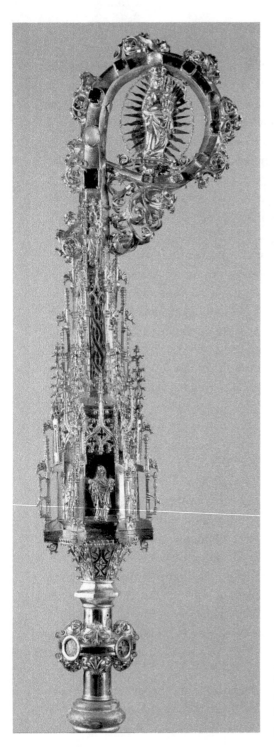

*Figure 2.12* Abbess's crosier from the Cistercian convent of Medingen, Hermen Worm (Lüneburg), 1494, gilt silver, h. 56 cm. (Ev. Damenstift Kloster Medingen [Lower Saxony].)

tapestry from the convent of Dominican nuns in Freiburg im Breisgau (Augustiner Museum, Freiburg i.Br., Inv. A 1705/[11508]), which draws on the world of antique mythology, underscore the self-consciousness and, to a certain degree, the high level of learning cultivated by enclosed women. The famous thirteenth-century world map that perhaps originated at Ebstorf similarly testifies to their wide view of the world around them (fig. 2.13).

## The Cells: Everyday Piety—Extraordinary Visions

The monastic cell, including its apparatus of private devotional imagery, is an innovation of the late Middle Ages. The Dominican reformer Johannes Meyer (1422–1482) criticized this development when he reported that on Saint Martin's Day in 1397, the reformed nuns of Schönensteinbach were enclosed by Conrad of Prussia, who granted each of them a different devotional image:

> Now the worthy brother Conrad gladly would have given the sisters something, the same for each as the other: indeed, he had little images of the Passion of our Lord. But they were unlike, one how he was flagellated, another, the crowning with thorns, another like this, the other like that; then our beloved Lord transformed them all with a great miracle so that they all were similar crucifixes, and Mary and John stood under the cross. So the blessed father gave each sister an image of the crucified Jesus; then they took the crucifixes and blessed the same father and the duchess and blessed everyone and took their leave of the world and everything in it and went willingly into the cloister. Then Father Conrad locked [the gate] with the most secure lock with which a cloister can be closed in the name of the Father and the Son and the Holy Ghost, the Virgin Mary, St. Dominic, and St. Bridgit.[25]

A miraculous transformation of images defines the ideal of *Christiformitas* embodied by the act of entering enclosure.

In light of the variety of late medieval devotional imagery from convents, the reformers remained frustrated. Johannes Busch (1399–1479/1480) reports that, on entering the convent of the Holy Ghost in Erfurt, he found that the nuns had broken up the altarpiece and removed its images, both sculpted and painted, to their oratories, where they were accustomed to "have devotion from them . . . in private [*in privato*]."[26] Devotional imagery

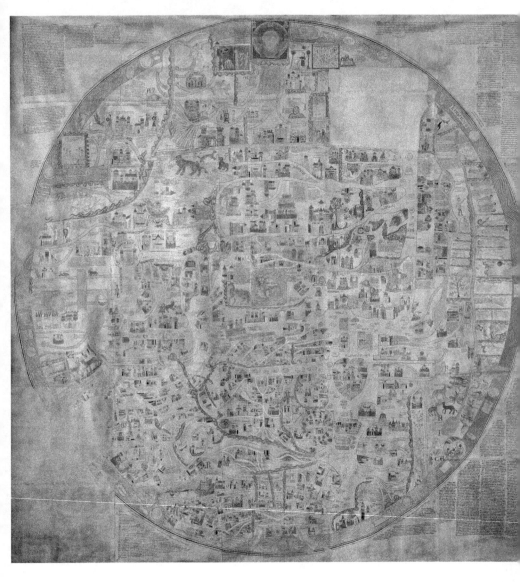

*Figure 2.13* Ebstorf world map, original Ebstorf or Lüneburg, ca. 1300 (destroyed in WWII); modern copy at Ebstorf. (Ev. Damenstift Kloster Ebstorf [Lower Saxony].)

was portable and traveled with ease from choir to cell. Whether drawings, prints, or small-scale figurines, private devotional images were often reproductions of monumental works that were accessible to the entire community. In order to satisfy their hunger for images, nuns did not simply rely on what they received from outside the walls; they also created images for themselves or elaborated works that they had received as gifts. Small statues of the Christ Child, some complete with cradles, were especially beloved (fig. 6.5). Adorned with jewelry and silk outfits, they were transformed into cult images.

The cell as such, like privately held images, stands in conflict with the communitarian ideal of traditional monasticism (*vita communis*). In contrast to hermits and anchoresses, monks and nuns inhabited dormitories, not individual cells (not to mention the luxurious apartments reserved for abbesses). The cell represents as much a concession to individual privacy as it does to retirement, contemplation, and the revival of the hermitic ideal. "Private devotion" is therefore, by definition, a problematic term, closely linked to the thorny issue of private property in monastic life, a touchstone topic in spiritual treatises of the period. The trunks that line the cloister corridors of Wienhausen, Lüne, and Ebstorf encapsulate the problem (as do inventories). The trunks, which contained the dowries that nuns brought with them on entering the convent, also enabled them to hoard private possessions, contrary to the regulations of reformers, who, beginning in the fourteenth century, systematically but never successfully sought to eradicate the practice. Visitation reports (never an entirely reliable source) recount nuns secreting objects that they did not want the abbess to see.

Whereas some devotional objects were designed to contain the viewer's fantasy or channel it in particular direction, others were calculated to give it free rein. To use a metaphor popular in spiritual treatises of the time, images were like a seal that could be impressed into the soft wax of the soul. Inscriptions combined with complex visual strategies to form the viewer's reactions and response. Passion piety in particular was pushed to often bloody extremes, frequently with an erotic edge articulated in vocabulary appropriated from the Song of Songs (cf. fig. 5.2). Nuns themselves describe their pious practices as a form of play (*quasi ludendo*).[27] In other images, didacticism and devotion carry equal weight. Not all nuns were mystics, but images allowed nuns of ordinary gifts to participate, if only

by proxy, in the visionary flights of famous nuns whom images held up as exemplars of piety and devotional practice.

## The "Werkhus": Nuns as Readers, Scribes, and Artists

In the *Codex Gisle*, a gradual from the Cistercian convent of Rulle near Osnabrück, a colophon records that this outstanding manuscript was written, notated, foliated, and decorated with golden initials and beautiful miniatures by the humble nun Gisela von Kerzenbroeck. Gisle, identified by an inscription and holding an open prayer book, appears with five other nuns in the initial for the feast of Christmas (fig. 5.2). Even if the origins of this precious manuscript are far more complex than the formulation in the inscription suggests, it nonetheless testifies in various ways to the importance of books—their possession, their use, and their production—for female monastic communities. The creation of a costly manuscript required intensive collaboration, not only at the level of craft but also in terms of conceptual and financial planning. All these activities contributed to the round of praise that represented the monastery's central task. They also were a way of ensuring oneself a place among the deceased who would in turn be commemorated.

All convents required a minimum number of liturgical manuscripts in order to perform services. In addition to these, other books were needed: biblical and spiritual texts that made up the reference library, as well as Psalters and prayer books, many of which belonged to individual sisters, who often brought them along on their entrance to the cloister. Manuscripts came as gifts or were commissioned, or else they could be produced in the monastery's own scriptorium or in collaboration with outside artists. The Poor Clares in Cologne had an extraordinarily active workshop that between 1320 and 1360 produced a large number of liturgical books both for their own use and for outside patrons. The books made by the nuns vary greatly in quality, containing, sometimes even within a single manuscript, miniatures of both greater and lesser accomplishment. Similarly characteristic is the use of iconographic formulas rarely found outside the enclosed world of the convent. A baldachin altarpiece from the convent of Poor Clares in Nuremberg, dated to the second half of the fourteenth century, further testifies to the complexity of exchanges between the painter's workshop and the nuns as patrons (fig. 2.14).[28]

*Figure 2.14* Coronation of St. Clare, part of a winged altarpiece, probably from the Poor Clares of Nuremberg, Nuremberg, ca. 1350/1360, h. 40 cm. (Private collection, Great Britain.)

In the fifteenth century, monastic reforms led to higher expectations when it came to the production and ordering of books. Liturgical reforms required new manuscripts, and reinforced enclosure increased demand for prayer books, devotional literature, and copies of sermons. The library of the Dominican convent of St. Katharina in Nuremberg offers an outstanding example. Unusually large, by the time of its dissolution during the Reformation, it included approximately five hundred volumes. The

manuscripts were collected, copied, decorated, and, as indicated by two contemporary inventories, carefully cataloged as well.

The reform also stimulated the production of textiles. The convent of Lüne near Lüneburg represents an excellent example. As indicated by account books, during the sixteen years following the introduction of reforms, a new abbess oversaw the production of approximately eighty-five square meters of colored wool embroidery. Most of these textiles were communal efforts, produced by several sisters working side by side, the completion of which was marked by special celebrations. The account book from Lüne even records the sweets and special treats that the nuns engaged in embroidery received as their reward when they presented the completed product to the rest of the members of convent, who had gathered to receive it. The production of textiles not only provided an appropriate means of imposing discipline and the basic Benedictine requirement of combining prayer and work, it also enabled the convent to create a common, living tradition and document itself for a broader public. Textiles played an important role in the cultivation of *memoria*, the collective commemoration of donors and the dead in prayer exercises. Nuns recollected their patrons not only in liturgical prayer but also as they were working on tapestries or embroideries, thereby creating a concrete, material record of their membership in the community (fig. 2.15). For example, at the Augustinian convent of Heinigen in Saxony, when the nuns added their own names to the border of the gigantic "Philosophy embroidery," they literally inscribed themselves into tradition and requested the nuns who succeeded them to pray on their behalf. In all these activities, Mary provided the perfect model. Pictorial as well as apocryphal written sources testify to her status as a virgin serving in the temple, where she industriously worked away at her loom or her embroidery, combining craft with prayer in exemplary fashion.

The Nuns' Choir: The Inner Church

All monastic churches, whether male or female, set aside a space for their members to celebrate the Divine Office. In addition to separating themselves from the laity (spurred in part by the Gregorian reform), female monastic communities strove for (or were compelled to seek) a rigorous

*Figure 2.15* The martyrdom of St. Bartholomew and the veneration of the patron by the nuns; detail of the Bartholomew choirstall hanging from Kloster Lüne, 1492, wool embroidery, h. 76, w. 492 cm. (Textilmuseum, Kloster Lüne [Lower Saxony].)

separation of the sexes. The subjugation of women to the clergy nonetheless required that these various constituencies maintain contact, if only under carefully regulated circumstances: profession, consecration, communion, confession, processions, not to mention last rites. In light of these liturgical requirements, the architecture and furnishings of nuns' choirs were complex yet varied. Even within individual orders, there was no single, universally valid building plan. By the later Middle Ages, the choir—which served as the place not only where the office was sung but also, no less important, where meditations (usually after matins) were held—was usually, if not always, located in a gallery at the west end of the church. It could also be placed at the east end of the church or, occasionally, either in the nave or in the arm of the transept, usually to the north, on the same side as the cloister.

Barriers, which in the twelfth century sometimes still took the form of hangings or curtains, increasingly became fixed architectural features that enforced enclosure, even as they allowed for dramatic, if infrequent, moments of revelation, usually focused on the consecrated host on the high altar, seen through small windows or slits known in England as "squints." The display of the host in a monstrance on the altar in the

nuns' choir enhanced enclosure by making such openings unnecessary (see fig. 7.4).

Nuns were allowed to move around the monastery more freely than statutes might seem to allow; mixed solutions and shared spaces were common. Processions were only one occasion when this ritualized sharing of spaces occurred. At Trebnitz, the nuns' choir, to which the founder, Hedwig of Silesia (1174–1243), had access, took the form of a gallery that projected from the crossing into the nave. At St. Peter's in Salzburg, the nuns' choir, known as their basilica, was situated in the parish church adjacent to the men's monastery and consisted of a raised gallery occupying the center of the nave. Although the altar in the choir was separated from the nuns by a screen, indulgences testify that on certain days the public and their priest continued to have access. The choir in the nave was replaced with another, less obtrusive gallery over the right aisle, dedicated in 1454. The nuns opposed their relocation, going so far as to take legal action. Even after construction of the new choir, many nuns continued to use the old space and were only prevented from doing so by its demolition in 1458.[29]

The Dominican convent of St. Katharinenthal, which was secularized in 1868, is unusual not only in that much of its decoration, albeit scattered, survives but also because it is so well documented. For example, the so-called sister book or chronicle of St. Katharinenthal, a collection of reports on the lives of members of the community, relates how the prioress Adelheit Hüterin was embraced by the still-extant large crucifix (former church of the monastery of St. Katharinenthal, Diessenhofen, Kanton Thurgau, Switzerland) that appeared to her like the three Marys following the Resurrection. The designation of some of the most famous works, most notably, the group of Christ and St. John reproduced in figure 2.4, as so-called *Andachtsbilder*, or devotional images, has obscured their function as cult images atop altars in the choir and as parts of a larger, liturgical ensemble, of which textiles, manuscripts, and metalwork also formed a part. The well-documented rivalry between adherents of the two "Johannsen"—John the Evangelist and John the Baptist (see fig. 2.5)—which was later criticized by the reformer Johannes Meyer (1422–1482) as a "*krieg*," that is, a struggle, and "unpraiseworthy piety," represents only one dimension of competitive cults that utilized artworks of the highest quality in order to attract and hold the attention of viewers.[30]

# Notes

1. Mohn 2004:6.
2. Ibid.: 9.
3. Ibid.; Mersch 2004.
4. Cat. Essen/Bonn 2005: nos. 233a–d, 351–353.
5. Jäggi 2004b.
6. Böse 2000.
7. Carroll 2003:193 n. 28: "Der lieb Christus sprach nut: nemet min kruz uf uch, er sprach: ieder mench neme sin kruz uf sich!"
8. Mittermaier 1965, 1966:243.
9. Gardill 2005.
10. Borchling 1905:392.
11. Bock and Böhler 1997:111–113.
12. König 1880:225–227: "die jegeliche frowe besunders hatt, all ir köstliche husrat."
13. Ibid..
14. Weis-Müller 1956:31.
15. von Zahn 1884:21–22.
16. Finke 1891:105–106.
17. Hamburger 2004d.
18. Kamann 1899, 1900:7:171: "ein zillige vigure unsers lieben hern leiden."
19. Schönbach 1909/1976:9.
20. Ritzinger and Scheeben 1941:37–38 (no. 14).
21. Bihlmeyer 1916:81–82.
22. Glatz 1881:89.
23. See, for example, the richly decorated throne from Bersenbrück (Westphalia), reproduced in Cat. Bonn/Essen 2005:494 (no. 438).
24. See Staatsarchiv Nürnberg, Reichsstadt Nürnberg, Kloster St. Klara, Akten und Bände, Nr. 13 Prod. A; cat. Essen/Bonn 2005: nos. 437, 495 (Andrea Stieldorf).
25. Reichert 1908–1909:2:35.
26. Grube 1886:610–611.
27. Gertrude d'Helfta 1968–1986:3:232.
28. Parts of it are today in Berlin, Frankfurt, and private property. See cat. Essen/Bonn 2005: nos. 459, 512–513 (Stefan Kemperdick).
29. Schellhorn 1925.
30. Reichert 1908–1909:2:62.

III

---

# Between This World and the Next

## The Art of Religious Women in the Middle Ages

JEFFREY F. HAMBURGER AND ROBERT SUCKALE[*]

## Royal Foundations and Cloisters

The stronghold of the *Frauenstift* of Quedlinburg, founded in the year 936 at the behest of Queen Mathilda (d. 968), the wife of King Henry I, looms large over the surrounding region. The church complex makes clear the powerful position of such *Frauenstifte* and monasteries and the respect in which they were held in the Middle Ages. Some female foundations, for example, those at Nivelles and Mons, astonish simply on account of their size. Others, like the Münster in Essen, impress by reason of their self-confident citations of the imperial coronation chapel in Aachen, officially the most important church in the German Empire. The same holds true for the works of art that belonged to these *Frauenstifte*, which in most cases are of the highest quality. The few pieces of the treasure of Quedlinburg that survive from the Ottonian period provide no more than a glimpse of what the *sanctimoniales* (holy women) once possessed.[1] The *Quedlinburg Itala* alone (Berlin, Staatsbibliothek, Cod. theol. lat. fol. 485), the oldest fragment of an illuminated Latin Bible, gives an impression of the richness and quality of the treasury's holdings. Because of its close ties to the Ottonian royal house, Quedlinburg assumed

---

[*] The first section, on the early and High Middle Ages, was written by Robert Suckale; the second section, on the later Middle Ages, by Jeffrey F. Hamburger.

a particularly prominent position in the circle of east Frankish and early German female monastic communities.

Similar precedents can be found in western France, Italy, and England. Among the most important were Sainte-Croix, the cloister of St. Radegund in Poitiers and that of Queen Bathilde in Chelles, the royal cloister of San Salvatore/Santa Giulia in Brescia, as well as the Anglo-Saxon double monasteries at Hartlepool, Whitby, and Barking. All these monasteries, which were founded as early as the sixth to eighth centuries, had close ties with the reigning royal house and recruited many of their abbesses from the ruling families.

Not every *Frauenstift* had a female ruler as a founder or protectress. Many female rulers, however, founded their own *Stifte* or monasteries. Of these the last was established by Empress Maria Theresia (1717–1780) in Innsbruck. These institutions did not serve only as places of retreat for the founders or, for that matter, as homes to provide for innumerable female members of ruling families, as is all too often maintained. Far more important was their proper purpose as places in which the foundation's community maintained a ceaseless round of intercessory prayers on behalf of the founders and their families, the living as well as the dead. At least during the early Middle Ages, it was believed that prayers from the mouths of virgins dedicated to God were at least as pleasing to God as the reading of masses.

The largest *Frauenstifte* did not, however, always offer an isolated, quiet, and cloisterly life. For example, Quedlinburg was obliged to hold an open court on an almost annual basis and receive large groups of guests. The abbesses of all the large imperial foundations were committed to providing, organizing, and maintaining court quarters for peripatetic rulers and all those who came in their train. All things required for a ceremonious coronation had to be kept at the ready, among them, the costly liturgical implements worthy of gatherings of this nature, such as the liturgical comb that can still be found in the treasury of Quedlinburg, as well as the appropriate imperial and pontifical vestments and much else besides.[2] In general, the women proved successful. Thus, for example, during the absence of her nephew, Otto II (983–1002), in Italy, it was the abbess Mathilda of Quedlinburg (955–999) who in the year 997 assumed the regency over the Saxon kingdom.

The women of the high and highest aristocracy who governed these foundations were often extremely conscious of their status and so protec-

tive of their freedoms that they rejected any restrictions that might have been imposed by canon law. Of this, the donor image in the Hitda-Codex provides a demonstration (fig. 3.1): Hitda, dressed in garments appropriate to the performance of the Divine Office, is shown the same size and almost at the same height as St. Walburga, the patroness of the monastery, to whom she offers the book. Anyone familiar with the visual culture of the period would have recognized the image's citation of the Byzantine ivory depicting the coronation of Otto II and Theophanu. This self-consciousness involved not only the aristocratic but also the spiritual position of the abbess. She governed not only her community of sisters but also the congregation of subordinated male clerics, the canons, and the parishes that belonged to the foundation.[3]

It comes as no surprise that the works of art found in such high-ranking foundations are so close to those of the court. The treasuries of foundations were so richly outfitted that they took on connotations of rulership (figs. 3.2 and 3.3). This can still be seen clearly only in Essen and, to a lesser extent in Quedlinburg or Solingen-Gräfrath. These treasuries were conceived less as financial reserves than as a means of giving visual and material expression to the aspirations to rulership of the institutions that housed them.

Learned Images

The internal constitutions of *Frauenstifte* took as their model the Institutio sanctimonialium, or so-called Aachen rule, which had been approved by the emperor Louis the Pious in 816.[4] Nonetheless, they never banded together into larger congregations on the model of monastic orders. Local conditions governing their foundation and their respective connections to local and regional political entities led to a great variety of individual customs, including in the habits of the canonesses. This relative freedom makes itself especially clear in the art made and commissioned by the sisters. There are hardly any typical traits; instead, one finds a great many diverse and often unique works of art. In part because *Frauenstifte* participated more directly in public life than did monasteries, they often gave more thought to the impact that their commissions would have. A good example is offered by the doors of St. Maria im Kapitol in Cologne (fig. 3.4). The scenes from the life of Herod

JEFFREY F. HAMBURGER AND ROBERT SUCKALE

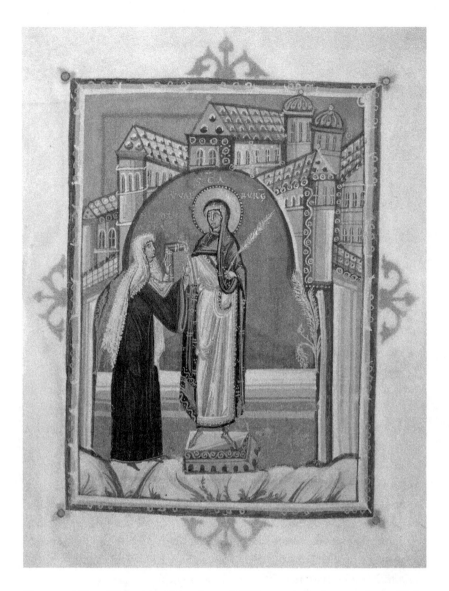

*Figure 3.1* Abbess Hitda giving the codex to St. Walburga, dedication page in the Hitda-Codex from Stift Meschede, Cologne, second quarter of eleventh century. (Universitäts- und Landesbibliothek Darmstadt, Hs. 1640, f. 6r.)

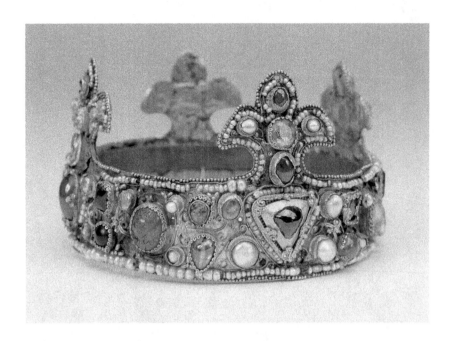

*Figure 3.2* Crown from Stift Essen, western Germany, tenth–eleventh century, inner dm. 11.8 cm. (Domschatz Essen, inv. 12.)

clearly communicate an opposition to political tyranny, a message that can hardly have been intended for the sisters themselves.[5]

For the performance of liturgical prayer, it would have sufficed to read Latin or simply to learn certain texts by heart. Yet canonesses were also required to understand Latin texts. In the early Middle Ages, women had considerable access to education. They also had opportunities—more than is commonly recognized—to participate in affairs of state and to influence social issues of the day. As a result, more than a few canonesses received some training in matters political and theological.

Despite its exceptional character, the theological subtleties of the pictorial program of the Uta Codex from Stift Niedermünster in Regensburg do not distinguish it fundamentally from the iconographic imagery developed by the clergy of the city's cathedral or the Benedictines of St. Emmeram (fig. 3.5).[6] It is nonetheless indicative of the sisters' intellectual ambitions that they chose to adorn the Codex aureus (Golden book) of their foundation with such ambitious cosmological imagery. It is hardly possible to distill the complexity of this profound pictorial program into

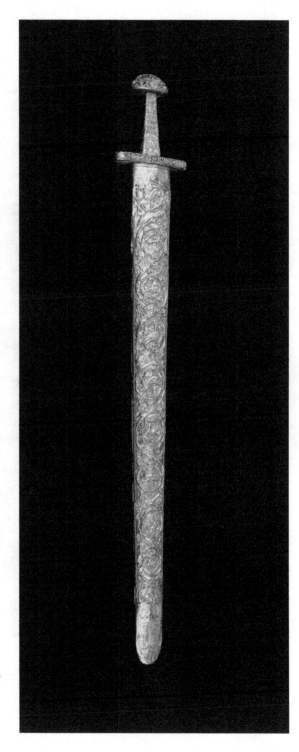

*Figure 3.3* Sword from
Stift Essen, sheath, Lower
Saxony, ca. 1000, l. 93.6
cm. (Domschatz Essen,
inv. 13.)

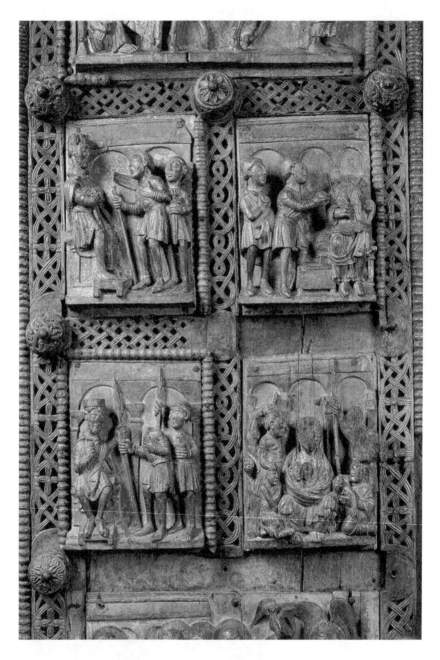

*Figure 3.4* The Herod scenes from the wooden doors of St. Maria im Kapitol, Cologne, ca. 1049 or 1065.

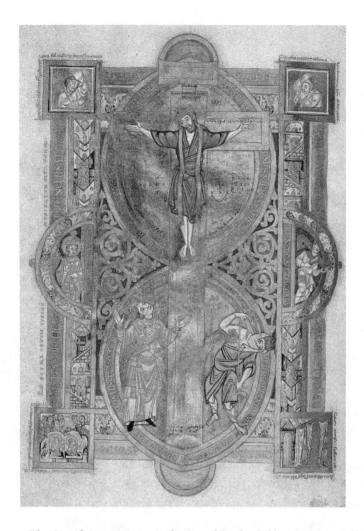

*Figure 3.5* The Crucifixion miniature in the Gospel Book of Abbess Uta from Stift Niedermünster in Regensburg, first quarter of the eleventh century. (Bayerische Staatsbibliothek, Munich, Clm 13601, f. 3v.)

a few sentences. The cross is presented as the governing principle of the universe, in keeping with Pythagoras's teaching on the nature of harmony, according to which musical intervals are in harmony with the trajectories of the stars and the dimensions of the cross. The Savior's death on the wood of the cross is represented as a turning point in history and, simultaneously, as a triumph over death. Introduced to the world by Adam and Eve, death itself is decisively struck down by a kind of fist or club that rises

from the vertical beam of the cross. Christ is represented as both king and priest. The image also depicts the moment of the Church's birth in the Mass, which daily repeats Christ's sacrifice on the cross, securing for the faithful a treasure trove of grace for the salvation of their souls. The depiction on the facing folio, a representation of St. Erhard celebrating Mass on the church's altar, elaborates similar themes. In this context, it is important to note that the woman who commissioned the work, the abbess Uta (in office 990–1025), was among the supporters of the monastic reform that the saintly bishop Wolfgang wished to carry out in the female monastic communities of Regensburg.

If one looks back from the vantage point provided by the encyclopedic learning of a towering personality such as Hildegard of Bingen (ca. 1098–1179), who had wide-ranging intellectual interests and subtle theological knowledge, one can ask if it is necessary to attribute the program of the Uta Codex to a spiritual adviser or whether in fact it could be attributed to the abbess or a theologically trained sister, comparable to the teacher and poet Roswitha of Gandersheim.

Other witnesses to the patronage of canonesses provide further testimony to the strength of their interest in theology. A good example is the book cover of the Gospel Book of the abbess Theophanu (in office 1039–ca. 1058) in the treasury of the *Frauenstift* in Essen. Decorated with an inset ivory plaque, it develops a pictorial program that traces the history of salvation in theological as well as historical terms along a vertical axis extending from the bottom to the top, beginning with the Incarnation to Christ's return at the Last Judgment. The image simultaneously serves as a representation of the two natures of Christ and the ascent from the earthly to the spiritual.

Many *Frauenstifte* had among their duties the education of girls and young women, and the nuns had to be prepared for this task, in which they were aided by not being so cut off from the world as those living in enclosure. They also were more familiar with the outside world than were most nuns, given that from the High Middle Ages they had been allowed to own private property, supervise their own households, complete with servants, and make extended visits to their families. The abbesses could participate in important events at court and similar gatherings. On top of all this, they were in most cases not bound by eternal vows and could even enter into marriage, if need be. It is therefore only to be expected that, more than cloistered nuns, they concerned themselves with questions of marriage and family. A trace of such interest can be seen in the Hitda-

Codex, a Gospel Book that, contrary to the tradition of Bible illustration, includes a scene such as Christ and the women found in adultery as a means of criticizing contemporary male-dominated society's self-righteous and overbearing judgments of women. The same holds true for the story of Peter's mother-in-law—not a favorite subject among those radical reformers who, given their opposition to the marriage of priests, did not relish representations of Peter (that is, the first pope) as a married man.

## New Marian Images

The doctrine of the Incarnation of Christ in the Virgin Mary, one of the central mysteries of Christian faith, was the subject of intense reflection, precisely because Mary exemplified the role and dignity of women in the divine plan of salvation.[7] Many of the Marian images made for nuns and canonesses make Christ's human nature their theme by emphasizing his nakedness, his vulnerability, and his need to nurse at his mother's breast. No less popular was the theme of the deep love between mother and son, based on the model of the love of bridegroom and bride, understood as the love of Christ for his Church. The principal source for this subject was the Song of Songs, especially as interpreted in the sermons of the Cistercian abbot Bernard of Clairvaux (1090–1153). An increasingly large and varied repertory of Marian images in which mother and child embrace, often cheek to cheek, or in which their love for one another is expressed by a variety of other gestures gave expression to Incarnational themes of this nature. The necrology from Obermünster in Regensburg (ca. 1177–1183), in which nine different types of Marian imagery can be found, demonstrates the extent to which images and statues of this kind could once be found in Frauenstiften (fig. 3.6).

A subtle subject of which women were especially fond is the image type known as the Virgo inter virgines, that is, the fellowship of the Virgin Mary with other female saints. Many early examples of this particular image type have been disassociated from their original context, so their patronage and function are not always easily recognizable. The image provided an especially appropriate expression of the ideal of sisterly equality as it was expressed in the rule of Aachen.[8] An enlightening example is the way in which the sisters of Stift Obermünster chose to represent themselves in their necrology, which doubled as a kind of Liber vitae, in that it

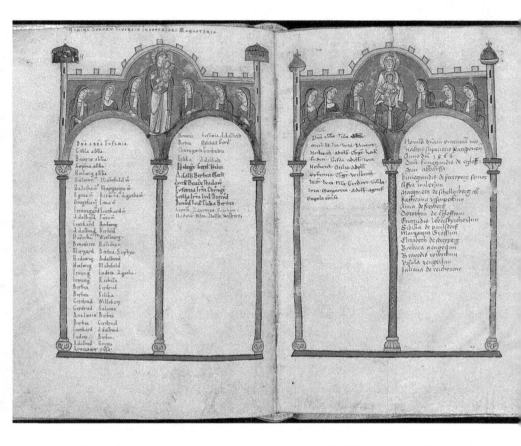

*Figure 3.6* Opening from the necrology of the Frauenstift Obermünster in Regensburg with a list of the names of the living sisters, 1177–1183. (Bayerisches Hauptstaatsarchiv, Munich, KL Regensburg-Obermünster Lit. 1, f. 65v–66r.)

listed not only the dead but also the living on whose behalf one should pray. The image represents the entire community, comprised of seventy-two individuals, precisely as many as Christ had disciples. Although the abbess leads the convent, all the sisters are represented in the same way, without hierarchical distinctions among them according to their offices or origins. Also included are the lay sisters and servants, who normally were never considered worthy of representation. The *Frauenstift* represents itself as a community in which women prayed and lived together, with male assistance, but under the direction of women. Under these circumstances, it seems only a matter of course that the two painters who illuminated the book were included in its intercessory prayers.

In other works, one finds, above all, expressions of the wish that women be given more just consideration in relation to the dominant male sex. For example, when in the Collectar from Hildesheim (Hildesheim, Dombibliothek, Ms. 688, f. 83v), the Lamb of God is adored by as many women as men, one can conclude from this modification of the customary iconography that a high-ranking religious woman was the patron.[9]

From the eleventh century onward, canonesses appear to have developed an especially close relationship to female patron saints. A good example is provided by the panel of the Last Judgment from the Roman *Frauenstift* of Santa Maria di Campo Marzo, in which both female donors, the canoness Benedicta and the abbess Constantia (in office 1061–1071), had themselves represented at the lower left in front of the wall of the Heavenly Jerusalem, which is designated as Paradise (fig. 3.7).[10] Just behind the wall, at the center, stands the Mother of God, accompanied by two female saints, most likely Praxedis and Pudenziana, both of whom are highlighted by their bright red garments and deferential gestures.

## Church Reform and the Status of *Frauenstifte* in the High Middle Ages

In her time, Hildegard of Bingen was by no means an isolated figure. The *Hortus deliciarum* (Garden of Delights) of the abbess Herrad of Hohenburg (d. after 1196), a compendium of salvation history and moral theology that was destroyed in 1870, had no equal in all of medieval art. Both women were characteristically engaged with the reform of the church. Canonesses could hardly dispute the fact that many *Frauenstifte* and monasteries were in need of reform. Nor could they deny that the many new orders that were founded from the late eleventh century on did a better job of guaranteeing the upholding of monastic ideals. Unlike countries such as England and France, where *Frauenstifte* were effectively abolished in the course of the twelfth century, in the empire church reformers were not able to convince all the canonesses to adopt the stricter Benedictine rule. Nonetheless, many foundations shared the spiritual aims of the ecclesiastical reformers and took an active part in reforms. For example, the monastery of Clus, founded by the canonesses of Gandersheim for the clerics that administered to them, was established according to the strict principles of the Hirsau reform. Beatrice II, abbess of Quedlinburg (in office 1130–1160) saw to

*Figure 3.7* Last Judgment, panel painting from the Frauenstift Santa Maria di Campo Marzo, Rome, probably 1061–1071, h. 289, w. 242 cm. (Vatican Museums, Vatican City.)

it that St. Wiperti, the church of the canons who were subordinate to the canonesses, was taken over by Premonstratensian monks. The Cistercian monastery of Michaelstein near Blankenberg, which she founded in 1147, belonged directly to Quedlinburg. She did nothing, however, to change the way of life in her own house.

Beginning in the late eleventh century, the use of illuminated prayer books for private prayer became more common, as did, in later centuries,

books of hours. Although little information about the individuals who commissioned or received such books survives, one can assume that most manuscripts of this kind were made for women. In general, images assumed increasing importance in all female religious institutions, as well as in the private realm. It is striking how many of the surviving early examples of antependia and altarpieces come from female monastic communities. The same holds true for early panel paintings, many of which adopt and adapt to new needs types taken from early Christian and Byzantine icons. New devotional imagery of this kind, with its intensely emotional pictorial language, is by no means limited to the new orders. To the contrary: some of the earliest and most impressive pictorial inventions were created for *Frauenstifte*. The *crucifixus dolorosus* (the sorrowful crucifixion, fig. 3.8) and the sculpture of the *Eleousa* (a type of Madonna in which the infant presses his cheek against the cheek of his mother) made for St. Maria im Kapitol are signal examples.[11] Other figural types that were especially beloved in *Frauenstiften*, as in sacred drama, were statues of the Madonna with a movable Christ Child and Holy Sepulcher groups.

Canonesses defended themselves against all attempts to rob them of their independence and to impose on them unwanted novelties. Even as they were compelled to adjust their way of life to changed circumstances, they tried to conserve as many old traditions as they could. A woven tapestry in Quedlinburg with representations of the Late Antique allegorical story the Marriage of Mercury with Philology, dated around 1205, exemplifies this tendency (fig. 3.9). The old imperial foundation now belonged to the local Saxon dynasty; the patron, the abbess Agnes of Meissen (in office 1184–1203), was descended from the ruling house. The didactic imagery of the model was nonetheless elaborated by means of an allegorical representation of the relationship between *regnum* and *sacerdotium*, that is, between worldly and spiritual rulership. The canonesses clearly did not desist from conceiving of themselves in terms of a superior, overarching framework defined by imperial politics. Artistically as well as stylistically, in technique as in its masterly technical execution, the fragment belongs among the most important works of its time. It testifies to the level of artistic accomplishment achieved by canonesses and nuns in the textile arts such as tapestry, weaving, and embroidery. The style suggests an orientation toward the art produced for the court of Henry the Lion in Braunschweig. The tapestry testifies to the continuing vitality of the concept of the female foundation even in a period that witnessed the breakup of the empire into smaller territories.

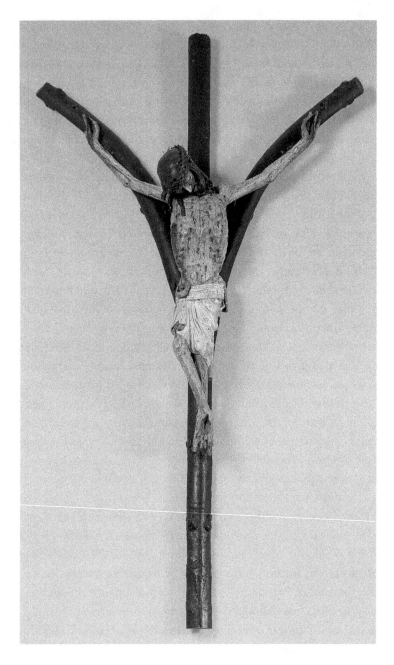

*Figure 3.8 Crucifixus dolorosus* (plague cross) from St. Maria im Kapitol, Cologne, 1304, h. 150 cm.

*Figure 3.9* Personifications of the Virtues and of secular and sacred rulership (*imperium et sacerdotium*), detail from the tapestry of Agnes of Meissen, abbess of Quedlinburg, ca. 1205. (Cathedral Treasury of the St. Servatius-Stiftskirche, Quedlinburg.)

## Women's Place in the Later Middle Ages: Reality Versus Representation

What might Gisle, who commissioned (and perhaps also painted) the magnificent codex that bears her name, have thought of the Hitda Codex? The initial for Christmas does not distinguish Gisle from her fellow nuns as they chant from beneath the bed in which the Virgin gives birth to the Savior. Only an inscription at the end of the manuscript identifies her as the one who made it (or had it made). During the later Middle Ages, even the most lavish liturgical manuscripts portray their patrons in secondary positions vis-à-vis the representations of sacred history at the center. In the lectionary from the convent of the Holy Cross in Regensburg and the gradual of St. Katharinenthal, the portraits of nuns and donors that pepper the borders are, for the most part, relegated to the margins.[12] In this respect, the regal portrayal of the abbess Hitda, which places her on almost the same footing as St. Walburg, offers a striking contrast to the saint's effigy in the *Salbuch* of St. Walburg in Eichstätt, dated 1360 (fig. 3.10). The sister of Willbald, the first bishop of Eichstätt, Walburga (ca. 710–779/790) served as abbess of a double monastery at Heidenheim, and her community at Eichstätt, founded a century later, originally took the form of a *Frauenstift*. Widely venerated, Walburga's image also appears on the cover of the Theophanu Gospels from Essen.[13] The *Salbuch*, however, paints a very

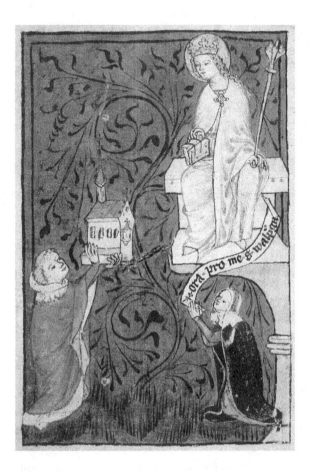

*Figure 3.10* Count Leodegar presenting the monastery he has reformed to St. Walburga, dedication image in the *Salbuch* of the abbey of Benedictine nuns, St. Walburg, Eichstätt, 1360. (Abtei St. Walburg, Eichstätt [Bavaria], front pastedown.)

different picture: it commemorates not the earliest phase of the abbey's history but rather its renewal in the eleventh century, when, under the guidance of Bishop Heribert of Eichstätt (in office 1022–1042), Leodegar, the count of Lechsgemünd-Graisbach, fulfilled a vow by providing for the conversion of the *Frauenstift* into a Benedictine convent.[14] Head bared to reveal a tonsure, Leodegar (who eventually became a priest) presents his foundation to the saint. Walburga presides from a throne resembling an altar, decked out with the attributes of queenship: a crown and lily scepter. In the Hitda Codex, abbess and saint communicate with one another almost as equals. In contrast, in the *Salbuch* Walburga appears in the guise of

an image within the image, as remote—and regal—as a Madonna on her proverbial pedestal and twice the size of those who adore her.

The structure of the miniature in the *Salbuch* echoes the relationships that regulated the life of nuns within enclosure (and possibly refers to the layout of the abbey in Eichstätt, in which the shrine with the saint's body was raised up by the altar above her vaulted *confessio*). An image provides access to the holy, but a male cleric plays a mediating role (as they would have in the transactions recorded in the book). Whereas Leodegar enjoys access to the life-giving gaze of the saint (the only figure seen frontally), the lowly nun, confined beneath the cryptlike arch that supports the throne, cannot see the saint—or the altar—directly. Her piety, at least as presented in this picture, depends on speech, not sight.[15] It is the nun's prayers, however, that activate the image. In response to her petition, the image within the image appears to come to life.

The *Salbuch* is not alone in mapping out overlapping, if not always congruent, patterns that are structured in terms of gender, social rank, and religious hierarchies. A dedication image honoring the Viheli family presents another image within an image in the form of a Madonna and Child (fig. 3.11). "Dominus Syfridus vihlin decanus in herrenberg" (Baden-Württemberg, region of Böblingen) celebrates Mass at the altar, perhaps that to which the nuns made substantial donations.[16] Unfurled scrolls identify "hayl dy junger," "Katherine," "hayl dy elter," and "Gerdrut" (subprioress, 1368–1404) as sisters by blood as well as by profession at the Dominican convent of Maria-Reuthin (near Calw). In contrast, Siegfried and the monk Götzo von Mengen, perhaps the nuns' confessor, play dominating roles.[17] The women are not physically present; the family celebrates Mass in the midst of an idealized *hortus conclusus*, an idealized space far removed from choir and cloister, where the interaction of nuns and their male mentors was strictly curtailed and controlled.[18] No hint is given as to whether the altar in question should be imagined in the lay church or whether it might instead be located in the nuns' choir, questions that, to this day, remain unanswered regarding some of the most important surviving examples, for example, the Clarenaltar from Cologne, which also represents the celebration of Mass in a prominent position (fig. 3.12).[19] More important than any real space is the idealized context of the memorial culture that binds the various members of the family in a community of prayer.[20] The image presents (or purports to present) a microcosm of a macrocosm in which sacred and secular realities intersect

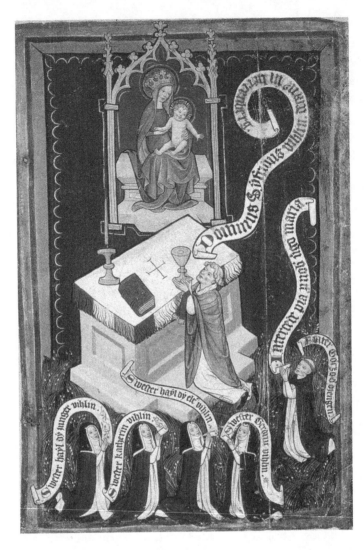

*Figure 3.11* The Viheli family celebrating Mass, Swabia, ca. 1410, parchment leaf, h. 52.5, w. 54.5 cm. (Württembergisches Landesmuseum Stuttgart, inv. 7796.)

and in which everything—and everyone—occupies its proper place. Yet works of art commissioned by and for female religious communities did not merely document religious and social relationships, they also sought to establish and secure them. Despite the speech scrolls that give voice to the Viheli sisters, we are always left to ask: who speaks for enclosed women? In trying to give voice to medieval nuns, does the historian risk playing the ventriloquist? Given the pervasive power of men within the church,

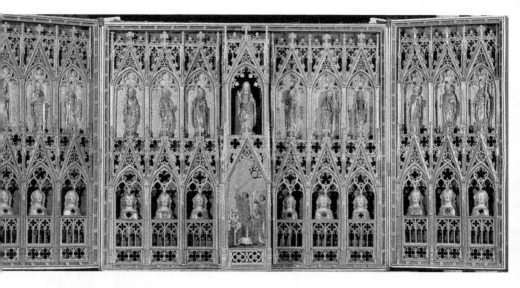

*Figure 3.12* Altarpiece from the monastery of St. Clara in Cologne, second opening, Cologne, ca. 1360. (Cathedral of Cologne.)

can any form of authentic female expression be identified, and, if so, how should it be interpreted?[21]

## Between Altar and Oratory: Images in Enclosure

Images such as the mid-thirteenth century Mary Magdalene from Adelhausen in Freiburg convey something of the vitality with which images would have confronted susceptible onlookers (see fig. 2.8).[22] For an aristocratic woman pursuing a life of penitence (not true of all nuns), the Magdalene offered an attractive model and mirror image.[23] Her figure is anything but static because of the torsion of her body, a movement enhanced by the ebb and flow of her stylish, courtly garments. Mendicant constitutions strictly forbade fine clothing, including fur linings.[24] More appropriate to *Reuerinnen*—sometimes former prostitutes—were the starched cloaks (*pepla crispa*), commonly called *Ransa* (*vulgariter dicta Ransa*), thought to have been worn by the Magdalene, their model.[25] The elegant, seductive figure from Freiburg reaches out to the viewer, yet, hand to her heart, she also withdraws in contemplation. The ointment jar in her hand evokes,

even if it does not demand, the presence of Christ's body. At St. Katharinenthal, a nun, Mia Goldastin, contemplates an image of Mary with Christ in Gethsemane and then hears Christ forgive her sins.[26] The Magdalene from Freiburg also seeks to place its viewer in the presence of the Lord. In the passionale made for Kunigunde, daughter of Ottokar II (in office 1258–1278), king of Bohemia, and, against her father's will, abbess of the venerable convent of St. Georg in Prague, the devout princess appears at Christ's feet in place of the archetypal penitent. Christ appeals to the viewer: "See the wounds and the horrible blows that I have borne."[27] The call to inspect and enter into Christ's wounds was to become one of the leitmotifs of later medieval art.

Enclosure curtailed nuns' freedom to interact with the world. In a society that invested virginity with such value, however, it enhanced their powers of prayer and intercession. Nor was the inner life of the convent entirely inaccessible. Images and texts provide some insight into the otherwise unapproachable and now irretrievable spaces, mental as well as physical, of enclosure. The life of Elsbeth Achler von Reute (1386–1420), better known as Bona von Reute (or "die Gute Beth"), was written shortly after her death by her confessor, Konrad Kügelin (ca. 1364–1428), to exemplify the piety promoted by the Franciscan third order, which sought to reshape the life of the laity in accordance with ideals of poverty and ascesis. Despite its propagandistic purposes, the life provides a plausible description of the barriers that separated the outer church from the nuns' inner church.[28] Konrad describes how he delivers the Sacrament to the charismatic women in his care, in particular, how he must mount the stairs that lead from the high altar to their raised choir, where he find Elsbeth languishing in her oratory in the choir stalls. Elsbeth Achler has no direct access to the celebration of Mass at the altar but nonetheless participates by means of visionary spiritual communion, telling her astonished confessor: "I received from my beloved bridegroom, Christ, the son of God, and I have also seen him in his divine nature."[29] At St. Katharinenthal, a nun need only stand on the stalls to see the consecrated host. What she sees, however, is anything but ordinary: "And thus she joined and united her heart entirely with God. And as our lord observed, he spoke to her out of the hands of the priest in the form of the host: 'Look at me and look at me with desire, for you will look at my divine visage for all eternity according to all your heart's desire.'"[30] Accounts such as this, even if not to be taken

at face value, indicate not only that enclosure was permeable but that sight was central to female spirituality.[31]

Dominican statutes from shortly after 1259 stipulate that "nuns neither install pictures by their seats nor procure for themselves images or little chapels [*capellulas*]."[32] The friars eventually forbade the construction of oratories around beds in the dormitory.[33] The hoard of devotional objects found at Wienhausen and Ribnitz indicate that legislation was honored in the breach. The choir was a place for private as well as communal prayer. At Heilig Geist in Erfurt, Johannes Busch recounts, he and his fellow reforms removed from "behind the altar" (*retro dorsus*), that is, from the nuns' choir, "images of Christ and the saints, both sculpted and painted," that the nuns had placed there "for their own devotion, . . . replacing them toward the east in the space between their choir and church, so that all could see them equally, have devotion from them in common and not in private [*in privato*] in the manner to which they were accustomed."[34] At Wennigsen, southwest of Hanover, Busch claims to have come across nuns prostrating themselves in the choir amid a circle of images, including two burning wax effigies, in an effort to ward off the unwelcome reformers.[35] Such stories seek to scandalize, but there is no reason to doubt their essential truth. Might the images seen by Busch at Wennigsen have included the two-sided Madonna still suspended above the nuns' choir? The image aptly captures the two faces that female monastic communities had to present: one to the world without, the other turning its back on that very same world.

Important female patrons also had access: at Trebnitz, the founder, Hedwig of Silesia (ca. 1178/1180–1243), stole into the nuns' choir to kiss their seats, a ritual act of veneration and humiliation. Proceeding from the virgins to the Virgin, to whom the high altar was dedicated, Hedwig then encountered Christ, the mystical bridegroom, in the triumphal cross hanging over the altar, who responds to her petitions by extending his right hand in blessing.[36] One thinks of the crucifixion with crossed arms from Helmstedt, derived from a bust-length *Schmerzensmann*, which, even if not inspired by visions, could easily have provoked them.[37] At St. Katharinenthal, it is the prioress, Adelheit Hüterin, and two other nuns who see themselves embraced, not by Christ but by the great crucifix in the choir.[38] The stereotypes that mark these sources do not diminish their value.[39] Even if not descriptions of experience, they served as edifying exemplars that

shaped the expectations that viewers brought to images and that in turn heightened their often drastic visual rhetoric.[40]

## The Eucharist and the Topography of Visionary Experience

At Wienhausen, the nun who opened the door to the sacristy cupboard confronted a cross-section of Christian hierarchy and history, from Christ in heaven, represented by the Nativity at the upper level, to, at the bottom, the monastery's founders and patron saints, all gathered around the gigantic monstrance at the center, in which, as on the altar in the nuns' choir, the consecrated host is prominently displayed, flanked by angels and apostles. Like the murals in choir, the image positions the community within the continuum of sacred history. The monstrance first acquired currency in the second half of the thirteenth century, in the wake of women such as Juliana of Cornillon (1192–1258), who instigated and propagated the cult of Corpus Christi.[41] Following a miracle in 1317, the monstrance from the Cistercian convent of Herkenrode became the focal point of devotion to the Corpus Christi. An indulgence from Herkenrode most likely illuminated by the nuns of the abbey shows nuns in procession outside the walls with members of the clergy, carrying the ostensorium in which the abbey's miraculous host was housed (see fig. 8.3).[42] Johannes Meyer (1422–1485)—normally no friend to such extravagances—relates that at Schönensteinbach (Alsace), following the octave of Corpus Christi, Margreth Slaffigin followed the priest who removed the monstrance from the nuns' choir, wailing: "O woe, they wish to take from our eyes our greatest possession, our most precious treasure, that which we love with our hearts most deeply." Later, having fasted until compline (i.e., until late at night), she drank the water the priest had used to wash his hands "mit grosser begird und andacht."[43] In its combination of abjection and exaltation, transgression and humility, Meyer's account captures essential aspects of female monastic piety.

By tying private experience to the cult, visions and the images featured in them lent themselves (and the women who experienced them) sacramental authority and authenticity. Images and visions compensated for those things, persons, and places that were so manifestly lacking within the confines of enclosure.[44] Images, whether in books or monumental paintings, allowed nuns to go on imaginary pilgrimages in spirit (*Pilgerschaft im*

*Geist*) without ever setting foot outside the walls.[45] The bridal imagery that plays so important a role in the imaginary of female monasticism is more than merely a substitute, however.[46] Through the Marian liturgy, the Song of Songs provided a common inheritance for all of Western Christendom.[47] Only in the context of female monasticism, however, was sexual imagery so consistently translated into visual form. In the *Rothschild Canticles*, a mystical miscellany made for an unidentified woman, most likely a nun, around 1300, the image of Christ descending in a fiery sunburst to join his bride in bed has a sexual energy unparalleled in Christian art before Bernini's sculpture of the ecstasy of St. Teresa.[48] At Chełmno (Kulm) in Poland, the imagery of the Song of Songs literally becomes all-encompassing: thirty-two scenes from the Song of Songs form part of a cycle that, much like the *Banklanken* from Saxon convents, runs right around the nuns' choir, likening the enclosed space to the bed chamber (*cubiculum*) in which Christ consummates his love for his brides.[49] The same cycle recurs a hundred years later in the Netherlandish *Canticum canticorum* block book: a clear example of the transmission, transition, and, eventually, normalization of a novel form of imagery that, following its first formulation in the context of female spirituality, later found its way to the laity at large.[50]

Images play prominent roles in visions, as props but also as protagonists.[51] No other body of medieval texts testifies in such detail not just to what could be seen in medieval monasteries but also to how those images ostensibly were experienced. Visions lent concrete form to otherwise invisible mysteries. In a dream vision attributed to Gertrude of Helfta (1256–1301/1302), the mystic sees a crucifix leaning over her bed, as if it were about to topple over. Pressing the image between her breasts, she echoes the Song of Solomon 1:12: "a bundle of myrrh is my beloved to me, he shall abide between my breasts." Gertrude removes the iron nails from the corpus, replacing them with cloves, then kisses the corpus repeatedly.[52] When she finally falls asleep, the image extends its right arm and embraces her, whispering in her ear a love poem, in fact, a stanza from the *Jubilus* that, in the Middle Ages, was attributed to St. Bernard.[53] Elsewhere, Gertrude provides an impassioned and theologically literate apology for images and the devotional practices associated with them, describing her visions in pictorial terms as "imaginary depictions" ("depictas imaginationes") that lead her in turn to that hidden manna from heaven ("manna illud absconditum") that eludes all imagining.[54] Each of her key experiences of union takes a work of art as its principal point of

departure. Gazing at an image of the side wound painted on a page and beseeching Christ that he transfix her heart with the "arrow of his love" ("ut transfigas cor meum tui amoris sagitta"), Gertrude is penetrated by a ray of light that, in her words, "in modum sagittae acuatus, qui per ostentum extensus contrahebatur, deinde extendebatur, et sic per moram durans, affectum meum blande allexit."[55] The sexual imagery derives from the evocation of wounding sight in the Song of Solomon 4:9 ("vulnerasti cor meum soror mea sponsa vulnerasti cor meum in uno oculorum tuorum").[56] The dynamics of sight are matched by the dramatic double image in the *Rothschild Canticles* of the Sponsa—a figure of the soul as bride of Christ—who points to her eye even as she, like Longinus at the Crucifixion, thrusts her phallic lance into the passive, receptive flesh of the naked Christ (fig. 3.13). Similar imagery occurs in the allegorical image of Christ crucified by the Virtues, of which most early instances—for example, the magnificent miniature in the lectionary from Heilig Kreuz, Regensburg (fig. 3.14), the mural in the Michaelskapelle at Göss (Austria),[57] and the stained glass window opposite the entrance to the nuns' choir in Wienhausen (Lower Saxony)[58]—come from female houses. In these and related images—so arresting, in part, because they attempt to spell out some of the central paradoxes of Christian dogma, such as the notion of a God who willingly submits himself to death—gender roles are not so easily assigned. Like Gertrude's writings, the opening in the *Rothschild Canticles* is transgressive, not just in the way in which it forces the eye to leap from one folio to another and back again but in other, still more evocative ways that reverse roles and break down the barrier between the image and the viewer. Christ directs his own self-sacrifice, as both the bride in the image and the Sponsa Christi who holds the image in her hands penetrate him with the "prick of love."

Why the disproportionate emphasis on images and visual experience in female monasticism of the later Middle Ages? Is it simply that the texts reflect the prominence of images in female piety (witness the decorative program at Wienhausen, which leaves no surface, no object, unadorned)? Or is it that, in more complicated ways, they embody the importance of experience per se as a historical category that, in keeping with age-old prejudice, was associated not simply with the body but, above all, with women, whom theologians cast as less intellectually capable than men?[59] According to this view, images feature prominently in female piety in part because women, it was felt, were incapable of rising above them. Women,

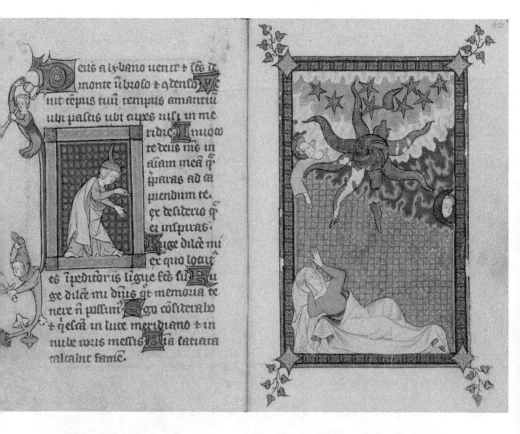

*Figure 3.13* Mystical marriage (*connubium spirituale*): Christ descending to the bed of his bride, miniature in the *Rothschild Canticles*, Flanders, ca. 1300. (Beinecke Rare Book and Manuscript Library, Yale University, New Haven, Ct., ms. 404, f. 65v–66r.)

however, went their own way with images.[60] Before one dismisses their devotions as child's play, one should recall that it in some ways they do not differ in kind from the dramatic use of monumental sculpture in liturgical rites. Liturgical props include not only Holy Sepulchers, of which many of the early examples—such as the imposing yet little-known fourteenth-century figure of Christ from Chełmno—come from convents, but also the Palm Sunday donkey (*Palmesel*), drawn into the church on Palm Sunday, and the standing figure of Christ, drawn up through an opening in the vaults on Ascension Day.[61] Too ill to maintain her regular contemplative regime ("interiori studio contemplationis"), Gertrude (or, rather, a nun writing under her name) describes how she settled, reluctantly, for an exterior image: a sepulcher in which she places, as if in play ("quasi

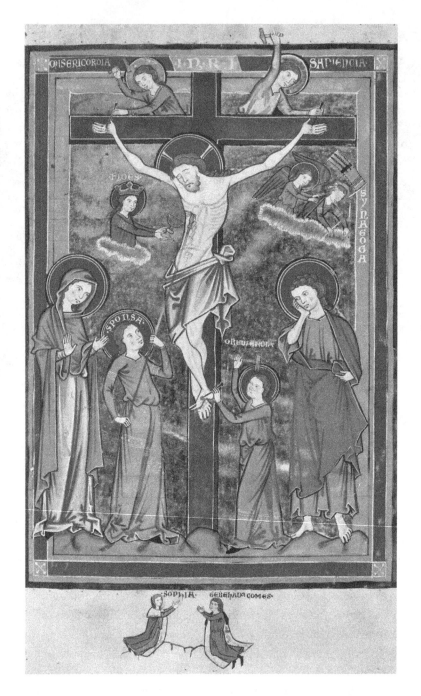

*Figure 3.14* Crucifixion of Christ by the Virtues, full-page miniature from the lectionary of the Dominican convent of Heilig Kreuz in Regensburg, Regensburg, 1270–1276. (Keble College, Oxford, ms. 49, f. 7r.)

ludendo"), an image of the crucified Christ in memory of the Passion.[62] Devotional dolls of this kind survive in large numbers. Gertrude asks Christ if he can take pleasure in a devotional exercise that engages the senses more than the spirit ("magis sensualiter deservit quam spiritu"), to which Christ, using an unlikely comparison, replies that he, like a greedy usurer, eagerly accepts every token of affection.

In addition to its somatic side, female spirituality also had a strong intellectual streak, which was no less bound to images, albeit in different ways.[63] It is hardly by accident that Meister Eckhart (ca. 1260–prior to 1328) preached at St. Katharinenthal, where, alongside the statues of the two St. Johns, the nuns could have read John Scotus Eriugena's (ninth century) esoteric homily on the Evangelist in an unprecedented Middle High German translation.[64] The decoration of the gradual from which they would have accompanied Mass in their choir exhibits not only unequaled splendor but also unparalleled iconographic and intellectual complexity. In this respect, the gradual and other works like it represent an extension of the claims embodied by ambitious works of art such a s the monumental Philosophy Tapestry, dated 1516, from the Augustinian foundation of Heiningen (see fig. 9.3).[65] Dominated by the enthroned figure of Lady Philosophy at the center, the tapestry embodies an ambitious intellectual program, complete with representations of classical poets and philosophers and quotations from their works. An inscription around the outer edge contains the names of all the nuns of the convent, celebrating their contribution and commemorating them for all eternity.

## Conclusion: The Monastery in the World

It is perhaps best to end, as does the story of female monasticism in the Middle Ages, on a less exalted note. Mysticism itself has a social history, and not all nuns were visionaries or mystics. Most of the images made by and for nuns served didactic functions closely linked to their daily activities, be it spinning or baking *Krapfen*. All these tasks were absorbed into religious routines. The *Buch im Chor* (Book in the Choir) of Anna von Buchwald (prioress of Preetz in Schleswig-Holstein from 1484 to 1508) reads almost like a diary–cum–account book in its day-to-day reporting of the struggle not only to reform and renovate the community but also to

protect it against the predations and neglect of the clergy.[66] The procuring and production of images whether as gifts for donors and patrons or as objects of exchange formed part of these efforts. In this respect, enclosed woman, far from being cut off from the world, stood at the charged, porous, yet highly volatile boundary that separated them from the *saeculum*.

Like the canonesses who, in many respects, served them as models in all things except their pursuit of poverty, Agnes of Prague, Hedwig of Silesia, Agnes of Königsfelden, and Elisabeth of Thüringia passed back and forth between the world and the cloister.[67] Revered or championed as saintly already in their lifetimes, women such as these fashioned themselves as living legends, in part by taking representations of saintliness as their models.[68] The contrast with male monasticism could not be clearer (or at least with its vanguard elements). In the twelfth century, Bernard of Clairvaux railed against images, arguing that, in contrast to the clergy who cared for the laity in cathedrals, monks had no need of luxurious liturgical furnishings. Female monasticism of the later Middle Ages turned the tables: far from holding up an ideal of imageless devotion to the laity, it led the way in introducing new genres and novel practices, not just the full spectrum of devotional imagery but extensively illustrated prayer books,[69] icons,[70] painted retables,[71] and custom-made devotional compendia such as the Passionale of Kunigunde of Prague, whose frontispiece Kunigunde dominates as if she were herself the queen of heaven (fig. 3.15).[72] In this dynamic, the position of women and their images is constantly in flux, both on the margins yet, at the same time, on the cutting edge.

For Bernard of Clairvaux, reform meant, above all, banishing images and all that they stood for (curiosity, waste, and, potentially, idolatry). Referring to Mary sewing in the temple, a Cistercian contemporary wrote, "it is not becoming for nuns and women who are dedicated to God to take pains on this kind of work; besides, gold threads do not cover nakedness or keep out the cold; they feed the curiosity of the eyes and that alone, and therefore women doing this kind of work can be called not so much workers as delighters of the eyes."[73] Curiosity, argues the author, is a particularly female failing. Against this foil, late medieval representations of Mary as a virtuous seamstress in the temple mark a complete reversal in attitudes (and one that would shape early modern attitudes and representations of female domesticity).[74] The intricately wrought textiles

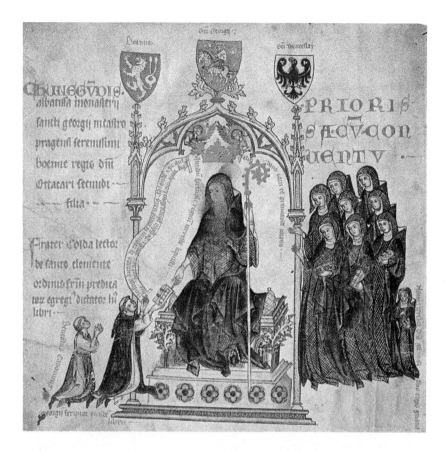

*Figure 3.15* Presentation of book and coronation of Kunigunde, dedication image in the Passionale of the abbess Kunigunde from the Stift of St. George in Prague, ca. 1310/1320. (Národní knihovna, Prague, ms. XIV.A. 17, f. 1v.)

produced by female monastic communities from the twelfth well into the sixteenth centuries testify to close association of manual labor and spiritual reform in the spirit of the Benedictine injunction *ora et labora*.[75] Not all the images made by nuns for their own use meet modern criteria of aesthetic merit, but they nevertheless speak with uncommon clarity of the aspirations and values of those who made them. We are the ones who need to shift our perspective. If the manuscripts illuminated by women often emulate textiles in their bright coloration and ornate patterning, it is because of the prized place of textiles within their religious routines (as at the courts to which their families belonged). Through donations and

purchases, female communities had access to works of art from the outside—if resources allowed, then from the best that contemporary artisans could supply. The images that they made for themselves gave expression to and fulfilled aspirations that otherwise went unmet. At the same time, an honest appraisal of the art of female monasticism reveals unanticipated splendors and accomplishments. Enclosed women did not merely participate in the broader artistic currents of the Middle Ages; they consistently changed their course.

## Notes

1. Cat. Berlin 1992.
2. Kötzsche 1994.
3. Fürstenberg 1995.
4. Schilp 1998.
5. Beuckers 1995, 1999.
6. Cohen 2000.
7. Suckale 2002:49.
8. Schilp 1998.
9. Cat. Bamberg 2002: nos. 121, 284–286 (Gude Suckale-Redlefsen).
10. Suckale 2002:12–13.
11. Suckale 2004.
12. Bräm 1992.
13. Röckelein 2000:98–99.
14. Schlecht 1886; Hamburger 1997a.
15. Bruzelius 1992.
16. Gand 1973:64; Gand 1979.
17. Gand 1973: nos. 74, 75, 81, and 90; Janssen 1993:21–22; 1999.
18. Jäggi 2004a; Vandenbroeck 1994.
19. Wolf 2002:86–89.
20. Signori 2000; Kern-Stähler 2002.
21. Hamburger 1998b:13–34.
22. Bock and Böhler 1999:50–55.
23. S. Lewis 1995:284.
24. Ritzinger and Scheeben 1941:30.
25. Grube 1886:582–583.
26. Meyer 1995:123.
27. Toussaint 2003:165–169, 173–175.
28 Siegfried Ringler, "Kügelin, Konrad," in Ruh 1978–:5:cols. 426–429.

29. Bihlmeyer 1931:105.
30. Meyer 1995:118.
31. Hamburger 1998b:35–110.
32. Ritzinger and Scheeben 1941:26.
33. Ibid.: 30.
34. Grube 1886:611.
35. Ibid.: 556–557.
36. Braunfels 1972:2:fol. 24v.
37. Von der Osten 1967; Vetter 1972:197–198; Hecht 2003.
38. Meyer 1995:35.
39. Vassilevitch 2000; Jäggi 2004b.
40. Belting 1981.
41. Oliver 1999.
42. Oliver 1995.
43. Reichert 1908–1909:2:80.
44. Lentes 1992; Dinzelbacher 1992; Hamburger 1998b.
45. Fabri 1999; Rudy 2000; Gärtner 2002.
46. Bynum 1996.
47. Fulton 1998.
48. Hamburger 1990:72–77.
49. Ibid.: 85–87, 98.
50. Bartal 2000.
51. J.-Cl. Schmitt 2002.
52. Gertrude d'Helfta 1968–1986:2:192–207.
53. Wilmart 1944.
54. Hamburger 2000b.
55. Gertrude d'Helfta 1968–1986:2:248.
56. Hamburger 1997a:101–136.
57. Kirchweger 1999.
58. Becksmann and Korn 1992:224–226.
59. Biller and Minnis 1998.
60. Hamburger 2004a.
61. Tripps 1998; Aballéa 2003.
62. Gertrude d'Helfta 1968–1986:2:232.
63. Hamburger 2004c.
64. Hamburger 2005.
65. Taddey 1966; Eisermann 1996:242–258.
66. Faust 1984; Eberl 2003.
67. Benešovská 1994; Marti 1996; Klaniczay 2000.
68. Kleinberg 1992.

69. Hamburger 1998b; Hamburger 2000a.

70. Hamburger 1998a.

71. Toussaint 2003:41–70.

72. Hamburger 2002a.

73. Hamburger 1997a:181–192.

74. Kroos 1970.

75. Oliver 1997.

# Church and Cloister

## The Architecture of Female Monasticism in the Middle Ages

CAROLA JÄGGI AND UWE LOBBEDEY[*]

### The Early and High Middle Ages (Sixth through Twelfth Century)

Scholarship on monastic architecture does not identify building types typical of women's institutions before the emergence of female Cistercian monasteries in the twelfth century.[1] An examination of the surviving structures or those known through excavation or the archaeological investigation of existing church buildings demonstrates that in the early Middle Ages building types and architectural styles hardly differed between male and female convents.[2] From the period of Carolingian reforms, a distinction was drawn between female convents that followed a Benedictine monastic rule and those that took as their model communities of canons. In many cases, however, the sources do not permit one to determine clearly which rule a convent was following at any given period. For this reason, it is not very productive to parcel out specific building types to these two ways of life. Instead, one can pose the questions: where did the female convent have its place in the church, and where and how did the women live?[3] These two questions can also be connected. In answering them, it should be remembered that, in light of the organization of church space, service at the altar was always performed by male clerics.

[*] The first section, on the early and High Middle Ages, was written by Uwe Lobbedey; the second section, on the later Middle Ages, by Carola Jäggi.

Moreover, it should be recalled that, especially in the early period and in the twelfth century, female monasteries often were joined to male convents to form double monasteries.

## The Early Period

For both sexes, it can be said that the few church buildings and monastic complexes of the early period that have survived or been excavated provide an all-too-incomplete picture of circumstances at the time. Most structures have either been lost or replaced by newer buildings. An Irish source, the *Vita secunda Sanctae Brigidae* of Cogitosus (ca. 650–675) describes the church of the monastery founded by St. Brigida (d. ca. 525) in Kildare:[4] The church, presumably constructed of wood, was large, tall, and divided into three parts. A transverse wall, decorated with paintings and textiles, separated a room to the east that housed the altar. An additional wall running from the transverse wall to the west facade separated the space along the main axis into two equal parts, each of which had a portal. Whereas the priest and male members of the laity entered the church through the right portal, the nuns and female members of the congregation entered through the left. Doors led from both rooms into the area reserved for the altar, the one on the right for the bishop, priests, and choir (*schola*), the one on the left for the abbess and her virgins and widows. About the conventual buildings we learn nothing, but from other early Irish monasteries it is known that, as a rule, they consisted of an aggregation of small buildings within a circular enclosing wall.

Early Anglo-Saxon written sources hint at the existence of small residential buildings or cells as well as buildings for common use, such as the dormitory of the nuns of Barking, mentioned by Bede (d. 735).[5] The churches most likely adhered to the simple Anglo-Saxon model with a single vessel and a rectangular choir. The results of excavations at the double monastery of Whitby in Northumbria, founded in 657, do not permit much in the way of reconstruction.[6] The church was presumably centrally located, more or less on the spot where the transept of the ruin of the Gothic church now stands. Among a number of rectangular buildings that lie to the north of the church, constructed of stone and varying in size, at least two can be identified as living quarters because of the presence of hearths. It is possible that there was a previous construction phase, in

which only wood was employed. Finds in this area indicate women's ac-
tivities, among them, the production of textiles. They also underscore the
wealth of the monastery, which served as a royal mausoleum.

From the many Merovingian monastic foundations within the terri-
tory of the Franks, only a few physical remains are known. In Jouarre
(founded in 635 as a monastery of monks but converted into a double
monastery soon thereafter), the complex comprised three churches.[7] From
the funerary crypt of St. Paul are preserved some early marble capitals and
the cenotaphs of Bishop Agilbert (d. before 690), most likely from the
end of the eighth century, and four abbesses from the eighth century.[8] A
complex of three churches, known from excavations, also lay at the heart
of the monastery of Nivelles, founded around 650.[9] Best documented is
the funerary church of the monastery, a structure with an extended single
vessel. During the Carolingian period, the veneration of the first abbess,
Gertrude (ca. 626–659), at her tomb led to the construction on this site of
the great abbey church and, later, as its successor, the great church that still
stands, dedicated in 1046. In Metz, the nuns of Saint-Pierre-aux-Nonnains,
most likely founded in the seventh century, established their cloister in a
Roman hall capped by an apse that had been erected around 400.[10] The
eastern third of the building was raised and separated from the rest of the
building by a barrier. The famous stone barriers decorated with figural and
ornamental carving were added in the eighth century. Removed at a later
date, their remnants were incorporated into the walls of the subsequent
structure. Around 900 the church was converted into a basilica by adding
partitions running the length of the building between the old outlying
Roman peripheral walls.

It can be regarded as a piece of archaeological good luck that the mon-
astery of Hamage (in northern France, east of Douai), founded around
625–639 by an important aristocratic family, was never rebuilt following
its destruction by the Normans in 881–883.[11] Excavations carried out
since 1990 have revealed a church constructed in stone and postholes
from wooden living quarters of various periods. For the seventh century,
a residential structure covered by a single roof can be reconstructed. Small
cells, each with a hearth, surrounded a larger central space. In the ninth
century, there was a rectangular courtyard, with structures supported by
posts on its western and southern sides. To the north, a corridor filled
with graves leaned against the stone church. The eastern side has not yet
been excavated.

One of the most important female monasteries is San Salvatore/Santa Giulia in Brescia, founded in the middle of the eighth century by Desiderius, at that time the duke, later the king of the Lombards, and Ansa, his wife.[12] With the exception of its west wall, the church, which was built in the eighth or ninth century, survives intact. The central vessel and aisles of the basilica have apses at their east end; a small hall crypt is located under the central apse. South of the church stands a series of three adjoining courtyards, altogether 118 meters long in their present condition, that, although much rebuilt in later times, nonetheless contain a good deal of their earlier fabric. One of the three courtyards probably stands on the site of the nuns' old cloister.

Of the many monasteries and foundations from this period within the territory of the empire whose churches are known, for the most part by means of excavations, only a few can be named here. In both size and structure, they vary considerably. The female foundation of Niedermünster in Regensburg was erected in the eighth or perhaps only in the ninth century in a preexisting single vessel church whose interior was twenty meters long and ten meters wide, with an attached rectangular choir adding an additional five meters.[13] A barrier separated the eastern third of the structure from the rest of the building, which was fronted in the west by a porch. Only in the middle of the tenth century was a basilica structure with a transept erected. In Graubünden (Switzerland), most likely in the second half of the eighth century, the female monastery of Mistail received a single-vessel church with three apses, still completely preserved.[14] With an interior measuring around 16.50 by 11.40 meters, it was a sister structure to the male monastic church of the same type preserved in nearby Müstair.

Where was the nuns' choir located in these churches? The general assumption is that nuns and canonesses found their place in a gallery at the west end of the church. In Germany, this was generally the case from the twelfth century onward. In France, however, as in Switzerland and England, choirs at ground level were common.[15] In churches to which the laity was not admitted, they occupied the entire nave, as, for example, at the double monastery of Fontevrault in France (Loire valley, Anjou, twelfth century).[16] In this instance, the choir and the transept were reserved for the monks; the nuns occupied the nave, which was vaulted with domes. In Germany, too, isolated examples of nuns' choirs at ground level

can be found, even in later periods (as at St. Maria im Kapitol in Cologne). Whether the barriers mentioned in other churches defined nuns' choirs or the area for male clergy remains uncertain. Excavations cannot provide evidence of galleries insofar as they stood on continuous beams that ran from one wall to another. It must also be borne in mind that, at least among canonesses in the High Middle Ages, an elaborate processional liturgy led through the church and adjoining buildings. In some *Frauenstifte*, galleries are documented from the ninth century onward, not only in the western portion of the church but also, above all, as has been demonstrated by the latest research, in the transept.[17]

Carolingian and Ottonian *Frauenstifte* were for the most part established by wealthy aristocratic families or even by ruling monarchs. They are largely found in Alemannia (southwestern Germany and northern Switzerland), Lotharingia (roughly the Netherlands, Belgium, Luxembourg, Alsace, Lorraine, and portions of northwestern Germany, including Aachen and Cologne), and Westphalia and Lower Saxony.[18] Among these churches are the most remarkable monuments in the history of medieval architecture. Comparable to cathedrals and the largest male monastic churches of the period, many of them were built as three-aisled basilicas with transepts, crypts, and westworks. At Meschede in Westphalia, the existing seventeenth-century church preserves enough of original late-ninth-century structure that it can be reconstructed in all its essential features.[19] The elevated square choir served as the space where the male clerics conducted their services. It was originally surrounded by a two-storied crypt with a well-preserved tomb for the relics of the patron saint, St. Walburga, which attracted the veneration of pilgrims from far and wide. The transept arms included apses for secondary altars. Additional altars were located at the closed eastern ends of the aisles flanking the nave. A tall bell tower to the west rounded out the ensemble. The women's choir was located in a gallery in the south transept. An additional gallery was located in the westernmost bay of the nave. From this it can be concluded that there must have been processions between these two galleries (and additional spaces), as well as to the various altars. The incorporation into the basilica's walls and floors of jars to enhance the resonance of chant indicates that special consideration was given to its performance. The source for this special construction feature is the treatise on architecture of the Roman architect Vitruvius (written ca. 33–22 b.c.e.), which, as indicated by copies produced at the time, was known in the Carolingian era.

The best-preserved church of a foundation from the Ottonian period, that in Gernrode, was begun in 959 (fig. 4.1).[20] The church is known for the galleries in the nave. The westwork has a square central space that is as wide as the nave to which it is attached. Its main story, illuminated by elevated windows, stands above a low-lying ground floor and supports an additional story that rises like a tower above the central structure. To the sides are attached two-story antechambers and stair towers. The function of this complex western structure, to which analogies can be found in similar and varied forms in Carolingian and Ottonian cathedrals and male monasteries, has been the subject of a great deal of inconclusive debate. It is apparent, however, that neither the gallerylike space in the main floor of the westwork nor the galleries in the nave served as the proper place of the women's choir. In accord with extant liturgical sources and the spatial proximity to the eastern dormitory wing of the cloister, it is far more likely that it lay in the gallery located in the eastern arm of the transept, not only from the twelfth century, from which time it is attested, but also from the first phase of construction.

## Monastery Churches from the Early to the Late Romanesque Period

The single vessel church that was characteristic of the early Middle Ages also remained in use in later periods. A good example can be found at Vreden in Westphalia. The abbey with Carolingian origin had close ties to the monarchy. The existing church was built toward the end of the eleventh century on a cruciform plan.[21] In contrast, the church of the foundation of St. Maria im Kapitol in Cologne (ca. 1040–1065) is unusually elaborate. The aisles of the nave continue around the trefoil plan of the choir. Surprisingly, the entrances for the laity were located at the vertices of the conchae, whereas those for the canonesses were located in the nave.[22] The west choir of the *Frauenstift* at Essen, built around 1000 or, perhaps more likely, toward the middle of the eleventh century, is enormously impressive (fig. 4.2).[23] Seen from the exterior, it is flanked by two-story annexes and stair towers, crowned by an octagonal tower. On the interior, the half-dome of the apse stands on four piers that map out a half-hexagonal plan. The arches of the lower story and the columns that make up the screens in the arcades of the upper story reference the church of the imperial residence of Charlemagne at Aachen. The cramped adjoining rooms served

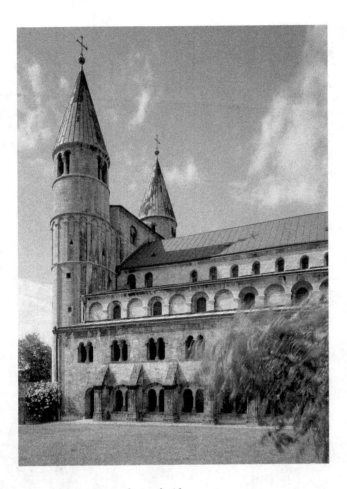

*Figure 4.1* St. Cyriacus in Gernrode, south side.

liturgical functions but were not the site of the women's choir, which here as elsewhere was located in a gallery in the transept. Around 1030 a complete but smaller imitation of the cathedral in Aachen was built for the nuns of Ottmarsheim in Alsace (dedicated 1049).[24] Here it must be mentioned that most Carolingian and Ottonian churches for canonesses underwent important transformations during the Romanesque as well as in the Gothic period. A good example of this phenomenon is Herford, rebuilt around 1220–1260 as a typical hall church. The transept gallery for the canonesses still survives, as one of various examples.

Seldom can responsibility for supervision of new construction be assigned as clearly as at the Rupertsberg near Bingen, where between 1158

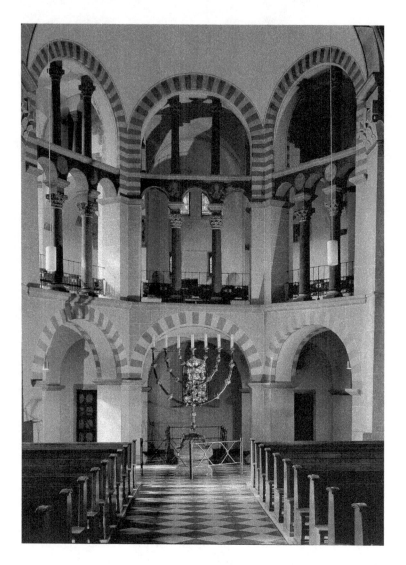

*Figure 4.2* The west choir of the former Stiftskirche Essen, probably ca. 1000.

and 1165 Hildegard of Bingen oversaw the building of the monastery that she had founded in 1150, but of which, unfortunately, only fragments survive, rebuilt in the modern period.[25] These remnants, along with views that date to from the seventeenth through the nineteenth century, permit one to reconstruct a very simple basilica without a transept, covered by a flat wooden ceiling, in which the architectural emphasis lay on the facade

of the choir. The apse was flanked by two towers. At the east, the exterior was articulated with applied pilasters and friezes around the arches. Under the choir there was probably a small crypt. There is no evidence of where the nuns' choir was located. A new reconstruction locates it at the east end of the nave, that is, on the spot customarily reserved for the choir stalls in male monasteries.

In the twelfth century, especially in northern Germany, one encounters a building type that is typical of female monasteries. It is perhaps hardly accidental that its appearance coincides with the monastic reforms of the first half of the century, which placed great emphasis on the enclosure of women.[26] A hallmark of these buildings is a large stone gallery to the west, frequently combined on the exterior with a facade with two towers that, as a rule, does not provide the entrance. An almost entirely preserved vaulted basilica from the third quarter of the twelfth century can be found at Lippoldsberg on the Weser, a building in which the clarity and power of Romanesque architecture is especially apparent.[27] Almost half of the central vessel, one-and-half bays, is occupied by a hall of piers that carries a nuns' gallery. At its eastern end projected a small balcony, providing an altar place for the gallery. The nuns had access to their choir on the gallery via the west wing of the cloister north of the church that is partially preserved. Two towers slightly set back from the west front of the nave, of which only one survives, dominated the exterior. Such large galleries at the west end of churches also occur in newly constructed foundations, to name only two examples in Westphalia, in the churches at Metelen[28] and Langenhorst,[29] both from the thirteenth century.

### Cloister Buildings

As with male monasteries, our knowledge concerning the early development of cloister complexes of female monastic foundations, especially the structures in enclosure that developed around the square cloister courtyard, is very scanty.[30] As noted previously, this type of arrangement, exemplified by the St. Gall plan of around 820, cannot be found in the Irish–Anglo-Saxon sphere.[31] At Mistail, there was no cloister.[32] Excavations have revealed the foundations of a large building for the nuns, possibly datable to the eighth century, with an axis divergent from that of the church. The foundation at Vreden mentioned earlier, newly constructed in the late

eleventh century, also apparently possessed no more than a single house for the canonesses alongside the church and, perhaps, several individual houses for the *Stiftsdamen* with their households.[33] As indicated by the excavated remains of Freckenhorst (Westphalia), however, cloisters with four wings were in use from the ninth century.[34] Numerous examples in monasteries and *Frauenstifte* can be cited from the eleventh century onward. Variations on this type are also the rule in England from the twelfth century onward.[35] Cloisters of this kind were even added to the churches of *Frauenstifte* at a time when canonesses already possessed individual houses.[36] The one surviving wing of the three originally attached to the *Frauenstift* at Gerresheim near Düsseldorf, built around 1230–1240, provides a good example.[37] In this case, the dormitory was directly connected to the choir of the canonesses in the north transept, which was also the case, for example, in Herford. Nottuln (near Münster) is an interesting case.[38] In the eleventh century, a claustral complex was built with an eastern wing four meters in width that apparently contained the dormitory. The somewhat wider south wing housed the refectory and the kitchen. The cemetery was attached to the western wing of the cloister. In the course of rebuilding the church in the twelfth century, the east wing was abandoned, and a west wing added in which a dormitory is later attested. A new structure housing an apartment for the abbess was erected in lieu of the former east wing and extended farther toward the east. This realignment apparently mirrors a change in the location of the women's choir from the east to the west of the church. As in the case of male monasteries, variety prevails when it comes to the location of the cloister complex in relation to the church: occasionally to the south, less often to the north, but also to the east and the west. Sometimes, perhaps because of preexisting conditions, they were not built on axis.

## The Late Middle Ages (Thirteenth to Sixteenth Century)

### The Monasteries of Cistercian Nuns

In the wake of the church reforms of the late eleventh century and the upsurge in the number of wandering preachers and eremitical movements, a number of new orders arose to respond to the increasing desire for a return to the belief structures and forms of life of the early church. In light

CAROLA JÄGGI AND UWE LOBBEDEY

of the fact that numerous women participated in these movements, it was only logical that the new orders gave thought to how they might best offer both men and women a spiritual home. The aforementioned monastery of Fontevrault was founded by Robert of Arbrissel (ca. 1045–1116) as a double monastery, as were the monasteries of the Gilbertines and the early foundations of the Premonstratensians. In contrast, Robert of Molesme (ca. 1028–1111) had only men in mind when, with the construction of Cîteaux in Burgundy in 1098, he founded the Cistercian order. In response to ever more pressing requests from groups of pious women, however, even the Cistercians were unable in the long run to exclude them.[39] In 1124–1132, pressure of this kind led to the foundation of the first female Cistercian monastery at Le Tart near Cîteaux.[40] It was soon followed by others, so many, in fact, that the order felt itself unable to cope with the pressure. As a result, in 1228 the General Chapter of the Cistercians ruled to adopt no further female houses. Especially in Germany, however, this ruling remained without effect. In the first half of the thirteenth century, no fewer than 150 female monastic houses were incorporated into the Cistercian order in Germany, and by 1300 their number grew to more than 300.[41]

Whereas male Cistercians favored remote sites for their monasteries, those of Cistercian nuns are often located in the vicinity of settlements, castles, or even within cities.[42] A further difference in comparison with the cloisters of the male branch of the order involved the process of their foundation, which, in the case of women's houses hardly ever took place at the initiative of the order itself but rather, for the most part, was instigated by pious private parties, who in this fashion secured a long-lasting means of support for an already existing unaffiliated community of devout women. In return, they chose the cloister in question as their place of burial and expected from the nuns eternal intercessory prayers and the liturgical rites of commemoration. This also explains why in the case of female Cistercian houses, no single, compulsory ideal plan was ever adopted on a transregional basis.[43] Rather, local traditions and the availability of nearby construction materials played a determining role in the choice of building types and forms, not to mention whatever preexisting buildings the patron might have provided. It was not unusual for convents to be attached to an established parish church. For the most part, in those cases in which rebuilding or additional structures were required, local craftsmen were hired. Influences that can be traced to architects or masons attached

to the order can be identified far less frequently than in the case of male Cistercian houses. In the cases of monasteries such as Trebnitz in Silesia, whose church was dedicated in 1219, or Las Huelgas in Spain (1220–1225), in which the formal language of the architecture betrays transregional, even international, characteristics, these variations can, for the most part, be attributed to the role of high aristocratic patrons, who intervened by exploiting their economic and political connections to ensure that "their" monasteries embodied all that was best and most beautiful in the art of their time.[44]

One has only to look at the collections of plans assembled by scholars such as Anselme Dimier, Michel Desmarchelier, and others to see just how enormous was the variety among the churches of Cistercian nuns.[45] For the early period in France (twelfth century), Dimier was able to establish a decided preference for single vessel churches with a transept and a rectangular choir, while in the second quarter of the thirteenth century, the basilica type seems to have become more widespread, frequently also with transepts and rectangular choirs but occasionally also with choirs terminating in apses. Side by side with such churches, simple hall churches, often with a simple rectangular plan but occasionally also with an architectonically articulated presbytery, continue to be found. Both single-vessel churches and basilicas are found in German-speaking regions. It is striking, however, to what extent the basilica form was popular in Germany among Cistercian nuns in the twelfth and early thirteenth century, whereas after the middle of the thirteenth century, long single-vessel churches come to dominate, varying only in the shaping of their choir and in architectural details.[46] Ernst Coester saw in this preference for the hall a self-conscious return to the "modest church buildings from the missionary period in Europe," which, in their simplicity, "gave expression to willing poverty and early Christian models of asceticism in the spirit of the apostles."[47] In contrast, Roberta Gilchrist and others have stressed functional considerations and have sought to explain the preference of Cistercian nuns for single-vessel churches in terms of their exclusion from service at the altar, which made secondary altars as well as side chapels and side aisles redundant.[48]

The lack of a binding plan for all churches of Cistercian nuns can also be explained by the fact that the statutes of the order provided no guidance on this subject. Instead, they simply recommended restraint in matters architectural. In contrast, it was stipulated that there should be both a church and a conventual tract in which the women could carry out their

daily duties in privacy. The same held true for the church, in which the nuns had to have their own choir from which they could follow services at the altar without the celebrant being able to see them. The nuns' choir was also to be separated from those parts of the church that held the converses and, if the church doubled as a parish church, from the lay congregation as well. In Germany, the nuns' choir in churches of Cistercian nuns was located in a gallery, as in the older *Frauenstifte* (figs. 4.3 and 4.4). In contrast to these older structures, however, it was now always placed at the west end of the nave.[49] In France, as a rule, the nuns' choir was also located at the western end of the church, but at ground level, not in a gallery.[50] The Swiss Cistercians occupy an interesting intermediary position in this regard, in that, as in the case of the monks, the choir of the nuns was located just to the west of the presbytery and separated from the church of the converses to the west by a dividing wall or some other barrier to sight.[51] Several altars are often attested: in addition to the high altar in the presbytery, there was frequently an altar both in the nuns' choir and in the lay church. The altar in the nuns' choir would have served primarily as a place for displaying the consecrated Host (*Sanctissimum*).[52]

In most cases, the position of the nuns' choir determined that of the dormitory. Nonetheless, with regard to the layout and location of monastic buildings, a wide spectrum of possibilities can be identified.[53] In her research on the Cistercian monasteries of central Germany, Claudia Mohn has been able to establish that by no means all women's convents had a four-sided, enclosed cloister. Other solutions existed, some of which involved loosely arranged agglomerations of structures spread over the site and connected to the church and each other by passageways.[54]

## The Mendicant Orders: Poor Clares and Dominican Nuns

As in the course of the early thirteenth century the Cistercians made it increasingly difficult for communities of women to be incorporated within their order, the new orders of the Franciscans and Dominicans offered themselves as alternatives. For both, the question of how best to accommodate women within their ranks quickly became an issue. As early as 1206, Dominic had founded a women's convent at Prouille in southern France, and in 1219/1220 Pope Honorius III (ruled 1216–1227) personally entrusted him with the oversight of the convent of San Sisto, which

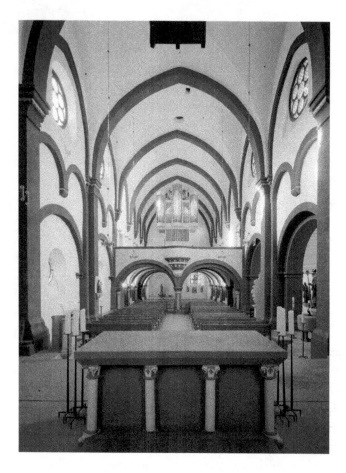

*Figure 4.3* View toward the western nuns' gallery of the former Cistercian nunnery of St. Thomas an der Kyll (Rhineland Pfalz), consecration 1222.

had been founded by his predecessor, Innocent III (ruled 1198–1216), as *universale cenobium monialium Rome*: all the nuns of the various monasteries of Rome, who previously had wandered the streets of the city, were now to lead a strictly governed monastic life.[55] Francis was more skeptical concerning the establishment of a female branch of his order but was unable to stem the tide of enthusiasm unleashed by his movement in Assisi and its surroundings. It was above all Pope Gregory IX (ruled 1227–1241) who promoted the wishes of the *pauperes dominae* (the poor women of the lord) to attach themselves to the Franciscan order.[56] Already before the middle of the thirteenth century, numerous women's communities were affiliated

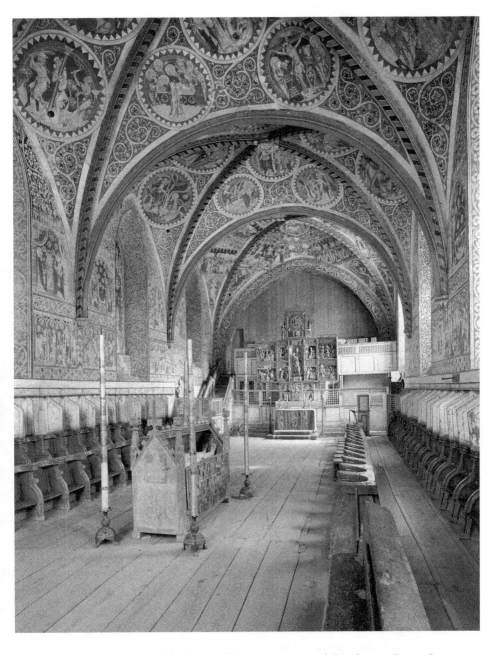

*Figure 4.4* Nuns' choir of the former Cistercian nunnery of Wienhausen (Lower Saxony), view toward the east, ca. 1330.

with the mendicants, in Italy and in other regions in which Romance languages were spoken, mainly with the Franciscans, but in regions north of the Alps above all with the Dominicans. Both orders were active primarily in urban centers, such that large cities like Strasbourg, Freiburg, Basel, and Bologna quickly had up to ten or even more female mendicant cloisters within their walls.[57]

Like Cistercian nuns, the female branches of the mendicant orders had neither an ideal plan nor statutes that strictly controlled building. The rules of the orders limited themselves to requiring simplicity and functionality: "The buildings of the monastery are humble and without too many superfluities and not too immodest."[58] The statutes cede far more place to the rules governing enclosure, which, even if only indirectly, had an influence on architecture.[59] In both the Dominican and Franciscan orders, lifelong enclosure was required of nuns who had professed their full vows. Once they had entered the monastery, they were not to leave its confines except when a natural catastrophe threatened their lives or a daughter foundation required new personnel. Even their last resting place had to lie within the walls. It was also forbidden to outsiders to enter any of the spaces belonging to enclosure. Exceptions were granted only to confessors, to doctors, and sometimes to the aristocrat patron, but even in these cases strict rules had to be followed. Every communication of the nuns with the outside world had to pass via a window with a grille (fig. 4.5) and turnstiles in the monastery walls, whose number, size, and location were prescribed with precision in the order's statutes. To what extent these rules were actually put into practice is often not easy to establish. In general, it can be said that here, too, one has to reckon with a wide range of solutions, not all of which conformed to the respective rules of the order.

Above all in Italy, popes and bishops often granted communities of women who wished to affiliate themselves with the mendicant orders old churches or monastic complexes, which were then adapted to their new function by the addition of partitions or by means of other measures. In regions north of the Alps, private patrons played a more important role by providing such communities with a landed estate or other profane buildings. In most cases, however, these buildings did not serve the needs of the nuns for very long, so that, most often at the same time they were incorporated into an order, a few years after their founding, a new monastic complex had to be erected. To this end, wealthy patrons, women among them, had to assume responsibility for the expenses of rebuilding. For the

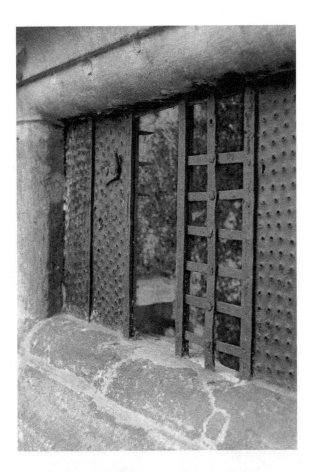

*Figure 4.5* Speaking grille from the former monastery of Poor Clares at Pfullingen (Baden-Württemberg), ca. 1300. Long iron spikes, which prevented visitors from approaching the window too closely, can be seen through the opening.

newly constructed choir of the Dominican convent of St. Katharinenthal in northeastern Switzerland, dedicated in 1305, the donors came from the families of the nuns themselves. A nearby foundation of Augustinian canons also contributed, however, in that it provided construction materials free of charge.[60]

In light of varying conditions such as these, it can hardly surprise that the architecture of the female branches of the mendicant orders is very closely bound up with the local artistic landscape. As a matter of fact, the second half of the thirteenth century witnessed an increasing tendency toward the emergence of regional groups. At this time there appeared

along the Upper and Middle Rhine a large number of churches of Dominican nuns, in addition to a small number of churches of Poor Clares, in which, as in contemporary churches of male mendicants, a relatively short nave, with one to three aisles, is combined with an extended choir several bays in length terminating in a polygonal apse.[61] The choir stalls of the nuns were located in the western portion of the choir. In eastern and central Switzerland, however, the partitioned rectangular spaces already employed by Cistercian nuns were common, with the nuns' choir in the eastern portion of the church. In the western parts of Teutonia, we once again encounter lengthy single-vessel churches with short, retracted choirs. In these, the nuns' choir was usually located, as in most Cistercian convents in the region, on a gallery to the west. In isolated cases, one finds both, a gallery and a long choir, from which can be concluded that the gallery was used by the convent only at special times as a place of prayer or as a place for sick and infirm nuns.

In general, there was an altar in the nuns' choir, at which, however, Mass was celebrated only at high feasts. Otherwise, it was used to display a monstrance with the consecrated host, which consoled sisters for whom, on more than 350 days of the year, the transubstantiation of the elements at the altar remained beyond their field of vision.

Over and beyond the general tendencies in the architecture of the female branches of the mendicant orders, there were also always places that fall outside the framework on account of the models to which they aspire. The funerary church of St. Clare in Assisi is an important example in which a formal resemblance to the church of San Francesco takes precedence over the needs of the nuns. Other important examples include monasteries founded by aristocratic patrons such as St. Francis in Prague, Santa Chiara in Naples, Königsfelden (fig. 4.6), and St. Maria in Obuda (Budapest)—all of them houses of Poor Clares that in their formal language and in the richness of their decoration rival contemporary cathedrals and abbeys of monks. Only with difficulty can they be brought into accord with the oath of poverty of these "poor sisters of the lord."[62] The royal female founders of these convents took care that, whenever possible, a small convent of brothers would be attached, so that the sisters would never be without spiritual support. Above all, however, given that these monasteries often doubled as dynastic mausolea, foundations of this kind assured an especially effective cultivation of the rites of commemoration for the family of the donor.

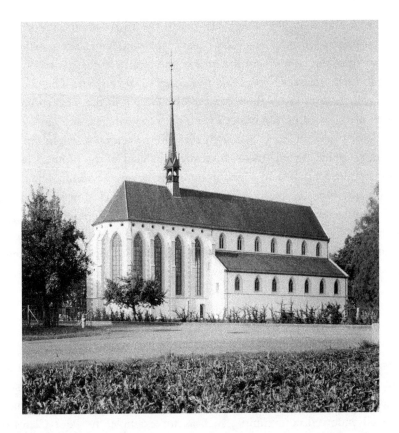

*Figure 4.6* View from the north toward the former monastery of Poor Clares at Königs-felden (Canton Aargau), first half of the fourteenth century.

## The Double Monasteries of the Birgittines

In the fourteenth century, the Birgittines lent new life to the concept of the double monastery. Like their twelfth-century models, their monasteries simultaneously housed a convent of brothers and one of sisters.[63] In her *Revelations*, the founder of the order, Birgitta of Sweden (1302/1303–1373) laid out with great care just how the monasteries were to be organized, so that the coexistence of men and women in close proximity to one another would be unproblematic. The ideal convent would have sixty nuns, thirteen monks, four deacons, and eight lay brothers. At the head of the community was the abbess, assisted in spiritual matters by a general confessor. Birgitta also stipulated that, whereas the church would be used in common by the

brothers and sisters, the living quarters of the two communities should inhabit strictly separated enclosures, that of the nuns, whenever possible, to the north of the church and the *curia* of the monks to the south.[64] In the church itself, both sexes were also to occupy separate spaces. The choir of the brothers with the high altar should be located in the western part of the church, raised up a few steps from the nave, whereas the nuns' choir should be placed in a free-standing gallery in the central vessel. In this way, the nuns would be able to see both the high altar of the brothers to the west and the Marian altar, which stood to the east on a podium. The north wall of the brothers' choir, which faced the nuns' enclosure, served as an architectural divider between the sexes. Five small openings placed just above the floor enabled the nuns both to give confession and to receive communion. The implication of these rules can still be seen at Vadstena, the Swedish mother church of the Birgittine order (fig. 4.7).

## Conclusion: The Fifteenth and Sixteenth Centuries

For female monasteries, already in the course of the fourteenth century but more frequent in the fifteenth, tendencies can be observed in many places that indicate a loosening of the orders' original ideals. Especially in well-endowed communities such as, for example, the Poor Clares of Cologne, common dormitories were abandoned in favor of cells. Individual sisters enjoyed the considerable proceeds of endowments, and the enforcement of enclosure became increasingly lax.[65] Efforts at reform, be it on the part of the orders or, increasingly, on the part of cities, followed quickly. Hand in hand with such efforts came building measures designed to reinforce and reestablish strict enclosure. A further step in this direction is represented by the insistence of the Council of Trent (1545–1563) on the visibility of the host. It was in light of such measures that Carlo Borromeo (1538–1584) advised several north Italian women's convents to move the nuns' choir from the western galleries to which they were accustomed to a space behind the altar. This space could be furnished with a small window that, on the one hand, permitted a good view of proceedings at the altar yet, on the other hand, made it impossible for the nuns to overlook all the goings-on in church in an inappropriate manner, as they previously had done so eagerly.[66] In this way, Borromeo reached back to a building measure that was widely adopted along the Upper Rhine, but also in

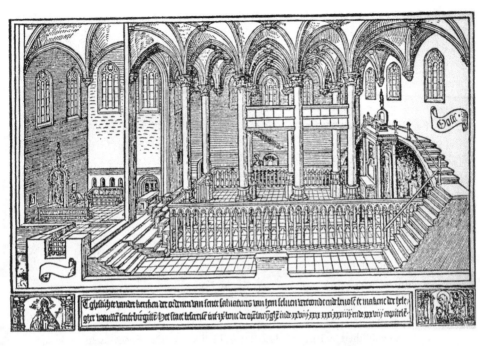

*Figure 4.7* The nave of Vadstena, the Swedish mother monastery of the Birgittine order, Dutch woodcut, early sixteenth century.

central Italy, as early as the second half of the thirteenth century and that now, three hundred years later, was given new life in northern Italy, since it apparently was still of value for the life of nuns in strict enclosure. At least this was the official view of the church; whether the nuns saw it the same way is beyond our knowledge.

## Notes

1. In general, see Braunfels 1969; Binding and Untermann 2001; see also the second half of this essay. Gilchrist 1994 has identified those features that are specific to female monasteries in England, but by beginning in the twelfth century, she bases her conclusions for the most part on the wealth of evidence from the Late Middle Ages. See also Bodarwé 1997: esp. 132–135; Ellger 2003.

2. For pre-Romanesque church building, see above all: *Vorromanische Kirchenbauten* 1996–1971, 1991; Sennhauser 2003.

3. See most recently Muschiol 2003a. See also Wemhoff 1993:24–26, 30–32, 38–39.

4. Ahrens 2001:2:195. Kildare was at least for while a double monastery and for a time an episcopal seat.

5. Bede 1982:2:234–235 (IV.9): "de domo, in qua sorores pausare solebant" (from the house in which the sisters were accustomed to rest).

6. Cramp 1976:223–229, 1993.

7. On this subject, see Bodarwé 2002.

8. Delahaye 1993; Duval et al. 1991:139, 211, 220, 225, 227, 232.

9. *Vorromanische Kirchenbauten* 1996–1971:236–239.

10. Sapin 2002:60–61.

11. Ibid.: 61–62.

12. Cat. Brescia 2000:496–498; Cat. Brescia (Saggi) 2000:143–155.

13. *Vorromanische Kirchenbauten* 1966–1971:276–277, 1991:339–340; Konrad, Rettner, and Wintergerst 2003:657–662.

14. *Vorromanische Kirchenbauten* 1966–1971:221; Sennhauser 2003:1:123–124. For a while, a second church with one nave was immediately adjacent.

15. Aubert 1943:2:190; Coester 1984:87, 91, 200; Sennhauser 1990:18; Gilchrist 1994.

16. Simmons 1992.

17. First established by Irmingard Achter and Hilde Claussen. See Muschiol 2003a: 800–805; Ellger 2003:144–146.

18. See Ellger 2003, with bibliography.

19. *Vorromanische Kirchenbauten* 1966–1971, 1991:276–77.

20. *Vorromanische Kirchenbauten* 1966–1971:98–100, 1991:143–44; Jacobsen 2003.

21. Lobbedey 2000:89–113.

22. Kosch 2000:65–67.

23. Lange 2001.

24. Haug and Will 1965:47–56.

25. Cat. Mainz 1998:74–94 (Dethard von Winterfeld et al.).

26. Cf. Parisse 1991:484–486.

27. Thümmler 1970:15, 270.

28. Lobbedey 2000:163–166.

29. Ibid.: 159–162.

30. Brenk 2002; Ellger 2003.

31. Jacobsen 1992; Sennhauser 2002.

32. Sennhauser 2003:127.

33. Lobbedey 2003.

34. Lobbedey 1996:98–99.

35. Gilchrist 1994:92–95.

36. See Ellger 2003:148–156.

37. Kubach and Verbeek 1976:1:319–320.

38. Lobbedey 1996:100–102.

39. Still fundamental are Grundmann 1935/1970:203–208; and Degler-Spengler 1985. Most recently, see Mohn 2006.

40. Veyssière 2001.

41. Krenig 1954:11–12; most recently, Mohn 2006.

42. Coester 1984:2; Mohn 2006.

43. Eydoux 1952:151–169; Dimier 1967:19; 1974:8, 15.

44. Gleich 1998.

45. Dimier 1947, 1967, and 1974; Eydoux 1952; Desmarchelier 1982.

46. Eydoux 1952; Coester 1984; Binding and Untermann 1985:273; Brückner 1991/1994; Gleich 1998:116; Kosch 2001; Mohn 2006.

47. Coester 1984:3.

48. Gilchrist 1989:253; see also Dimier 1974:8; Goll 1996:218.

49. Coester 1984; Mohn 2006.

50. Eydoux 1952:154; Desmarchelier 1982:85–86.

51. Sennhauser 1990:15–24.

52. Ibid.: 16 and 24–26; Zimmer 1990.

53. Mersch 2004:56–102.

54. Mohn 2006.

55. Grundmann 1935/1970:208–213; Degler-Spengler 1985.

56. Grundmann 1935/1970:253–284.

57. Most recently and extensively, Jäggi 2006.

58. A German version of the Dominican constitutions of 1259, in a manuscript of the first half of the fifteenth-century from the monastery of St. Michael, Bern, cited in Studer 1871:509–520. In the case of the Poor Clares, only the rule for Longchamp, dated 1263, explicitly forbade excessive luxury in buildings ("aedificiorum superfluitatis excessum") (*Bullarium Franciscanum*, vol. 2, no. 77 [Rome, 1761], 485).

59. For extensive discussion, see Jäggi 2006:9–10.

60. According to the fourteenth-century *Liber fundacionis*, cited in Meyer 1995:145: "Ein bvorger von Costenz, der hiesse Eberhard von Cruzelingen. . . . Vnd alle die grawen stein, di an den venstern sint, die sante er her ab gehowen vnd bereit." See also Descoeudres 1989:61–64; Jäggi 2004a:55–57; 2004b:64–67.

61. Jäggi 2000.

62. See Jäggi 2001, 2002, and 2006.

63. Hilpisch 1928:79; Wentzel 1948:750–755; Nyberg 1983:218–219.

64. On Birgitta's architectural instructions, see Wentzel 1948:755–757; Nyberg 1965:32–42; Binding 1983:219–220.

65. Weis-Müller 1956; Uffmann 2000; S. Schmitt 2002.

66. Grassi 1964; Testoni Volonté 2001.

# "Nuns' Work," "Caretaker Institutions," and "Women's Movements"

## Some Thoughts About a Modern Historiography of Medieval Monasticism

JAN GERCHOW AND SUSAN MARTI

"In the second half of the tenth century there lived . . . in the famous foundation of Gandersheim . . . a nun Hrotsvith [Roswitha], the first in a series of German women authors. . . . An unusual occurrence, this nun, part poet, part bluestocking. She was most industrious." Thus begins an anonymous account (whose author can be identified as the Swabian publisher Johann Scheible), who goes on to relate that Roswitha's dramas served to dispel the "tedium of dull winter evenings." Their "subtle and sublime musing and dabbling" nonetheless amounted to nothing more than a "shrill tintinnabulation whose learned tinkling made itself most unpleasant."[1]

Stereotypes such as these—the "industrious" but intellectually unambitious works of female religious, the "idleness in the monastery," the surplus daughters of the nobility who had to be "cared for" in cloisters—have left their mark, not only on the contemporary popular picture of female monasticism in the Middle Ages but also, in part, on scholarship about the subject. In this essay, we wish to investigate select concepts employed in art-historical as well as historical research on religious women and trace their roots in patterns of thought and values that go back to the eighteenth, nineteenth, and twentieth centuries. In the context of art history, it is under the headings "*Nonnenarbeit*" (nuns' work) and "*Nonnenmalerei*" (nuns' painting) that the issue of the artistic productivity and creativity of nuns was addressed. In the context of history, such terms as "*Versorgungsanstalt*" (liter-

ally, retirement community) and the *"religiöse Frauenbewegung"* (the religious women's movement) whose origins and applications need to be sketched, not least because they stand in contradiction to one another. A short essay such as this can no more than provide an outline by way of an answer; a full-fledged history of the concepts in question cannot be given here.

## *"Nonnenarbeit"* and *"Nonnenmalerei"*: A History of the Terms

If one consults the principal dictionaries and encyclopedias of the eighteenth and nineteenth centuries, one finds that most references to the productivity of nuns are limited to discussions of matters culinary.[2] The term *"Nonnenarbeit"* first appeared in the seventh volume of Grimm's dictionary, published in 1889, where it is defined briefly as the "handiwork of nuns," with a cross-reference to the term *"Nonnenwerk"* (nuns' work), which has the same meaning.[3] The dictionaries of Matthias Kramer (1640–1729/1732), a lexicographer who lived in Nuremberg, are cited as the source for both terms.[4]

To the best of our knowledge, the terms *"Nonnenmalerei"* (nuns' painting) or *"Nonnenmalereien"* (nuns' paintings) first appear in German art-historical works during the early 1930s, mostly but not always with reference to illuminated manuscripts or single-leaf images of the fifteenth century.[5] In the first volume of his history of German Gothic painting, published in 1934, Alfred Stange (1894–1968), who taught in Bonn and, from the late 1930s onward, was a strong supporter of National Socialism, referred to the "unskilled, childish language of nuns' paintings" (*Nonnenmalereien*), taking as an example a painted box produced in the stylistic aftermath of the choir murals at Wienhausen.[6] Derogatory, disparaging adjectives such as "childish," "unskilled," "naive," "puppetlike," "colorful," "tapestrylike," "dilettantish," and others consistently accompany the term and continue to be found in contemporary publications.[7] "Everything is far removed from reality, dreamy, as if in a fairy tale. Everything lives without depth. The hands of the nuns were skilled, tidy, and industrious; their works are in part quite charming, but, judged as part of a history of art conceived in terms of the development of style, they are without significance," wrote Christian von Heusinger in 1953 concerning manuscript illumination from female monasteries in Freiburg (fig. 5.1). The term continues to be used in much the same derogatory, dismissive fashion in following decades.[8]

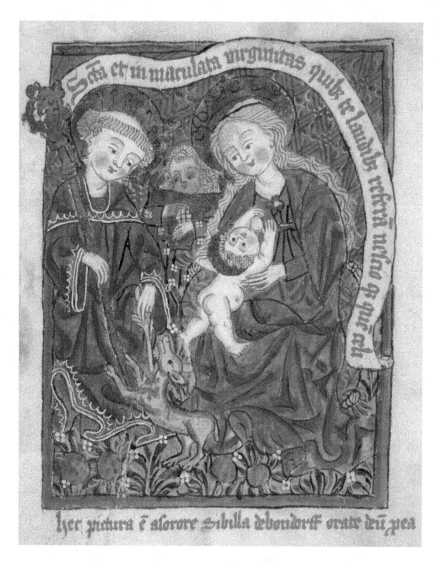

*Figure 5.1* Mary and a saint, miniature with the signature of the Poor Clare Sibylla von Bondorf, prefacing a Clarissan rule from the Bickenkloster in Villingen, late fifteenth century. (The British Library, London, Add. ms. 15686, f. 1r.)

The association of naïveté, childishness, playthings, and puppets with nuns' work is hardly a coinage of the early twentieth century. As Jeffrey F. Hamburger has shown, it already characterized the Enlightenment's conception of female piety,[9] and it also had its place in nuns' own view of themselves.[10] One must, however, take into account the changing connotations of certain terms. For example, the medieval notion, rooted in theology, of *Kindsein im Kloster* (of being a child in a cloister) has no equivalent in the language of early-twentieth-century art historians.[11]

One searches in vain in the above-mentioned publications for a precise definition of just what is meant by "*Nonnenmalerei*" or "*Nonnenarbeit*." The terms only crop up when a certain work does not meet classical aesthetic norms. Thus, for example, in referring to the beautiful illuminations in the Codex Gisle (fig. 5.2), Stange notes that they "probably were painted by a female artist" and identifies her as a nun but refrains from using the designation "*Nonnenmalerei*."[12] Stange's inconsistency brings to the fore a lack of clarity that persists to this day and has been compounded by ill-considered judgments of quality that seldom are made explicit: Is the term used as a general designation for all late medieval illumination from the hands of nuns, regardless of its quality? Or does it refer only to a subset with its own functional and aesthetic characteristics, determined by genre, namely, to those images known, if misleadingly, ever since the publication in 1930 of a work on the subject by the historian of folklore, Adolf Spamer, as *kleine Andachtsbilder* (small devotional images), for the most part diminutive single leaves from female monasteries?[13]

Since 1987 Jeffrey F. Hamburger has devoted numerous essays and books to these works from the hands of late medieval nuns, which previously were paid little attention except by historians of folklore.[14] To his credit, he has freed these works from the stigma attached to them as artistically modest devotional products of popular piety and instead analyzed them in the monastic context in which they were created and used. For the first time, Hamburger refers to the aesthetic category of ugliness in the context of ideals that were normative for nuns: humility and obedience.

Whereas Hamburger employs the term "*Nonnenarbeit*" for drawings, colored prints, and miniatures of the fifteenth century with simple artistic forms but frequently with highly complex content, Judith Oliver, in her publications on German liturgical manuscripts from female monasteries of the thirteenth and fourteenth centuries, uses the term "*Nonnenbücher*," "nuns' books."[15] Like Hamburger, she points out that if one approaches

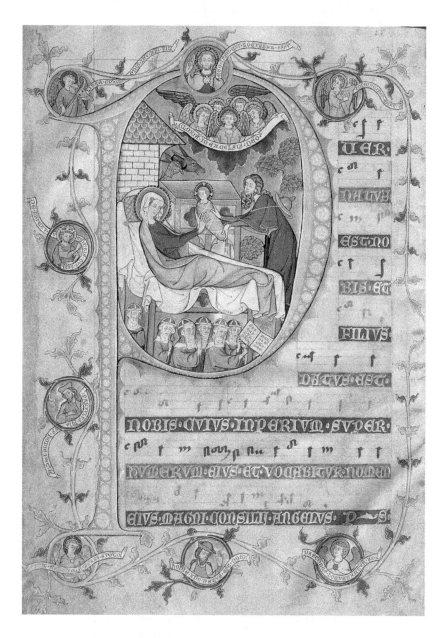

*Figure 5.2* Birth of Christ, Initial *P* opening the Christmas liturgy in the Codex Gisle, a gradual from the Cistercian nunnery of Rulle near Osnabrück, ca. 1300. (Bischöfliches Generalvikariat, Diözesanarchiv, Osnabrück, p. 25.)

works made by and for nuns solely in terms of their function or their place in social history, the "art" in "art history" threatens to get lost. She pleads for taking into account additional visual elements, for example, the aesthetic of textiles, the layout and calligraphy of texts, and the synesthetic interplay of music, color, and words.[16]

As in the past, therefore, current research regards a great variety of objects—be they small, late-fifteenth-century colored devotional images made of papier-mâché or large, richly illuminated liturgical manuscripts of the thirteenth and fourteenth centuries—as "*Nonnenmalereien*," "*Nonnenarbeiten*," or "*Nonnenbücher*" (nuns' paintings, works, or books). These concepts, however, are seldom clearly differentiated from one another, and we often don't know whether they are being applied regardless of considerations of quality for all examples of a particular artistic genre or, as has more frequently been the case since Stange, only for those of more modest caliber.[17]

## Special Cases in Art History: Women as Artists

The words that Stange chose to describe works of art from the hands of nuns are surprisingly similar to those employed in the handbook *Die Frau als Künstlerin* (The woman as artist), published in 1928 by Hans Hildebrandt (1878–1957), professor of art history at the Technische Hochschule (Technical University) in Stuttgart. Hildebrandt's publication follows in a line of earlier works dedicated to the same subject, most of them addressed to a female audience, and continues to employ stereotypical ways of categorizing certain artistic genres and themes significant for women's "nature."[18] For the first time, a book on the subject is richly illustrated, and the Middle Ages are granted a relatively large amount of space. For Hildebrandt, three personalities embody the "three types of the female artist" ("weibliches Kunstgestalten"): whereas Uta, the abbess of the foundation of Niedermünster in Regensburg, is the "organizer of female artistic activity"; Hildegard of Bingen is "a figure of the purest female character, all fantasy, full of feeling." Herrad of Hohenburg, the author of the *Hortus deliciarum*, in turn, embodies "naive joy in storytelling," and her work exudes "more grace than greatness."[19] Hildebrandt's goal is not the delineation of different historical situations but rather the construction of a characterization of "*Frauenkunst*" (women's art) that over centuries remains the same: "accentuating flatness," "naive," "playful," "charming,"

"delightful," "full of feeling," "rich in detail," and more. The compilation of a separate history of women's art implicitly serves to confirm the rule that truly creative art can only be created by male genius and that the art of women is more properly associated with the work of uncivilized peoples and folklore traditions.[20]

To its credit, feminist art history, first as it developed in the United States starting in the 1970s and then, some years later, in Germany, made transparent the gender-specific construction of such definitions of art and artists, whether women or men, and exposed the mechanisms by which women have been excluded from the history of art. At the outset, the primary concern was to make known "forgotten" female artists;[21] the direction of research has since changed dramatically so as to avoid the pitfall "of inscribing a complementary 'feminine' history within the already existing 'masculine' one."[22] As part of investigating women's creativity, attention was focused on the previously unquestioned center of art-historical analysis, the perspective of the heterosexual, white male,[23] as well as on the related concepts of authorship, authority, and authenticity, all of which are connected with the image of the artist as genius.[24] In so doing, feminist research focused above all on the myth of the artist in modernity and gave only marginal consideration to medieval conditions of production or conceptions of the artist.[25]

An art history organized around names solely in lexical terms cannot do justice to the complex reality of female creativity in the Middle Ages. It thus not surprising that of the approximately 590 names listed in alphabetical order in the two-volume *Dictionary of Women Artists* published in 1997, only 5 come from the period before 1500.[26] Named in addition to Hildegard of Bingen and Herrad of Hohenburg, are the Spanish manuscript illuminator Ende, who together with a priest illuminated a sumptuous Beatus manuscript; Teresa Díaz, who in 1316 signed the frescoes in the choir of a Spanish church; and the Poor Clare Caterina Vigri, who painted prayer books in Ferrara. The choice seems arbitrary, as the list could easily be extended.

Of greater importance are the fundamental questions posed by Annemarie Weyl Carr in her systematic introduction to the period of the Middle Ages.[27] In the Middle Ages, authorship had many connotations, connected to numerous roles: artist, designer, programmer ("concepteur"), entrepreneur, and patron all contributed to the making of a work of art. It is therefore important to inquire into what cultural resources were available to women, into the different medieval forms of authorship, and into the relationship of such roles to the names that have come down to us

in inscriptions and documents. For religious women especially, one must also take into account their communal and familial networks, the culture of communication and exchange, and the forms of collaboration among nuns, clerics, and their respective circles of family, friends, and relatives.

## The Great Exceptions: Hildegard of Bingen and Roswitha of Gandersheim

Whereas woman as patrons have loomed large during the last twenty years of research on medieval art, women as artists have been thrust into the background. This is especially true with regard to textiles, an artistic medium that continues to be marginalized in the German-speaking realm. In light of the incomparable documentation that we have for textiles, this situation is, to put it mildly, paradoxical. At least as far as Germany is concerned, if not so much the English-speaking world, it underscores the enduring institutional separation of so-called high art from applied arts that was already established in the nineteenth century.[28]

The example of Hildegard of Bingen, whether as painter or designer, demonstrates the subject's complexity and exemplifies the range of different positions represented by current research. The central question is, was Hildegard herself the originator of the painted representations of visions in the manuscript of the *Scivias* from the Rupertsberg monastery that, since the Second World War, has been known only from photographs and copies? While previous art-historical research never questioned Hildegard's authorship,[29] today it is hotly debated.[30] Whereas Madeline H. Caviness posits that now-lost sketches designed and colored by Hildegard herself served as models for the miniatures,[31] Lieselotte Saurma-Jeltsch, in contrast (by way of marking out the poles in this debate), argues that the images were created only after Hildegard's death and that they thus represent a first, transformative step in the reception of Hildegard, in which the "orderliness of the images" is imposed on the "vehemence of the visions."[32] For Caviness, who interprets the images from her perspective as a postmodern feminist in terms derived from semiotics, psychoanalysis, and the theoretical models of the New Historicism, Hildegard's images stand outside the "scopic regime" of her patriarchal society.[33]

Hildebrandt's aforementioned characterization of Hildegard as a "figure of the purest female character" reduces a complex situation to a question of

gender. The same took and continues to take place with regard to the poet Roswitha of Gandersheim (ca. 935–ca. 975). She is frequently mentioned first and foremost as a representative of her sex and then, in addition, designated the "first German poetess" and thereby appropriated as a spokesperson for an as-yet nonexistent nation, namely, Germany.[34] She is not analyzed as a personality in a specific historical situation (that of a virgin at the foundation of Gandersheim) and as part of a culture of communication (that of learned Latin literacy) but rather in terms of her biologically determined gender. As has been emphasized over the last fifteen years by the new generation of gender studies, social class, the culture of communication, opportunities for education all represent categories of analysis that must be taken into consideration in addition to gender.

In this context, the concept of gender as a social and cultural construction is of fundamental importance. "The question of what makes women women, and what makes men men is not answered in biological terms, but rather in terms of historical, social and cultural discourses."[35] It is more consequential to investigate what importance was attached to being a man or a woman and in what specific contexts, how such categories stand in relationship to others used to define difference, such as age, class, race, social standing, and education, and, not least, to what extent such categories reinforced, contradicted, or in some way compensated for each other.[36]

To summarize all too simply, for Roswitha, it can be said that her ability to be productive as a writer depended on her social standing much more than on her gender.[37] This changes in the late Middle Ages. Caritas Pirckheimer (1467–1532), the highly cultivated abbess of the community of Poor Clares in Nuremberg who had a strong interest in humanism and was the first female reader of Roswitha known by name since the tenth century, offers a telling example. According to her letter of thanks to the humanist Conrad Celtis, who made available to her the edition of her works that he had made possible in 1502, she could only engage in the activity of writing with the assistance of men, a process in which gender played a more prominent role than social rank.[38]

## "Homes for Aristocratic Ladies"

The term "rank" immediately brings to mind yet another complex area of research on female monasticism that has left an impression on contempo-

rary popular understanding of female monasteries in the Middle Ages: the social composition and the societal function of these convents.[39] Hildegard of Bingen offers an especially telling example. It was Hildegard, the founding abbess of the Benedictine convent on the Rupertsberg near Bingen and member of a free, aristocratic family, who around 1148 defended the aristocratic exclusivity of her monastery by arguing that no one would put oxen, donkeys, sheep, and goats together in the same stall.[40] The example of Hildegard is cited again and again whenever the goal is to show that medieval female monastic communities were founded by aristocrats and their inhabitants came from a markedly exclusive, select social group. This argument can be found in the ecclesiastical history of the nineteenth century as well as in the most recent publications.[41] The works published shortly after 1900 by followers of Aloys Schultes seemed to offer a statistical basis for female monasteries as an integral element of the "aristocratic church."[42] Klaus Schreiner (1964) and Franz J. Felten (since 1992), however, have been able to show that for both male and female monasteries, neither the texts of rules nor what little available data from male and female houses is amenable to statistical analysis can be said to support any conclusions concerning the ranks of their members or even regarding the principle of exclusivity per se. The same holds true, to a lesser degree, even for the late Middle Ages (1250–1500), as isolated, normative rules regarding the subject begin to appear.[43]

Similar conclusions can be drawn with even greater emphasis for the early Middle Ages: Hildegard was always regarded as a typical representative of a Benedictine monasticism that was already antiquated by the middle of the twelfth century and that, in the face of new religious ideas and orders, appears to have been essentially a lost cause as regards its social exclusiveness. In fact, Felten argues for the plausibility of Hildegard's having for the first time explicitly broken with the old ideal of indifference to the social origins of the inhabitants of the monastery, and this at a time when reform movements were reasserting such ideals. To the contrary, in anticipation of a development that otherwise first clearly manifests itself in the early thirteenth century, Hildegard at a very early stage asserts the importance of social difference rather than being its last defender.[44]

The notion of the female monastery as an institution to care for its inhabitants is closely linked to that of its putative aristocratic exclusivity. The accommodation of unmarried daughters of the various Saxon tribes was introduced in 1979 (1984 in a German translation) as the most important motivation for the foundation of the many female convents between the

Rhine and Elbe from the ninth to the eleventh century.[45] In 2003 Wilhelm Kohl reasserted this view, for which he himself had argued since 1980, as representative of the state of research.[46] The most recent research on the late Middle Ages does not present a different picture. Thus, for example, in 2002 the historian Bernhard Neidiger, commenting on the female monasteries that remained untouched by reform in the fifteenth century, states: "Either their status as places that provided for the care of daughters of the urban patriciate or the nobility was respected, or it was thought that religious life as conducted in these convents was appropriate and that no intensification of enclosure and ascetic demands was desirable."[47] Similar statements can be found, in part, in French as well as English research.[48] In the short space of this essay, the reasons for the persistence with which historians have remained attached to the thesis that female monasteries served as places to provide for the care of the aristocracy cannot be investigated. One possible reason can, however, be pointed out, namely, the high aristocratic *Damenstifte* of the early modern period. Between the sixteenth and eighteenth centuries, they did in fact function as exclusive, aristocratic institutions for the care of family members whose typical characteristics then established themselves in cultural memory. Essen, Thorn, Vreden, Elten, and St. Ursula in Cologne and Buchau am Federsee are outstanding Catholic examples. Comparable Protestant examples include Herford, Quedlinburg, and Gandersheim.

Viewed superficially, it is possible to conclude that such apparently useless institutions indeed served as homes established to care for these women in waiting: daughters of the aristocracy who had no chance in the marriage market. Ute Küppers-Braun, however, has nonetheless been able to characterize these institutions convincingly as an indispensable part of aristocratic networks that functioned and flourished, above all, as "place[s] for the upbringing and socialization of aristocratic daughters" and as "communal instruments of control to ensure marriages appropriate to their rank."[49] These *Damenstifte* had a central role in cementing convictions and establishing identity—but only in the early modern period.

Another motif, closely related to that of female monasteries as institutions for taking care of their inhabitants, makes clear to what extent modern preconceptions concerning medieval communities of women were influenced by such ideas: the notion that they served to provide materially for poor, unmarried, or widowed women. The evangelical church historian Johann Lorenz von Mosheim (d. 1755), who taught in Göttingen, introduced this motivation as one of many for the establishment and success

of the beguines in the High Middle Ages.[50] At the same time, a discussion was taking place in German and Austrian territories over the relative utility of dissolving or maintaining religious institutions. In contrast to any conception of female monasteries as women's communities belonging to an order, whose binding vows and "useless" prayer were even put forward as reasons for dissolution by Catholic rulers, the notion that they could be of indispensable benefit when it came to the maintenance of unmarried and widowed women was championed. "*Frauenstifte* are places of refuge where aristocratic women can remain decorously," opined one of the fiercest opponents of contemplative orders, the elector and archbishop of Cologne Maximilian Franz of Austria (ruled 1784–1801).[51] In the course of dissolving its monasteries in 1802–1803, the government of Prussia introduced the same arguments with regard to most of the independent *Damenstifte* in Westphalia and the Rhineland, transforming them into institutions for the care of women, not only daughters from aristocratic families but also the needy daughters of Prussian officials and officers.[52]

It appears as if in the course of the nineteenth century, the caretaking hypothesis came to be judged according to the standards of the secularizers as a more positive way of defining the utility of female monasteries. To the professional historians of the nineteenth century, supported by the bourgeoisie, the hypothesis surely would have seemed both plausible and welcome. It was easily brought into accord with the Biedermeier conception of womanly domestic duties to her family, which in turn was to be backed by male family members. Cultural historians of women seized on the caretaking hypothesis in the nineteenth century. In this context, both Karl Weinhold's *Die deutschen Frauen in dem Mittelalter* (German women in the Middle Ages, 1851) and, above all, Carl Bucher's *Die Frauenfrage im Mittelalter* (The woman's question in the Middle Ages, 1882) should be mentioned. Catholic church historians such as Gerhard Uhlhorn, in his *Christliche Liebesthätigkeit im Mittelalter* (Christian charitable activities in the Middle Ages, 1884), characterized certain forms of female religiosity, such as the beguines, as ways of "offering assistance and accommodation to poor widows and virgins."[53] In the nineteenth century, the very topical subjects of women's emancipation, women's work, and the first women's movement provide the backdrop for this interest in women's history in the Middle Ages. As far as the Middle Ages are concerned, both Weinhold and Bücher took for granted a surplus of women resulting from the Crusades and the practice of feuding. A lack of opportunities for marriage was alone

responsible for the influx of unmarried women and widows into female monasteries as ideal institutions for their upkeep.[54] Weinhold and Bücher made a categorical argument out of something that can hardly be shown from the sources for lack of data amenable to statistical analysis and declared it the only reason these female communities existed, without paying the least bit of attention to their religious motivations.

There are thus at least two problems inherent in speaking of the upkeep of women in medieval monasteries. The sources simply do not support the notion that these institutions recruited exclusively from the aristocracy in order to maintain women in a surrounding befitting their status until the fourteenth century. Furthermore, the sources also do not support the assumption that there was a surplus of women in the Middle Ages, which in turn takes for granted that female monasteries functioned primarily as poorhouses, workhouses, or hospitals.

### Women's Movements

A third, more evident problem with the hypothesis that monasteries provided for the upkeep of women is its lack of attention to, or inability to take seriously, the religious motivations that led women to live in a monastery or a *Frauenstift*. The Protestant church historian Herman Haupt (1854–1935) argued against this hypothesis by asserting religious motivations: "In contrast, one is obliged to consider the foundation of the beguine movement as one link in the chain of the varied religious movements of the twelfth and thirteenth centuries that marked the increasing independence with which the lay world participated in a process of freeing itself from paternalistic priests to address fundamental religious questions and, at the same time, breaking through to the point at which they could interiorize the life of the church."[55] The idea of a "religious movement" was not only at odds with Weinhold and Bücher's materialistic analysis; it also had a pronounced confessional point. It evoked the true community of the laity as a movement "from below" against the "paternalism" of the official (Catholic) church.[56] Without making it clear, Haupt projected the origins of the evangelical confession before the Reformation into the "religious movement" of the High Middle Ages. Unified in criticism against the materialistic hypothesis of "upkeep," even a Catholic historian such as Joseph Greven adopted the concept of a "religious movement," employing it in

his work on the origins of the beguines to apply to the world of women in the diocese of Liege.[57]

As has been shown by Martina Wehrli-Johns, the Protestant historian Herbert Grundmann seized on Haupt's concept of a religious movement, using it in the title of his famous *Habilitationsschrift*, published in Leipzig in 1935: *Religiöse Bewegungen im Mittelalter: Untersuchungen über die geschichtlichen Zusammenhänge zwischen der Ketzerei, den Bettelorden und der religiösen Frauenbewegung im 12. und 13. Jahrhundert* (Religious movements in the Middle Ages: Investigations into the historical contexts linking heresy, the mendicant orders, and the religious women's movement in the twelfth and thirteenth centuries).[58] He had first discussed the concept in 1934 in a lecture entitled "The Historical Bases of German Mysticism," which employs the then-popular nationalistic concept of German mysticism (*deutsche Mystik*). The scholarly fascination of Haupt's concept of a "religious movement" was probably enhanced for Grundmann by the National Socialists having seized power through their own "movement" (*Bewegung*). At the very least, the historical circumstances would have colored the connotations of the word. Grundmann tried to explain the phenomenon of vernacular German mysticism in terms of the dominant role played by women in the "religious movement" north of the Alps. To this end, he minted the concept of a "religious women's movement." This movement, which was perceived as being independent, was only integrated into the church, including the Dominicans and Franciscans, with great difficulty. In German-speaking regions, women had transformed the poverty movement into something "extremely subjective and spiritual, into religious experience" and thereby made possible the flowering of mysticism.[59] Similarly to Haupt, Grundmann attaches clear values to his use of the term: mysticism, especially that of women, is interiorized, active, and spontaneous, in contrast to the exteriorized, passive, and formal religiosity of the official church.

The new edition of Grundmann's work (which, it should be added, was hardly accepted without reservations by the National Socialists) was published in 1960 in the framework of an international resurgence of research that, in the context of the cold war, understood itself as part of a confrontation between western, Christian and eastern, Marxist orientations. The tenth International Congress of the Historical Sciences, held in 1955 in Rome and devoted to the theme "Movimenti religiosi populari et eresie," directly opposed Marxist research on such "social-religious movements" as the "pauperes Christi" (Werner 1956), on "social-religious currents"

(Erbstösser 1970), and the "women's movement in the context of Cathar-ism and Waldensianism" (Koch 1962). Both of the latter have recourse to the argumentation of the nineteenth-century bourgeois "materialists."[60]

Most recently, the concept of a "women's religious movement" once again enjoyed popularity under the banner of feminism in the 1970s, as did the concept of "female mysticism." The role of women in the reli-gious resurgence of the eleventh through thirteenth centuries is viewed as part of a chain of women's movements: "from the earliest foundations of early Christian communities, through the women's movement of the Middle Ages, and through the most varied women's movements of the early nineteenth century into our own times, one can trace this dissident culture that nonetheless helped establish new norms."[61] A critical exami-nation of the concept in terms of the history of gender has, to the best of my knowledge, yet to be written.

With Hedwig Röckelein, it can be said that the concept of a "religious woman's movement," including all its derivatives ("female religious move-ment" [Degler-Spengler 1985], "medieval women's movement" [Weinmann 1990]), is controversial and thus should best be avoided as an analytical cat-egory,[62] at least insofar as it is not clearly distinguished and differentiated from women's movements in modernity, whether the popular evangelical movement against the official church or nationalistic movements of any kind. Complete avoidance of the term, however, can hardly be expected, as a cer-tain tendentious militancy has been a part of the concept of a "women's movement" from the very beginning. In 2003 Gisela Muschiol also plead-ed that we should seek "not to discover a religious women's movement but rather the desire for the self-evident participation of women in the process of renewing Benedictine monasticism or in the religious poverty movement."[63]

In the Middle Ages, only in exceptional cases did women's desire for such self-evident participation meet with comparable enabling conditions governing male and female monasticism. As a result, women's monasti-cism developed distinctive forms of life, distinctive normative demands, and, at times, distinctive visual worlds. The preceding contributions to this book make this clear. To describe these distinctive aspects equally, to reflect on them critically, and to do so in relation to the culture of male monasticism are preconditions for historical research into gender that have yet to be fulfilled.

This essay has demonstrated the heterogeneity of the current state of research and the astonishing juxtaposition of tenacious stereotypes and in-

novative historical methods. All this is mirrored as well in history of women's emancipation over the last 150 years, which is by no means complete. As in the past, our own research still echoes this multiplicity of voices, complete with contradictions. We therefore have to keep in mind the historical screen on which such efforts and concepts are projected; we are dealing with a history that is almost one thousand years old. Alone the differences between the sixth and the fifteenth century explode the image of the nun of the Middle Ages. Like this essay, this volume can only provide stepping-stones toward a better understanding of this long and varied epoch. It attempts, however, something that has rarely been tried: to encompass the enormous range of this great span of time. In this way, phenomena that often are discussed separately, such as the early female monasteries and *Frauenstifte* and their relationship to the reform movements of the High Middle Ages and the variety of forms of life in the late Middle Ages, can be examined together. At the same time, breaks and points of departure emerge more clearly, for example. the eleventh through thirteenth centuries as a period of experimentation insofar as the construction of "womanhood" was concerned. The purpose of this book is to bring this variety and these lines of development to light. As part of that process, frequently employed terms and current value judgments have to be reevaluated. This essay is intended to provide a few pointers in that direction.

## Notes

1. Scheible 1860:494 and 496.

2. In *Zedlers Universallexikon*, vol. 24 (Leipzig, 1740), one finds listings for "*Nonnen-Brod*" (a marzipan dough), "*Nonnenblätzlein*" (a cookie), and "*Nonnen-Teig*" (a baking dough), but no composite terms from the realms of art history or the history of craft.

3. *Grimms Wörterbuch* (Leipzig, 1889), 7: col. 883.

4. In which of his many dictionaries Kramer employed the expressions could not be determined.

5. The claim by Christian von Heusinger (1953:78; repeated by Hamburger 1997a:227 n. 10) that both terms go back to Hans Wegener is false. In the cited publications by Wegener (1927, 1928), one finds only the expression "*Nonnenarbeiten*," not "*Nonnenmalereien*."

6. Stange 1934:104. The art historian Hermann Beenken (1896–1952) referred in 1933 to tools "for the use of a painting nun" (1933:333).

7. See, for example, Haller 2003:632.

8. Heusinger 1953 and 1959: passim; Beer 1959:46; Kroos 1978:298 n. 117.

9. Hamburger 1998b:22.

10. For the late medieval expression *"nunen gab,"* see Signori's essay in this volume.

11. See Schreiner's essay in this volume.

12. Stange 1934:63.

13. Spamer employs neither the term *"Nonnenmalerei"* nor *"Nonnenarbeit"* but speaks instead in gender-neutral terms of *"Klosterarbeiten."* For criticism of the way in which Spamer and, later, Appuhn (Appuhn and Heusinger 1965; Appuhn 1978) characterize early prints as *kleine Andachtsbilder* and the consequences for ensuing assumptions about their function, see Schmidt 2003a.

14. See, inter alia, Hamburger 1997a, 1997b, and 1998b.

15. Judith Oliver bases herself on Renate Kroos (Oliver 1997:107). Despite Oliver's repeated use of the German term *"Nonnenbücher,"* it cannot be found, contrary to what the author indicates, in Kroos, who only speaks of *"Nonnenmalereien."*

16. Oliver 1997:110.

17. In the cumulative index of medieval manuscripts cataloged according to the guidelines of the German Research Institute, the terms *"Nonnenarbeiten"* and *"Non-nenbücherr"* do not occur. In the manuscript descriptions, *"Nonnenmalerei"* occurs once, *"Nonnenhandschriften"* three times. The relevant works are indexed under the rubric *"Andachts- und Gebetbuch."*

18. Forerunners of these publications are Ernst Guhl's *Die Frauen in der Kunstge-schichte* from 1858 and Karl Scheffler's *Die Frau und die Kunst: Eine Studie* from 1908, both hardly illustrated. Schuchhardt 1941 draws extensively on Hildebrandt and, in keeping with National Socialist ideology, places far more emphasis on themes drawn from secular art. On Guhl, Scheffler, and Hildebrandt, see Nobs-Greter 1984:62–79 and 101–120.

19. Hildebrandt 1928:44 and 53. Already in 1896, Lina Eckenstein offered a far more accurate and subtle analysis of Herrad's *Hortus deliciarum*; see Eckenstein 1896/1963:238–355.

20. See also Schade and Wenk 1995:350–351.

21. Pathbreaking for the Middle Ages were Miner 1974, Carr 1976, and cat. Braunschweig 1983.

22. Schade and Wenk 1995:351.

23. Ibid.: 341.

24. Ibid.: 352.

25. The representations of women and femininity in medieval works of art were the subject of strong interest; for German research, see, e.g., the essays collected in the proceedings of the conferences of women art historians: Bischoff et al. 1984; Barta Fliedl et al. 1987; Lindner et al. 1989.

26. See the chronologically organized overview of all names treated in Gaze 1997:xxi.

27. Carr 1997:3–4.

28. In recent years, the textiles produced in women's monasteries of the fifteenth century have been subject to greater interest across various academic disciplines.

29. See, e.g., Hildebrandt 1928:44; and Schomer 1937.

30. The report on research for the Hildegard Jubilee in 1998 offers a point of entry into this complex topic; see Heerlein 2000:554–560; Niehr 2000; Felten 2003:182, 187–188. From the perspective of research on gender in the Middle Ages, see Lundt 2003:71–74 and 106.

31. Caviness 1997b:88–92.

32. Saurma-Jeltsch 1998.

33. For a short summary of her method, see Caviness 1997a. For a more extensive discussion, see Caviness 2001; and, on Hildegard specifically, inter alia, 22, 170.

34. For extensive commentary on this topic, see Cescutti 1998:11–24.

35. Griesebner and Lutter 2000:58. For a short summary of the discussion, with additional bibliography, see Klinger 2000.

36. Griesebner and Lutter 2000.

37. Cescutti 1998:286; 2000:38–40.

38. Cescutti 2000:36–38; 2004.

*The text up to this point was written by Susan Marti. The remainder of the chapter is by Jan Gerchow.*

39. "Homes for aristocratic ladies" is quoted from anonymous, "Canonissen oder Canonissinnen," in *Allgemeines Kirchen-Lexikon,* ed. Joseph Aschbach (Frankfurt, 1846), 1:923–924. See also popular accounts from the nineteenth century, such as the *Kulturgeschichte der Deutschen Frau, in drei Büchern nach den Quellen von Johannes Scherr* (1817–1886), first illustrated edition checked against the second edition of the original and edited by Max Bauer (Dresden 1928): "for the monasteries were the ideal places for the upkeep of the daughters of the poorer nobility who had no dowries" (145). In ecclesiastical histories, this image was reinforced by authorities such as the church historian Albert Hauck in Leipzig: "Such conditions were produced by the fact that in many cases it was not the striving toward holy sanctity that led nuns to enter monasteries but rather external considerations. Female monasteries were in part nothing more than places for the care of the daughters of well-to-do households. This is especially true for a not insignificant number of the older, independent, aristocratic convents" (1913:422, in the chapter on the period 1122–1250).

40. Haverkamp 1984; Hildegard of Bingen 1965:203. On this subject, see also Felten 2000b.

41. Hauck 1913:422; Ennen 1988:61; Parisse 1988:94. See also Kohl 1980; Crusius 2001a:16; Althoff 2003:31; Neidiger 2003b:54.

42. Schulte 1910 and the overview in Felten 2001: passim.

43. Felten 1992, 2000b, 2001; Schreiner 1964. On *Frauenstifte*, see, among others, the references provided by Schäfer 1907:234–238, although it must be noted that the sources before the thirteenth century can only be used with great caution, for which see Felten 2001.

44. Felten 2000b.

45. Leyser 1984:107–109.

46. Kohl 1980; 2003a and b.

47. Neidiger 2003b:54.

48. E.g., Parisse 1983a; Bautier 1990; Eckenstein 1896/1963:79–81, 143–145; Power 1922:4–6; McNamara 1996:176–178.

49. Küppers-Braun 2002:52–54. For extensive commentary on this topic, see Küppers-Braun 1997.

50. Johann Lorenz von Mosheim, *De Beghardis et Beguinabus commentarius*, ed. Georg Heinrich Martin (Leipzig, 1790). See the important review of research by Wehrli-Johns 1992/1998:14–16 and 32–34.

51. Staatsarchiv Münster, Fürstentum Münster, Kabinettsregistratur E 13 A Nr. 5, cited in Kohl 1975:85–87. See Klueting 2004.

52. "Das adliche freiweltliche Damenstift zu Neuenherrse" (Abdruck aus den Annalen der Preußischen Staatswirthschaft und Statistik, Bd. 1, Heft 4, Halle and Leipzig 1804, 41–77), in *Zeitschrift für vaterländische Geschichte und Alterthumskunde* 43, no. 2 (1885):124–146, Statut 134–146, cited in Klueting 2004:191.

53. Weinhold 1851; Bücher 1882; Uhlhorn 1884/1895:464.

54. See Osthues 1989 and the review of research in Röckelein 1992:388–389; 2002:586–588; and Signori 1997a:39–40. See also Muschiol 1994:4–9.

55. Haupt 1897:517; cf. 518, with an explicit rejection of the "caretaker" hypothesis, to which Haupt only grants a certain legitimacy beginning in the fourteenth century.

56. For the history of the term "religious movement," see the extensive remarks of Wehrli-Johns 1992/1998 and 1996.

57. Greven 1912.

58. Grundmann 1935/1970; Wehrli-Johns 1996.

59. Wehrli-Johns 1996:288–290.

60. Ibid. Koch 1962 speaks of a "surplus of women," of a "question of how to take care of daughters," and of "convenient caretaking institutions" (30–32 and 181–182).

61. For the Middle Ages, Kuhn 2002:181, bases herself on Weinmann 1990. See also the way female mystics are treated in Lerner 1993:87–89.

62. Röckelein 1995.

63. Muschiol 2003b:79.

# The Visionary Texts and Visual Worlds of Religious Women

BARBARA NEWMAN

Of all the writing produced by medieval women—a corpus far greater than was once imagined—the vast majority comes from religious women, whether they were nuns, canonesses, beguines, tertiaries, or recluses. When we look at medieval women as readers or biographical subjects, the influence of consecrated women is still disproportionate. Legends of female saints outnumber the panegyrics of queens and other great ladies, just as the letters, poems, and treatises of spiritual advice composed for nuns outnumber those written for their secular sisters. Yet, statistically speaking, nuns never constituted more than a small percentage of the female population, and their numbers were always significantly fewer than the proportion of men vowed to the celibate life as priests, monks, friars, or clerics.

Like their aristocratic sisters who patronized courtly poets, nuns came from the upper strata of society, a fact that helps explain their influence on the cultural imagination as well as the surviving literary record. But, more to the point, nuns and their monastic brethren belonged to a Latin textual community grounded in Scripture, exegesis, and liturgy. This culture was textual to the core, in contrast to the fundamentally oral and performative culture of the aristocracy. Even in the later Middle Ages, when the vernacular had largely displaced Latin as the medium of devotional writing for women, writing as such still held a central importance for vowed religious that it had yet to attain for the laity. The textual disciplines of meditative

reading (*lectio divina*), liturgical chant, and scribal work fostered a degree of interiority and conscious self-fashioning that we now take for granted but is in fact one of the most enduring legacies of medieval monastic culture.

All monastics were to some extent bilingual, knowing at least one local vernacular or mother tongue in addition to Latin, the universal father tongue. As a learned language, Latin was acquired at school or in the cloister, rarely at home, and it was the ultimate language of authority—of the Bible, divine worship, canon law, and formal theology. Most women were strangers to it, and even nuns tended to achieve less fluency than their monastic brethren since they had no opportunity to attend cathedral schools or, later, universities where learning flourished. Nevertheless, monks and nuns through the early twelfth century shared a common literary culture, with Latin as its sole medium of written communication. In the course of that century, several factors conspired to drive a wedge between women and men in the religious life. One was the rise of scholastic theology, a new mode of religious thought far removed from the contemplative, biblically grounded theology of the Benedictines. It was based instead on the application of philosophical logic to Christian doctrine and aimed at the establishment of comprehensive intellectual systems. Even more important, it flourished in the arena of public disputation, a realm of intensely competitive exchange among quick-witted young men and their teachers from which women were excluded. In the second place, priestly ordination gradually became the norm for monks during the twelfth century, whereas earlier it had been the exception. Thus, at the very time the Gregorian reform movement was taking radical measures to enhance clerical prestige (such as requiring mandatory celibacy), nuns found themselves reduced in stature, no longer the religious equals of monks but a subset of the laity.

A third factor, the rise of vernacular writing, played an ambivalent role in women's religious lives. By the mid-twelfth century in France and the early thirteenth in Germany, England, and the Low Countries, the vernaculars had emerged as literary languages in their own right, suitable not only for such secular genres as epic, lyric, and romance but also for devotional and mystical writing. In many cases, religious women and their clerical friends stood at the forefront of this emergence. The flowering of vernacular mysticism—a development intimately linked with women—created a whole new realm of religious expression, often daring in its stylistic experimentation and imaginative play, its appeal to inner

experience rather than textual authority, and its openness to the influence of secular literary forms. Yet this outpouring of vernacular spiritual writing also contributed to the growing intellectual split between men's and women's religious lives. Over time, clerical and scholastic theology, which remained firmly Latinate, grew increasingly distant from what we now call spirituality, while religious women came to specialize in affective piety conveyed through vernacular texts. Significantly, some of the most celebrated male mystics—men such as Meister Eckhart and Henry Suso—wrote in Latin for their clerical brethren but in German for their female friends and disciples.

Germany also provides some striking exceptions to the decline of women's Latinity. It is a remarkable fact that virtually all the substantial Latin texts extant from the pens of medieval women come from German-speaking lands. These include the narrative poems and plays of Hrotsvit of Gandersheim; the massive theological and epistolary corpus of Hildegard of Bingen; the visions of her protégée Elisabeth of Schönau, coauthored with her brother, Ekbert; the letters and sermons produced by the twelfth-century nuns of Admont; the learned and lavishly illustrated encyclopedia *Hortus deliciarum*, compiled by Abbess Herrad of Hohenburg; the intertwined revelations of Gertrude of Helfta and her friend Mechthild of Hackeborn; and the *Vitae sororum*, or collective hagiography, from the Dominican nuns of Unterlinden. Latin writings by women elsewhere in Europe are briefer, mainly lyric poems and letters, and most of them date from before 1150 and the triumph of the vernaculars.[1] This continuing tradition of Latinity among German nuns testifies to the high educational standard that prevailed in many nunneries and *Damenstifte*, which were proudly aristocratic, wealthy foundations, long after religious women elsewhere had ceased to aspire to a full mastery of the language.

Whether composed in Latin or in the vernacular, most women's texts appeal to visionary experience as a mark of divine favor, a source of truth, and, not least, a warrant of religious authority. In fact, visionary writing is the sole medieval literary genre that is actually dominated by women. Saints' lives corroborate the perception of visions as a female specialty: later medieval hagiographers devoted more space to women's visions and ecstasies than to men's. The most important reason for this emphasis was negative: spiritual authority was denied to all women on the basis of St. Paul's dictum, "I permit no woman to teach or to have authority over men; she is to keep silent" (1 Tim. 2:12). Prophets, however, were partially

exempt from this rule, for the Old and New Testaments agreed that God bestowed the gift of prophecy without regard for gender. Like the biblical prophets, medieval visionary women claimed direct communication from God and the consequent right—or rather duty—to make his revelations known to the church. Even though many later medieval visions are more devotional than prophetic, visions still gave women license to write about religious matters, which would otherwise have been off limits to them.

It may also be the case that women really experienced more visions than men. Friars and monks were more likely to spend their time teaching, preaching, and writing, but nuns devoted themselves to contemplative prayer, which included a strong visual component. In spite of a lingering theological prejudice against images, the everyday life of monastics involved devout meditation before works of religious art, which ranged from the ubiquitous crucifix and Pietà (fig. 6.1) to drawings produced by individual nuns for their own use. Spiritual guidebooks, often addressed to women, taught believers to grow in compassion for Christ by systematically visualizing scenes from his life. Nuns in particular were encouraged to cultivate such practices because, for physiological reasons, women were held to be more imaginative than men. The soft, porous female brain, physicians taught, could receive impressions more easily than the harder masculine body, just as soft wax more easily accepts the imprint of a seal. Since this impressionable quality made women more prone to demonic suggestions as well as divine revelations, it was vital to imprint the hyperactive female imagination with sacred images in order to keep evil ones at bay. The regular use of images and visualizations in prayer bore fruit in visionary experience, which was highly valued in religious communities despite the suspicion that greeted women who made extravagant claims about it.[2]

In this essay, I will consider three distinguished monasteries for women—Rupertsberg in the twelfth century, Helfta in the thirteenth, and Unterlinden in the fourteenth—with attention to the ways that women's visionary spirituality evolved over time. Each community gave rise to a significant body of Latin religious writing, and each bears witness to a visual culture reinforced by its visionary nuns. In the final pages, I will look at two vernacular mystics on the margins of respectability: the beguine Mechthild of Magdeburg, who ended her tumultuous life as a nun at Helfta, and the heterodox *Schwester Katrei*, a text linked to the circle of beguines around Meister Eckhart.

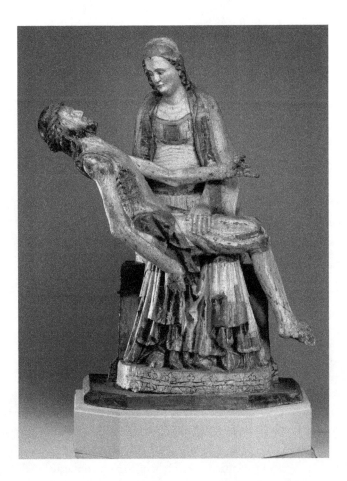

*Figure 6.1* Pietà from the former Dominican nunnery of Adelhausen, ca. 1360/1370, linden wood, original polychromy, h. 159, w. 102 cm. (Adelhausen-Stiftung Freiburg, inv. 11437.)

Hildegard of Bingen (1098–1179), foundress of the Rupertsberg, may be the most famous of all medieval nuns. Her extraordinarily varied output includes a massive trilogy of theological books structured around her visions; several hundred letters to monastic, clerical, and lay correspondents; a large body of liturgical chant, including a sung morality play; two saints' lives; and a scientific and medical encyclopedia, along with other medical writings that survive in draft form. Hildegard owed some of her exceptional success to her origins in the high nobility. Recent research suggests that her mother may have been a Staufer and thus a kinswoman of Frederick

Barbarossa,[3] who called on Hildegard's prophetic gifts early in his reign and protected her community as long as he lived, despite her eventual break with his schismatic politics. Her early life typifies the religious patterns of this expansionist age. As a young girl, Hildegard was enclosed together with her older relative Jutta of Sponheim; both girls took a vow of virginity as recluses. Their hermitage was adjacent to the male monastery of St. Disibod, then under reconstruction after a period of decay. As time passed, other aristocratic girls came to join Jutta and Hildegard, until their community became large enough to incorporate as a nunnery under the Benedictine rule. A few years after becoming *magistra* upon Jutta's death in 1136, Hildegard claimed a more potent form of authority by publicizing the visions she had experienced since early childhood, and by 1150 she had achieved sufficient stature to found her own monastery.

More than any other German nun, Hildegard could lay valid claim to the title of prophet. The description of her prophetic call, which she experienced in 1141, is closely modeled on Old Testament paradigms. God tells her she must "cry out and write" the mysteries of Scripture because learned priests, who ought to be performing this task, have become lazy and effeminate. Therefore God has raised up a weak woman to confound strong men (1 Cor. 1:27), despite the scorn of those who wish to keep her "contemptible on account of Eve's transgression."[4] Hildegard is prophetic, too, in her insistence on speaking truth to power. With the passage of time, she grew increasingly critical not only of the emperor but still more of the powerful prelates in his service. She is prophetic, finally, in her fascination with the future. No element of her work would prove more influential than her predictions of calamities to come, ranging from the disendowment of clergy at the hands of secular princes to the coming of the Antichrist.

Hildegard's first book, *Scivias* (*Know the Ways of the Lord*), bears witness to her visual and visionary world. The celebrated Rupertsberg manuscript—now lost but well known from a hand-painted modern facsimile—bore illuminations almost certainly based on the seer's own sketches and verbal instructions. Her visionary texts themselves reveal a painterly imagination that is rare in such writings, where the visual element proper is often surprisingly weak. In other writers, an account of Christ's or Mary's appearance may serve chiefly as a pretext for instructive dialogue. Hildegard's vision texts, by contrast, give detailed accounts of the shapes, colors, proportions, movements, and spatial relationships of each element in the sce-

nario unfolding before her. Lavish use of gold leaf conveys the sparkling radiance the seer so often described, marking the Rupertsberg *Scivias* as both an extravagant luxury object and a witness to its author's theophanies. In a vision of the Trinity (*Scivias* II.2), for example, Hildegard describes a radiant light (the Father) suffusing a sapphire-blue figure (the Son) who blazes with a glowing fire (the Holy Spirit), even as the light and fire mutually bathe one another. The painter gives form to this vision by representing the light and fire with concentric rings of gold and silver leaf, shimmering with wavy red and gold circles that convey a sense of vibrant, dynamic life (fig. 6.2). In the center of the mandala stands the divine Christ, blue as heaven, hands opened outward in a gesture of self-offering or adoration. This celestial Logos is a beardless, androgynous figure, in contrast to the incarnate Christ who is always bearded in the *Scivias* paintings.

Very different in style is the famous illuminated manuscript of Hildegard's *Liber divinorum operum* (*Book of Divine Works*), prepared in the early thirteenth century for a failed canonization bid. This summa on cosmology develops an elaborate set of analogies between the cosmos and the human microcosm, structured around parallel exegeses of the creation in Genesis and the incarnation in the prologue to John's gospel. The book opens with a new Trinitarian vision (fig. 6.3) that contrasts tellingly with the one in *Scivias* II.2. Hildegard now sees a divine figure with four wings, "a beautiful and marvelous image like a human form [*quasi hominis formam*] in the mystery of God."[5] Again the language is carefully androgynous ("*homo*" in Hildegard is a gender-neutral term). This resplendent figure is surmounted by the face of an older man (*senioris viri*) and holds a lamb in its hands. In a lyrical speech of self-revelation, the visionary form identifies itself as "the supreme and fiery force that kindled every living spark," then as Rationality, then as unlimited Life (*integra vita*). A "voice from heaven" reveals to Hildegard that the image she sees is Caritas, or divine Love, elsewhere a feminine personage, while the old man signifies the eternal goodness of God and the lamb, the gentleness of Christ. The "monster" beneath the Divine One's feet is Satan. In the illuminator's masterful composition, the arresting details of Hildegard's account fuse with elements of conventional Trinitarian iconography: the gray-bearded man suggests God the Father, the Lamb is given a cross and nimbus to identify it clearly with Christ, and Caritas is painted entirely in red, the color of the Holy Spirit—a detail not supplied in the text. Finally, the artist adds a prophetic author portrait, which appears in abbreviated form in all the paintings of this manuscript.

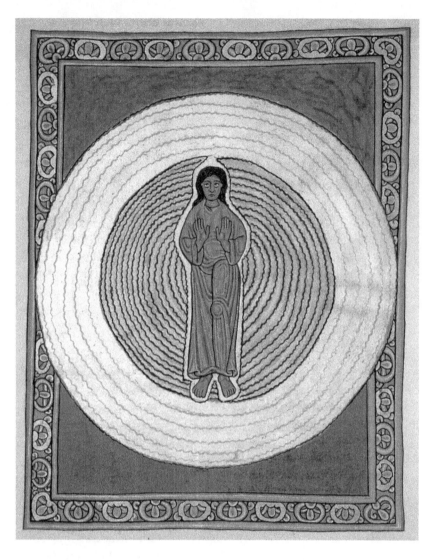

*Figure 6.2* Christ in the Trinity, miniature in the Rupertsberg *Scivias* manuscript of Hildegard of Bingen, ca. 1165. (Facsimile of lost original from the abbey of St. Hildegard in Eibingen [Rhineland-Pfalz], twentieth century, f. 47r.)

Hildegard receives divine illumination in the form of heavenly fire streaming through a window carved into the frame of the vision itself. She writes what she sees on wax tablets whose form recalls those received by Moses on Mount Sinai, while a trusted nun stands by to assist and, on the other side of a barrier, her secretary, Volmar, prepares a fair copy on parchment.

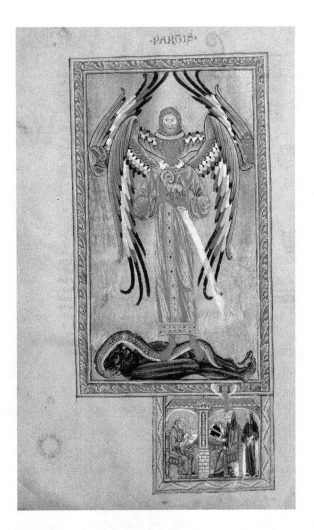

*Figure 6.3* Charity and the Trinity, miniature for the first vision in Hildegard of Bingen's *Liber divinorum operum*, Mainz, ca. 1230. (Biblioteca Statale Lucca, Cod. 1942, f. 1v.)

Although Hildegard devoted boundless energy to the nurture of her spiritual daughters, she dominated the Rupertsberg absolutely. No other nun there received visions, wrote books, composed music, or competed with the towering figure of the foundress in any way. When we turn to the Saxon nunnery of Helfta, which flourished as a center of female spirituality in the late thirteenth century, the picture is quite different. This community, loosely affiliated with the Cistercian order, boasted three famous spiritual writers as well as others whose names have not come down to us.

Whereas Hildegard's visionary experience exalted her to singularity and international fame, the Helfta nuns confided their visions to their sisters and collaborated in transcribing them, producing elegant Latin volumes that testify as much to communal aspirations as to individual holiness. Two of these nuns were intimate friends, Gertrude "the Great" (1256–ca. 1302) and Mechthild of Hackeborn (1241–1298); both entered the cloister as children. Gertrude was instrumental in transcribing Mechthild's *Liber specialis gratiae*, while Mechthild in turn helped to write Gertrude's *Legatus divinae pietatis*. The visionary mode of these works is more intimate and inward-looking than Hildegard's. Cosmological and political dimensions have all but disappeared, giving way to an even stronger liturgical and sacramental focus. Where Hildegard aimed to correct erring prelates and teach Catholic doctrine, Gertrude and Mechthild strove to intensify devotion by recording the special favors God had granted them. The world outside the convent has faded to insignificance.

Gertrude's visual universe is governed by a single image, the crucifix, on which she loved to gaze. Her book refers frequently and sometimes anxiously to this act of devotion, as if torn between a desire to venerate the cross and a fear that such fervent external piety might be idolatrous. Once, for example, Gertrude sees or imagines that the crucifix hanging near her bed is about to fall off the wall. She asks Jesus why he is leaning down, and he replies, "The love of my divine heart impels me toward you."[6] He then tells her how greatly this devotion pleases him: just as a king going on a journey entrusts his queen to a favorite relative, so he has left the crucifix to his bride as a token of his love. On another occasion, Gertrude is gazing at the painted Crucifixion in her prayer book after receiving communion, when a ray of light darts out of Christ's side wound like an arrow to pierce her heart with the wound of love.[7] Such experiences reveal the close connection between religious women's visions and their attraction to sacred art. Gertrude's contemplation of a beloved image leads to an inner experience of grace that in turn intensifies her devotion to the crucifix.

Later on, she experiences a more complex vision of the Sacred Heart, a devotion that her writings would help to disseminate throughout Christendom. Praying for her sisters, Gertrude understands that Christ has given each a "golden tube" with which to draw grace and sweetness from his heart, as if drinking from a straw. The tube represents free will. In response Gertrude offers Christ her own heart to be purified. "Then the Son of God appeared, offering to God the Father her heart united with his divine

heart, in the likeness of a chalice, made of two parts, joined with wax." Seeing her heart thus transformed, Gertrude begs Christ "that you may always, at your pleasure, have it at hand, clean, and ready to pour into it or out of it at any time you please, and for whomsoever you please."[8] The mystic here sees her heart—the symbol of her love and generosity—as a ceremonial flagon, like the chalice of the Eucharist, from which others may drink and be refreshed. Significantly, it is after this experience that she realizes God wants her visions to be recorded in a book "for the good of many."

Mechthild of Hackeborn, whose visions were more elaborate than Gertrude's, shared her friend's devotion to the Sacred Heart. In several visions she perceived the heart of Jesus as a golden house or as the gate of heaven. As a rose, the Sacred Heart issued streams of fragrant perfume; as a fountain, it flowed with purifying water; as a harp, it resounded with sweet music to the honor of God.[9] Until the end of the Middle Ages, women's mystical texts and the artworks they used would abound with images of the wounded heart, the crucified heart, the heart as a house, and the heart inscribed with the monogram of Jesus or symbols of his Passion (fig. 6.4). This devotion to the Sacred Heart overlapped with others such as the widespread cult of Christ's wounds, the Holy Name (promoted by Henry Suso), and the Eucharist itself. Christ's side wound was understood as the passage leading to his sacred heart, the source of baptismal water and Eucharistic blood; in eternity he feasted there with his chosen bride and slept with her in the embrace of love. Many female mystics would replicate Gertrude's experience of exchanging hearts with Jesus. These devotions were not practiced exclusively by nuns, yet their intimate, domestic character made them especially attractive to cloistered women. In the cult of the Sacred Heart, the interior of Christ's body became, like the female womb, an archetype of nurturing and sheltering space.

By the fourteenth century, the most prominent women's communities in Germanic lands were Dominican nunneries. Many of these houses had originated as beguinages—informal religious households founded by widows or other devout women—but in the mid-thirteenth century they gained protection and prestige by affiliating with the order of preachers. The generation of Dominican sisters that flourished between 1315 and 1350 created a remarkable new genre, the so-called *Schwesternbücher* or *vitae sororum*, modeled on the thirteenth-century *Vitae fratrum* celebrating the saintly lives of early friars. Eight of these High German *Schwesternbücher* have come down to us, along with several others in Dutch.[10] Many more

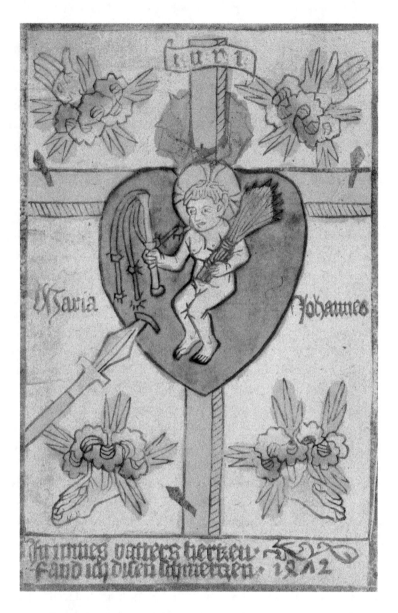

*Figure 6.4* The Christ Child in the Heart with the five wounds and the instruments of the Passion, southwest Germany, 1472, woodcut. (Staatliche Museen zu Berlin, Kupferstichkabinett, inv. 128-1.)

were almost certainly lost in the nineteenth-century destruction of monastic libraries after secularization. Each surviving book begins with the community's foundation story, followed by short biographies of its holy dead, to create a collective hagiography. The sister book from Unterlinden in Colmar (Alsace) is deservedly famous as one of the earliest and most complete examples of the genre and the only one composed in Latin. It was written around 1320, chiefly by Sister Katharina von Gueberschwihr.

Sister Katharina's narrative opens with a highly idealized portrayal of convent life at Unterlinden, praising the sisters' spiritual fervor, their "austere and rigid life," their exemplary devotion to Christ and his Mother. Following a universal trend toward more penitential forms of religious life, the nuns' spirituality was more ascetic than a Hildegard or a Gertrude would have countenanced. During Advent and Lent, "all the sisters would go to the chapter house or other suitable places after Matins and fall upon their bodies with various kinds of scourges, cruelly and ferociously lacerating their flesh even to the shedding of blood, so that the sound of whipping resounded throughout the monastery, rising more sweetly than any music to the ears of the Lord of Hosts, who is greatly pleased by such works of humility and devotion."[11] This tradition proved as lasting as it was intense: some eighteenth-century scourges from Unterlinden are still extant. The more rigorous sisters, not content with their rough habits, are said to have imitated the saintly hermits of old by wearing hair shirts and iron chains beneath their clothing. Yet this violence directed against the nuns' own bodies coexisted with a tender, even sentimental piety focused on the child Jesus (the object of joyful longing) and the crucified Christ (the object of tearful compassion). This link between sentimentality and violence is characteristic of fourteenth-century religious literature. Although the cultivation of such emotional extremes is typically linked with women, the nuns' piety is reinforced by the vitae of such male figures as Henry Suso and Friedrich Sunder, which were composed for a largely female audience.

In the Dominican sister books, we find a radical democratization of grace. Phenomena that had once characterized only saints—visions, voices, clairvoyance, miraculous multiplication of food, even levitation—are now part of the community's everyday life. The traits that Sister Katharina and her peers remembered best about each nun were the "special graces" she had received. Visionary experience, represented as a unique miracle in Hildegard's life and still exceptional in Gertrude's, has now become

normative. The contents of the nuns' visions tend to be formulaic, for they shared these experiences freely as models to be imitated. Along with the traditional virtues of charity, humility, and obedience, the nuns implicitly prized the virtue of imagination: the ability to visualize Christ and his Mother so vividly that they appeared in the flesh or to meditate so attentively before an image that it came to life. Once when the prioress Adelheid of Rheinfelden was suffering from temptation, "the gracious Lord Jesus appeared to her visibly one day as if bound to the pillar, all livid and bloody with wounds, bearing the marks of the nails in his hands and feet, and pierced by the spear as if he had been crucified that very day, so that the blood gushed abundantly from his fresh wounds."[12] Seeing his compassionate gaze, she was consoled and freed from her trials. Another nun, Adelheid of Torolzheim, remembered a Eucharistic vision she had experienced as a girl. When a priest came to bring communion to a sick person, she peered curiously into the pyx and saw "an uncommonly beautiful little boy seated inside, dressed in priestly vestments, with curly golden-blond hair."[13] This curly-haired Christ Child was a favorite sculptural type in convents (fig. 6.5). After the sick man had received the host, the Child disappeared, and the little girl wept inconsolably.

Paintings, statues, reported visions, and manuals of meditation reinforced one another, all serving to brand the nuns' consciousness deeply with standard iconography. The intensity with which nuns could respond to sacred art appears in the legend of Gertrud of Brugge. One day this sister "was standing in choir before the image of the glorious Virgin," praying for the forgiveness of her sins, when she "suddenly saw with her bodily eyes" that the Christ Child, sitting in his mother's lap, had lifted his hand and extended it toward her, promising, "You will never be separated from me and my beloved mother, even to eternity, and I will be gracious to your sins and remember them no more." Elated by this promise, the nun seized Christ's hand so forcefully that she broke the statue: "The Child's hand remained in her own, separated from its body by some divine power. As a proof of this reality, the hand could never again be restored to the image by any means, although it was very often tried. And so that holy image, divinely deprived of a hand, is kept in the monastery to this day."[14] Far from blaming Sister Gertrud for carelessness, Sister Katharina presented the event as an act of God: the nun had a material proof of Christ's promise, while the community cherished their broken statue more than ever as a reminder of the miracle. Long after Sister Gertrud's death, the edifying tale could be

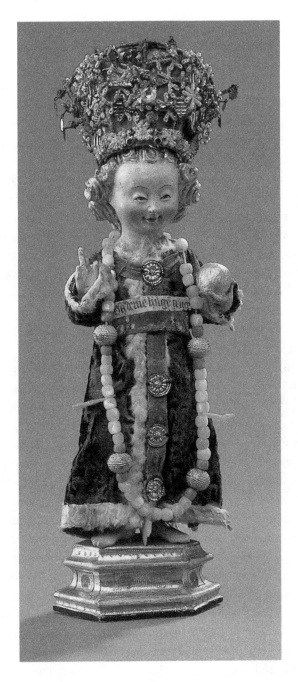

*Figure 6.5* Christ Child with garments and crown from the convent of Heilig Kreuz in Rostock, ca. 1500. (Kunstsammlungen, Staatliches Museum Schwerin [Mecklenburg-Vorpommern], inv. Pl. 600.)

told to each generation of novices when they first encountered the image. In fact, the whole legend could have been inspired to explain an already-damaged statue.

One distinctive feature of the sister books is their insistence on the realistic nature of the nuns' visions. St. Augustine had ranked spiritual visions higher than bodily ones and imageless intuition higher still. Although theologians for a thousand years dutifully repeated this hierarchy of visionary experience, the authors of the sister books would have none of it. Instead, the nuns constantly see visions "with their bodily eyes" or hear angelic song "with their bodily ears." To them, the more vividly a spiritual experience resembles a physical perception, the more persuasive it is. This preference should not be taken to imply a lack of intellectual sophistication, as both medieval and modern critics have charged, but to suggest an intimate bond between the nuns' spirituality and their bodily experience. Just as their self-inflicted pain forged a link between their own bleeding bodies and Christ's, so, too, their visionary experience united the physical world of the convent, saturated with holy images, and the heavenly world where God dwelled in bliss with his saints and angels.

This cloistered world was, in theory and practice, intensely inward-looking. Although nuns retained strong ties with their families, exchanged gifts and letters with friends outside the convent, and even borrowed books from other monasteries, their spiritual striving was directed toward a contemplative ideal that had little to do with the needs of the outside world. A genuine alternative emerged in the late twelfth century with the beguine movement, flourishing in the Low Countries and the Rhineland. With no founder, no established rule, no solemn vows, and no hierarchy, the early beguines were mostly urban women who experimented with the possibilities of living a devout life in the world. Single yet free to depart and marry if they chose, they supported themselves through a combination of private wealth and labor in the textile trade and supplemented a nunlike routine of liturgical prayer with service to the poor and sick.[15] Some clerics, such as the celebrated preacher Jacques de Vitry, praised this movement as a sign of renewal in the church, but others found it threatening because beguines, being neither monastic nor secular women, were subject to the authority of neither husband nor abbot. They represented a broader range of the social spectrum than nuns, including aristocrats and daughters of wealthy merchants as well as poorer women migrating from the countryside to the city in search of work. Often suspected of heresy,

the beguines were largely suppressed by the Council of Vienne in 1311, although conventualized beguinages survived well into the modern era in parts of Belgium. It is among these women that we find some of the most theologically and poetically gifted writers of the Middle Ages.

Of the beguine Mechthild of Magdeburg (ca. 1207–ca. 1282), we know little beyond what she says in her book *Das fließende Licht der Gottheit* (The flowing light of the Godhead). This volume, composed in Low German but surviving only in Latin and High German translations, is among the most dazzling monuments of medieval religious literature. Interweaving prose and verse, it blends a variety of genres including love lyrics, visions of heaven and hell, theological speculation, prayer, prophecy, autobiographical reflection, critiques of the institutional church, and allegorical dialogues between the soul and the Virtues. In her old age, threatened by encroaching blindness and harassed by the clergy whom she had criticized, Mechthild took refuge at Helfta, where she dictated the final chapters of her book. Compared with the visions of the cloistered nuns there, the beguine's experiences are more idiosyncratic. Her vivid eroticism reflects the influence of vernacular love poetry rather than Latin exegesis, and her tone is at once more lyrical, more anguished, and more powerfully individual. Sometimes it is even reminiscent of Hildegard's prophetic voice. Mechthild's presence at Helfta may have been a catalyst inspiring the nuns to record their own visions, for reverential accounts of her death appear in both Gertrude's *Legatus divinae pietatis* (5.7.2) and Mechthild of Hackeborn's *Liber specialis gratiae* (4.8.259).

Like the nuns of Unterlinden, Mechthild looked to the order of preachers for support: her confessor and editor, Heinrich of Halle, was a Dominican. Unlike the sister books, however, her *Fließende Licht* seldom mentions the liturgy and pays little attention to sacred art. Yet one of her visions strikingly anticipates a later iconographic theme (fig. 6.6). Mechthild sees God the Father enthroned in heaven: to his left stands the Virgin Mary, her breasts dripping with milk "in honor of the heavenly Father and as a favor to humankind," while at God's right hand stands Jesus "with his open wounds bloody and unbandaged, ready to prevail over the Father's justice."[16] Neither the blood nor the milk will cease to flow until Judgment Day, for these twin fountains of mercy stream forth continually on behalf of sinners. This motif, known as the Double Intercession, first appeared in visual art in the mid-fourteenth century, almost a hundred years after Mechthild wrote, and became an artistic commonplace only in the mid-fifteenth.

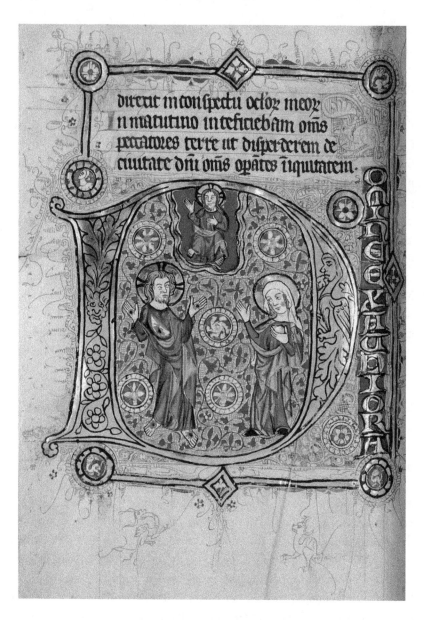

*Figure 6.6* Double intercession, initial to Psalm 101 in a psalter from the double monastery of St. Andrew in Engelberg, second quarter of the fourteenth century. (Stiftsbibliothek Engelberg [Canton Obwalden], Cod. 60, f. 120v.)

Only once does the beguine dwell at length on an actual artwork. In a dialogue with Christ's mother, Mechthild asks why Mary could not afford to sacrifice a lamb, since she was enriched by the gifts of the Magi. The Virgin explains that she spent the money to help poor orphans, dowerless maidens, invalids, and the elderly—a reminder of the social ministry in which beguines themselves were engaged. With the remaining gold, Mary procured a "hunger cloth to which the common people went for their prayer."[17] A hunger cloth, named after the Lenten fast, was an embroidered curtain hung before the sanctuary of a church during Lent to symbolize penitence. Mechthild connects this church furnishing with the veil of the temple that, according to legend, the Virgin wove during her pregnancy. In describing Mary's allegorical hunger cloth, Mechthild gives us an unusually detailed account of one kind of textile women would actually have woven for their parish or convent church. The left half of Mary's hunger cloth is black, embroidered with symbolic designs in green, while the right side is white and embroidered in gold. These two halves represent the Old and New Testaments. A vertical golden stripe runs down the center, bisecting a gem-studded border to produce a cruciform figure adorned with a lamb. When Christ, the Lamb of God, was sacrificed on Good Friday, Mary tells the seer, this hunger cloth fell to the ground. The lifeless *figura* is superseded by its fulfillment, just as the veil of the temple was rent from top to bottom when Jesus died on the cross—and as the actual hunger cloth was removed from the church before Easter.

Although the visual element has loomed large in this survey of women's religious texts, it would be an error to conclude that visions and images held unquestioned sway. I end therefore with the mysterious German treatise known as *Schwester Katrei* (Sister Katharine), which survives in seventeen manuscripts and is sometimes titled "Meister Eckehartes Tohter von Strâzburc." Eckhart taught in Strasbourg from 1314 to 1323 and attracted many disciples among the city's large population of beguines, who were subjected to persecution from 1317 to 1319. The anonymous author of *Schwester Katrei*, probably a woman, might have written in response to these troubles. The treatise takes the form of a dialogue between an unnamed master, presumably Eckhart, and his spiritual daughter, a beguine who is seeking "the fastest way" to God. Father and daughter agree that this is the way of absolute poverty, detachment (*Gelassenheit*), and renunciation of creatures, but the priest tries to

persuade his penitent that such a difficult path "is not meant for women." Indignantly, she protests that she can suffer just as much as any man, taking Mary Magdalene as her example, and goes into exile to prove it. Some time later the beguine returns, so transfigured by her suffering that the priest no longer recognizes her. She joyfully proclaims that she has "become God" in mystical union, and the dialogue resumes, this time with the beguine as teacher and the priest as her disciple. He regrets that he knows only through books what she has now learned from experience. After more instruction, the priest is finally enabled to experience ecstasy, while the beguine achieves such perfection that she is "established" in permanent union with God.

The doctrine of *Schwester Katrei* is a blend of Eckhartian mysticism, heterodox motifs reminiscent of ancient gnosticism, and polemical defense of the spiritual capacities of women. Modern scholars have sometimes linked the treatise with *The Mirror of Simple Souls*, a mystical dialogue by the French beguine Marguerite Porete, who was burned at the stake in Paris in 1310. Certain propositions from Eckhart, too, were posthumously condemned, yet the safely anonymous *Schwester Katrei* escaped censure. For my purposes, the most interesting feature of this text is its sharp polemic against the kind of women's spirituality I have examined here. While Meister Eckhart was notably cool toward visionary experience, his skepticism is nothing compared to Schwester Katrei's withering scorn. Some religious people, she declares, "implore God to appear to them as he was when he was a child, as he was when he walked here in time, and as he was on the cross. In other words, they beg God to appear to them in his external shape [so] that they may look at him with external eyes . . . [and] gossip about it and receive comfort from it."[18] But in truth these people are no better than unbelievers, and they are justly deceived by the devil who "appears to the people when and how he wants to: sometimes as a child with curly hair in the consecrated host; at other times, he appears to them as a youth of twelve or as a pious man of thirty."[19] Such devotion is pure folly, for neither Christ nor his Mother has visibly appeared to anyone since they ascended into heaven. As for the Eucharist, if God were to reveal himself in the host as he truly is, "the eyes of the people would break," and everyone in the church would be annihilated by his splendor.[20] Given these extreme views, it is no surprise that *Schwester Katrei* does not mention a single work of art.

# Notes

1. Angela of Foligno and Birgitta of Sweden are not true exceptions, since they dictated in Italian and Swedish to confessors who translated their teachings into Latin.

2. Newman 2005.

3. Marsolais 2001.

4. Hildegard of Bingen 1978: I.1.

5. Hildegard of Bingen 1996: I.1.

6. Gertrude d'Helfta 1968–1986: III.42.

7. Ibid.: II.5.

8. Ibid.: III.30.

9. Finnegan 1991:135–136; Mechthild von Hackeborn 1877.

10. Winston-Allen 2004.

11. Ancelet-Hustache 1930:340 (chap. 4).

12. Ibid.: 396 (chap. 23).

13. Ibid.: 416 (chap. 28).

14. Ibid.: 414 (chap. 27).

15. Simons 2001b.

16. Mechthild of Magdeburg 2003:83 (II.3).

17. Ibid.: 371 (V.23).

18. "Schwester Katrei" 1981:357.

19. Ibid.: 358.

20. Ibid.: 368.

# Patterns of Female Piety in the Later Middle Ages

CAROLINE WALKER BYNUM

Since the nineteenth century, scholars have tended to describe the piety of late medieval religious women as somatic and ecstatic, as characterized, that is, by extravagant self-punishment and bodily mutations as well as by intense union with the divine. A surprising amount of textual material survives not only for and about but also by women, including, for Germany, what many hold to be two new woman-authored genres, so-called sister books (*Schwesterbücher*) and collections of revelations (*Offenbarungen*). In it, we encounter a spirituality whose goal is a pressing of self into God and God into self that both surges beyond the bounds of language and threatens to break out in the adherent's very flesh. Women flagellated themselves, fasted, and wore hair shirts. For some of them, admirers claimed stigmata or miraculous bodily changes such as levitation, fierce stirrings of the heart, and swellings of the womb. Their own stories of their religious communities and the *exempla* and visions they collected for the edification of their sisters stress a close contact with the Christ Child and with the crucified God-man, imaged in very earthy language, both erotic and maternal or familial. The literature that circulated in monastic and beguine communities encouraged meditative techniques in which the narrative of Christ's life or devotional images such as the Pietà (*Vesperbild*) and "Man of Sorrows" (*Schmerzensmann*) were visualized with wracking emotional response. Some of the greatest women writers (for example, Margaret Porete [d. 1310]) wrote of a contemplative union beyond all imagination

or language; others (for example, Catherine of Siena [d. 1380; fig. 7.1] and Julian of Norwich [d. 1416/23]) produced works of theology by probing and glossing encounters that had visionary elements. But it is easy to over-emphasize or misinterpret the somatic and visionary aspects of this piety. So I begin with two examples to make the complexity clear.

## Examples of Female Piety

The first example comes from one of the many sister books or convent chronicles of the fourteenth century, collections of short accounts of women's religious experiences written by women for women. It seems to arise from and express the meditations and quasiliturgical performances with Christ dolls in which nuns engaged during Advent to prepare themselves spiritually for the coming of Christ. The sister book of Töss de-scribes Adelheid von Frauenberg as desiring that her body "be martyred" for the baby Jesus, her kerchief be used for his diaper, her veins woven into a little dress for him, her blood poured out for his bath, her bones burnt to warm him, and "all her flesh be used up for all sinners"; it then adds that she begged for herself one drop of the Virgin's milk. In this multivalent use of mothering imagery, the nun is bearer and minder of the child for whom she dies yet nursing baby to the mother who suckles him; mother-hood is blood sacrifice and reparation for all sinners, as well as comfort, dependency, and union. Much about the date and authorship of the sister book of Töss is disputed, but what is significant here is the reflection of actual meditational practice and the fact that the highly somatic language remains an image of spiritual yearning and has not yet become an explicit vision, as it does later in the text, when Mary appears and "gives her tender breast into [the nun's] mouth."[1]

We can compare Adelheid's complex meditation-cum-vision with a prayer Henry of Nördlingen recommended to his spiritual advisee, the nun Margaret Ebner, at the same period and a somewhat earlier passage on the theme of clothing Christ written by Gertrude the Great of the Saxon monastery of Helfta.[2] Encouraging in Margaret a highly somatic piety and yet missing the homey details of dress and diaper, Henry described the Christ Child as demanding from Margaret "your soul as a cradle, your heart for a pillow, your blood for my bath, your skin for a blanket, and all your limbs as a living offering for all my suffering." Gertrude, feeling

…und vnd sprach vo dem
crucz her ab/zu ir/du aller
liebste tochter katherina
du haust mangen großen
streit durch meinen wille
erliten vnd die haust du

…am vnlauwer
vngezimt getranck/ich
sag dir/dacu daz du dem
natur als gar ober wunde
hast mit dem getranck so
wil ich dir am getranck
geben daz ober treffelich

*Figure 7.1* Catherine drinking blood from the side wound of Christ, colored drawing in *Der geistliche Rosgart* (A spiritual rose garden), a German translation of Raymund of Capua's life of St. Catherine of Siena, transcription by Elisabeth Warüssin, a nun in the Katharinenkloster Augsburg, 1466. (Staatliche Museen zu Berlin, Kupferstichkabinett, inv. MS 78 A 14, f. 28r.)

herself asked by the baby at Candlemas to prepare him for his presentation in the temple, weaves a meditation in which she imitates both child and mother and provides an explicit theological gloss: the baby's garments are the white robe of innocence, the green tunic of grace, and the royal purple mantle of charity. Whatever mutual influence there is among such texts, whatever shaping a male adviser such as Henry or a charismatic monastic leader such as Gertrude provided for ordinary sisters, bodily images are here, first, a way of talking about basic theological concepts such as grace and sacrifice, second, an expression of intense spiritual yearning, and, third,

an articulation of an encounter with Jesus and his mother that seems located in the very flesh of the adherent.

The other example I wish to cite is very different. Anna von Munzingen, author of the Adelhausen nuns' book from the second decade of the fourteenth century, reports that when a sister named Metze Tuschelin prayed to be spared the office of prioress, she heard a voice saying: "Go back to the chapter room and receive obedience. For you shall know that I prefer your obedience. It weighs more before my eyes than Abraham's obedience, for he sacrificed what was outside him while you sacrifice what is inside: that is, your own will."[3] The point is quite explicitly a valuing of inner over outer. Abraham's proposed blood sacrifice of Isaac, usually understood as a foreshadowing of Eucharist and atonement, becomes a kind of practice or work, a mere external observance; the nun's will is, in some sense, her self, and its renunciation is her ultimate service of and surrender to God. We are far from, for example, the vision in which Mechthild of Hackeborn (Gertrude's sister nun at thirteenth-century Helfta) saw Mary offer the blood of the divine heart in a golden pyx as a sacrifice to her Son and understood herself to be, like Mary, an intercessor.[4] Although the theological and devotional message is still presented as a revelation, no sensual language describes Metze's vision; extravagant imagery, whether of family or blood, is displaced. The obedience given priority among the virtues is both old and new. A traditional monastic vow going back to St. Benedict himself, it is at the same time a reworking of Eckhart's radical notion of Gelassenheit (detachment or disengagement from practices and works) into something tamer, intended to curb female enthusiasm.[5] Nonetheless, like Adelheid's yearning to use up her flesh for sinners, Metze's vision is of service. This innermost of sacrifices spills out into the most mundane of chores for others: administration. Hence, as these examples make clear, the piety of monastic women from 1200 to 1500 involves the extravagance of language and behavior often attributed to it, but it is also characterized by inwardness, theological subtlety, and a paradoxical union of community and service with contemplation and renunciation.

## Recent Scholarly Controversy Over Women's Piety

Before I proceed further, a few issues must be cleared away, for during the past two decades a number of scholars have questioned the possibility of discovering the religiosity of medieval women.[6] French feminism,

especially as received by American literary critics, has tended to identify writing itself (especially writing in Latin) as male; hence the female represents margin and silence, and the woman who takes up pen to write steps immediately into a male activity and sensibility. Influenced, sometimes only obliquely and distantly, by this argument, a number of Anglophone medievalists have queried whether, in texts dictated to or copied by male scribes, one can hear the voice of the woman at all. If a work of hagiography, even of autohagiography (a text in which the subject shapes herself to fit a saintly model), is formed according to normative understandings of sanctity and produced as a brief for canonization or a treatise on spiritual formation, how can one hear or see the woman behind the text, or even be confident of intuiting the female readers for whom the model of sanctity was intended? German scholars, in a very different version of this linguistic turn, have engaged in a lengthy argument about whether devotional texts—especially but not exclusively those by and for women—are genres purveying models and topoi or descriptions of actual religious experience.[7]

I have no space to explore these positions here. But it is important to answer such suspicions both by agreeing that it is impossible to distinguish genre and experience (after all, every experience of the past we retrieve—mystical or somatic—is text) and by insisting that there is no reason to hold that all texts by, for, and about women are a kind of ventriloquism of male concepts, concerns, and stereotypes. Despite a deeply rooted conviction of female weakness and inferiority (complexly incorporated in the writing of many women in the concept of a separate female sphere of prayer and mystical encounter complementing male priesthood and authority), the later Middle Ages were a period of female religious creativity.

A number of points must be noted. First, we are not limited to seeing nuns or beguines through models provided by male advisers. As Kate Greenspan has pointed out, it was actually not unusual in the thirteenth and fourteenth centuries for women to write,[8] and since they sometimes wrote in other genres (Herrad of Hohenburg, for example, produced an encyclopedia), their decision to pen convent chronicles or books of revelations (which they produced more frequently than did men) surely expresses choice and sensibility. Women produced important work in Latin, and the decision to write in the vernacular was, as Sara Poor has demonstrated in the case of Mechthild of Magdeburg, not so much a reflection of limited education as a commitment to a female and/or lay audience and to a missionizing goal.[9] Second, the much-discussed *Schreibbefehl* (command

to write) in women's texts, which has been interpreted as eclipsing the woman behind a male adviser or a male God, came from prioresses as well as from confessors and God. It is of course (as it is in male-authored texts) a humility topos and a conventionalized excuse ("someone made me do it") for the audacity of writing. It is also, however, an assertion of authorial voice. To claim that God (or even one's superior) speaks through one can be affirmation as well as abnegation of self.

Third, we should note that recent scholarship (on, for example, Elisabeth of Schönau [d. 1164/65], Beatrice of Nazareth [d. 1268], and Angela of Foligno [d. 1309]) has shown how collaboration between woman and amanuensis shaped the resulting text. We hear a process of question and answer in which the power and creativity goes both ways; in the case of Angela of Foligno, the male scribe's sense of his inferior understanding is palpable. It is not only the male voice that dominates.[10] Moreover, in cases (for example, those of Beatrice and of Catherine of Siena) where we can compare the woman's own writings with the account of confessor or hagiographer, we find important differences. This reassures us that we hear the woman in the woman's text and gives hints as to how to find her in the male-authored depiction. But we find similar differences in cases where we can compare a woman's self-construction with texts in which other female authors construct her. As Simone Roisin (1947) pointed out long ago, those (whether hagiographers, chroniclers, or advisers) who describe the piety of others tend to externalize devotion into miracle and bodily signs; those who describe their own religious development speak of hidden yearnings and consolations. Beatrice of Nazareth's confessor describes as bodily events (storms of emotion, trances, bodily twistings) what she treats as modes of spiritual encounter. We find the same contrast of interior piety and externalization when we compare the portions of Gertrude the Great's *Legatus* written by Gertrude herself with those books penned about her by her equally gifted sister nuns of Helfta. Those who lived with her saw as exterior phenomena (visions, miracles, and somatic events) moments she located within the heart. It is surely true that some of the visionary and corporeal events mentioned in fourteenth-century nuns' books are tropes. "Levitation" may indeed mean spiritual excitement rather than flying twenty feet above the convent floor. And even the few male-authored texts that attribute to men somatizings and ecstasies (such as those of Henry Suso [d. 1366] and Friedrich Sunder of Engelthal [d. 1328]) were probably crafted as models not of behavior but of devotion for the nuns these preachers and

chaplains advised. In other words, the religious behavior we see in texts is of course mediated by texts and constructed by those who created the texts. But nothing in these texts or their circumstances suggests that the numerous women authors who depicted themselves or other women had any less authorial agency, independence, and creativity than the men who sometimes wrote for and about women. The genres and models constructed and propagated by women are evidence of their spirituality, not merely traces of male concepts foisted on them. Indeed, when male authors feminize themselves, even if they do so in order to provide models to women, we may well want to see the influence going the other way.

Fourth, not every reference in texts by men or women to bodily manipulation or ecstatic experience is metaphor or topos. James of Vitry's passing reference to Mary of Oignies cutting off pieces of her flesh convinces us of its reliability exactly because of his concern to gloss it as unacceptable. And we have women-authored reports of similar female self-mutilation. Marguerite of Oingt, for example, wrote of the Carthusian nun Beatrice of Ornacieux: "She evoked the Passion of our Lord so strongly that she pierced her hands with blunt nails until [they] came out at the back of her hand."[11] In a world where pious people, monastic and lay, were encouraged not only to meditate on but also to perform the events of Christ's life and passion, the line between self-induced and other-induced, between inner and outer, tended to disappear. The enormously popular *Meditations on the Life of Christ*, written for a nun, enjoined visualizing the passion until the adherent experienced Christ's pain and loneliness; Ludolph of Saxony [d. 1377] went a step further and urged the pious to slap themselves as Christ was slapped (although not too hard). Philip of Clairvaux reported that the beguine Elisabeth of Spalbeek performed the crucifixion in a kind of pantomime or dance; he also reported that stigmata appeared miraculously in her body.[12] Without claiming that every vision described in a sister book was true or that the love wounds reported in female bodies in the later Middle Ages were (or were not) visible, we must still note that such tales represent a kind of devotion unknown in the early Middle Ages; we must also note that they are usually told of women, not men.

Church authorities as well as male spiritual advisers engaged in a paradoxical dynamic of encouraging and repressing women's spirituality. On the one hand, they fostered extravagant female piety with its bodily disciplines and ecstatic access, in part as an object lesson against dualist and anticlerical heresies. Women's Eucharistic and ascetic enthusiasms were held

up as pious alternatives to what was seen to be Cathar denial of the body. Male advisers repeatedly had recourse to women both for prophetic information they could not achieve directly and as substitutes (through fasting and suffering) for reparation they owed but could not make because of bodily weakness. Yet some preachers and advisers campaigned against women's religious virtuosity by ridiculing it. (Albert the Great called it silly, and Tauler, who encouraged female piety, warned against visions.) They also, in the so-called literature of spiritual discernment, attempted to externalize inner experience into an outer behavior that could then be tested for authenticity.[13] By the early fifteenth century, there were regular calls for the interrogation of religious women, in part because of the role played by visionaries such as Catherine of Siena and Birgitta of Sweden (d. 1373)—not to mention Joan of Arc—in the politics of the Avignonese papacy and the Hundred Years War. Even where their external exuberance was dampened, women's interiority could threaten. The denigrating name "beguine" for those northern European women who lived in quasi-institutionalized religious communities probably originates in the word "to mumble" or pray privately.[14] On the very eve of the Reformation, a visitation to the nuns of Wienhausen legislated against private prayer.[15] Such a dynamic of encouraging and repressing reveals an uneasy sense of women's piety as powerful and valuable, however dangerous.

The most threatening and the most creative manifestations of women's religiosity—political visions, antinomian strivings, or quietist self-abnegation—were, however, far from the piety of the ordinary monastery. The books that circulated there were primarily handbooks for meditation or collections of short spiritual extracts, many of them written by men. Thus we can ascertain not only what extraordinary women wrote but also what ordinary nuns—at least in relatively observant houses—read.[16] We can therefore be confident that we know a good deal about how female monastic piety was modeled and imagined and how it was practiced.

## Christocentric and Eucharistic Emphases

Women's spirituality was fundamentally Christocentric. Visions, liturgy, and prayers focused on the events of Christ's earthly life—in the thirteenth century, especially on the Incarnation and Nativity; in the fourteenth and fifteenth centuries, on the suffering and bloodshed of the Crucifixion (fig. 7.2).

*Figure 7.2* Catherine of Siena flagellating herself, colored drawing in *Der geistliche Rosgart* (A spiritual rose garden), a German translation of Raymund of Capua's life of St. Catherine of Siena, Upper Rhine or Alsace, first half of the fifteenth century. (Bibliothèque nationale de France, Paris, Ms. all. 34, f. 4v.)

Utilizing and heightening themes found in Cistercian, Carthusian, Franciscan, and Dominican (male) piety, women prayed to be incorporated into Christ's body through the side wound or to take him into their own breasts or wombs and expressed such yearning in corporeal, often erotic, images of sexual union, pregnancy, or suckling. As Rosemary Hale has demonstrated, identification with Mary was also important, not as a literal role model but as a paradoxical image of spiritual fecundity achieved by the pure (virgin) soul given over to obedience, intercession, and love. Indeed, in their anxious desire for closeness to the Christ child, some nuns expressed competition with Mary for the baby or brushed her aside as an interfering mother-in-law.[17] Thirteenth-century visions and prayers are filled with light and comfort; the wounds of Christ glow, and the fluid running from his side is honey, not blood. Even in the darker fourteenth- and fifteenth-century piety, where nuns pray repeatedly for suffering or conflate illness with Christ's crucifixion, the pain is frequently asserted to be sweetness as well, and Christ is seen to reach down from the cross to embrace the sinner. As the popular fourteenth-century Middle English text *A Talkyng of the Love of God* explained:

> When in my soul with a perfect intention I see You so piteously hanging on the cross, Your body all covered with blood, Your limbs wrenched asunder . . . then I readily feel a marvelous taste of your precious love . . . which so fills my heart that it makes me think of all worldly woe sweet like honey, wheresoever I go. . . . Where is there any bliss, compared with the taste of Your love at Your own coming, when Your own mother, so fair of face, offers me Your own body on the cross. . . . Then the love begins to well up in my heart. . . . I leap at Him swiftly as a greyhound at a hart, quite beside myself, in loving manner and fold in my arms the cross. . . . I suck the blood from his feet. . . . I embrace and I kiss, as if I was mad. I roll and suck I do not know how long. And when I am sated, I want yet more. Then I feel that blood in my imagination as it were bodily warm on my lips and the flesh on his feet in front and behind so soft and so sweet to kiss.[18]

Small wonder that nuns, beguines, and recluses, raised on such devotion, saw the guilt and the forgiveness of their sins as pouring blood and visualized the love they owed in return as bathing and feeding Mary's baby or taking him down from the cross into their arms (fig. 7.3).

Women's focus on Christ's body is seen especially in the central place they gave to the Eucharist (fig. 7.4). The most common vision in fourteenth-century nuns' books was of the Christ Child in the host, a vision

*Figure 7.3* A Dominican nun embracing the blood-covered Christ in her arms, miniature from the cover of a book of hours from the convent of St. Margaret and Agnes in Strasbourg, second half of the fifteenth century. (Bibliothèque du Grand Séminaire, Strasbourg [France], ms. 755, f. 1r.)

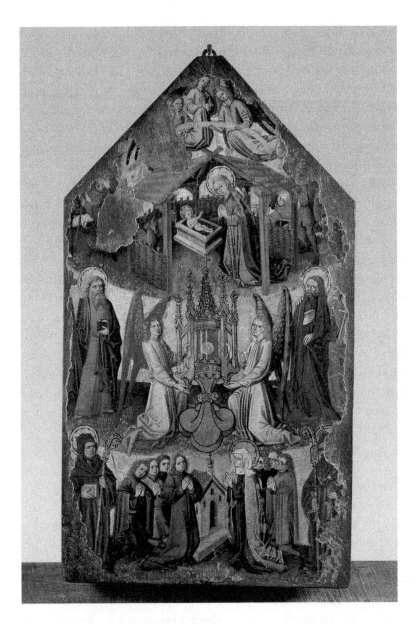

*Figure 7.4* Adoration of the host in a monstrance, panel painting from the former Cistercian nunnery of Wienhausen, ca. 1450–1460, oak, h. 87.5, w. 50.5 cm. (Kloster Wienhausen [Lower Saxony], inv. WIEN Cb 4.)

in which women sometimes bypassed or even claimed for themselves a sort of clerical authority. By the fifteenth century, at least in the north of Germany, women's houses were especially apt to claim blood relics (bits of Christ's blood supposedly left behind on Calvary) or miraculous hosts (consecrated wafers that bled to demonstrate the presence of Christ) and to foster pilgrimages to them. The one sin Margaret Ebner could not encompass in the empathy she usually felt for even egregious sinners was that of a woman who sought to sell a host to the Jews.[19]

Eucharistic piety expressed a deep sense of contact with the divine through the physical stuff of creation. But we must not forget that the human person was, in the later Middle Ages, understood to be a psychosomatic unity (soul and mind as well as flesh). For all the equation of female with flesh and Mary with the container and provider of Christ's body—an equation that facilitated women's sense of identification with and access to the body of Christ—women were also associated with spirit. The late medieval understanding of the female body as open and exuding led to a sense that women were especially prone to invasion by spirit (divine as well as demonic). Psychological theories of the senses as mediating between *corpus* and *anima* tended to undercut a sharp distinction of body from soul.[20] Women's sense of identification with Christ's humanity involved incorporation as much into his feelings of abandonment as into his fleshly wounds.

## Trinitarian and Soteriological Emphases

Women's devotion to Christ's humanity and to the Eucharist has been much studied in recent years. Two themes of equal importance have, however, been less discussed: the commitment to service (especially of souls in purgatory) and the deeply Trinitarian nature of women's theology and devotion. Despite the highly individualistic nature of much late medieval piety, focused increasingly on the believer's personal, inner encounter with God, the twin commitments of the eleventh- and twelfth-century reform movement—to withdrawal from yet conversion of the world—continued in women's piety. Beguines served the sick and poor in towns. Visionary nuns and recluses provided prophecies for the powerful of church and court and were sometimes known as mothers to the men they advised (an appellation to which Jean Gerson strenuously objected).[21] Nuns served

their sisters in kitchen and choir. Of the more than three hundred women mentioned in the sister books, a third held office for the community; visions of Christ among the cabbages and chamber pots were often granted as reward to those who, in obedience, left the liturgy for mundane tasks.[22] The illness from which so many holy women suffered was conceptualized as an alternative to officeholding and rendered not only for the nun herself but also as a substitute for the expiatory pains owed by others in purgatory. Reflecting the late medieval enthusiasm for quantification, nuns' intercessions were understood to release specific numbers of souls from purgatorial suffering. Adelheid Langmann and Christina Ebner of Engelthal were supposedly allowed to release, respectively, thirty thousand and a million souls.

The concern of religious women with death and purgatory sometimes expanded into a universalism of great theological sophistication.[23] Late medieval soteriology, especially as elaborated by female theologians, went beyond the substitution theory of Anselm or the exemplarism of Abelard: Christ's sacrifice on the cross was not only a substitute for the unpayable penalty owed by humankind or an example of love. It was also, as Julian of Norwich argued, the lifting of a representative human being—one who incorporated all humankind—into the presence of God. Hence religious women, who spent much time in prayer for others, often found it difficult to believe that a merciful Father would damn anyone. Scholars have noticed this universalism (and the danger of heresy charges it could entail) in exceptional figures such as Julian or Hadewijch, but we find strong hints of it among cloistered nuns as well. Gertrude and her sister nuns, for example, displayed again and again a powerful sense that all unite in Christ's suffering, which he took on in order to become merciful and to frighten vice and punishment away from all humanity.[24]

Such striving toward universalism was sometimes expressed in images of enclosure, that is, of all humankind gathered under the mantle or in the womb of Mary or caught up into the heart or entrails of Christ. These images of safety found in God, which clearly reflect devotional objects such as the "Opening Virgin" (*Schreinmadonna*), the "Madonna of Mercy" (*Schutzmantelmadonna*), or the "Throne of Mercy" (*Gnadenstuhl*, fig. 7.5) popular in convents, sometimes had Trinitarian overtones. The "Opening Virgin," for example, often contained the Trinity. (It was eventually condemned for exactly this aspect.) A strong sense of the circulation of love among the persons of the Trinity figures much more centrally in the

*Figure 7.5* "Throne of Mercy" reliquary from the former Cistercian nunnery of Holy Cross in Rostock, late thirteenth century. (Kunstsammlungen, Staatliches Museum Schwerin [Mecklenburg Vorpommern], inv. Pl. 34.)

spirituality of religious women such as Angela of Foligno, Catherine of Siena, and Julian of Norwich than scholars have realized. The Trinity is a major theme in the nuns' books as well. In the revelations of Adelheid Langmann, for example, where the encounters with God are primarily Trinitarian, Adelheid sees a soul for whom she has prayed receive communion from Mary in the form of three breads for the three persons of the Trinity.[25]

## Gendered Imagery

There is a final aspect of women's piety to which much attention has recently been devoted: the gendering of its imagery. As scholars have increasingly recognized, the metaphors of late medieval spirituality were wonderfully creative and fluid. All three persons of the Trinity were imaged as both feminine and masculine: the devout of both sexes could imagine themselves as brides to Christ the bridegroom, child to God the mother, troubadour seeking a Jesus who was Lady Wisdom or Lady Love. Cloistered women for the most part used female or infant images (bride, mother, child) for the self (especially when writing for other women). Their understandings of the social roles implicit in gender could be remarkably flexible, however. Gertrude the Great, quite unselfconsciously, used "father" as an image of feeding, "mother" as an image of harshness and discipline. Noting this richness and polyvalence of description should warn us once again against any simplistic assumption that the undoubtedly misogynist stereotypes of women as garrulous, oversexed, morally irresponsible, and weak of intellect—stereotypes that circulated both in learned theology and in folk wisdom—were incorporated directly into the self-understanding of nuns.

## Conclusion: Piety as Paradox

Much in late medieval piety seems horrible and voyeuristic to modern taste, and nuns themselves did not fail to see and even chafe against the horror. When Christina Ebner of Engelthal saw a vision of Christ as he hung on the cross, she was terrified. The nun who recorded some of Gertrude's visions commented that blood is "in itself a detestable thing" and

wondered that it became glorious when shed by or for Christ.[26] But religious women also had confidence that their own lives of suffering and service were caught up with all creation into God's love for them and their love for God. Faced with the narrative of an earthly life that led to Good Friday before Easter Sunday, they struggled to incorporate both Crucifixion and Resurrection into their inner and outer selves, sometimes acting out the events in liturgy and meditation, sometimes displaying in their bodies the wounds and risen glory of the Lord, sometimes preferring invisible, interior encounter to any outer work or discipline.

Like all religions, Christianity is deeply paradoxical, because it must give significance to both life and death. Paradox is not, by definition, solvable; it can only be asserted, experienced, lived. Christian devotion is especially inflected with paradox, because it places at the very center the shocking, oxymoronic enfleshing of the divine. It is this coincidence of opposites that late medieval women sought to convey and live. In a final example, we hear a female author struggling to speak the unspeakable, piling paradox on paradox in an evocation of heaven that imagines it as a moment of Eucharistic communion in which humans are souls and God is body. The author of the Oetenbach nuns' book described Ita of Hohenfels thus:

> She saw how the blood and flesh of Jesus Christ was united with the saints and with the souls. Thus through each soul, God's blood and flesh shone with special radiance as well as her saintly life, as it had been on earth (with suffering and special purity or whatever virtue she had especially practiced); all this was shining especially, radiant through our Lord's blood and flesh. And this union that she saw was so great and blissful, how the blood and flesh of Jesus Christ surged into the souls and how the souls again surged into his flesh and blood, just as if they were one.[27]

Although modern scholars have described this period of women's history as "the silences of the Middle Ages," women's piety, like women's art, seems not silenced and eclipsed but resonant and visible as it had never been before.[28] The texts and images women produced emphasize not void and darkness but access through the stuff of creation (the bodies of adherents, the wood and pigment of panel paintings, the smells and sounds of the liturgy) to an incarnate God they encountered and loved. Despite the repression they sometimes suffered and the diffidence they frequently dis-

played, women continued to assert, characterize, and explore that encounter. As the awkward language of the Oetenbach sisterbook clearly shows, the beloved, addressed best in glorious paradox, was always more than they could articulate or depict. But it seems characteristic of their spirituality that the beloved was *more than* not *other than* their words and images. Body, text, and image were not hindrances to but means of attaining a God who was incarnate and divine, present yet beyond.

## Notes

1. Rublack 1996:26–27; G. Lewis 1996:21–25, 112.

2. Margot Schmidt and Leonard P. Hindsley, introduction to Ebner 1896/1993:54; Gertrude d'Helfta 1968–1986:2:296.

3. G. Lewis 1996:249; Garber 2003:90, 206.

4. Mechthild von Hackeborn 1877: chap. 1.12–13, 37–45.

5. Williams-Krapp 1990:65.

6. For examples, see Petroff 1994 and Chance 1996.

7. For the respective positions, see, for example, Peters 1988 and Dinzelbacher 1988. See also Köbele 1993:21–26.

8. Greenspan 1996:216–236.

9. Poor 2001.

10. Mooney 1999; Wiberg Pedersen 1999; Coakley 2004.

11. James of Vitry 1867:551–552; Margaret of Oingt 1990:49.

12. Bynum 1987:256; Simons 2001b:130; Caciola 2003:114–115.

13. Grundmann 1961:414; Bynum 1987:84–87, 241–243; Caciola 2003:114–115; Elliott 2004.

14. Simons 2001b:121–123.

15. Mecham 2003:126.

16. Ninety percent of extant German religious manuscripts come from the 10 percent of houses that were reformed (Schiewer 1998:78).

17. Hale 1990; Elkins 1997; Clark 2000.

18. *A Talkyng* 1950:61; see also xxxi. The passage comes from the third part, *The Wohunge*, written for a nun (or possibly a recluse), although adapted in *A Talkyng* for a male reader.

19. Ebner 1896/1993:148–149.

20. Bynum 2004b:588–594; McGinn 1977; Newman 1998b. For the way in which theories of vision as intromission and extramission tended to undercut a sharp body-soul division, see Biernoff 2002:133–164.

21. Jean Gerson, *De examinatione doctrinarum*, in Gerson 1987:1: col. 14.

22. Garber 2003:61–104, esp. 65 and 94.

23. McNamara 1991:199–221; Newman 1995; Sweetman 1997:606–628; Watson 1997; Bynum 2004a.

24. Gertrude d'Helfta 1968–1986: chap. 3.17–18, 3:72–74, 80–104.

25. Watson 2003; Tomkinson 2004; Garber 2003:147.

26. Hindsley 1998:159–160; Gertrude d'Helfta 1968–1986: chap. 3.17, 30, 3:72–74, 142.

27. G. Lewis 1996:175.

28. Klapisch-Zuber 1992.

# Time and Space

## *Liturgy and Rite in Female Monasteries of the Middle Ages*

### GISELA MUSCHIOL

If one examines everyday life in monasteries and *Stifte* of the Middle Ages, whether for men or for women, it becomes apparent that nearly all aspects of this life were informed by the liturgy, that is, by church services, the sacraments, and other ritual actions. The various forms of liturgical activity, whether performance of the Divine Office, the Mass, devotions, sacramental rites, or even private prayer, govern in specific ways the scheduling and spaces of monastic life; they establish the conditions of communal coexistence and have an impact on material demands.

In the history of female monastic communities, even financial conduct, attempts at discipline, the acquisition of education, and efforts at reform were repeatedly justified in terms of liturgical necessity. In this sense, liturgy involves far more than simply the prayer of the hours or the celebration of the Eucharist, baptism or masses for the dead. Also informed by the liturgy are such rites and acts as coronations, homage, meals, and even the handing-over of a set of keys. Not least, the majority of the works of art made and used in female monastic communities—liturgical books, vestments for the celebration of Mass, altar hangings, liturgical implements, and much more—were required because of the liturgy. The following discussion is intended to serve as an introduction to the workings and functions of the liturgy—understood in this all-encompassing fashion—in female monasteries.

In this context, it should be mentioned that there is not a long tradition of research on the liturgy in female monastic houses. Quite the contrary,

scholarship on monasticism has traditionally held female monasteries to be irrelevant in terms of liturgical history.[1] Only in the last few years have scholars investigated the liturgy and cult practices of female communities with greater intensity.

## Forms of the Liturgy

In light of modern prejudices, even the historical literature has sometimes limited its concept of the liturgy to the celebration of Mass. Such a limitation, however, is by no means justified, whether from a historical or theological perspective or with a view to describing female monasteries. Especially for women's houses, the daily celebration of the Divine Office was of greater importance than the Mass, which was at times celebrated once a week or even less frequently.[2] The prayer of the hours, which derived from the communal prayers in honor of God as performed in the Jewish and early Christian traditions, had already occupied the major part of daily prayers in the early Gallican rules for female monasteries.[3] In the rule of St. Benedict and the Institutio sanctimonialium, that is, in the two rules that very probably provided the basis for the norms followed in all female monastic communities,[4] the Divine Office also stands at the center of everyday liturgical life, albeit with different degrees of intensity.[5] In concrete terms, according to the Benedictine rule, this means that the community of women assembles seven times a day for the major and minor hours in the spaces reserved for the divine services in order to speak and sing an established sequence of psalms and hymns, to hear a reading from the Bible, to which they respond with certain prayers, and finally to be dismissed with a blessing, usually given by the abbess. The prayer of the hours originated as prayer performed by the laity, a feature that did not disappear in female monasteries. The director of prayer was the abbess or the prioress, whichever was the leader of the community. This was as true for the Gallican monasteries of the early Middle Ages as it was for the aristocratic *Frauenstifte* of the late Middle Ages.[6]

The celebration of the Mass was conducted in very different circumstances. The Benedictine rule, which was adapted for use in female monasteries in the Carolingian period, mentions Sunday Mass only a single time and then only in passing. According to this rule, whoever, after Sunday Mass, reads the weekly lesson at meals on a rotating basis is required to

ask for the blessing for herself.[7] Apart from this passage, the celebration of Mass is not considered to be worth another mention, whereas disposition of the prayer of the hours is described in great detail over many chapters.

For the women in the monastery of Caesaria in Arles, however, from which survives the earliest rule written specifically for women, there is already an indication that occasionally (*aliquotiens*) a Mass should be performed in the monastery.[8] Whether this stipulation indicates a regular Mass on Sundays is questionable. Instead, sources do refer to the celebration of communion without a priest in nuns' convents of the High Middle Ages.[9] This practice, however, did not represent a normal state of affairs, as clergy are known to have served most female monastic communities from the ninth and tenth centuries onward.

In the High and late Middle Ages, the frequency with which Mass was celebrated in female communities changed and, along with it, the spiritual access of individual nuns to their faith (fig. 8.1). In the late Middle Ages, it was especially through religious women that the celebration of the Eucharist and its meaning gained a different interpretation; the Eucharist and food were seen as standing in a new relation to one another, and fasting acquired a new meaning that culminated in the liturgy.[10]

In the same period of the High and late Middle Ages, devotional practices focused on certain themes took on added importance, both in female monasteries and in the world outside. These included devotions to the Passion of Christ and to Mary, who as the mother of Jesus acquired a position of special importance in female communities.[11] Christologically oriented devotions to the Holy Cross, eucharistic piety, and devotions to saints that varied from region to region also formed part of the liturgical program of convents.

The distance from communally celebrated devotions to special forms of personal piety was not great. Although by definition private prayer does not form part of the liturgy, the latter requiring the participation of a group of people, almost all private prayer took the liturgy as its point of departure and was influenced by it. The degree to which female communities in particular developed their own liturgical forms of prayer that impinged on the design of works of art can, for example, be demonstrated in images and other objects and their use in Dominican convents.[12] The graceful cradles for the Christ Child that were used in church at Christmas initiated forms of prayer in the cells focusing on Jesus as an infant.

*Figure 8.1* Procession with nuns and clerics, prefatory miniature to *La Sainte Abbaye*, Maubuisson (?) (France), before 1294. (The British Library London, Add. ms. 39843, f. 6v.)

One of the fundamental obligations of women in convents was intercessionary prayer for the founders and benefactors, as well as for living and deceased members of the family.[13] Such prayer determined the identity of the community and lent it legitimacy. Already, since Gregory the Great, the prayer of women was considered more effective than that of men. The prayer of virgins was believed by some theologians to be especially effective given that, in their view, its purity allowed for greater proximity to God.

This attitude, however, changed in the wake of the formation of Carolingian prayer associations, which no longer regarded prayer as the only act of intercession but compared the celebration of Mass with the reading of the psalms according to a strict exchange rate. For example, the shorter duration of a Mass compared with the length of a complete prayed or sung psalter—that is, all 150 psalms—increasingly led to the prayer of psalms being replaced as a memorial offering by the Mass.

In this regard, female convents lagged behind male monasteries, since they had to employ and support priests for the celebration of Mass, while in male communities the monks themselves could simply be ordained. Although this development distanced male monasteries from the ideal enshrined in the rule of St. Benedict, which regarded the monastery mostly as a lay community and allowed priests to join only exceptionally, it served demands for individual and collective memoria. Yet female monasteries were not excluded from memorial confraternities, and the memorial books of male monasteries continue to show affiliations with female communities. Given, however, that memorial services provided a source of income, women's communities were definitely at an economic disadvantage.

## Liturgical Times

As already demonstrated, quotidian life in monasteries and *Stiften* was organized according to the prayers of the hours. In the same manner, the liturgy structured the seasons. The liturgical calendar of holidays specified periods of fasting twice a year: before the high holidays of Christmas and Easter. The fast before Easter began six weeks before the feast. The pre-Christmas fast took the Lenten fast as its model and traditionally began on November 11, the feast day of St. Martin. In a period of fasting, not only did the menu change, so did the liturgy. For example, one abstained

from singing the Alleluia in the Divine Office. Like periods of fasting, the feast days of certain saints and martyrs affected the duration and intensity of the daily liturgy. The feast day of the convent's male or female patron or the memorial days of certain saints of the order or the diocese entailed additional recitations of psalms as well as more extensive celebratory readings. Furthermore, important feasts such as Christmas, Epiphany, Easter, and Pentecost were distinguished by longer nightly vigils with twice the number of psalm prayers and additional readings.

No less than the course of the year, the life of the nun in the convent was determined by liturgical rites. Above all, the initiatory rite of profession marked the beginning of monastic existence. Over the centuries there developed a sequence of rituals, such as the cutting of hair, the changing of clothing, the presentation of a ring as a sign of the marriage with Christ, the supplication at the altar, the *Altarsetzung* (the placing of a virgin who is entering the monastery on the altar), and the ordination of virgins. These individual rites were framed by psalms and prayers, accompanied by incense, candles, and singing, and celebrated differently in various convents. Acceptance into a convent did not always follow the terms and formalities of profession as stipulated by the rule of St. Benedict. In the early Middle Ages, the changing of clothes constituted the accepted sign of entry in the convent. According to the Institutio sanctimonialium, which in this respect reflects the rule of St. Benedict, a repeated reading of the text of the Institutio was a requirement.[14] Later centuries made the presentation of the veil the sign of admission, which also took on the form of a liturgical ritual. The sacramentary of the women's abbey of Santa Giulia in Brescia (Bibliotheca Civica Queriniana, Brescia, Cod. G VI. 7) documents the complete rite of the consecration of a virgin. It began with the candidate giving her new clothes to the bishop, who spoke blessings over them and handed them back to the woman except for the veil. In the sacristy, the candidate put on her new garments and returned to the altar carrying two lit candles. Here she was greeted by her sisters with a special antiphon. After that, the Mass of the consecration of virgins began, which contained special prayers for the variable parts of the Mass. After the reading of the Gospel, there followed the central act of consecration by the bishop with two special prayers and the presentation of the veil. This ritual of consecration includes no mention of a laying-on of hands. The end of the Mass is marked by the presentation of the newly consecrated nun into the hands of the abbess by the bishop, who reminds her at the same time of her re-

sponsibility for the soul of the consecrated virgin.[15] Quite frequently, such a consecration of a virgin provided the occasion for a commemorative donation, especially when the young girl had been given by her parents as an oblate *(puella oblatae)* to a convent. In Brescia, a separate memorial list was introduced on the occasion of the oblation of Gisla, the daughter of Emperor Lothar.[16]

In addition to the presentation of the veil, from the tenth century until the late Middle Ages, many monasteries included as part of the consecration of virgins a coronation ceremony. After taking her vows and receiving the veil, the aspiring nun was crowned by the bishop with a small fabric crown, which might be decorated with gold thread and red crosses. The crown was interpreted as a bridal wreath on the occasion of her symbolic marriage with Christ as well as a crown of thorns. In sixteenth-century Lower Saxony, some convents preserved this custom through the age of reformation, despite strong opposition from Protestants.[17]

The end of a nun's life within a convent was shaped by the liturgy no less than its beginning. Given that nuns were not supposed ever to leave the monastery, the end of convent life came only with death, which was understood as birth into eternity. The Institutio does not allow for the discharge of a religious woman, even if in this respect the practice of later centuries of the Middle Ages differed.[18]

From a nun's perspective, the liturgy for the dying and the dead would have been a source of comfort given that this passage was presumed to constitute the most dangerous part of the consecrated life. It was during death and the prayers that accompanied it that—or so it was believed—it was finally decided if the merits of each nun's life would be accepted in the Last Judgment. Not without reason, the sacramentary of Brescia contains a wide-ranging series of prayers for the dead and dying. The series opens with a formula for a Mass to be said for a sick woman close to death. There follows a total of eight prayers for the different stations of the ritual farewell: a prayer for the forgiveness of sins *(reconciliatio animae,* the reconciliation of the soul) in the face of death, a prayer over the body of the deceased complete with the *commendatio animae* (commendation of the soul), and then others to be said during the washing of the body, for the laying-out in church, for the funeral, at the grave, after the interment, and finally another prayer with the *commendatio animae* for the presentation of the soul to God.[19] Moreover, the sacramentary and memorial book of Brescia also contains a funeral Mass that stems not from the Roman but

from the Gallican liturgical tradition. All these various rites emphasize the extent to which ritual framing was meant to provide security in a situation experienced as endangering. Masses for the deceased celebrated at fixed intervals on the third, seventh, and thirtieth day after the death belong to this same liturgical context, as does the annual memorial that had to be celebrated for deceased virgins of the convent as part of the commemorative obligations.[20]

## Spaces for Liturgy

The church of the monastery or of the *Stift* obviously provided the most distinguished place for celebrating the liturgy communally. Yet it was by no means the only place for liturgical celebrations, and neither was it accessible in its entirety to the community. There were additional oratories in the convent buildings, where a part of the hours was celebrated. Occasionally, distinctions would be drawn between either summer and winter oratories or between public and private places for the liturgy of the Divine Office. Already at Arles, a separation of public and private oratories was known; the rule of Aurelian specified that matins, lucernarium (what later became vespers), duodecima, vigils, and nocturns should be observed in the basilica, whereas secunda, terce, sext, and none should always be held in the inner oratory. In winter, vigils and nocturns were also moved to this inside oratory, presumably on account of the temperature. In the convent of Caesaria, too, there existed public and nonpublic prayer spaces. According to the convent's rule, some prayers were even supposed to be said in the basilica in order to allow the participation of the public.[21] Chapels on the convent grounds or in proximity to the convent could also be accessed for special prayers, for example, in honor of special saints. The *Liber ordinarius* for the community in Essen (Domschatz Essen, Hs. 19) recognizes such special chapels for select divine services.[22] From the High Middle Ages onward, in addition to the church, the chapter house also served as a space for liturgical celebrations, because it was the place for the liturgical commemoration of the deceased male and female benefactors and founders who were interred there. The chronicles of double monasteries of the Hirsau observance, for example, Zwiefalten and Petershausen, document lay burials in the chapter house or in front of the altar of chapels belonging to the monastery.[23]

The nuns' gallery, a typical feature of convent churches, whether monastery or *Frauenstift*, manifests the public's relationship to enclosure within the context of the liturgy. Already in chapter 27 of the Institutio, we find the stipulation that virgins celebrate their Divine Office behind a curtain, separated from priests and any possible congregation. The gallery provided an ideal way to satisfy the requirements of ecclesiastical legislation, prompted primarily by notions of cult purity and impurity regarding the exclusion of women from the area around the altar, while simultaneously permitting various forms of visual and auditive participation in the divine service.[24] During the High and late Middle Ages, however, the possibility of such participation was limited once again. In Cistercian convents and the female mendicant orders but also in the female communities of the Hirsau congregation, the space around the altar was separated by walls from the liturgical space reserved for the nuns, windows with grates permitting no more than auditory participation in the Mass.[25] Evidence of liturgical separation is especially clear at double monasteries such as Admont. It is worth noting, however, that the obligation for such separation applied only to the Mass, the liturgical celebration that was impossible without male assistance. Enclosed women also moved the celebration of the Divine Office to the gallery, though the process by which this development took place has not yet been investigated. Also awaiting further investigation is the entire question of the roles and functions of altars in the galleries.[26]

All in all, rules for enclosure had a broad influence on the liturgy, extending far beyond the space of the church per se. The often expressed requirement to keep convent churches simple and unadorned with images, textiles, or works of art necessitated liturgical asceticism or, even more, enclosure for the eyes. As the historical record demonstrates, however, such prohibitions of church decoration were contravened extensively. This very fact indicates that the practice of enclosure for the most part did not correspond with its theoretical elaboration and that practical necessity often transcended the strictness of regulations. Above all, the normative pronouncements of sources about the strictness of enclosure must be regarded with due skepticism.

Last but not least, processions constituted a spatial component of the liturgy and were included in the seasonal course of liturgical celebrations. The early Gallican rules for female communities as well as the late medieval *Libri ordinarii* from Essen and St. Ursula in Cologne recognize manifold forms and

numerous reasons for processions within the cloister, inside the church, and to destinations outside the convent such as chapels and other churches.[27]

## Conditions for the Liturgy

The changing role and significance of enclosure were paramount among the conditions for the celebration of the liturgy in women's convents and *Frauenstifte*. Certain liturgical dimensions of enclosure have already been discussed. Of fundamental importance, however, is that the topos of strict enclosure in female communities should be considered very critically in the context of general social conditions in the Middle Ages. Enclosure was hardly limited to convent communities: city gates were closed at night, so that even entire urban communities were subject to nightly enclosure. A broader gender perspective demonstrates that all women, whether religious or lay, were subject to limitations on their mobility, especially with respect to their public actions. Thus, in some respects, the investigation of enclosure as a norm and form of living stands only at its beginning, and its consequences for the liturgy cannot be determined conclusively.

Despite these desiderata for further research, there are indications that everyday life in the convent affected the liturgical treatment of enclosure. For example, during the early Middle Ages, liturgical rites governed the presentation of keys in female Gallican communities. Female conventual officers, such as the keeper of the food cellar, the keeper of the wine cellar, the gatekeeper, the librarian, and other office sisters received the keys to their store- or workrooms over the gospel book.[28] It cannot be documented if such prominent ritual use of keys was preserved over the centuries.

Without doubt, a significant condition of the liturgy in female communities lay in the relationship of the women to the priests and deacons who were attached to the convent or commissioned to conduct its services.[29] This relationship changed in the course of the Middle Ages. In early Gallia, clerics were allowed to enter the rooms of the women only by way of exception for certain liturgical celebrations and had to leave immediately thereafter. In contrast, the sacramentary from Brescia demonstrates that a regular pool of clerics had to belong to a convent for the celebration of the convent Mass and the fulfillment of the eucharist memorial obligations as well as for parts of the liturgy of the dead. According to the same

sacramentary, the consecration of virgins even necessitated the presence of a bishop. Smaller communities of clerics can be confirmed for churches of *Frauenstifte* in the German Empire. The relationship between the nuns' convent and the group of clerics was not always free from tensions and occasionally had to be regulated by written contracts. As far as the liturgy was concerned, it certainly led to the gender-related dependency of the enclosed women on clerics. These forms of dependency could extend beyond the liturgical realm, yet many abbesses from the high aristocracy defended their interests with self-confidence.

Finally, the role of education in convents should also be discussed in the context of the conditions imposed by the liturgy. One could not celebrate the liturgy without a modicum of education. At the very least, reading was required for the recitation of the psalms as well as for the lessons from the Bible, which changed regularly. Even if after a relatively short time a large part of the psalms could be recited from memory rather than read from a book, one of the main tasks of religious women consisted of learning how to read enough to meet the requirements of the liturgy. This skill had to be acquired at the latest in the convent, if not beforehand. The virgins in the convent of Caesaria in Arles were even supposed to know some readings from the Bible by heart.[30] The quest for literacy was also one of the reasons that young girls were accepted in the communities: they could still easily learn how to read. To justify these efforts at education, the Institutio quotes from a letter by Jerome to Laeta in which he designs a teaching program for girls: not only should the lessons in psalms and hymns make them into little fighters for Christ, the liturgy of the hours required that they know the books of the Old and New Testament.[31]

Reading alone did not constitute a sufficient condition for living in a convent. The ability to write was a further desideratum because numerous books had to be produced to meet the diverse requirements of the liturgy. Furthermore, in addition to writing, the arts of drawing and painting were welcome. The liturgical books from convents, like those of male monasteries, contain miniatures, initials, or full-page images. Without literacy, liturgy could not be celebrated.

Certain changes of daily life brought about by the liturgy should also not go without mention. Many sources document prayers and blessings before and after the communal meals. Gregory the Great recommended the blessing of spoons in order to expel demons, who especially like to sit there.[32] For the women's daily gathering in the chapter house, there exists a

special prayer to be said by the abbess on behalf of those who have to leave the convent, both before their departure and following their return.[33]

## The Culture of Liturgical Objects

Indispensable for any liturgical activity were the books with texts of the Holy Scripture for reading in divine services, codices containing lessons from the church fathers for nocturnal prayers, and hagiographical collections of lives for the memorial days of saints who were registered in the calendar of feast days of the convent or the *Frauenstift*. Sacramentaries and breviaries were needed for the women's use, and memorial books and lists also had to be maintained on a regular basis. All these books testify to liturgical literacy, and many of them were created by nuns in convents. Recent research has demonstrated that because of liturgical requirements women's communities could well be centers for the production of books (fig. 8.2).[34] In addition to books, liturgical vestments were also created in convents, textile work being generally regarded as *opus feminile*.[35] The fine embroideries in imitation of gold ornaments belonging to the Merovingian queen Balthildis (see fig. 9.1) are famous, as are the antependia and figural tapestries from convents in Lower Saxony of the late fifteenth century (fig. 2.15).[36] Women's communities usually commissioned other religious objects required for liturgical celebration. These included liturgical vessels such as chalices and patens for the Mass or images and statues to adorn church space. If we view the decoration of the nuns' gallery in Wienhausen, which, in all probability, was commissioned by the nuns from a workshop in Braunschweig, it becomes clear that shaping the liturgy was a phenomenon that transcended the confines of a convent. Rather, communication about the decorative program's theological and liturgical dimensions took place in a dialogue with the nuns' environment.[37]

In conclusion, the spectrum of possibilities regarding the significance of the liturgy in medieval convents is very broad. At one end, it revolves around the idea that the Divine Office, if celebrated by virgins, had greater efficacy or value. At the other end, it involved their banishment from the area around the altar on account of their supposed cult-related impurity. In all areas, however, it involved liturgical books created by women and liturgical vessels commissioned from elsewhere. Moreover, the liturgical

*Figure 8.2* Ornamental page in the *Sacramentarium Gelasianum* from the abbey of Chelles, ca. 750. (Biblioteca Vaticana, Vatican City, Reg. lat. 316, f. 132r.)

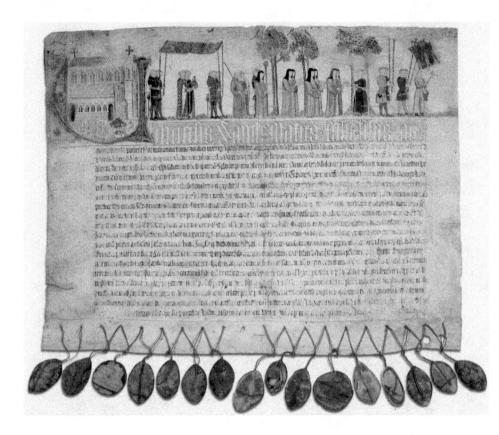

*Figure 8.3* Nuns in a Corpus Christi procession, miniature on a letter of indulgence from the Cistercian monastery of Herkenrode, 1363. (Provinciaal Museum voor religieuze Kunst, Sint-Triuden [Belgium].)

development of the entire church did not bypass the female communities. Quite the contrary: in the context of the Carolingian renaissance, efforts to reform liturgical books can be documented in female scriptoria as well as in writing centers of male monasteries. In the course of the High Middle Ages, the introduction of the feast of Corpus Christi was prompted by the efforts of the nun Juliana of Liège (fig. 8.3). Easter plays, from which the tradition of spiritual drama developed, were especially common in convents. For example, they are documented at Nottuln in Westphalia and indirectly at St. Ursula in Cologne.[38]

The liturgy was a constitutive component of monastic communities. It provided the reason for their foundation and for regular donations. When-

ever the liturgy was no longer celebrated with the desired discipline, either the significance of the convent in question decreased or reform efforts resulted in a renewal of liturgical life following the reimposition of discipline. The practice of this liturgy had different features in male and female monasteries. With respect to the social significance of their liturgies, however, male and female communities of the Middle Ages differed only marginally.

## Notes

1. For fundamental studies, see Berger 1999; Muschiol 1994.

2. See Muschiol 1994:193–195.

3. Ibid.: 106–120.

4. Schilp 1998:12–18.

5. Salzburger Äbtekonferenz 1992:116–137 (chaps. 8–20); "Institutio sanctimonialium" 1906/1979:446, 448–450 (chaps. 10, 14–18).

6. See Muschiol 1994:104–106; Arens 1908.

7. See Salzburger Äbtekonferenz 1992:166 (chap. 38, sec. 2).

8. See Muschiol 1994:192.

9. See Leclercq 1981.

10. See Bynum 1987.

11. See Signori 1995.

12. See Lentes 1996.

13. See the contribution by Hedwig Röckelein in this volume.

14. "Institutio sanctimonialium" 1906/1979:444 (chap. 8).

15. See Angenendt and Muschiol 2000:48–52.

16. Ibid.: 54.

17. First, the *Pontificale Romanorum*, Mainz, ca. 950, documents crown and ring; see Metz 1985: no. 8. For late medieval coronations of nuns, see cat. Bonn/Essen 2005:426–427 (Eva Schlotheuber).

18. See "Institutio sanctimonialium" 1906/1979:450 (chap. 18).

19. See Muschiol 2000b:223–226.

20. See Angenendt and Muschiol 2000:42–44.

21. See Muschiol 1994:114, 149–150.

22. See Arens 1908:84–86.

23. See Muschiol 1999–2000: chap. 2.4.1 regarding Zwiefalten, chap. 2.4.2 regarding Petershausen.

24. See Muschiol 2001:140–141.

25. See Barrière 1992; Bruzelius 1992; and the contribution to this volume by Carola Jäggi and Uwe Lobbedey.

26. Zimmer 1990. About the late Middle Ages, a most interesting resource is Weilandt 2003.

27. See Muschiol 1994:149–154; Muschiol 2001:138–140. See also G. Wegener 1969 and Arens 1908.

28. See Muschiol 1994:343–344.

29. See the contribution by Klaus Schreiner in this volume.

30. See Muschiol 1994:111.

31. See "Institutio sanctimonialium" 1906/1979:453 (chap. 22).

32. See Muschiol 1994:176–177.

33. Ibid., 75. See also Muschiol 1999–2000: chap. 3.2.1–3.2.3, on the initial decrees of Heloisa's convent Le Paraclet.

34. See Beach 2004; Bodarwé 2004.

35. Kuchenbuch 1991.

36. See Appuhn 1986:33–45; Hiltrud Westermann-Angerhausen, "Antependium," in: Lexikon 1980:1: col. 693–694.

37. See Appuhn 1986:17–21; Michler 1968:62–65.

38. See Muschiol 2001:139 and n. 50 there; Fellerer 1950.

# Founders, Donors, and Saints

## *Patrons of Nuns' Convents*

HEDWIG RÖCKELEIN

## Nuns' Convents and Their Patrons

I n the Middle Ages, monasteries and canoness houses originated at the initiative of wealthy and influential laypersons and bishops or were founded as filiations of existing convents. The founders equipped the religious establishments with material goods and protected them legally and politically.[1]

During the first centuries, the lay founders were recruited exclusively from nobility and royal dynasties; both social groups did not differ much with regard to their conduct and interests in the foundation of monasteries. First and foremost, noblemen as well as kings were looking for a burial place and a community that would tend to the commemoration of their ancestors. For the convent itself, a royal patron opened wider perspectives and responsibilities than an aristocratic donor. Royal monastic communities were given preference through privileges, were tied into political and religious missions, and multiplied their power through the founding of affiliated houses. A monastery such as Chelles (northeast of Paris), which was founded by Queen Balthilde around 658/659 and was designed from the start as a royal convent, had the best prerequisites to develop into a religious and political center of power by virtue of being the seat of a queen dowager (Balthilde, from 664/665 until her death in 680; in Carolingian times, it was as the appanage of the Carolingian

queens). It thus served as a burial site of queens (Balthilde; fig. 9.1), as a prominent cult center (at Chelles, because of the considerable acquisition of relics during the eighth and ninth centuries), and as a place for educating the progeny of the aristocracy.

Bishops founded convents in order to strengthen their spiritual and political influence within their dioceses. Since they usually descended from the aristocracy, they established convents on properties belonging to them or their relatives. Like a private monastery, the convent was directly subject to the power and authority of the bishop. He usually appointed a female relative such as a sister or a niece to be prioress. In the seventh century, however, the bishops in Gallia mostly founded monasteries for men; female monasteries were endowed predominantly by laypeople.

Beginning in the High Middle Ages, other social groups started founding monasteries. Between 1080 and 1170, hermits and itinerant preachers joined bishops in initiating the foundation of monasteries in England and northern France.[2] At the end of the twelfth century, the lower aristocracy, at a level below that of the king and the dukes, began to take over this role. In Central Europe during the second half of the twelfth century, ministerials—former indentured servants beholden to the bishop or the king who had risen to the ranks of the lower nobility—occasionally appear as founders. These families and the new urban elite of the bourgeoisie and the patricians increasingly began to found monasteries beginning in the thirteenth century.

The relationship between the founders and their spiritual community lasted beyond the initial act of endowment. Based on a private legal relationship of dependence, a legal and social construct rooted in Roman client laws, the donor of a foundation was obligated to extend his enduring protection and support to the community originating within it. If the foundation got into legal arguments with third parties, he, as the *patronus causae*, took on the role of the advocate.

The founder influenced decisions regarding personnel, such as the appointment of the abbess and ecclesiastical advocate, the two most important administrative positions in the convent. In the course of the systematic establishment of parish churches in the twelfth century, the rights of the patron (*ius patronatus ecclesiae*) were anchored in canon law, allowing the founder and his descendants to appoint the prebends of canons and clerics and to take charge of the parishes' jurisdiction.

The founders conferred the spiritual and divine patronage of con-

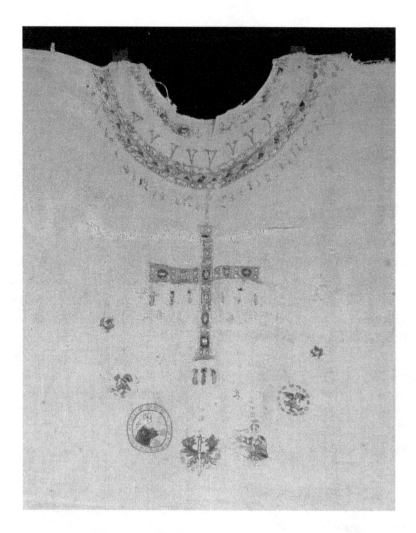

*Figure 9.1* Tunic of Queen Balthilde from the abbey of Chelles, Neustria, second half of seventh century, linen with silk embroidery, h. 117, w. 84 cm. (Musée municipale Alfred Bonno, Chelles [Ile-de-France], inv. 21-001-001.)

vent on one or more saints. Bodily remains, so-called relics, of the patron saint(s) were buried in tombs underneath or in front of the main altar of the church belonging to the convent. They were also inserted into the mensa (table) of the altar, exhibited in the crypt under the choir, or presented in a shrine on the altar. The church as well as the religious community belonging to it received the name of the patron saint, the so-called *patrocinium*.

## Reciprocal Obligations Among Founders, Donors, and Religious Women

The foundation of a convent required the initiating donor to provide an endowment to ensure a permanent material base for the institution. In return for this, the donor expected services from those members of the convent whom he had benefited with his favor. Through a process of give and take, there emerged a reciprocal relationship among the founder, his family, and the circle of individuals created by the foundation or the institution established thereby, which endured beyond the death of individuals, whether the founder or the first nuns.

The support provided by the founding family usually continued as long as the family was represented in the administrative functions or among the members of the convent and as long as the convent rendered the expected services. Later, the responsibility of the founder was taken over by donors (*donatores*) and benefactors (*benefactores*), who often inherited the convent after the founding families had died out or been superseded in political and economic power. Some later benefactors contributed more toward the increase of the power and wealth of the convents they inherited than had the original founders.

### The Patrons' Gifts

Founders and donors granted convents a solid material base by giving them land, which ensured the daily living of the conventuals and allowed them a certain luxury. At the request of founders and other high-level supporters, kings were willing to upgrade endowments. The properties given by kings as gifts to convents originated in the family estate of the dynasty, in the royal domain, in reverted fiefs, or in the form of confiscations from rebels or possessions deeded to the king by the courts. From time to time, convents let the king confirm their properties in order to fend off the demands of third parties.

Occasionally, convents also inherited property. The *dos*, the widow's estate, of female founders and other members of the community were sometimes added to the endowment. In addition to donations of land, allowances to exploit waters (fishing and shipping rights) and forests (rights for cutting wood) were of vital interest for convents.

Founders reinforced the political, legal, and economical bases of convents by using their political connections to gain privileges from bishops, kings, and popes. The king could improve the economic situation of a convent by the granting of regalia. In a decree dated August 4, 990, Otto III granted the abbess Gerberga II of Gandersheim the privilege to admit local and outside merchants to market, to levy duties, and to coin her own currency.[3] He conferred on her the royal bans for the market and declared this area a space of immunity. Furthermore, he permitted the merchants residing in Gandersheim as well as those traveling through it to live and deal according to the laws of the merchants of Dortmund.

Convents strived for the protection (*tuitio*) of the king, the governor, the bishop, and the pope and tried to gain certain liberties (*libertates*). For their protective services, bishops demanded in return an annual interest and tithing. Papal protection in turn diminished the rights of the bishop. At the request of Otto I and Otto II, the convent of Gandersheim was put under papal protection on January 1, 968. John XIII barred the bishop of Hildesheim from making demands on the convent, especially regarding tithing, and he confirmed for the *Frauenstift* the free election of the abbess.[4]

Female monasteries were especially interested in immunity as well as in the free election of the abbess and the advocate. This helped them stave off episcopal and royal demands and reduce the judicial rights of the royal counts. By granting immunity, the king renounced his right to levy taxes and other services, and he prohibited his counts from exercising court justice on convent grounds. The immunity reinforced the autonomy of the monastic judiciary and the position of the prior as legal representative of the convent in secular matters.

## The Convents' Countergifts

For the donations and other manifold forms of support that founders and benefactors granted convents, they expected services in return. These consisted first and foremost of prayer and intercession for benefactors during their lifetimes and beyond their deaths. Most donations were tied to the obligation that nuns would pray for the donor (intercessory prayer for the salvation of his soul) and remember him. On account of their chastity, *virgines* had been considered from the time of the church fathers especially able to pass on the intercessions and prayers of the members of the convent

to God. The prayers of the virgins were meant not only to maintain the connection between the living and the dead but also to reduce the burden of the founders' sins in the other world.

The prayer obligations for founders and benefactors dominated the everyday lives of nuns and canonesses and structured the course of their days. During the prayer of the hours and the celebration of masses, they commemorated the deceased. To keep from overlooking anyone, they made lists of their living and deceased benefactors. Later, the names of the dead were entered at the specific date of death into the liturgical calendar, a procedure that helped structure the course of Mass and of the prayer of the daily hours within the cycle of the church year. In the late Middle Ages, obituaries were created, which kept a precise record of the time and duration of the prayer expected as well as the donations received. Other donors secured their commemoration by having themselves depicted with the patron saint in the breviary, which was used daily in the convent. This happened in the case of Richiza of Perg, the second wife of Adalram of Waldeck-Feistritz, the founder of the double monastery Seckau, who is shown kneeling together with Cunigunde, the putative miniaturist of the nun's breviary, in front of the Virgin (Graz, University Library, Cod. 286, f. 62v).

The obituaries of the Dominican convent in Unterlinden in Colmar impressively testify to the longevity of the memorial activity of female monasteries. They were created at the end of the thirteenth century and were maintained until the beginning of the eighteenth century. At the convent of Unterlinden, the commemoration of the founders was intertwined with the history of the convent and the biographies of its members. One of the two obituaries (Colmar, Bibliothèque de la Ville, ms. 576) documents in the index of the deceased benefactors the amount and kind of their donations (capital, rent, estates, houses, grain, wine, and so on), as well as the day on which Mass was to be celebrated on the donor's behalf.

The commemoration of deceased founders and benefactors was secured not only by written records but also by means of pictorial images. Because of the fragility of the materials, however, there exist only very few testimonies of this kind from before the twelfth century. One of them can be seen in the processional cross from the *Frauenstift* in Essen, which was donated by Abbess Mathilde II (in office 971/973–1011) in memory of her brother Otto, the duke of Swabia. From the thirteenth century, there survives an increasing number of visual testimonies in memorials such as stained glass painting, sculpture, panel painting, and woven or embroidered

textiles. In contrast to written and oral practices of memoria, which limited remembrance to anniversary celebrations, such visual representations of deceased benefactors intensified and made permanent remembrance of the founders, lending them perpetual presence. Wherever the founders were represented next to the patron saints on the altar on embroidered cloths and tapestries or in painted antependia, they gained the status of intercessors for mankind. Such images transplanted donors into the vicinity of the holy. On the fragment of an antependium from the altar of the Augustine *Chorfrauen* in Heiningen, the chief patrons of the convent—Mary, Peter, Augustine, John the Baptist, Paul, and Nicolas—flank the figure of Christ in a mandorla (fig. 9.2). The lateral parts of the woven fabric show female and male saints (Stephan, Laurence, Vitus, Dionysius, Georg, and C[yriacus?]). Next to Catharine and Mary Magdalene there was space for the two foundresses, Hildeswit and Walburgis, who can only be identified by the inscriptions.

The founder had the right to be buried in a central location in the church. Reserved for him was the place at the bottom of the steps of the main altar positioned in the choir space, in greatest proximity to the *sacrum* and the *confessio* of the saint, whose remains were kept either under the altar or in the crypt beneath it. Later benefactors had themselves interred in the choir chapels in the main and side aisles of the church, with their tombs decorated with representative monuments. The donors of liturgical vessels, manuscripts, and altarpieces had their coats of arms affixed to their donations or had themselves depicted there.

Apart from the epitaph of Walburga of Neuenheerse (ninth century), early tomb monuments have not survived. Only from the twelfth century onward do such early monumental memorials exist in greater numbers. During the High Middle Ages, older monuments were often restored. The renewal of the commemoration of the founder points to the established rights and habits of the convent during times of crisis and reform. The same purpose was served by the contemporary emergence of founding legends and efforts of the convent to have the founder acknowledged and recognized by the curia within the framework of a formal process of canonization. On the Rupertsberg antependium, which originated after 1210, the convent saints Mary, Martin, and Rupert, together with Hildegard, the founder of the convent, gather around the *Majestas Domini* with the symbols of the four evangelists. A few years later, the process of canonization was begun for Hildegard, the founder of the convent.

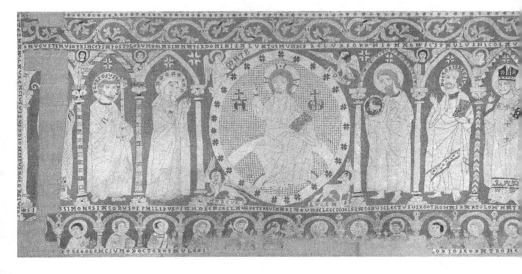

*Figure 9.2* Antependium from the monastery of Heiningen, ca. 1260, h. 106, w. 236 cm. (Kloster Marienberg, Helmstedt [Lower Saxony], Römer no. 2.)

Narratives of foundation, the so-called *fundationes*, were recorded together with the biography of the founder and combined with the chronicle of the convent or with legends paying tribute to the influence of the patron saint. Female monasteries secured the memories of the founding family in an archive; they were the treasuries of the aristocratic and royal families. The marriage deed of the empress Theophanu was handed down as a family heirloom to the *Frauenstift* at Gandersheim. In this way, the memory of the wedding gifts of Otto II to his bride was preserved in the family convent of the Liudolfinger. In the *Frauenstift* of Gandersheim, Roswitha recorded the deeds of Otto the Great, and here was kept a manuscript copy of the *Antapodosis* (London, The British Library, ms. Harley 3717), a historical compendium written by Liutprand of Cremona praising the heroic actions of the Ottonian rulers in Italy.

Communities of religious women were responsible not only for the commemoration of their founders but also for social and charitable missions, which were delegated to convents by their benefactors. The convents gave alms to the poor and needy, ran hospitals for the sick and elderly, and educated external male and female students. In return for the alms, the recipients, as well as the sick and the students, were obligated to pray for the founder. Aristocratic families sent their daughters to convents to be

educated and instructed in preparation for their later roles as wives, as administrators of large estates, and as representatives of rulership. After the completion of their political assignments as corulers in the government or as regents for their minor sons, aristocratic and royal widows found in convents a quiet, protected place for their old age.

## The Patronage System in Convents: Networks, Barter Relationships, Affiliations, and Rights of Patronage

Female monasteries were not just objects of patronage by founders, donors, and powerful laypersons and clerics; they also developed their own systems of patronage. They supported each other by exchanging compendia of rules and books. In Saxony, numerous convents increased their influence by the founding of affiliated houses. They staffed their affiliated daughter houses with nuns of their own or provided an abbess for the new convent. They also equipped them with manuscripts, liturgical vessels, and relics of saints. Some abbesses from the royal Ottonian family acquired an unusual accumulation of power by ruling over great women's foundations in personal union: in addition to her role as abbess of Gandersheim (1002–1039), Sophia, the sister of Otto III, also assumed the same position at Essen (1012–1039). Her sister Adelheid (d. 1043), who reigned from 999 in Quedlinburg, later also ruled simultaneously over Vreden, Frohse, Gernrode, and Gandersheim.

As administrator over the estates of the convent, the abbess exercised the rights of patronage. She was the patroness of the estates, the churches, and the serfs. In this function, she toured and controlled the convent's properties. Abbesses received patronage rights over parish churches when they were given manor churches as gifts by noblemen. Parish churches that predated the foundation of convents would be subsumed under the patronage of convents by the decree of the bishop. Shortly before 1266, that is, ten years following the foundation of the Cistercian convent of St. Nikolaus in Aldersleben (diocese of Halberstadt), the local parish church was incorporated. According to canon law, abbesses were allowed to appoint priests for the parish churches and to nominate and assign the prebends for the communities of clerics dependent on them, as well as the vicars for chapels and altars. Based on the secular and ecclesiastical rights of patronage, some female monasteries constructed widespread dominions during the late Middle Ages and the early modern period. From this, for

example, Essen and Herford deduced the right to be represented in the assembly of the provinces.

## The Saint as Patron and the Patrocinium of the Convent

The client relationship between the members of a convent and their patron saint resembled that between them and their founder. The patron saint, however, was much more important than the founder: he was the symbolic representative of the convent, the church, and the whole social and religious community. The spiritual community named itself after him, after his *patrocinium*, not after the founder or the locality. Gifts of property or donations for the salvation of the soul were addressed to the saint, not the abbess or the convent. When entering the convent, the novice gave herself to the saint and entrusted herself to his patronage.

### The Function of the Patron Saints

Manifold help and support was expected of the saints.[5] First and foremost, martyrs and confessors were to transmit the prayers and requests of the nuns to God. Furthermore, the monastic community hoped for effective protection against earthly dangers, catastrophic storms and fire, and attacks from enemies and for help in cases of disease. Like the founder, the saint was called on in the convent's legal matters. He was considered the objective guarantor of law, an incorruptible judge who would be able to reveal the truth. If an oath was to be taken, it was done upon the relics of the saints on the altar. If contracts regarding debts were made, the saint stood as guarantor of the debtor and the payment of debt.

### The Election of the Patrocinium in Convents

Given the great numbers of saints populating the convents, it is not easily ascertained which saints female monasteries preferred as patrons. There was not only one but several churches, there was not only one but many altars, each of which held its individual patrocinia and relics of saints. I define as patrons those saints who are documented by name in the charters

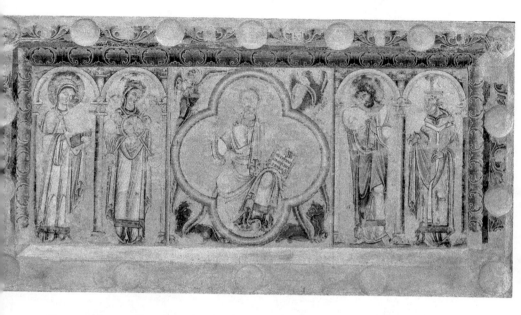

*Figure 9.3* Antependium from the church of the former monastery of St. Walpurgis in Soest, ca. 1170, tempera on linden wood, h. 99.5, w. 195.5 cm. (Westfälisches Landesmuseum für Kunst und Kulturgeschichte Münster [loan from the Westfälischer Kunstverein], inv. 1.)

as recipients of properties or of episcopal, royal, or papal privileges, as well as those to whom gifts are addressed in dedication images or those who appear as representatives of the convent in seals and coats of arms, for example, John the Baptist who appears along with the popes Anastasius and Innocent in the great seal of Gandersheim. From the High Middle Ages, patron saints are depicted with other saints in sculptures, stained glass, and panel painting (fig. 9.3) as well as in textiles.

Analysis of a European database of female monasteries has shown that most medieval convents chose Mary as their principal patron, often accompanied by two or three other saints.[6] The patrocinia of Mary developed somewhat proportionately with the number of new foundations of convents (fig. 9.4). At a marked distance but still fairly widespread were Peter and John the Baptist, who often kept company with Mary in a group of two or three (fig. 9.5). This cluster reflects the phenomenon of church families within convents. Not all those patrocinia, however, develop in parallel with the wave of the founding of convents but rather, to a certain extent, contrarily. For example, Peter, who was elected patron in absolute

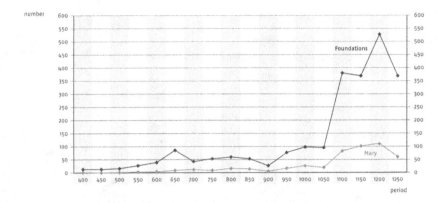

*Figure 9.4* New foundations of female monasteries and foundations of female monasteries with Marian dedications, 400–1300.

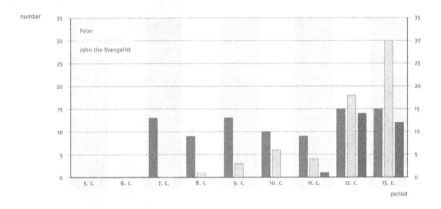

*Figure 9.5* A comparison of the number of dedications to Peter, John the Baptist, and John the Evangelist, 400–1300.

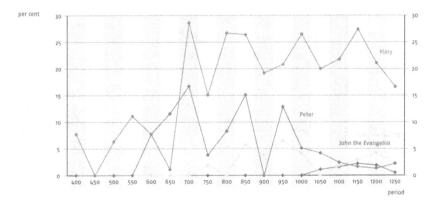

*Figure 9.6* The percentage of dedications to Mary, Peter, John the Baptist, and John the Evangelist among all foundations of female monasteries, 400–1300.

numbers with equal frequency from the seventh to the fourteenth centuries, lost much of his importance after 1100 in comparison with the increasing foundations of convents (fig. 9.6). The top group of Mary, Peter, and John is followed by a great number of saints who were chosen as patrons by only 2 to 3 percent of convents.

In addition to various Christological patrocinia can be found dedications to the archangel Michael, Paul the confessor, John the Evangelist, the Apostles, Mary Magdalene, James, Andrew, and Bartholomew, the protomartyr Stephen and the martyr Lawrence, the bishops Nicolas of Myra and Martin of Tour, the Merovingian abbot and founder of a monastery Leonard of Noblac (near Limoges), the founder of the Benedictine order and Clares (from the first half of the thirteenth century). Among female patron saints of the convents, only the three virgins and martyrs occur in numbers worth mentioning: Agnes (from Rome), Margaret (from Antioch), and Catharine (from Alexandria). Knightly saints such as George, Vitus, and Maurice, the latter of whom can be regarded as *patronus specialis* of the Ottonians, may reflect the aristocracy's participation in the founding of convents.

The patrocinia elected by women by no means represent the complete hierarchy of saints. The chief patrons of convents are made up of the universal saints of the church (Mary, Christ, the Apostles, and martyrs), to whom one or more special patrons were added marking the convent as differing from others. Their choice agrees mostly with the cathedral churches: there, too, Mary is most frequently named as the patron and in clearly subordinate position the Holy Cross, the Savior, the Trinity, the protomartyr Stephen, Peter (and Paul), Andrew, James, and John the Evangelist. Convents differ from the cathedral churches insofar as they limit the great number of male martyrs from Gallia, Milan, Spain, and the East to Lawrence, Maurice, and Martin and prefer the virgins and martyrs Agnes, Catharine, and Margaret to the male saints. In the early Middle Ages, the choice of patrocinium among convents differs markedly from male monasteries: monks most frequently seek the protection of the princes of the apostles, Peter and Paul, as well as Andrew. Mary was not granted a leading role.

*Procuring Relics of Saints*

The founders helped procure the relics of saints, which were required for the foundation and the equipment of the main altar. If convents founded a

daughter house or if bishops founded a private monastery, they passed on the patrocinium of the mother church and shared their treasury of relics with the new foundation. While the popular universal patrocinia are not suitable for tracing such affiliations, those of rare saints provide evidence for them. In other cases, the local bishop in charge provided relics for the dedication of the altar.

Not only the religious but also laypeople, kings, and noblemen took care to provide relics for their foundations. In this, the aristocratic lords of the private monastery were supported by friends and relatives holding religious offices and having the necessary connections. In the early and High Middle Ages, many a saint often had to give way to the founder, who himself was revered as a saint later on. Only rarely a holy foundress or abbess was accepted by other convents as a patroness; the exceptional case was Gertrude (d. 659), the daughter of Pippin the Older. She was the first abbess of the convent of the double monastery Nivelles (Diocese of Namur), which St. Amandus had founded, aided by his mother.

## Institutional, Private, and Public Cult

Patron saints were in charge of the whole institution and all its inhabitants, the nuns, the canonesses, the clerics, the *conversi*, in short, the whole *familia* of the monastery, including the tenants of the convent. They represented and symbolized the community in its entirety to the outside world and helped their members develop a common identity, despite often diverging interests and the potential for conflicts. During times of reform, the patrons of convents fulfilled their function of granting identity in special measure. After the completion of reforms in the fifteenth century, the nuns of a number of convents collaborated in embroidering or weaving tapestries depicting the lives and suffering of the patrons of the convents. In added texts, they emphasized the exemplarity of the saint and professed themselves to be followers of the reform. Reform works of this kind are the Magdalene tapestry from the convent of the *Weissfrauen* in Erfurt, the choir stall hangings with the legend of St. Bartholomew from the convent of Lüne, a tapestry with the legend of St. Walburg in the eponymous convent in Eichstätt, and the tapestries with legends of the saints Elisabeth and Anne in the Cistercian convent of Wienhausen showing the patron saint of the convent, St. Alexander.

Although female monasteries, because of the strictures of enclosure and their focus on the prayers of the hours, were required to keep their distance from the world of the laity, some convents still developed into centers of lay cults. Reverence was paid to the patron saints; their miraculous statues and relics; to the tomb of the foundress of the convent, an abbess, or a saint; and also to recluses living near the convent. Cult images such as the "Golden Madonna" of Essen exercised great attraction for the laity (fig. 9.7). Miraculous images (*Gnadenbilder*) inspired regular pilgrimages. Alternatively, the discovery of a miraculous image could in some cases initiate the founding of a convent.

## The Relationship of the Convents to Their Founders, Benefactors, and Patron Saints

It seems as if female monastic communities enjoyed a closer relationship to their founders, benefactors, and patron saints than did male monasteries, and not only during the founding phase. Convents remained connected with their benefactors even during the High Middle Ages, when many male monasteries dissolved their relations as clients of the founders in the wake of the Cluniac reforms or as a result of affiliation with the Cistercians. Instead, male monasteries joined the hierarchal federation of a monastic order governed by a male principal. Within these monastic alliances, female monasteries constituted a minority. During the first great wave of foundations of convents in the late eleventh and twelfth centuries, around 60 percent of female communities decided to remain autonomous as Benedictine or Augustine *Chorfrauen* without ties to a monastic association.

There are several reasons for the close attachment of convents to the families of their founders and benefactors. In troubled times, convents sought the safety of the protection of towns and castles and the proximity of the families of their founders and patrons. The *virgines* maintained a close bond with the families of the founders and patrons by virtue of the obligation of daily prayer for the living and the dead over many generations. Furthermore, the inhabitants of the *Frauenstifte*, among them, girls from aristocratic founding families residing there temporarily for the purpose of education and training and aristocratic widows who chose to retire there, maintained steady contact with their relatives. Until the late Middle Ages,

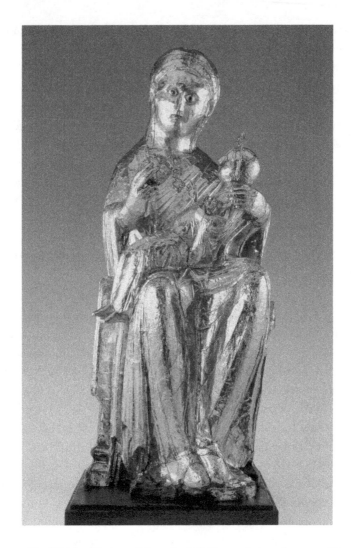

*Figure 9.7* The "Golden Madonna" from the Stift Essen, 980/990, h. 74 cm. (Domschatz Essen, inv. 2.)

these factors led women in monastic communities to maintain a much more intense connection than did monks with their founding families and with the providers of their material support.

Although the mendicant orders of the thirteenth century proclaimed strict observance and organized themselves into well-defined provincial associations, they refused to admit numerous communities of women who applied for admission. As a consequence, many female convents were at

first excluded from the associations of orders and monasteries.[7] This only changed during the 1230s and 1240s as a result of pressure imposed by the popes, who considered the autonomous and uncontrolled position of the female monasteries a greater danger than the burden represented by the *cura monalium* for the male monasteries. Since the Dominicans and Franciscans made strict enclosure and a well-funded material basis precon-ditions for the incorporation of nuns' convents, all while prohibiting any begging, the nuns of the orders of St. Clare and St. Dominic had to con-tinue to rely on the income of real estate donated by their relatives, which bound them to their benefactors. Only in the fifteenth century did the reform congregations of Windesheim and Bursfelde seem to have been successful in reducing the family ties of the Benedictine convents and the Augustine *Chorfrauen*, in part against the considerable resistance of the inhabitants and their families. Now that they were more firmly and more permanently integrated into the orders, they were paid more visitations and subjected to stricter controls. As proven pictorially by the choir stall hangings of Lüne monastery, the attachment of the convents to their holy patron saints intensified during this phase of decreasing client connections with their benefactors.

## Notes

1. I am currently working on a monograph on this subject.

2. For the development of the convents in France and England, see esp. Venarde 1997.

3. Sickel 1893/1997: no. 66.

4. Jaffé et al. 1885, 1888/1956: no. 3721. The original, which still existed in the thirteenth century, was written on a roll of papyrus and has not survived. All that remains is a copy in minuscule on parchment from around 1000, produced during the so-called Gandersheim dispute.

5. Hattenhauer 1976.

6. This analysis is based on a database containing 2,513 entries. It includes nuns' convents from all over Europe founded between 400 and 1300. There is information about the patrocinia from 1,131 (45%) of those convents. The database was compiled at the Lehrstuhl für früh- und hochmittelalterliche Geschichte at the Georg-Au-gust-University in Göttingen [wwwuser.gwdg.de/~roeckele/frameset.html (link for FeMo-Database-project)]. It is based on Matrix, a database accessible at matrix. bc.edu/MatrixWebData/matrix.html, and two unpublished lists provided by Dr. Ka-trinette Bodarwé, University of Göttingen, and Prof. Robert Suckale, art historian

at the Technische Universität Berlin, which between them provide coverage of the entire late Middle Ages. It was supplemented by regional literature on monasteries. I am grateful to Robert Suckale and Katrinette Bodarwé for sharing their materials and to my assistants Katharina Mensch and Cai-Olaf Wilgeroth for compiling the database and helping to evaluate the data and prepare the graphs of the results.

7. See Degler-Spengler 1985.

# Pastoral Care in Female Monasteries

## Sacramental Services, Spiritual Edification, Ethical Discipline

KLAUS SCHREINER

The abbesses of medieval female monasteries held secular powers of jurisdiction. As feudal rulers over properties and people, they were in charge of territories and their populations. As female rectors of high and lower churches, they assigned benefices, sinecures, and canonical seats. As governesses of imperial abbeys, they belonged to the order of the princes of the empire. Like abbots, they carried insignia—a staff and a cross pendant on the chest, sometimes also a miter—that expressed symbolically their elevated status within the church and in the outside world. Because they were women, the priestly powers of teaching and consecration were withheld from them: they were not allowed to preach in church, to hear confessions, and to celebrate Mass. As Christians of the female gender, they were supposed to be silent in church, because it was considered unseemly for a woman to speak in front of the community (1 Cor. 14:34–35). In order to participate in the means of salvation and grace of the church, nuns needed the help of men, who thanks to their ordination were equipped with priestly authority. As far as spiritual and sacramental matters were concerned, female monastic communities thus encountered limits established by gender.[1] Pastoral care in female monasteries was the domain of men. As confessors, preachers, pastoral guides, and liturgists, clerics and monks were obligated to take care of the spiritual well-being of nuns. Where male monasteries fulfilled their spiritual and liturgical duties autonomously, female monasteries could not. They simply

did not possess the degree of independence to which monks, all of whom could be ordained, could lay claim as a matter of course. To join an order was of existential importance for female monasteries. Male monasteries were spared such problems. In order to celebrate the liturgy, to forgive sins, and to preach the word of God, men did not need help from outside.

## Pastoral Care for the Spiritual Salvation of Nuns in the Early Middle Ages

In 512 Bishop Caesarius of Arles (ca. 470–542) wrote a rule for virgins (*regula ad virgines*) for the nuns of the convent Saint-Jean in Arles in order to put in writing the principles governing a virginal way of life. In his view, the basic requirement of a virginal life was that nuns keep their distance from men. No man was to be allowed to enter either the enclosure or the chapels and prayer rooms. Exempt from this prohibition were the administrator, who in collaboration with the abbess addressed all organizational questions concerning the management of the convent, and visiting bishops, priests, deacons, and subdeacons, who were supposed to say the convent Mass. Also admitted were two lectors, whose task was to read the epistle and the gospel.[2] Nuns were supposed to limit their contacts with men to the bare necessities, in order to preserve their good reputation and their virginity, which was endangered by their female weakness. The men needed and tolerated were helpers in secular matters as well as clerics, who celebrated Mass for the nuns.

In 816 an imperial council in Aachen ratified a program of ecclesiastical reforms that included regulations governing the conduct of women dedicated to God. The leading spiritual and secular figures convened at Aachen also directed their reforming intentions at the priests who fulfilled pastoral duties in female monasteries, took confessions there, and celebrated Mass on their behalf. The reform measures, compiled in the Institutio sanctimonialium Aquisgrani, stipulated that priests serving convents should be housed outside the monastery building. Only at certain times did they have permission to enter the convent with a deacon and a subdeacon. The latter two were required to be exemplary and honorable, pursuing not their own interests and needs but rather only what pertained to the Lord Jesus Christ. Clerics were allowed to remain inside the convent only as long as they celebrated Mass. Even if they publicly (*publice*) preached to the

nuns, they were to leave as soon as their sermons were concluded. If a nun wished to confess her sins to a priest, she was to do it in the church where she could be seen by all the other nuns. By the same measure, the priest was always to be accompanied by the deacon and the subdeacon, in order to protect himself with credible witnesses against malicious gossip.[3]

Nuns were to keep their distance from men. They were strictly prohibited from taking on tasks during the celebration of Mass that were among the obligations of ordained priests. It was considered a sin for women to serve at the altar or to assume duties that were the prerogative of men, be it reading from the Bible during Mass or singing the Alleluia or antiphons. A *capitulare* of Charlemagne's dating from 789 admonished: "We hear that against the custom of the holy church some abbesses bless men with the laying on of hands and with the sign of the cross and that they adorn virgins with their priestly blessing. You shall know, most holy fathers, that this must be totally forbidden in your dioceses."[4]

Abbesses were subject to the prohibition against preaching. Theologians distinguished between the "good word," which was permitted for women, and the official sermon, from which they were excluded. Based on this distinction and church law, abbesses were also prohibited from preaching publicly. Within the framework of their administrative office, they were merely permitted to instruct their fellow nuns in matters of faith.

Objections to fundamental theological and canonical decisions that excluded abbesses from any liturgical and sacramental rites continued to be raised in the late Middle Ages. Deviations from the accepted norm are proven by the fact that Pope Innocent III thought it necessary to intervene against abbesses who in his opinion usurped priestly functions. The addressee of his decree referring to this matter was the bishop of Burgos, in whose diocese abbesses consecrated nuns, heard their confessions in case of transgressions, and moreover were so bold as to preach publicly about the gospel, which they read at Mass. In his apostolic letter, the pope bound the bishop in duty to do all he could to put a stop to the religious and ritual practices of the abbesses, which he judged to be "equally inappropriate and repulsive." He tried to support his reasoning with theological argument, conceding that the most blessed Virgin Mary may have exceeded all the apostles in rank but adding that the Lord did not grant the keys to the heavenly kingdom to her but to them. He added that, as far as he knew, the life of Mary provided no incident that would justify the assumption of priestly functions by abbesses.[5] The

pope's high esteem for the Mother of God could not keep him from reminding everybody urgently of the privileges of the apostles, which were indecorous for Mary.

## Female Monasteries in the Reform Orders of the High Middle Ages

Ulrich of Cluny, the former prior of the Cluniac convent of Marcigny, praised Abbot William of Hirsau (d. 1091) for excluding "the weaker sex"—meaning the female community of Hirsau—from his monastery and moving it to a place at a sufficient distance.[6] The praise lavished by the Cluniac on the reform abbot of Hirsau is characteristic of the attitude of abbots and monks from Hirsau and Cluny, who had initiated and paved the way for far-reaching reform movements directed at female religious. The introduction of double monasteries, whose legal and spiritual organization also guaranteed the care of the souls of the women, was not among the explicit goals of the orders of Cluny and Hirsau, which they explained in greater detail in their statutes. If in keeping with local requirements, monasteries belonging to their circle were established as double monasteries, strict cautionary rules were impressed upon all concerned in order to safeguard the moral purity of monks and nuns living together and alongside each other. For these orders, a double monastery presented predominantly an ascetic problem. On the whole, a theological basis for the communal life of men and women characteristic of double monasteries cannot be found in the writings of the monastic reform movements of Cluny and Hirsau. There are, however, exceptions.

Writing between 1120 and 1156, the author of the chronicle of Petershausen, a monastery near Constance reformed by Hirsau, answered with remarkable candor the question as to how monks should behave toward women, especially those living in monastic communities.[7] In his effort to restore various monastic ways of life to their early, archetypal Christian roots, he reminded monks of the original Christian community in which the apostles remained in prayer together with Mary, the Mother of God. He emphasized that in the early church "pious virgins fought together with the holy disciples for God." In view of the existing communality between women and men, it would be exceedingly praiseworthy and welcome "if women bent on a monastic life found admission in monasteries

of the male servants of God, in order for both sexes to reach salvation at the same place, although separated from each other." There was nothing morally questionable let alone anything ethically suspect for the chronicler of Petershausen about double monasteries that gathered men and women in a single building. As far as he was concerned, the community between men and women institutionalized within the double monastery was a biblically justified form of expression of a communal quest for salvation that transcended the boundaries of gender.

The chronicler of Petershausen shared in the confidence and decisiveness of men such as Robert of Arbrissel (ca. 1045–1116) and Norbert of Xanten (1080/85–1134) who sought to provide women of all social strata with ways of entering into a regulated monastic life. As described in his *Life*, the itinerant preacher Robert of Arbissel supported "the aims and goals of religious women" with all his might. At Fontrevrault, in the bishopric of Poitiers, Robert founded a double monastery in order to bind his female followers within traditional ecclesiastic structures.[8] He justified his foundation by pointing out that the crucified Savior had entrusted his mother to the care of his apostle John (John 19:27). Following the example of Christ's commendation of his mother on the cross and the way in which he served and protected her, monks should also be of service to nuns. The main church in the female tract of a double monastery should therefore be dedicated to the Virgin Mary, and the main church in the male tract to the apostle John.

In 1120 Norbert of Xanten created the prototype of a Premonstratensian double monastery at Prémontré. Norbert's foundation offered those women who had followed him as an itinerant preacher an opportunity to actualize their ideal of religious life supported by a rule and bound to a firm order that was approved by the church.[9] Around 1140 a contemporary author, Herman of Tournai (d. 1147), who had led the Benedictine monastery St. Martin at Tournai from 1127 until 1136, described the beginnings of Prémontré in glowing terms. Herman was full of praise for the extremely strict discipline of the Premonstratensian female communities, in which not only women from poor or rural backgrounds but also ladies of great nobility and exceeding wealth took the veil. He portrayed Norbert as an admirable innovator, who through his foundation of the monastery had opened the possibility for women to dedicate their lives entirely to God in the community of like-minded others. The regular canon James of Vitry (1160/70–1240), who was universally held in high esteem on

account of his preaching, glorified the pious matrons, widows, and virgins who found a spiritual home in Premonstratensian double monasteries as precious jewels, as decorations and ornaments of the order. In his view, the connection between men and women, the two walls of the order, was a single cornerstone: Christ.

In the long run, the Premonstratensian monks came to consider those women who started communities and looked to the order for institutional and spiritual backing for their communal life less as brilliant jewels than as onerous burdens. In the late 1130s they started to disconnect the common living arrangements in a single monastic compound and to accommodate the nuns in their own convents at a distance from the monks. The openness to women shown by the Premonstratensians during the founding phase of the order was repressed and replaced by an effort to separate themselves from them.

Decrees and statutes intended to restore the Premonstratensians as an all male order lost their validity when counts and dukes, bishops and popes intervened on behalf of the pious women. Pressured by spiritual and secular powers, the order had to revise its exclusionary policies. The reactions provoked by this were clearly expressed by Pope Innocent IV in 1248. "Many," he remarked critically, "were outraged by this exclusion, and their piety toward the monasteries cooled off markedly, because the goods that they had donated with pious intentions for the upkeep of the nuns were used for different purposes against their wishes."[10]

Over the long run, the Premonstratensians' refusal to take into account the needs of the female religious movement prompted women increasingly to try to attach themselves to the Cistercians or, when denied access by the abbots and monks of the great orders, to search for areas of engagement and forms of community with heretics. During the 1120s and 1130s, when foundations of Cistercian female convents increased rapidly, the Cistercian General Chapter did not react with sensitivity or understanding to religiously motivated women who, as part of their search for meaning and salvation, sought to attach themselves to an order to ensure the continuation of their communities. Rather, like the Premonstratensians, over time the order of Citeaux also felt itself unable to take on the pastoral care and administrative responsibilities of the convents of female communities intending to lead a Cistercian life.[11]

Beginning in 1212, Cistercian abbots filed complaints at the annual meeting of the General Chapter about the female monasteries newly attached to

their order. They repeatedly complained that spatial distance between the convents and the monasteries was insufficient, resulting in frequent violations of the laws of enclosure, which were equally binding for men and women. Convents were supposed to be at least six miles removed from monasteries according to a decision in 1218. In order to ensure a convent an economic base sufficient to support the nuns living there, in 1219 the Cistercian General Chapter decided that the abbot should limit the number of nuns whenever he conducted a visitation. Also, a convent was only be accepted into the order if the petitioning nuns were prepared to observe enclosure strictly. In 1222 the General Chapter turned to the pope asking him in future to dispense the order from the obligation to provide monks for the pastoral care of the nuns. The General Chapter convened in 1228 reinforced this decision: the association of the order was no longer to accept any convents at all, whether those already extant or those yet to be founded. The General Chapter. however, could not prohibit convents from living "in the Cistercian way," that is, according to the customs and statutes of the Cistercians. It nonetheless forbade abbots and monks from taking on pastoral and visiting duties in convents. In 1230 the General Chapter again implored the pope to spare the order from requests for the incorporation of female communities.

The extant sources do not reveal whether there was an active effort to find a way to accommodate productively the religious needs and desires of women. Bernard of Clairvaux (1090–1153) repeatedly warned his fellow monks against having any contact with women. A theology of community convening men and women in their effort toward a decisive imitation of Christ and a life modeled after the apostles cannot be found in the writings of the Cistercians. In the statutes of their order ratified in 1237, the Cistercians added a special rubric "de monialibus non sociandis" (about nuns not to be included in the order), which amounted to a fundamental rejection. The text mentions neither foundations formed by private initiative nor voluntary acceptance of already existing communities. The only reasons for an acceptance to be countenanced and acted on appear to be "by reason of a command by the lord pope" ("ex precepto domini pape") or because of an internal necessity of the order ("necessitas ordinis"). In 1251 the order was finally able to achieve what it had so long aspired to: Pope Innocent IV assured them that he would no longer trouble them with requests for the incorporation of female monasteries.

## Ethical Standards: Norms for Spiritual Advisers, Preachers, and Priests in Female Monastic Communities

Following the foundation of female monasteries, which in the eleventh and twelfth centuries sought to attach themselves to the emerging reform orders, the spiritual adviser, the confessor, and the celebrant in female monastic communities became the subject of deliberations and debates in moral theology. What were such persons' tasks and obligations? What were their responsibilities, and how were they to conduct themselves in order to meet the expectations of the women in their pastoral care?

Writing in 1140, the author of the *Speculum virginum* (Mirror of virgins), whose name remains unknown, wrote this handbook for the pastoral care of female monasteries as a code of ethics to govern the practice of clerics responsible for the spiritual needs of nuns.[12] The reform movement of the Regular canons seems to provide the spiritual origin of the *Speculum virginum*, because they had made pastoral care one of the particular concerns of their order and reform. The foundation of the canons of Springiersbach, a center of the canonical movement in the archdiocese of Trier situated north of Kröv (Moselle), made "the foundation and counseling of female monasteries a primary task of the *cura animarum*."[13] Abbot Richard of Springiersbach (in office 1129–1158) was the son of a widowed ministerial called Benigna who had endowed a foundation designed as a double monastery on her widow's estate in the Kandel forest. He regarded as his personal obligation and mission "the support and spiritual counsel of female communities that had constituted themselves according to the rule of St. Augustine."[14] The author of the *Speculum virginum* endeavored to take this positive fundamental attitude into account by collecting numerous quotations from the scriptures of the Old and New Testaments in order to remind clerics and monks of their pastoral responsibility toward nuns. Focal points of his deliberations and admonitions were chastity, purity of mind, and the virtuous gaze, which monastic clerics were supposed to internalize in their interactions with nuns. As model for a good pastor for women, the author chose the virginal apostle St. John, to whom Jesus had entrusted his virginal mother. In the opinion of this author, monastic clerics fulfilled their obligations when the relationship between them, the pastors and teachers, and the nuns, their pupils, is dominated by the love and fear of God. The author of the *Speculum* is therefore horrified at monastic clerics who behave like roving wolves, neither willing nor able to control

their sensual concupiscence in their encounters with nuns. He also advises monastic virgins to seek counsel regarding questions about the interpretation of scripture from a priest, but only if his age and virtuous conduct of living commend him as an adviser of moral integrity. In his view, nuns do well, when, "following their love for the highest shepherd, they learn to distinguish true from false pastors and accordingly love the good shepherd, tolerate the hireling, and loathe the robber (John 10:1–13)."[15] In effect, the author says that whether the spiritual care for the salvation of the nuns bears fruit depends on the moral and spiritual bearing of those to whose care they entrust themselves.

Peter Abelard (1079–1142), in his deliberations concerning the pastoral care of nuns (*cura monialium*), assumed that monks and nuns would live communally in one monastery building complex, although in strict separation within. At the very core of monastic living he put chastity, poverty, and silence. As Abelard explained in his rule of a double monastery, in order to make such a goal obtainable for virgins leading the monastic life, certain interior and exterior prerequisites had to be fulfilled.[16] To ensure "that the abbess was more concerned with the spiritual issues of the sisters than their corporeal needs," Abelard considered it indispensable that monks following the model of the Apostles would take care of all tasks of external administration. By taking over this burden, the monks would allow the abbess to fulfill the "pastoral care of her sisters" as her first and foremost obligation. Only then would female monasteries be able to meet the "duties of their order in perfect strictness, when they were under the conscientious leadership of spiritual men." Monks owed nuns sacramental services and spiritual recourse. Moreover, in order to keep nuns "carefully from all carnal pollution" and "to take care of their carnal purity to the best of their abilities," they were supposed to prove themselves to be faithful housekeepers. In addition, the abbess is called to take care of the spiritual concerns of her sisters. She fulfills this obligation most efficiently if she does not leave enclosure and behaves in such a way that she becomes an example for her sisters by virtue of her conduct of living.

Abelard envisages a community in which the bonds of love, closeness, and friendship connect monks and nuns. At the same time, he pleads for a strictly separate life that prevents confidences between monks and nuns, which in turn might lead to sinful ways of conduct. The abbot is therefore not to confer with the abbess in private but always in the presence of two or three sisters. Also, such conferences should not take place

in a closed room. Whenever he talks with the abbess, the abbot should maintain a proper distance from her. "No brother may ever enter the area of the nun's monastery, unless he has honorable business, which cannot be postponed, but even then also only with the express permission of the abbot or the abbess." The reciprocal relations necessitated norms and controls, which were anchored institutionally. Human nature broken by the fall from grace of Adam and Eve, whose weaknesses and susceptibility to temptation also effected monks and nuns, demanded strict discipline. The ever-present thought of possible offenses required disciplinary measures, which would not permit unhindered natural relations between the sexes.

Abelard did not share the condescending prejudices to which misogynist moralists frequently fell prey whenever they commented on the weaknesses attributed to women. He held the dignity of women in high regard.[17] His conception of women, however, while free from degrading and disrespectful stereotypes, was still insufficient to enable him in his behavioral ethics to grant freedoms for women that would have eased the confining strictures of enclosure. In his instructions for separate and enclosed lives, he bowed to the power of tradition. Moreover, it remains remarkable that even an intellectually very sophisticated theologian such as Abelard, who in his proposed rule follows "the enlightened principles of the prophetic tradition of the New Testament,"[18] still clings to a notion of cult-related purity, which is at odds with his theology-based principles of internal ethical virtue. In spite of his unusually high esteem for women, he still attributed a gender-based impurity to the nuns, which excluded them from freely touching cult objects or grasping them with their hands. Neither the nun fulfilling the duties of a sacristan, he commanded, "nor any other nun should be allowed to touch the relics or the altar vessels or the altar cloth, except if they have been left to them to clean. For this work one should first summon monks or lay brothers from the male monastery and begin the job only when they are present. . . . The nun sacristan shall open the cupboards, the monks shall take the holy vessels from the cupboards and put them back again."

Abelard's rule for the life of nuns remained a programmatic plan. Moreover, the convent Le Paraclet, founded by Abelard in Champagne and under Heloise's direction around 1130, did not have the characteristics of a double monastery according to Abelard's design and theological reasoning. Heloise herself worried that the coexistence of men and women in one

monastery (*virorum ac mulierum in unum cohabitatio*) could easily lead to the ruin of their souls.[19] The nuns of the monastery Paraclet were bound in obedience exclusively to her as the prioress and abbess.

Despite all this, there are clues that permit the conclusion that Abelard's bold vision led to fresh impulses. From the circle of the foundation of canons in Marbach in Alsace there remains a precious illuminated manuscript that shows noticeable traits of Abelard's influence (fig. 10.1).[20] A guiding theme that determined the composition of the overall text lies in the *cura monialium*, the pastoral care provided by the canons of Marbach for their spiritual sisters in Schwarzenthann. The origin of the manuscript also allows us to recognize the partnership and collaboration between canons and canonesses. Whereas the text was written by Guta, a canoness from Schwarzenthann, the miniatures were painted by a canon of Marbach by the name of Sintram. In spiritual and legal respects, Marbach and Schwarzenthann formed a double monastery, although Schwarzenthann was at a distance of about six kilometers from Marbach.

## The Mendicants and the Pastoral Care of Women in the Later Middle Ages

The mendicant orders that originated at the turn of the twelfth century seemed to offer more favorable conditions for integrating religious communities of women into the spiritual and religious life and institutional structure of an order. There existed strong relations between St. Francis and St. Clare, who founded a convent for nuns of Franciscan orientation.

In 1206 St. Dominic had founded a convent in Prouille near Toulouse that aimed at guiding back into ecclesiastical norms those women of higher social standing who had become attracted to the teachings and religiosity of the Cathar heretics. After reclaiming these women for the true faith of the Catholic Church, he wanted to offer them a possibility within the church to realize their religious aspirations, which so far they had only sought and found within communities of heretics. His personal closeness to women, however, did not have the effect of creating norms and structures, and neither did it contribute to providing a legal base for the orders of men and women. An exemplary legacy, which could have obligated the followers of St. Dominic to assume the pastoral care of religious female communities, cannot be documented after the death of the order's

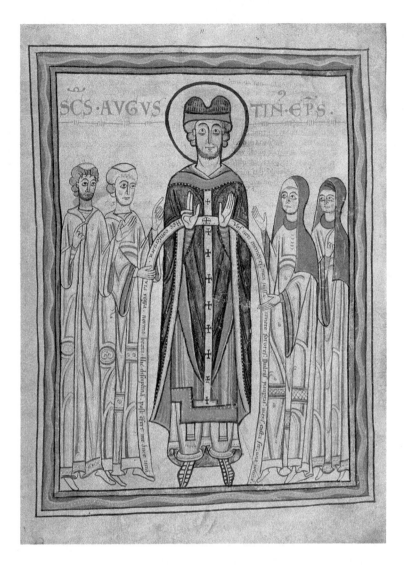

*Figure 10.1* St. Augustine with canons and canonesses from the double monastery of Marbach-Schwarzenthann in Alsace, colored drawing in the Codex Guta-Sintram, 1154. (Bibliothèque du Grand Séminaire, Strasbourg, ms. 37, f. 5r.)

founder. Everywhere in the order there was noticeable resistance against the attachment of new convents.[21]

In September 1252 the Dominicans obtained from Innocent IV a papal bull that freed them from all pastoral responsibilities toward the convents incorporated into their order. The pope granted this privilege noting that pastoral care in female monasteries would be an impediment to the mendicants' preaching activities. The order's most important duty was to be preaching, especially against heretics. Following the complaints of the nuns concerned, Cardinal Hugo of St. Cher, a former Dominican, was able to persuade the priors of the Dominican who had congregated in 1257 for the General Chapter in Florence to declare their readiness to assume pastoral care for all convents that formerly had belonged to the order, even those that had not been incorporated by the general of the order or an expressed decision of its General Chapter. In 1287 Herman of Minden, who from 1286 until 1290 was the *provincial* of the Dominican province of Teutonia, turned the agreement reached in 1257 into an internal instruction for the order, in which he explained to the brothers who were in charge of the pastoral care of nuns their tasks and obligations.

Taking a female community into an order obligated it to undertake forms of pastoral care related to the community. Individual spiritual guidance, which was cultivated and mediated by means of letters, is demonstrated by the long-lasting friendship between Jordan of Saxony, the general of the Dominican order (in office 1222–1237), and Diana of Andalo, a nun from St. Agnes in Bologna.[22] In Jordan's realm of feeling and thought, Diana of Andolo played the role of a "daughter," a "beloved," and a "companion" of whom he was able to say: "You love me more than you are loved by me." The spiritual subject matter of his letters was bridal mysticism as well as Christocentric interpretations of a virginal life. He repeatedly admonished Diana to be disciplined in her ascetic exercises. "Wakefulness, fasting, and weeping" he described and recommended as ways leading to the mystical union with God. In his relationship with Diana, he considered himself a priestly adviser and guide whose role it was to lead her, who had been called to be a bride, to her bridegroom Christ. The correspondence—altogether fifty-eight letters—contains some in which Diana of Andalo is required to show her fellow sisters a missive addressed to her in order to encourage them in their conviction that Jordan's letters were directed to each and every one of them. The letters exchanged between Jordan and Diana are impressive on account of their idiom of a

deeply felt, religiously motivated friendship, which implies a relaxed directness unburdened by ascetic cautionary regulations.

More recently, St. Francis of Assisi (1181–1226) has been lauded for an attitude toward women showing a "spiritual freedom" "without equal during his times."[23] He reassured the women of San Damiano, who were led by St. Clare (1193/94–1253), of his intention to look after them with "loving care" (*cura diligens*). This did not, however, keep him from admonishing his brothers in the *Regula Bullata*, dated 1223, that they were allowed to enter the convents of nuns only with permission of the pope. All his life, moreover, he strove to prevent the attachment of female monasteries to his order.[24] He feared that the pastoral care of women might distract his followers from their true vocation.

After the death of St. Francis, the popes were able to enforce what Francis had tried all his life to prevent: the assumption of pastoral care in female monasteries. By the power of their apostolic authority, they commended the female monasteries in central Italy, France, and Spain to the Franciscan order, which obligated that order to attend to the spiritual salvation of the nuns under their purview. Following requests from the convents, Pope Innocent IV commissioned the order in 1245 with a bull to carry out visitations, preach, hear confessions, and provide masses for the Franciscan nuns forming the monastery of San Damiano. The pastors were to be allowed to enter even the enclosure of the nuns while fulfilling their pastoral duties. The order asked, however, to be reassured that it would have to undertake only pastoral care and visitations in the female monasteries, not secular administrative duties. It also requested that it be relieved of the duty to enlist for female pastoral care brothers who were to be constant visitors in the convents. If necessary, it requested, they should be allowed to delegate pastoral obligations to appropriate chaplains from the ranks of the secular clergy unaffiliated with any order.

## Monastic Pastoral Care of Women Under the Auspices of Dominican Spirituality and Mysticism

What enlivened and reorganized the pastoral care in convents of the late Middle Ages was the inspiring power of Dominican theology and mysticism.[25] The pastoral care of nuns became an important mission of the Dominican order. As Herman of Minden had decreed in 1287, scholarly

brothers (*fratres docti*) were supposed to preach more frequently to nuns and to adapt their proclamations to the educational level of their audience. They also were to ensure that the proclaimed Word of God would become a source of solace and edification. Dominican preachers used their sermons as a means for the mediation of mystical thought. Nuns, thanks to their powers of grace to experience ecstasies and visions and outbursts of joy and pain, were extremely susceptible to the mystical teachings of the Dominicans. Not least for this reason, "the encounter of the preaching monks with the world of the Dominican nuns" is considered today "the social and historical context of a mysticism specific to the order."[26]

It was above all Meister Eckhart (ca. 1260–1328), Henry Suso (1295/1297–1366), and John Tauler (ca. 1300–1361) who influenced the piety and spirituality of the nuns in their pastoral care, through their scholarly theology, mystical spirituality, and not least through the pictorial power of their memorable language. Yet Eckhart, Suso, and Tauler were by no means alone in their efforts. In their orbit during the first half of the fourteenth century, there were armies of German-speaking preachers. Convent chronicles (*Schwesternbücher*) tell us about inspiring contacts and dialogues maintained by nuns with their Dominican preachers, confessors, and advisers. The scholarly brothers and intellectually curious nuns who were interested in philosophical and theological questions were connected by a demanding exchange of ideas about fundamental questions of faith and piety.[27]

Preaching was one task that Dominican preachers were supposed to assume in convents. Personal guidance in spiritual matters was another. At the Swiss convent of St. Katharinenthal (Canton Thurgau), a sister came in secret to the window of the confessional in order to have Meister Eckhart teach and edify her. What she discussed with Meister Eckhart she did not want her sisters to know. Before her death, she broke her silence and told a chronicler that she had conversed with Meister Eckhart about "high and ineffable matters." At the convent of Oetenbach in Zurich, Elsbeth of Oye complained to Eckhart about her inner suffering, whose origins neither she nor learned priests were able to explain. Eckhart gave her the following reply: "It was the pure work of God, which one should commend to God in free serenity."[28] By this, Meister Eckhart meant to say that abandoning the notion of the self leads to unity with God. At the convent of Töss (near Winterthur), Henry Suso advised the mystically gifted Elsbeth Stagel as his "spiritual daughter."

## The Pastoral Care of Nuns as Reflected in Late Medieval Reports of Experience

Another means of pastoral care was the visitation. The reports written by the Cistercian abbot of Himmerode in the late fourteenth century allow us to experience the manner in which visitations were conducted in order to implement appropriate measures of reform in the face of extant grievances. His letters and reports lend a voice to the experiences of Cistercian abbots as father abbots during their visitations of female monasteries.[29]

Extant visitation reports insist on the strict observation of enclosure. They also criticize the luxurious clothing of the nuns, which was against the rules of the order. In the opinion of the visitors, neither the nuns' pointed shoes nor their aristocratic eating habits could be reconciled with their oath of poverty. They also reported arguments and feuds among nuns as well as transgressions against the vows of chastity. Another subject of the visitation protocols and reformers' decrees was confession as an instrument of pastoral care. According to the statutes of the Cistercian order, visiting abbots were supposed to hear the nuns' confessions. A Cistercian abbot was also allowed to commission a suitable priest to hear confessions. Nobody was allowed to hear confessions without the permission of the respective principal of the order. A Cistercian convent was informed in writing about the assignment of a confessor by its father abbot. The monk assigned with spiritual care had to show his credentials as a confessor to the abbess. Sometimes the abbots of Himmerode sent elderly or ailing monks to the convents under their command. The relationship between the nuns and their confessors was ambiguous. There is testimony to amicable understanding as well as disparaging criticism among them. Abbesses and nuns criticized the human and intellectual weaknesses of the confessors assigned to them. Occasionally, their criticism reached the point of refusal to confess to the designated confessors. One reason might have been the personality of the confessor; another might have been resistance against an increase in monastic discipline, which was to be expected. Sometimes the abbots complained that the confessors were not sufficiently supplied with food and clothing, forcing them to fall back on their own means (literally, purse, "*bursa*") in order to maintain themselves.

# Review and Prognosis

From today's perspective, many aspects of the relations between pastors and nuns may appear strange. It is hard to reconcile the nuns' desire for self-sufficiency with the necessity on the part of the priests on whom they relied for the salvation of their souls of treating them as "children" or "daughters." Today it seems almost impossible to comprehend that female monasteries were unable to make decisions in fundamental areas of communal activity and life without the involvement of abbots. Such a lack of self-determination resulted in the emergence of relationships distorted by hierarchical inequity between nuns bound by obedience and abbots authorized to make decisions. Such structures of authority may lose some of their poignancy if we realize that the contemporary theological metaphor that made membership in a monastery tantamount to being a child implied membership in a family whose caring and directing head represented God the Father.

During the last century, historians occasionally maintained that it was pure misogyny that led the monks of the great orders to refuse to extend their pastoral care to the formations of communities of religiously motivated women. It is certainly correct that the normative discourses conducted by theologians, men of the church, and holy orders during the Middle Ages about the theory and practice of the pastoral care of nuns were marred by prejudices about women's powers of reason, their loose morality, and their ability, originating with Eve, to be easily seduced. This, however, did not prevent other voices from repeatedly insisting, in light of different images of woman, that there were arguments in favor of modeling the communal life of women and men on the communality of the early church, which was unmarred by original sin.

Nonetheless, the great orders of the High and later Middle Ages did not voluntarily develop initiatives fostering open access to the monastic vocation by forming female branches of their organizations. They did not act but reacted, and they did so for a long time by rejecting initiatives and decrees. The pastoral care of women was not a goal of the orders anchored in rules and statutes. Monks living in communities wanted to celebrate divine services, study and meditate, and convert infidels. They were afraid that the numerous women seeking pastoral care would soften the profile of their orders and endanger their identity. The Dominicans

described as their essential and highest goal (*finis ultimus*) the public "sermon for the salvation of man" (*praedicatio ad salutem hominum*). The pastoral care of nuns required time and energy that from the perspective of the monks and mendicants in question were urgently needed for more essential obligations.

When the great orders, prompted by the official church and laypeople founding convents, finally declared themselves ready, under certain conditions, to assume the pastoral care of convents, they created a religious form of living for women that was fundamentally based on enclosure. Enclosure provided a space specifically designed for the life and experience of women that demarcated them against the social environment. In general, enclosure, which was strictly enforced with great severity in convents, was justified with the argument that women needed firmer discipline on account of their natural weaknesses. The rule of the order for convents was based on the division of labor between men and women, specifying for men public opportunities for life and work—parish masses, study at the university, public sermons, and missions—whereas women were cut off from public church-related services and any possibility of active engagement with the world. The reciprocity between men and women institutionalized in double monasteries required that nuns pray for the monks and take care of their clothing.

The pastoral care of nuns made history by paving the way for the emergence of mysticism, that spiritual movement of the fourteenth century that shaped the history of thought and spirituality in fundamental ways by its inquiries, theological patterns of thought, and religious modes of experience. Learned Dominicans considered it a challenge to preach to nuns steeped in the aura of mysticism. In their sermons, Dominican preachers sought to do justice to the education and piety of their female audience. Writing in the vernacular, they strove to satisfy the nuns' demand for reading materials that served pious contemplation and theological immersion. Dominicans well versed in theology encouraged and asked nuns who were mystically gifted to put their experiences of God into writing in order in turn to make these accessible for others to read. It was through the conditions of the pastoral care of nuns that the proper spiritual value of the vernacular was discovered. Moreover, pastoral care in convents proved to be a constitutive factor in the rise of the vernacular in mystical sermons and edifying literature. The desire of nuns

to experience God greatly enriched the spiritual and religious culture of the late Middle Ages.

## Notes

1. For the anthropological, theological, and legal bases for the traditional exclusion of women from priestly offices, see Meer 1965; Raming 1973 and 2002.

2. Césaire d'Arles 1988: chaps. 36–37 [XXXIII–XXXIV], 218–221. See also Nolte 1986.

3. "Institutio sanctimonialium" 1906/1979:455, no. 27.

4. Quoted in Meer 1965:155.

5. *Acta Innocenti Papae III* 1944:325.

6. For the attitude of the Cluniancensians and the Hirsau monks toward the female religious of their time, see Wollasch 1992; Küsters 1991.

7. See Schreiner 1982:273–277.

8. See Parisse 1992.

9. For this and subsequently, see Grundmann 1935/1970:43–50; Felten 1984:93–102; 1992:286–291; De Kegel 2003.

10. Quoted in Felten 1992:289.

11. For this and subsequently, see Krenig 1954; Thompson 1978; Degler-Spengler 1985; Felten 2000a; Ahlers 2002:21–46, 47–94, and 195–227.

12. See Bernards 1955:167–175; and 1956.

13. Seyfarth 1990:45*.

14. Ibid.: 46*.

15. Ibid.: 149.

16. For this and subsequently, see T. P. McLaughlin 1956:258–260; Abelard 1979:282–289. Abelard's rule for a double monastery is examined and interpreted in Jenal 1994 and Griffiths 2004.

17. M. M. McLaughlin 1975.

18. Lutterbach 2004:139.

19. Muckle 1955:242.

20. For this and subsequently, see Griffiths 2003.

21. For this and what follows, see Grundmann 1935/1970:208–252 and 284–303; Decker 1935.

22. See Löther and Tramsen 1998 and Coakley 2004.

23. Marco Bartoli, "Franziskanerinnen," in *Lexikon* 1989:4: col. 822.

24. For this and subsequently, see Grundmann 1935/1970:253–273 and 303–312.

25. For the normative foundation and conventual practice of the Dominican care of nuns, see especially Bürkle 1999:57–131. For the meaning and function of

images in the pastoral care of nuns as practiced by the Dominicans, see Hamburger 1998b:197–232 and 522–534.

26. Ruh 1985:111.

27. Acklin Zimmermann 1993:54.

28. Ruh 1996:242.

29. For this and what follows, see Ostrowitzki 1999. For the legal framework and pastoral practice of the visitation by the Cistercian abbots in Cistercian convents, see also Oberste 1996:120–130.

# Household and Prayer

*Medieval Convents as Economic Entities*

WERNER RÖSENER

What was the economic foundation that made it possible for the numerous convents and female communities of the Middle Ages to realize their religious goals? Neither monasteries nor convents existed outside the material world. To the contrary, the material world largely determined the quotidian lives of monks and nuns. Male and female founders had to provide a sufficient economic basis of goods and income to make possible the religious purposes of the foundation. The problem of the difference between male and female monasteries arises in this context. How do convents differ from monasteries in economic matters? Do convents have an economic basis different from that of male monasteries and orders? Convents obviously depended more than monasteries on reliable material security, because strict rules of enclosure prohibited female communities to a large extent from earning their own living. The present state of research is characterized by the fact that the extant sources for the history of female monasteries have generally been less thoroughly analyzed than those of male monasteries. This deficit is especially true when it comes to convents' economic affairs, because they are mostly evaluated as religious institutions and less as economic entities. In light of the difficulties posed at the outset by this situation and the great discrepancies among different female communities, the following essay can attempt no more than a preliminary overview of the economic conditions of medieval convents.

## Older Convents: Foundations for Canonesses

For the oldest convents in eastern France and in the German realm of the Ottonians and Salians, very few sources survive. Problems with sources aside, foundations of female monasteries took place only very infrequently. Moreover, it is difficult to identify early convents and *Stifte* with a specific monastic rule. In the case of female convents, the validity of the Benedictine rule can often only be assumed. In addition to the rule of Benedict, the Institutio sanctimonialium issued by the imperial Diet of Aachen in 816 established an important standard for female monasteries.[1] The Institutio provided the first set of standardized norms for female communities in the realm of the Franks and came to be of great importance not only for the development of communities of canonesses in the early Middle Ages but also for the *Frauenstifte* of the High and late Middle Ages.[2]

What pronouncements concerning the economic matters of female communities following a canonical model can be found in the Institutio sanctimonialium? The number of members is related to the property of the community: the abbess is allowed to admit only as many women as can be supported by the financial means (*stipendia*) available. Any extant abuses are to be eliminated, and all religious women are to participate equally in whatever food and drink the *stipendia* provide. Concerning sufficient provisions, the Institutio aims at the equal treatment of all members of the convent in an attempt to form the members of the community into a homogeneous group. The abbess was required to provide each woman each day with three pounds of bread, the main staple of the time. In addition, the women were to receive up to three quarts of wine, depending on the region and special occasions observed by the convent. Smaller communities were asked to admit a smaller number of pious women rather than jeopardize proper provisioning and secure property. In addition to bread, the abbess was to give members of the convent other food, such as meat, fish, legumes, and vegetables. The provision of food was supposed to be especially generous on holy days. It was therefore recommended to abbesses that their indentured farms support not only agriculture but also cattle breeding and sufficient vegetable gardens.[3]

Guarantees for the material provisions of religious women served to create sufficient free time for prayer and service to God. The female community undoubtedly found its identity and justification in holy services; the daily routine therefore was marked and largely filled by praying the canonical

hours. Was there any time left for other activities? Two chapters of the In-
stitutio sanctimonialium of 816 refer to the handiwork of women. In addi-
tion to their obligatory prayer (*divinae lectiones*), religious women were also
obliged to engage in manual labor (*manuum operationes insistere*).[4] It remains
unclear, however, what forms of manual labor were meant by this. Such labor
probably entailed various activities intended mostly to prevent "idleness."

*Frauenstifte* were founded especially frequently in the tribal territory
of Saxony, which had been annexed to the realm of the Franks by Char-
lemagne. Important aristocratic families donated parts of their estates for
the economic provision of their monastic foundations.[5] These foundations
also serve as indications of the integration of the leading social strata of
Saxon society into the imperial Frankish aristocracy and of the readiness
of the Saxon nobility to participate actively in the Christianization of the
country. The Saxon *Frauenstifte* of the ninth century can thus be seen as
a means by which the Saxon nobility sought to establish their identity
within a Christian way of life.[6]

The economic structure of a female cloister living according to a canon-
ical model can be demonstrated through the example of the *Frauenstift* in
Essen, which was founded in 845/50 by Altfrid, the bishop of Hildesheim,
and the first abbess, Gerswid.[7] In this foundation for canonesses, the holy
women led a communal life in prayer, work, and church service under the
direction of an abbess. By means of donations and privileges from kings
and popes, Essen achieved a largely independent position and became one
of the first great imperial abbeys. Its obligations to the empire consisted
above all of material tributes. Numerous servants provided protection for
the foundation and administered the extensive estates.

In terms of dominion over territory, these properties were organized
in the form of villas according to a system known as socage (in which, in
return for tenure, tenants provided goods and fulfilled duties other than
military service). The convent acted as the landlord over the socage estates
and their dependent farms. The two largest groups of estates were situated
in the closest proximity to the foundation: the *Viehhof* (literally, the cattle
estate) and the estate at Eickenscheidt. These were the principal properties
within a landlord system responsible for the provisioning of the monastic
household. In addition to the bailiff of the manor, who took care of the
legal administration of the association of estates, the economic administra-
tion of the *Viehhof* was entrusted to an agricultural administrator (*Baumeis-
ter*, or *magister cultura*). Under his supervision, the twenty-seven subsidiary

farms located near the main estate rendered stable staff and labor services. Organized for the working of the extensive demesne land, these farms were managed by indentured farmers and serfs who maintained a continuous presence. Indentured servants and craftsmen were housed on the territorial estates of the cattle farm; they had to pay tithes to the main estate from their dependent farms. According to the testimony of the sources, 112 subsidiary farms belonged to the *Viehhof.*

Economic structures comparable to the *Viehhof* can be found at the Eickenscheidt estate located near Essen-Steele. Here, too, the bailiff joined an agricultural supervisor in the economic administration of the farm. The farming of the manor required numerous labor services, such as the plowing and harrowing of the fields and the mowing and binding of the grain. The demesne farms in the region of the later *Stift* had a relatively strict constitution dominated by the landlord. In the early Middle Ages, the office of the agricultural administrator points to the autonomous dominion of the landlord, which was largely reduced in the course of the High and late Middle Ages, when the villa system slowly began to disintegrate. In the properties of *Frauenstifte* in the Westphalian region, however, the villa system was less well established. Here other forms of lordship, involving the tithing of, for the most part, natural goods and money, predominated.

The *Frauenstift* of Essen was granted the immediate protection of the king by means of privileges of immunity from the Ottonians. This judicial transfer of authority reinforced the economic efficiency of the foundation. In the course of their territorial politics, the abbesses of Essen succeeded in concentrating the convent's properties and in constructing a baronial realm of dominion in the vicinity (fig 11.1). Thanks to its aristocratic origins, its independent position in the world, and its improved legal standing, it was even possible for Essen to achieve elevation into the ranks of imperial princes (Reichsfürstenstand), a development that certainly was not typical of most female monasteries. Economic structures similar to those at Essen can be found in many older convents such as the Saxonian *Stifte* at Liesborn and Gandersheim or at Buchau in southwestern Germany.[8]

## Benedictine Convents

A large number of the older convents lived according to the Rule of St. Benedict. Monastic foundations belonging to this Order had spread

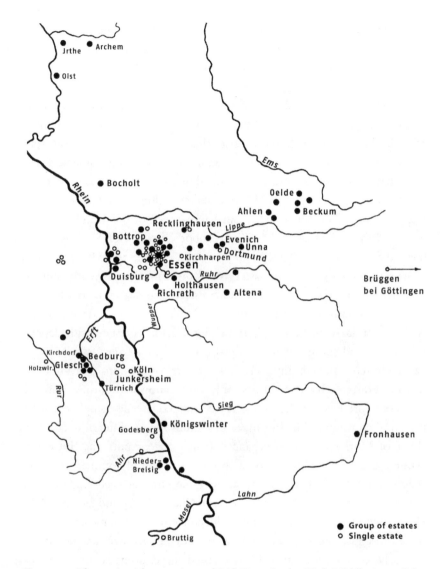

*Figure 11.1* The territorial possessions of Stift Essen in the High Middle Ages. (After Weigel 1960: 258).

throughout the Western world from the early Middle Ages. During the monastic reforms of the High Middle Ages, numerous convents were founded in proximity to monasteries under the influence of Cluny and Hirsau, especially in the German southwest. In these double monasteries, which were long neglected by scholars, the women enjoyed not only pastoral care and physical protection but also economic security.[9] Because of their close ties to male monasteries that derived their livelihood from properties that belonged to them as landlords, it does not come as a surprise that the convents were characterized by similar economic structures.

The development of a Benedictine abbey as double monastery can be traced at the abbey Muri, the familial monastery of the Habsburg family in northern Switzerland.[10] When Abbot Giselbert of St. Blasien reformed the monastery of Muri, nuns as well as monks were housed there. Muri remained a double monastery until the end of the twelfth century, at which point the nuns' convent was transferred to nearby Hermetschwil. This new location was centered on an old villa of Muri; according to the Acta Murensia, to this estate there belonged a socage estate with dependent farms and several smaller outposts, as well as a tavern, a mill, and a parish church.[11] In economic terms, the transfer of the nuns' convent from Muri to Hermetschwil was at first only a relocation within the territorial estate of Muri, because the monastery continued to take complete care of the nuns' convent and had to make provisions for its material needs. The abbot of Muri retained governance of the convent until the thirteenth century and entrusted the prior with the execution of commercial transactions. From the early thirteenth century, the nuns received income from a larger number of places both in the immediate vicinity and farther off. In Hermetschwil itself, the provision of the convent with the most important staples was guaranteed by a central farm tended by its own dependents. In the early fourteenth century, Muri granted the convent economic independence and had a proper estate administration set up in Hermetschwil.

The abbey of Benedictine nuns in Urspring near Schelklingen in Swabia originated as an independent convent.[12] Urspring was founded as an independent convent in 1127 after having received its founding members from Amtenhausen in the Black Forest. The founding charters name the brothers Adalbert, Rüdiger, and Walther of Schelklingen as donors of the initial estates. The properties that Urspring received in the course of the twelfth and thirteenth centuries were divided among a great number of places, not only nearby but also far removed, as was the case at other Benedictine

monasteries. At the end of the fifteenth century, the abbey's estates included around four thousand hectares in fields, one thousand *Tagwerk* (a measure of how much land could be mowed in one day), many mowing meadows, about 140 gardens, and over seventy forests. These properties were quite extensive and were tended by numerous indentured farmers who lived in a state of dependency on their landlords.[13] For a long time, the administration of these properties was handled from Urspring by a prior. Parallel to the expansion of its properties, in the fourteenth century the convent founded urban centers in the neighboring towns of Ehingen and Ulm. The convent's farmers delivered tithes of grain and money to these centers. Remaining tributes, consisting of chickens, geese, and eggs, were taken to the convent. Urspring's own demesne farming under the auspices of lay brothers was originally centered at the convent itself. After the abolition of lay brothers in the fifteenth century, the convent apparently felt compelled to let out larger parts of their own property to citizens of Schelklingen in order to ensure regular farming of these properties and the regular delivery of tributes.

## Convents of the Reform Orders (Premonstratensians and Cistercians)

The Premonstratensians, whose foundations spread all over Europe under Norbert of Xanten (1080/1085–1134), recognized from the beginning the importance of the religious women's movement. In addition to numerous double monasteries, which combined male and female houses, they also founded female monasteries as independent entities. Around 1180 a convent founded in Altenberg near Wetzlar joined the Premonstratensian order as an independent convent.[14] Because of the absence of a foundation charter, there is no precise information about the basic endowment of this female community. Only beginning in the thirteenth century are there more reports about its properties and farming estates. The most important properties were the neighboring villages of Beil, Dalheim, and Albshausen. In addition, there existed other properties dispersed among numerous towns in the vicinity. On the basis of a tax register from the middle of the fourteenth century, it can be stated that Altenberg was a tithing foundation in the manner of Benedictine monasteries.[15] The convent, however, also tended its own farms, which it finally gave up only at the end of the sixteenth century. Early concentrations of convent-operated farms were

located in the circle of Heuchelheim, Dagobertshausen, and Hülshof. To the east of the convent site, Altenberg owned large farm buildings, which were meant for the farming done by the convent itself. This was performed not by lay brothers but with the help of servants of the convent and paid laborers.

Various groups and individuals participated in the foundation of Cistercian convents. To a large extent, aristocratic dynasties and secular rulers but also bishops founded new Cistercian convents or helped extant religious female communities convert to the Cistercian order. They had to provide these new foundations with the necessary economic foundation, because, beginning in 1225, the order had made the acceptance of new convents conditional on their being provided with sufficient property to ensure that the nuns could live independently within strict enclosure without resorting to the collection of alms. In the region of Lake Constance and Upper Swabia, Eberhard of Rohrdorf, the abbot of the Cistercian monastery of Salem (1191–1240), was instrumental in helping Cistercian nuns establish their own institutions. As abbot of Salem, he supported from 1212 to 1240 the foundation of no fewer than six Cistercian convents, almost all of which had emerged from female communities and donations of prominent aristocratic families.[16]

Once the female and male monasteries of the Cistercians had achieved equality under the order's statutes, they also corresponded in terms of their organizational and economic structures. There were, however, important differences, which were connected with the special position of women within the society and church of the Middle Ages. Already the choice of a location for the foundation resulted in deviations from the norms accepted for the male monasteries of the order. Often, female Cistercians were located in the vicinity of larger settlements, even within the walls of a town, with parish churches providing their primary endowment and thus securing with their income a basis for the existence of the convent foundations.

At their foundation, Cistercian convents received a father abbot (*pater immediatus*) commissioned from a neighboring Cistercian monastery, who was empowered with certain rights.[17] The father abbot was especially responsible for the pastoral care of the Cistercian convents under his control. He also determined how many members the convent was allowed to admit and vetted the candidates as well as the lay brothers and manual laborers. In addition to spiritual concerns, he also had authoritative influence over the convent's economic life. This was not limited to counseling the abbess

but also often included authority to sanction property transfers and other financial transactions and approve administrative officials and individuals commissioned with representing the interests of the convent. Especially in these areas, the order increased the competence of the father abbot until Cistercian convents often depended on him in both spiritual and secular matters. During his annual visitations to the convents under his care, he examined the spiritual as well as economic concerns of the convents.

What was the economic background of convent members? How was the community's daily economic life organized? Like their male counterparts, the convent *familia* of Cistercian nuns consisted of diverse groups.[18] At the center were the nuns, who for the most part came from aristocratic dynasties or the families of urban patricians. Many convents dedicated themselves to cultivating the aristocratic-patrician element by drawing attention to their noble founders. This took the form, for example, of engraving their coats of arms on the silverware and other utensils. Between the prescribed performances of the hours, the nuns occupied themselves with the administration of their household economy. For this purpose, officials were commissioned by the abbess or elected by the convent. In addition to economic offices in the narrower sense of the term, there were positions internal to the convent such as the mistress of novices, of studies, of guests, and of the sick, as well as the scribe and the gatekeeper.

Lay sisters, who held the status of *conversi* within Cistercian convents, were responsible for physical labor in the monastery, kitchen, laundry, and garden, as well as for serving the nuns. As far as can be ascertained, they came from farming families or the lower strata of the urban population. They lived apart from the nuns according to the rules of the order, occupied their own seats in church, and wore a special converse's habit. They had to comply fully with the vows of chastity and poverty, but for them the rule of enclosure was less strict because of their various activities. In the course of the late Middle Ages, the number of lay sisters decreased in many convents; the housework that they had previously performed was done by secular maidservants, who were paid wages. The size of convents varied greatly, but diminished over time. Around 1280 there were fifty nuns each in the Westphalian convents of Bersenbrück and Benninghausen. In 1345 around eighty nuns lived in the Cistercian convent of Lichtenthal near Baden-Baden. In 1382 there were altogether 125 women at Heiligkreuzthal, not differentiating between nuns and lay sisters.[19]

In Cistercian convents, there were, in addition to the nuns and the lay sisters, several lay brothers, who lived according to rules of the order similar to those observed by the lay sisters.[20] They wore the same habit of the order as the converses in male monasteries and lived in a separate area of the convent, which often was situated in the forecourt near the workshops. These lay brothers often assumed leading administrative functions and performed important duties in relation to the convent's juridical dominion. For the convents, they usually represented the most important contact with the outside world, because the male converses were not subject to the same strict rules of enclosure as the nuns. This explains how it was that they were able to achieve considerable influence in the administration and economy of certain Cistercian convents. From the group of converses, abbesses recruited judicial officials and the highest administrators of the convent economy and governance. Lay brothers headed the convent's granges, farms, and administrative centers in the towns; they appeared in court as procurators of their convents; they organized the convent's trade and took care of the convent's guests. In addition, they also took over tasks common for converses in male monasteries, such as agriculture, viticulture, and the monastic workshops. Since grange farming and demesne economy was generally practiced less in female convents than in male communities, the jobs of lay brothers were limited to a considerable extent. Cistercian convents like Rottenmünster and Wald exercised control over distinct territorial estates with taxes paid predominantly in natural goods and cash, a system that generally differed little from that found in Benedictine convents.[21] Most Cistercian convents were characterized by dispersed holdings in large, individual estates and farms with dependent farmers.

## Female Monasteries of the Mendicant Orders

Beginning in the thirteenth century, the female communities of the mendicant orders, the Dominicans and Franciscans, came to play a dominant role. Alongside the monasteries of the Franciscans, the convents of St. Clare gained widespread importance. They attached themselves closely to the rules of the traditional convents, living in strict enclosure and focusing on the regular observance of the Divine Office and contemplation. They differed from the convents and communities of canonesses, however, in their insistence on radical poverty, a matter on which Clare (1193/94–1253) and

Francis (1181–1226) agreed completely. The traditional means of funding convents of Poor Clares can be traced through the example of the convent of St. Clare at Söflingen near Ulm.[22] This convent, which appears in charters in 1237, began as a community of sisters that incorporated itself as a conventual foundation on the land of the Stauffer imperial city of Ulm. The convent at Söflingen was founded with the collaboration of the Franciscans, who were active in Ulm from 1229, the Swabian nobility, and the leading citizens of the rising imperial city. The archive of the convent's charters contains numerous documents that testify to the ever-increasing property of this highly regarded community. The statutes of the Poor Clares did not prohibit this accumulation of possessions and the economic administration that they necessitated. The avowed poverty of individual sisters was maintained, because each renounced private property and the free disposition of her possessions. A review of the history of property belonging to Söflingen until the fifteenth century shows a continuous growth of its landed estates and the taxes derived from their natural goods and tithes. This property, which guaranteed a solid economic base for this female community, concentrated around three focal points: Söflingen, the city of Ulm, and estates in Neuffen and Esslingen. The village of Söflingen slowly was subsumed under the convent's control and formed a compact territory space with properties in the immediate vicinity.[23] The administration was handled by procurators engaged by the abbess, who at first were lay brothers and later secular servants. Necessitated by the expansion of the properties and the ensuing administration, a *Hofmeister* or central administrator headed the hierarchy of officials and the other employees of the convent.

## The Communities of the Beguines

Following the religious awakening of the twelfth and thirteenth centuries, many women apparently decided, even without a connection to an order, to live in communities that they governed themselves. Such communities originated in the towns of Flanders and spread from there in the thirteenth century to the Rhineland and areas within Germany.[24] Pronouncements about the economic situation of the beguines have to remain fragmentary, because research has not been able to clarify either their exact date of origin or their precise social and religious profile.[25] For the most part, these women lived in communities of ten to seventy members according

to a strict set of rules but without having taken vows to adhere to the rule of a particular order. When joining a community of Beguines, they gave up their former social positions, renounced marriage and all secular possessions, and committed themselves to chastity, voluntary poverty, and a religiously motivated life. In this way, the beguines chose a form of life that made it possible for them to be active in charitable works according to the gospel. It also ensured for them an autonomous economic existence without institutional dependence on the association of an order and without monastic enclosure. They fulfilled such tasks as nursing the sick, dressing the dead, and offering a simple education for girls in some towns. They made their living from textile crafts such as spinning, weaving, embroidering, and sewing. In some cities, their activity extended to include such occupations as the brewing of beer and the copying of manuscripts. Because of the lack of enclosure, to which traditional convents were subjected, the beguines were largely able to earn their own living by such means.

## Monastic Economy and Religious Reform

Female communities of the Middle Ages required a secure economic foundation base in order to attain their religious aims. The efforts at reform made in convents of the late Middle Ages permit one to observe the extent to which a religious way of life depended on economic security. Reforms in late medieval convents could be realized successfully only if they coincided with a renewal of the convent's economic basis.[26] As a result, monastic reforms addressed not only spiritual matters and the convent's inner world but also economic and social issues as well as matters involving governance.[27] As a result, the monastic reforms of the late Middle Ages cannot be considered solely in the context of internal efforts aimed at renewal within the orders. They were also motivated by external economic forces and by the support of secular powers, which for political reasons instigated reform with the goal of stabilizing their power. The feudal lords were interested in enhancing monastic discipline, gaining stronger control over economic matters, improving the use of financial resources, and decreasing the influence of regional aristocratic groups in the staffing of the convents.[28] The members of the city councils were also eager to guarantee the welfare of religious institutions and ensure the city's influence on the convents within city walls.

In the late Middle Ages, centers of monastic reform could be found in the Benedictine monasteries of Melk on the Danube, Kastl in the upper Palatine, and Bursfelde on the Weser. The Bursfelde reform movement permits an especially detailed charting of the connection between religious and economic measures in the affected convents.[29] For individual monasteries, the reorganization of their economic foundations and the restructuring of their finances were important preconditions for the revival of monastic discipline and observance of the rule. For female convents no less than male monasteries, economic and religious life stood in close relationship with one another. This is a field that should not be neglected in investigations of the religious life of monastic groups.[30]

## Notes

1. "Institutio sanctimonialium" 1906/1979; Schilp 1998.
2. See Moraw 1980:9–37.
3. "Instititutio sanctimonialium" 1906/1979:446 (canon 12), 447–448 (canon 13).
4. Ibid.: 445.
5. See W. Kohl 1980:112–114; Leyser 1984:105–107; Parisse 1983b.
6. W. Kohl 1980:137.
7. See Weigel 1960; Rösener 1980:139; Schilp 2000; Gerchow 2002.
8. W. Kohl 1975; Goetting 1973; Klueting 1986; Theil 1994.
9. Gilomen-Schenkel 1986:72–74; Muschiol 2003b:67.
10. See "Acta Murensia" 1883; Wollasch 1961; Rösener 1991:300–302.
11. Dubler 1968:24–25; Rösener 1991:433.
12. Eberl 1978.
13. Ibid.: 337.
14. Doepner 1999.
15. Ibid.: 47.
16. Rösener 1974:163–164.
17. Kuhn-Rehfus 1980:130.
18. Ibid.: 130–131.
19. Ibid.: 132.
20. See Toepfer 1983:171–173.
21. Kuhn-Rehfus 1992; Reichenmiller 1964.
22. Frank 1980. See also Cat. Ulm 2003.
23. Frank 1980:65.
24. Gleba 2002:118–119.
25. Simons 2001b.

26. See Elm 1980:188–190; Neidiger 2003a:81–83.

27. See Gleba 2000:133–135.

28. See Stievermann 1989.

29. Becker 1980:181–183.

30. Rösener 1983:245–247.

# Wanderers Between Worlds

## *Visitors, Letters, Wills, and Gifts as Means of Communication in Exchanges Between Cloister and the World*

GABRIELA SIGNORI

## Separated Worlds

From the beginning of Western monasticism, the cloister and the world have been perceived in antithetical terms. At the outset, theoreticians of monasticism hardly paid any attention to the strict spatial separation of the two worlds. They were for the most part concerned with values, not with boundaries or, for that matter, walls, that would make one world invisible to the other. Female monasteries present a different picture, one in which, from the sixth century onward, the magic word is "enclosure." According to Caesarius of Arles (ca. 479–542), the originator of subsequent thinking on enclosure, even mothers and sisters of enclosed nuns should not set foot within the cloister.[1]

The papal bull *Periculoso*, promulgated by Pope Boniface VIII (in office 1294–1303), which took Caesarius's *Regula ad moniales* (Rule for nuns) as its point of departure, represents a further milestone in the history of thought on enclosure.[2] From this moment, enclosure and reform went hand in hand when it came to female monasteries. "If they [women] wish to live in a religious community, they should keep themselves far from any communication with friends in the world," declares a visitation report from the year 1497.[3] No woman, so goes the line of argument, can both be with God and take pleasure with her friends in transient things. Other statues reduced the contact of nuns with the outside world to conversa-

tions conducted at the *Redefenster*, a window designated for this purpose, and then only in the company or control of two other sisters. Veils or grilles made eye contact with relatives and friends difficult, if not impossible. According to the Gospel of St. John (1 John 2:16), "all that is in the world, is the concupiscence of the flesh, and the concupiscence of the eyes, and the pride of life, which is not of the Father, but is of the world."[4]

For the advocates of enclosure, "the world" consisted primarily of the world of relatives. The families of the spirit and of the flesh remained, as in the thinking of Caesarius of Arles, irreconcilable. This may also explain why for so long the two worlds have hardly been brought into contact with one another in research on female monasticism. As a result, we know much more today about life in monasteries and reform movements of the medieval religious orders than we do about exchanges among monasteries. Even less is known about exchanges between cloister and world and the place of family members in such exchanges, although such traffic was no less essential to the prosperity and well-being of the convent than was adherence to the rule. It cannot be my task here to fill the gaps in prior research. In the following, it is my wish, rather, to present a few, select aspects or points of contact: letters, gifts, visits, and other forms of contact between cloister and world relating primarily, if not exclusively, to the later Middle Ages.

To Be in the World . . .

In the late Middle Ages, the overwhelming majority of female monasteries were not strictly observant of the rule. To this extent, if we wish to discover the many points of contact between cloister and world, the discussion concerning monastic reform can methodologically be very misleading. In the eyes of opponents of reform, a regular process of exchange between cloister and world was indispensable. Only in this way, for example, could young women be encouraged to enter convents; only in this fashion could the continuance of the community be secured. This at least was the view of the early sixteenth-century jurist Lucas Conratter, who took up the pen to argue against strict enclosure.[5] Research has hardly begun to compile systematically the arguments of opponents to reform. It appears, however, that many families were simply not willing to agree never to see their daughters again.

In considering such questions, one has to take into account a multitude of ways of life, differing by region and locality, often within the compass of a single order's habit. Another consideration is our rather diffuse knowledge of life in late medieval *Damenstifte*, a concept that first received precise definition toward the end of the fifteenth century. Exchanges with the world took on different forms in different regions, depending on the site and surroundings of the monastery. Communication with the outside was naturally easier in cities than in the remote valleys or hilltops that Benedictines had originally sought out. Even in cities, however, the relations of convents to public life were very varied. For example, in Biberach, the sisters of the community on the Ledergerberstrasse, the only female monastery in the city, left their house to attend important feasts at the city church. According to an eyewitness, their stalls, which were fenced in and closed by a door, were located near the bride's entrance. From above, however, it was still possible to see into them.[6]

Other cities were less eager to see their nuns out in public. This also held true for the processions that were so important a part of communal life. For example, in Strasbourg, the magistrate limited the participation of female monasteries to prayer within their walls.[7] In the late Middle Ages, there was no doubt about the benefits of such activity for the public good.[8] For this reason, the council of the nearby city of Basel had the monastery of Maria Magdalena an den Steinen reformed.[9] In Basel, however, the nuns took a more active role in the intercessory processions than they did in Strasbourg. Each of the four female monasteries in the city was visited during rogation week. According to the "Ceremoniale" (1517) of Hieronymus Brilinger (d. 1535), the principal singer was not permitted to sing at St. Klara (Kleinbasel) "because the nuns in the choir raised their voices in chanting the antiphon 'Regina celi.'"[10] In Zurich, the abbess and canonesses of the Fraumünster, carrying their treasury of relics along with them, took part in the annual Pentecost procession, walking behind the canons from the Großmünster through the streets of the city.[11]

Escapes from the everyday routine of life in the cloister such as processions were, however, seldom. On the other hand, break-ins were frequent, especially during the period of Carnival.[12] In his old age, the Frankfurt patrician Bernhard Rohrbach (d. 1482) recalled a youthful prank: "In the year 1467, on the Monday before Mardi Gras, St. Appolonia's feast day, of the people listed here [seventeen in all] groups of four took turns carrying

Johann Landecken in a wheelbarrow, in which straw was placed, and Johan Landecken was covered with *Lebkuchen* [gingerbread cookies], and he and the others were wearing long bathing costumes and had tied their heads with handkerchiefs and ran about with burning straw bundles and shouted '*nobis clares*' and thus went back and forth through the city and to the tavern called Limburg and to the convent of the *Weissfrauen* [White Virgins], there we sat him [Landecken] on the barrow in the middle of the parlors and danced round and round with the virgins."[13] The virgins with whom the sons of the Frankfurt patriciate carried out these shenanigans were, for the most part, their own sisters. These and other similar incidents led the council to reinstate its ban on Mardi Gras celebrations.

## Visitors and Other Guests . . .

So much for exceptions; now for the rule: visits were the principal means by which regular exchange with the world was permitted. Canonesses had the right to visit relatives for several weeks, even, if less frequently, for months at a time.[14] The sisters could also receive visitors in return. Many cloister complexes had in their west wings various rooms for guests, whether in halls or separate houses.[15] Family members, administrators, those conducting visitations, lords and ladies, bishops and other church and secular officials all came to visit, as did frequent messengers bearing letters or gifts.[16] Monastic account books inform us, inter alia, concerning the costs associated with high-ranking visitors. Episcopal registers and visitation reports provide information concerning violations of both active and passive enclosure.[17] The pope provided dispensations so that family members could visit relatives living in strict enclosure. Friedrich and Sigismund of Brandenburg received as well papal permission for both themselves and their mother and siblings to visit whenever they pleased their beloved sister Dorothea (d. 1520) in the monastery of Poor Clares in Bamberg.[18] Exceptions were also made as a matter of course for high-ranking individuals such as the king of France.[19]

Many female monasteries raised and instructed young women from families of the nobility and the urban bourgeoisie in both Latin and the German vernacular.[20] In 1520 Luther (1483–1546) praised nuns for this in his polemical tract *An den christlichen Adel deutscher Nation* (To the Christian nobility of the German nation).[21]

In addition to a series of manuscripts intended for use in school instruction in the cloister, the monastery of Ebstorf in Lower Saxony also preserves an exercise book with diarylike entries written by various female students. Helmar Härtel remarks: "The texts are written in the hands of untrained students. One employs a relatively careful textura [a formal bookhand], but the letters are rather clumsy, at a student level. The script is not fluent; there are numerous mistakes and spelling errors. . . . A whole series of hands can be distinguished, but all are based on a single, primary model, so that, loosely put, the students can all be said to belong to the same scriptorium."[22]

In the course of the fifteenth century, nuns' knowledge of Latin improved considerably. Nevertheless, in female monasteries the vernacular remained the principal language in which business was conducted, knowledge conveyed, and moral and religious instruction carried out. Most noble houses, however, deemed what girls learned in monasteries insufficient for the conduct of political affairs. As a precaution, when in 1505 Anna von Nassua (d. 1514), the duchess of Braunschweig-Lüneburg, sent her granddaughter Elisabeth to be educated at the Lower Saxon convent of Wienhausen, she also sent a master from court![23]

The younger the girls were, the more frequently they expected visits from their parents and their siblings. Were a visit not to take place, the disappointment was great: witness the letter from nine-year-old Margarethe, daughter of the Basel printer Johannes Amerbach (d. 1514), dated March 14, 1499. Her parents had placed her in the care of the Cistercian nuns of Engeltal near Muttenz, not far from the city of Basel. Only her mother, Barbara (d. 1513), however, visited her on a regular basis. She seldom saw her busy father. To her mother, she complained that he had promised to visit her soon, and she had looked forward to it greatly. Might he not be ill? she inquired.[24] Even after profession, visits from relatives remained one of the most frequent topics in the letters of nuns.

## Letters as Substitutes for Absent Visitors?

To her father, Pilgrim von Reischach, Amalia, the abbess of Lindau (1491–1531), writes that he should visit her as soon as possible.[25] Barbara Fürer, a nun in Gnadenberg, complains to her brother that if he were as fond of her as she of him, he would already have come much earlier.[26] Brigitta

Holzschucherin, a nun at Pillenreuth, desires nothing more than to have her mother come visit but gripes that, as she is old and weak, she instead will send her a St. John's Gospel and, to her uncle, the recipient of the letter, a handkerchief, in her words, "a childish nun's present."[27]

From the earliest times, letters connected the world outside the cloister with the world within its confines. That said, a letter is not simply a paper substitute for an absent person. Sometimes it also functions as a messenger, announcing or promising a visit. Barbara Fürer impatiently awaited the pending arrival of her mother, Walburg: "and come quickly, I pray you, dear mother."[28] Letters from the monasteries of Maihingen, Langenhorst, Lüne, and Söflingen, the latter published by the cultural historian Georg Steinhausen, all revolve around the subject of visits.

For an abbess, knowing how to write a letter was indispensable to governance. The necessary know-how could be found in collections of model letters. These same handbooks also taught how to address an abbess, a prioress, and other officeholders, namely, the one with the epithet "venerable," the other with the adjective "respectable."[29] The ability and possibility to write letters allowed ordinary nuns to stay in touch with relatives or to cultivate other friendships, for example, with chaplains from a neighboring city, as shown by the letters from Söflingen.

From late antiquity, nuns have engaged in correspondence. The letters of Jerome (347/348–419/420) to Marcella, Paula, and Eustochium were especially beloved, often copied and cited in female monasteries.[30] They showed generations of nuns that even worthy church fathers had no objections to correspondence between nuns and their spiritual fathers.[31]

Only a few letter collections from female monasteries have survived.[32] In 1881 Jakob Wichner discovered by chance at Admont a small collection of nineteen model letters in outline that had been bound into a vineyard's account book from the year 1431.[33] At the Westphalian convent of Langenhorst, a bundle of letters addressed to the abbess and several nuns served as stuffing for a reliquary cushion.[34] The letters from Söflingen were discovered in 1484 as the city council of Ulm stormed the convent and scoured the cells in search of items in contravention of the rule. This investigation turned up such objects as "women's lace slippers," prayer beads made of coral and gilded balls, as well as a bodice "with which one decorates and finely places around the breasts." In addition to such worldly frills were found letters and love songs ("various songs that belong in the world"), all of which interested the reformers far less,

however, than the forbidden items of clothing and the frequent visitations of men.[35]

In the diocese of Halberstadt, a visitation of the Cistercian convent of Adersleben took place around the same time as the inspection of the Poor Clares of Söflingen near Ulm. The scribe notes critically that the sisters were very poor and that they had no one to take care of them, adding that, because of the turnover of supervisors, enclosure could not be enforced. "There was a chaplain," he continues knowingly, "who came to Adersleben and wrote many letters to a virgin, Hille von Wyrde, about how she had confessed. At the request of the bishop of Hildesheim and Gebhard von Hoym [d. 1484], she was permitted to leave the convent, but on the condition that she never return."[36] Not everyone tolerated letters from nuns, at least not at all times. From the early Middle Ages, prohibitions of such letters occurred on a regular basis.[37] It might be added that, among the epistles that survive, there are no fiery love letters.

Among the many letters to and from abbesses, those dealing with business matters predominate. These concern new entrants, the purchase of cattle, money matters, petitions, bondsmen, judgment days, military obligations, and much more.[38] Occasionally, however, such letters can convey something of daily life in the cloister. For example, Brother Gerhard von Langenhorst writes about how he provided the *sorores scriptores*, the sisters who were active as scribes, among whom was a sister of his, with the supplies they needed to write (rulers, pens, parchment).[39] Later, Konrad, the apothecary of the bishop of Münster, gave the same sisters his prayer book, with the request that they rubricate the letters and add a prayer to "the venerable virgin," of which he had no example.[40] Another letter tells us that the sisters of Langenhorst, like those of Frensdorf, produced cloth. Whether it was for trade or for their own purposes remains unclear.[41]

Usually, concerns regarding the bodily well-being of the sender and receiver are the focus of attention. The correspondence between Katherina Lemlin (d. 1533) from the convent of Maihingen with her relatives, who lived in Nuremberg, shows how important it was for nuns confined to a cloister to keep informed and up-to-date about what was going on in the world, especially those events that affected their relatives.[42] The *cellaria*, or keeper of the wine cellar, at Gnadenberg lets her correspondents know: "Dear lady and dear virgin Barbara and dear sister Katarina, I write to inform you that I am well, God be praised, and I would be delighted to hear as much from you."[43] A nun named Gertrude (her last name cannot be

gleaned from the fragmentary letter) writes to Maria von Hüchtenbrock, the abbess of Langenhorst (1485, 1492): "First of all, friendly, kind greetings. Know, dear sister, by God's grace I am still well. I very much hope to hear the same of you."[44] Brother Hermann Bennyck informs his sister Kunne, who lived at Langenhorst, that he is well again and that she should send him some rosemary.[45] There are many letters in the same vein.

Small gifts were enclosed with many letters. Letters from Langenhorst often include requests for rosemary.[46] In turn, the sisters received small *Heiligenbriefe* (images of saints). Engele Warendorf, whose daughter Greteken lived at Langenhorst, presented her with a devotional image that she acquired at the monastery of Hohenholte directly from the abbess.[47] Elzeke von Löhne also sent small devotional images to her relatives at Langenhorst.[48] About the appearance and form of these images, however, the letters tell us nothing. Lebkuchen, nuts, roses, wine grapes, and salmon, including recipes for their preparation, accompany the letters to and from the convent of Söflingen near Ulm.[49] Sometimes one has the impression that the presents were more important than the letters, as if the letters were nothing more than accompanying notes, but that the gift was a device to secure an answer. In any case, presents preserved friendships. In the late Middle Ages, friendship and family often amounted to one and the same thing.

## Presents Preserve Friendships

The day on which a nun entered enclosure was comparable to a wedding in bringing the entire family together. When Catholics, those who continued to adhere to the old faith, immured a nun, observed an anonymous chronicler in Biberach, the relatives (*freundschafft*) held a large marriage celebration: "the virgins went along as they would have gone modestly to a wedding; they went to services in the churches, or the friars conducted Mass in their church, there they went, and they held sermons in their churches or at their house."[50] On an occasion such as this, Barbara, the niece of the Nuremberg patrician Walburg Kressin, received a silver bowl as a gift from her aunt.[51]

Wills provided for another form of gift exchange. Wills of nuns are relatively rare and, at least as far as the Middle Ages are concerned, virtually unexplored. Only nuns, canonesses, or beguines that had the right to

own property could leave a testament. The wills of beguines are marked by their close ties to local mendicant convents or to specific, named individual male or female convent members. For example, in 1296 the beguine of Strasbourg Hedwig left the Dominicans her house.[52] In 1318 the beguine Gertrude, a daughter of the squire Hugo von Truchtersheim, recorded similar intentions.[53] In addition, she left small, symbolic sums to virtually all the mendicant communities in Strasbourg and its surroundings. In contrast, in 1310 the beguine Juntha left all her landed property to her nieces. The movable goods she gave to her confessor, the Dominican Thomas von Neumagen.[54] Juntha's will is no different from those of childless widows living in the world. The same is true of most wills of canonesses—with one difference: canonesses evidently took no interest in the mendicants.

As in the case of clergymen's wills, siblings' children are of central significance in the wills of canonesses. For the canoness, the niece played the same role as the nephew in the wills of canons, that of foster child and spiritual successor.[55] If there were no relatives, the choice then turned to the *Klostertöchter*, that is, favored younger nuns or canonesses. For the most part, "mothers" and "daughters" shared the same spaces. Spatial proximity as well as emotional attachments often went hand in hand, as shown by testaments from Remiremont (Vosges), St. Cecilia in Cologne, and Klingental in Basel.[56] At times, however, close quarters could also cause conflict.[57]

Wills testify that the life of a canoness was by no means restricted to the cloister. These women were present in the life of the city, took part in business transactions, went on pilgrimages, and visited churches as well as their families, who also regularly came to visit them. The account books of the city of Basel for the years 1450–1454 indicate that several nuns from Klingental purchased a pension from the city. Elsa zum Rhein invested seven hundred gulden, and Dorothea von Friesen and Klara zum Luft invested two hundred apiece.[58] A generation later, the nuns preferred instead to invest their pensions with the bishop.[59]

Nevertheless, in the late Middle Ages, the transfer of goods from the cloister to the world was strictly regulated. In 1480 an official of the *Schöffengericht*, one of the city courts, swore that since he had been in office—and that was for more than thirty years—nothing had ever been left from a cloister to someone in the world, not even in times of plague.[60] Much more frequently, goods were bequeathed in the opposite direction. Among the goods that changed hands in this manner most frequently were devotional objects, prayer books, and small-scale works of art, but

legacies of money also occur, especially in the form of small annuities. Money was also the form of property that was most strictly regulated in exchanges between the cloister and the world, for in all cultures money is easily the most worldly of all goods.

In 1428 Wobbeken Boltzen, the widow of a city councilor of Lüneburg, left to her sister in the monastery of Medingen her best, fur-lined coat and to her sister Druden in the nearby monastery of Lüne her second-best lined coat. To her nieces in Medingen, she bequeathed her coral prayer beads and a small sum of money (*zwei Mark Pfennige*). She left the same sum to Taleken, a relative of her deceased husband, who lived in a convent in Lübeck, and to her brother's daughters at Medingen and Lüne. In addition, she gave Taleken a coat made of black woolen cloth from Arras.[61] Over centuries, the patricians of Lüneburg, made wealthy from the salt trade, endowed their daughters with small annuities that on their deaths were to be converted to commemorative functions.[62] With the introduction of reforms, only the gifting of clothes, prayer beads, and silver cutlery was prohibited. Occasionally, such gifts came with the expectation of a countergift in the form of intercessory prayers. In contrast to legacies left to institutions, most of those tied to individuals were free of conditions. Some reform measures forbade sisters and brothers all forms of private property. An exception was made for those who were ill, but otherwise only legacies addressed to the community as a whole were permitted.[63] In practice, however, such prohibitions were difficult to enforce and to maintain. Small gifts were the currency that sustained friendships in the cloister, as in the world.[64]

Not only money but also books, above all devotional books, passed from the world into the cloister. On her entry into the Dominican convent of St. Catherine's in Nuremberg around 1440, the widow Margarethe Tucher bequeathed the monastery her small but significant collection of twenty-six books of devotional literature, which, inter alia, included William of St. Thierry's *Letter to the Brethren at Mont-Dieu*, a life of Catherine of Siena, Henry Suso's *Little Book of Eternal Wisdom*, various didactic commentaries on the Ten Commandments—in short, some of the best sellers of contemporary devotional literature.[65] All over Europe, laywomen read and loved the same materials as beguines and nuns.[66]

In addition to devotional books, nuns frequently possessed house altars and small works of art made of alabaster or ivory. Such items were also among those that as a result of testaments wandered from the world into

the cloister. In the *bonne ville* (good city) of Tournai in France, numerous small house altars are attested from the first half of the fourteenth century onward. Most of the men or women bequeathing such altarpieces, including any accompanying accessories, left them to their parish church or to a nearby mendicant community. In 1438 the widow Catherine Dimanche, named the *Lombardin* (the Lombard woman), left her altarpiece and her many devotional objects to various institutions: to the Grey Sisters (Poor Clares) she left her "seven cloths, on which are painted the Passion of our lord, the resurrection, Pentecost, the Last Judgment, as well as saints Clare and Francis. . . . Further, I leave them the birth [of Christ]. . . . In addition, to the Brothers of the Holy Cross I leave my altar panel and the curtain, as well as two reliquary panels on which are painted the Last Judgment, Saint Anthony, and Saint Sebastian. Moreover, I give them two altar cloths. On one [cloth] is painted the Annunciation; the other is laced with silk, and on it there is a cover (souveronde) also of silk." (Tournai was not just a center for the production of panel painting. Artists such as Rogier van der Weyden also painted on textile supports.)[67] To the sisters of Sion near Audenarde, Catherine Dimanche left an ivory Madonna. Her large books and an alabaster image of the Virgin Mary with the Christ Child on her lap she left to the hospital in Valenciennes, and to the sisters of Campiaux she bequeathed a book entitled *Seul parler saint Augustin* (Alone the pronouncements of St. Augustine). Her godchild Catelotte received additional presents.[68] Most of her remaining books she left to religious women.[69] The anchoress of St. John's received her copy of the *Vitae patrum* (Lives of the desert fathers), the anchoress attached to the church of St. Catherine's her *Somme le roi* (a treatise of spiritual advice originally written for the king of France) and the *Voyage mon seigneur* (Travel of my Lord). To the anchoress of St. Nicaise she left her *Aiguillon d'amour* (the *Stimulus amoris*, or *The Pricke of Love*). To her cousin Catinne, she bequeathed a book titled *Audi filia* (Listen, my daughter). The domestic library of Catherine Dimanche differed little from that of the Poor Clares at Longchamp.[70]

As Kathleen Kamerick has shown, in the cloister as in the world, books and pictures formed a unity. The exchange of small-scale works of art appears to have been just as intense in Cologne, Lübeck, and Lüneburg as in Tournai.[71] For the fourteenth century, it is hardly possible to distinguish between the devotional literature and art that was owned by women in the cloister and in the world. Only in the fifteenth century did devotional imagery come to pose a problem in reformed monasteries. From this point

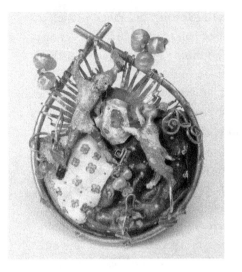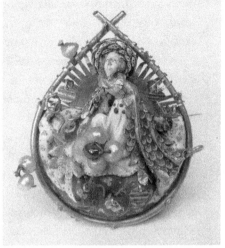

*Figure 12.1* Brooches from the treasury of Stift Essen, gold and enamel "en ronde bosse," Paris, ca. 1400. (Domschatz Essen, inv. 91-106.)

forward, at least as far as piety and devotion were concerned, cloister and world began to go their separate ways.[72] In reformed communities, common prayer drove out private devotional practices involving individually owned prayer books and private devotional imagery. Henceforth, reformers such as the Dominican Johannes Meyer (1422/1423–1485) considered private devotional imagery "worldly." Worldly were all things that were not communal. What was worldly and what was spiritual, however, was never clearly established. The boundary constantly shifted, either enclosing or shutting out. At the same time, the value of what was excluded changed as well. What once served the needs of piety was suddenly secularized.

## Conclusion

For the most part, previous research on monastic orders looked at medieval female monastic communities from the inside. In doing so, it excluded from view all those ties to the world that were no less important to their vitality. Convents maintained steady connections to the outside world and cultivated them carefully, in keeping with the order to which they were

attached and the fidelity with which they adhered to its rules. Among canonesses and unregulated monastic communities, the world was central to the conception of their way of life. "Worldly" meant living in style, private apartments, clothing, and birds and dogs as pets,[73] but it also referred to private prayer books and devotional imagery (fig. 12.1).[74] In spite of all injunctions to the contrary, the world was also always present in regulated communities, above all in the form of parents and siblings, who wrote when visiting was forbidden them or received dispensations that enabled them to visit their daughters, sisters, and nieces living in convents.

## Notes

1. Césaire d'Arles 1988:220 (chap. 37).

2. Makowski 1997:29–30.

3. Riemer 1924:100.

4. Schleusener-Eichholz 1984:797–815.

5. Mischlewski 1994:545; cf. Johnson 1989a.

6. Schilling 1887:51.

7. Signori 1997b:294–295.

8. Heimann 1986:38.

9. Reichert 1908–1909:50–51.

10. Brilinger 1938:206–212.

11. Welti 1925:82; cf. Lipsmeyer 1988.

12. Laven 2002:132–139.

13. Rohrbach 1884:212–213.

14. Schäfer 1907:203–204.

15. Gilchrist 1994:127, 166, 189.

16. Wormstall 1895: nos. 6, 9.

17. Johnson 1994:499.

18. Gill 1996:192–193; Machilek 1986:72–90.

19. Młynarczyk 1987:250.

20. Schäfer 1907:172–179; Gleba 2000:145–151; Crusius 2001a.

21. Luther 1962:62–63.

22. Härtel 1996:251.

23. Appuhn 1986:41–42.

24. *Amerbachkorrespondenz* 1942: no. 97.

25. Steinhausen 1907: no. 113.

26. Ibid.: no. 123.

27. Steinhausen 1894:95–96, 98–99; cf. Schieber 1993: no. 35, 88.

28. Steinhausen 1907: no. 35.

29. Christoph Huber, *Rhetorica vulgaris* (1477), Munich, Bayerische Staatsbibliothek, cgm 216, f. 7v.

30. Kurt Ruh, "Hieronymus, Sophronius Eusebius," in Ruh 1981:3: col. 1221–1233; Zarri 2000:82.

31. Alcuin 1895: no. 196.

32. The correspondence of the abbess Hildegard of Bingen represents an exceptional case, both in terms of its content and its extent (see Hildegard of Bingen 1991). The letters of Elisabeth of Schönau and Margaretha Ebner owe their preservation to the divine grace associated with their authors.

33. Beach 2002:34.

34. Wormstall 1895:150.

35. Miller 1940:49–54.

36. Riemer 1924:96.

37. Césaire d'Arles 1988:240–241 (chap. 54).

38. Wormstall 1895: no. 1, 8, 10–14, 18, 24, 26; Gleba 2000:105–106.

39. Wormstall 1895: no. 2, 3; see also Schieber 1993:61–64.

40. Wormstall 1895: no. 17.

41. Ibid.: no. 41.

42. Kamann 1899, 1900; Kruse 2002:465–506.

43. Steinhausen 1907: no. 28.

44. Wormstall 1895: no. 29.

45. Ibid.: no. 7.

46. Ibid.: nos. 4, 7, 39.

47. Wormstall 1895: no. 28. Hohenholte was at the time subject to one Richmot Warendorf; see Anna-Therese Grabkowshy, "Hohenholte," in Hengst 1992–2003:1:462–466. Cf. Schmidt 2003b.

48. Wormstall 1895: no. 30.

49. Miller 1940: nos. 15, 24, 37, 42, 44, 45, 51, 52.

50. Schilling 1887:85.

51. "Schenkbuch" 1876: no. 18, 39 (Pillenreuth) and no. 68, 74 (St. Katharina, Nuremberg).

52. Witte 1900: no. 349.

53. Ibid.: no. 880.

54. Ibid.: no. 664. See also Bönnen 1996.

55. Parisse 1983a:124, 126.

56. Signori 2000:166, 170–173, 184; see also Miller 1940:46; and Schäfer 1907:274.

57. Märtl 1995:365–405; Müntz 1998:111–120; S. Schmitt 2002:71–94.

58. Harms 1909–1913:1:185, 192–193.

59. Signori 2000:171–172; cf. Kuhn-Rehfus 1980:136.

60. Basel, Staatsarchiv Basel-Stadt, Gerichtsarchiv D (Kundschaften), vol. II, f. 21r.

61. Reinhardt 1996: no. 160. Cf. Riggert 1996:302–306.

62. Reinhardt 1996: nos. 155, 166, 205, 219, 237.

63. Oliva 1998:182.

64. Urbanski 1993:411–428.

65. Williams and Williams-Krapp 1998:15–23.

66. Hutchison 1989:215–227; Oliva 1998:68; Erler 1995, 2002.

67. Bosshard 1982:31–42.

68. Grange 1897: no. 801; cf. Lauwers and Simons 1988.

69. Młynarczyk 1987:159–176.

70. Kamerick 2002:155–190.

71. Hasse 1981:60–72; Schmid 1991:70–80; cf. Hegner 1996; Jopek 1988.

72. Lentes 1994:181.

73. Märtl 1995:382–385.

74. Fleck, Roolfs, and Signori 2003:13–19.

# Works Cited

Abaelard. 1979. *Abaelard: Die Leidensgeschichte und der Briefwechsel mit Heloisa*. Ed. and trans. Eberhard Horst. 4th ed. Heidelberg.

Aballéa, Sylvie. 2003. *Les saints sépulchres monumentaux du Rhin Supérieur et de la Souabe (1340–1400)*. Strasbourg.

Acklin Zimmermann, Beatrice W. 1993. *Gott im Denken berühren: Die theologischen Implikationen der Nonnenviten*. Neue Schriftenreihe zur Freiburger Zeitschrift für Philosophie und Theologie 14. Fribourg.

*Acta Innocentii Papae III.* 1944. Ed. Theodosius Haluscynskyj. Pontificia Commissio ad redigendum codicem iuris canonici orientalis III/2. Vatican City.

"Acta Murensia." 1883. In *Das Kloster Muri im Kanton Aargau*, ed. Martin Kiem, 3–102. Basel.

Ahlers, Gerd. 2002. *Weibliches Zisterziensertum im Mittelalter und seine Klöster in Niedersachsen*. Berlin.

Ahrens, Claus. 2001. *Die frühen Holzkirchen Europas*. 2 vols. Stuttgart.

Aili, Hans and Jan Svanberg. 2003. *Imagines Sanctae Birgittae: The Earliest Illuminated Manuscripts and Panel Paintings Related to the Revelations of St. Birgitta of Sweden*. 2 vols. Stockholm.

Alcuin. 1895. *Alcuini Epistolae*. Ed. Ernst Dümmler. Monumenta Germaniae Historica, Epistolae 4. Berlin.

Althoff, Gerd. 1991. "Gandersheim und Quedlinburg: Ottonische Frauenklöster als Herrschafts- und Überlieferungszentren." *Frühmittelalterliche Studien* 25:123–144.

———. 2003. "Ottonische Frauengemeinschaften im Spannungsfeld von Kloster und Welt." In Gerchow and Schilp 2003:29–44.

Ancelet-Hustache, Jeanne, ed. 1930. "Les 'Vitae sororum' d'Unterlinden: Édition critique du manuscrit 508 de la Bibliothèque de Colmar." *Archives d'histoire doctrinale et littéraire du Moyen Age* 5:317–517.

Andermann, Ulrich. 1996. "Die unsittlichen und disziplinlosen Kanonissen: Ein Topos und seine Hintergründe, aufgezeigt an Beispielen sächsischer Frauenstifte (11.–13. Jahrhundert)." *Westfälische Zeitschrift* 146:39–63.

Angenendt, Arnold, and Gisela Muschiol. 2000. "Die liturgischen Texte (Kommentar)." In *Memorial- und Liturgiecodex Brescia* 2000, 28–55.

Appuhn, Horst. 1961. "Der Auferstandene und das Heilige Blut zu Wienhausen." *Niederdeutsche Beiträge zur Kunstgeschichte* 1:73–138.

——. 1966. *Kloster Isenhagen: Kunst und Kult im Mittelalter.* Lüneburg.

——. 1973. *Kloster Wienhausen: Der Fund vom Nonnenchor.* Kloster Wienhausen 4. Wienhausen.

——. 1978. "Das private Andachtsbild: Ein Vorschlag zur kunstgeschichtlichen und volkskundlichen Terminologie." In *Museum und Kulturgeschichte: Festschrift für Wilhelm Hansen*, 289–292. Münster.

——. 1986. *Kloster Wienhausen.* Rev. ed. Wienhausen.

——, ed. 1986. *Chronik und Totenbuch des Klosters Wienhausen.* Wienhausen.

Appuhn, Horst and Christian von Heusinger. 1965. "Der Fund kleiner Andachtsbilder des 13.–17. Jahrhunderts in Kloster Wienhausen." *Niederdeutsche Beiträge zur Kunstgeschichte* 4:157–238.

Arens, Franz. 1908. *Der Liber ordinarius der Essener Stiftskirche: Mit Einleitung, Erläuterungen und einem Plan der Stiftskirche und ihrer Umgebung im 14. Jahrhundert.* Paderborn.

Aubert, Marcel. 1943. *L'architecture cistercienne en France.* Paris.

Banz, Romuald. 1908. *Christus und die minnende Seele: Zwei spätmittelhochdeutsche mystische Gedichte. Im Anhang ein Prosadisput verwandten Inhalts. Untersuchungen und Texte.* Germanistische Abhandlungen 29. Breslau.

Barrière, Bernadette. 1992. "The Cistercian Convent of Coyroux in the Twelfth and Thirteenth Centuries." *Gesta* 31, no. 2:76–82.

Barrière, Bernadette, and Marie-Elizabeth Henneau, eds. 2001. *Cîteaux et les femmes.* Paris.

Barta-Fliedl, Ilsebill, Zita Breu, and Daniela Hammer-Tugendhat, eds. 1987. *Frauen, Bilder, Männer, Mythen: Kunsthistorische Beiträge.* Berlin.

Bartal, Ruth. 2000. "'Where has your beloved gone?' The Staging of the Quaerere Deum on the Murals of the Cistercian Convent at Chełmno." *Word and Image* 16:270–289.

Bautier, Robert-Henri. 1990. "De la recluserie au chapitre des dames nobles: Les abbayes de moniales de Lorraine et spécialement Notre-Dame de Bouxières-

aux-Dames." In *La femme au moyen-âge,* ed. Michel Rouche and Jean Heuclin, 99–112. Maubeuge.

Beach, Alison I. 2002. "Voices from a Distant Land: Fragments of a Twelfth-Century Nuns' Letter Collection." *Speculum* 77:34–54.

———. 2004. *Women as Scribes: Book Production and Monastic Reform in Twelfth-Century Bavaria.* Cambridge Studies in Paleography and Codicology 10. Cambridge.

Becher, Hartmut. 1983. "Das königliche Frauenkloster San Salvatore/Santa Giulia in Brescia im Spiegel seiner Memorialüberlieferung." *Frühmittelalterliche Studien* 17:299–392.

Becker, Petrus. 1980. "Benediktinische Reformbewegungen im Spätmittelalter: Ansätze, Entwicklungen, Auswirkungen." In Max-Planck-Institut 1980, 167–187.

Becksmann, Rüdiger and Ulf-Dietrich Korn. 1992. *Die mittelalterlichen Glasmalereien in Lüneburg und den Heideklöstern.* Corpus Vitrearum Medii Aevi, Deutschland 7, Niedersachsen 2. Berlin.

Bede. 1982. *Venerabilis Bedae Historia ecclesiastica gentis Anglorum: Beda der Ehrwürdige, Kirchengeschichte des englischen Volkes (Text nach der Ausgabe von B. Colgrave und R.A.B. Mynors).* Bilingual ed. Trans. Günter Spitzbart. Texte zur Forschung 34. Darmstadt.

Bedos-Rezak, Brigitte. 1988. "Women, Seals, and Power in Medieval France." In *Women and Power in the Middle Ages,* ed. Mary Erler and Maryanne Kowaleski, 61–82. Form and Order in Medieval France 9. Athens, Ga.

Beenken, Herrmann. 1933. "Zu den Malereien des Hochaltars von St. Jacob in Nürnberg." *Zeitschrift für deutsche Kunstgeschichte* 2:323–333.

Beer, Ellen Judith. 1959. *Beiträge zur oberrheinischen Buchmalerei in der ersten Hälfte des 14. Jahrhunderts unter besonderer Berücksichtigung der Initialornamentik.* Schriftenreihe der Stiftung Schnyder von Wartensee 43. Basel.

Bell, Daniel N. 1995. *What Nuns Read: Books and Libraries in Medieval English Nunneries.* Cistercian Studies Series 158. Kalamazoo.

Belting, Hans. 1981. *Das Bild und sein Publikum im Mittelalter: Form und Funktion früher Bildtafeln der Passion.* Berlin.

———. 1994. *Likeness and Presence: A History of the Image Before the Era of Art.* Trans. Edmund Jephcott. Chicago.

Benešovská, Klára. 1994. "Les religieuses de la famille royale: Mécènes de l'art en Bohème du Xe au XIVe siècle." In *Les religieuses* 1994, 773–788.

Berg, Maxine. 1996. *A Woman in History: Eileen Power, 1889–1940.* Cambridge.

Berger, Teresa. 1999. *Women's Ways of Worship: Gender Analysis and Liturgical History.* Collegeville, Minn.

Berghaus, Günter, Thomas Schilp, and Michael Schlagheck, eds. 2000. *Herrschaft, Bildung und Gebet: Gründung und Anfänge des Frauenstifts Essen.* Essen.

Bernards, Matthäus. 1955. *Speculum Virginum: Geistigkeit und Seelenleben der Frau im Hochmittelalter*. Cologne.

——. 1956. "Zur Seelsorge in den Frauenklöstern des Hochmittelalters." *Revue bénédictine* 66:256–268.

Bertheau, Friedrich. 1917. "Wirtschaftsgeschichte des Klosters Preetz im vierzehnten und fünfzehnten Jahrhundert." *Zeitschrift der Gesellschaft für Schleswig-Holsteinische Geschichte* 47:91–266.

Beuckers, Klaus Gereon. 1995. "Bemerkungen zu den salischen Türflügeln von St. Maria im Kapitol." *Jahrbuch des Kölnischen Geschichtsvereins* 66:191–203.

——. 1999. *Rex iube—Christus imperat: Studien zu den Holztüren von St. Maria im Kapitol und zu Herodesdarstellungen vor dem Investiturstreit.* Veröffentlichungen des Kölnischen Geschichtsvereins 42. Cologne.

Biernoff, Suzannah. 2002. *Sight and Embodiment in the Middle Ages.* New York.

Bihlmeyer, Karl. 1931. "Die schwäbische Mystikerin Elsbeth Achler von Reute († 1420) und die Überlieferung ihrer Vita." In: *Festgabe Philipp Strauch zum 80. Geburtstage am 23. September 1932*, ed. Georg Baesecke and Ferdinand Joseph Schneider, 88–109. Hermaea 31. Halle.

——, ed. 1916. "Mystisches Leben in dem Dominikanerinnenkloster Weiler bei Eßlingen im 13. und 14. Jahrhundert." *Württembergische Vierteljahreshefte für Landesgeschichte*, n.s., 25:61–93.

Biller, Peter and Alistair J. Minnis, eds. 1998. *Medieval Theology and the Natural Body.* York Studies in Medieval Theology 1. York.

Binding, Günther. 1983. "Birgittiner-Baukunst." In *Lexikon des Mittelalters*, 2:219–220. Munich.

Binding, Günther and Matthias Untermann. 1985. *Kleine Kunstgeschichte der mittelalterlichen Ordensbaukunst in Deutschland.* Darmstadt.

——. 2001. *Kleine Kunstgeschichte der mittelalterlichen Ordensbaukunst in Deutschland.* 3d ed. Darmstadt.

Birch, Walter de Gray. 1889. *An Ancient Manuscript of the Eighth or Ninth Century Formerly Belonging to St. Mary's Abbey or Nunnaminster, Winchester.* London.

Bischoff, Bernhard. 1966. "Die Kölner Nonnenhandschriften und das Skriptorium von Chelles." In *Mittelalterliche Studien: Ausgewählte Aufsätze zur Schriftkunde und Literaturgeschichte*, 1:16–34. Stuttgart.

Bischoff, Cordula, Brigitte Dinger, Irene Ewinkel, and Ulla Merle, eds. 1984. *FrauenKunstGeschichte: Zur Korrektur des herrschenden Blicks.* Giessen.

Bock, Sebastian and Lothar A. Böhler, eds. 1999. *Bestandskataloge der weltlichen Ortsstiftungen der Stadt Freiburg i.Br.* Vol. 2, *Die Bildwerke: Mittelalter—19. Jahrhundert.* Amsterdam.

Bock, Sebastian and Lothar A. Böhler, eds. (with assistance from Maria Effinger).

1997. *Bestandskataloge der weltlichen Ortsstiftungen der Stadt Freiburg i.Br.* Vol. 1, *Die kunsthandwerklichen Arbeiten aus Metall.* Rostock.

Bodarwé, Katrinette. 1997. "Frauenleben zwischen Klosterleben und Luxus? Alltag in frühmittelalterlichen Frauenklöstern." In *Königin, Klosterfrau, Bäuerin: Frauen im Frühmittelalter,* ed. Helga Brandt and Julia K. Koch, 117–143. Münster.

———. 2000a. "Roman Martyrs and Their Veneration in Ottonian Saxony: The Case of the *Sanctimoniales* of Essen." *Early Medieval Europe* 9, no. 3:345–365.

———. 2000b. "'Sanctimoniales litteratae': Schriftlichkeit und Bildung im ottonischen Essen." In Berghaus, Schilp, and Schlagheck 2000:101–117.

———. 2002. "'Kirchenfamilien': Kapellen und Kirchen in frühmittelalterlichen Frauengemeinschaften." In Bodarwé and Schilp 2002:111–131.

———. 2003. "Bibliotheken in sächsischen Frauenstiften." In Gerchow and Schilp 2003:87–112.

———. 2004. "*Sanctimoniales litteratae*": *Schriftlichkeit und Bildung in den ottonischen Frauenkommunitäten Gandersheim, Essen und Quedlinburg.* Quellen und Studien, Veröffentlichungen des Instituts für kirchengeschichtliche Forschung des Bistums Essen 10. Münster.

Bodarwé, Katrinette and Thomas Schilp, eds. 2002. *Herrschaft, Liturgie und Raum: Studien zur mittelalterlichen Geschichte des Frauenstiftes Essen.* Essener Forschungen zum Frauenstift 1. Essen.

Bönnen, Gerold. 1996. "Ein lothringisches Beginentestament aus dem Jahre 1278." In *Liber amicorum necnon et amicarum für Alfred Heit: Beiträge zur mittelalterlichen Geschichte und geschichtlichen Landeskunde,* ed. Friedhelm Burgard, Christoph Cluse, and Alfred Haverkamp, 159–170. Trierer historische Forschungen 28. Trier.

Borchling, Conrad. 1905. "Literarisches und geistiges Leben in Kloster Ebstorf am Ausgange des Mittelalters. *Zeitschrift des Historischen Vereins für Niedersachsen* 4:361–407.

Böse, Kristin. 2000. "Der Magdalenenteppich des Erfurter Weißfrauenklosters im Spiegel des spätmittelalterlichen Reformgedankens: Bildinhalt und Herstellungsprozess." In Signori 2000:53–90.

Bosshard, Emil D. 1982. "Tüchleinmalerei: Eine billige Ersatztechnik?" *Zeitschrift für Kunstgeschichte* 45:31–42.

Bräm, Andreas. 1992. "Imitatio Sanctorum: Überlegungen zu Stifterdarstellungen im Graduale von St. Katharinenthal." *Zeitschrift für schweizerische Archäologie und Kunstgeschichte* 49:103–113.

Braunfels, Wolfgang. 1969. *Abendländische Klosterbaukunst.* Cologne.

———, ed. 1972. *Der Hedwigs-Codex von 1353: Sammlung Ludwig.* 2 vols. Berlin.

Brenk, Beat. 2002. "Zum Problem der Vierflügelanlage (Claustrum) in frühchristlichen

und frühmittelalterlichen Klöstern." In *Studien zum St. Galler Klosterplan II*, ed. Peter Ochsenbein and Karl Schmuki, 185–215. St. Gallen.

Brilinger, Hieronymus. 1938. "Ceremoniale Basiliensis episcopatus (1517)." In *Das Hochstift Basel im ausgehenden Mittelalter: Quellen und Forschungen*, ed. Konrad W. Hieronimus, 110–320. Basel.

Brückner, Wolfgang. 1991/1994. "Die fränkischen Frauenzisterzen und ihre Bauten im Wandel der Zeiten." In *Zisterzienser in Franken: Das alte Bistum Würzburg und seine einstigen Zisterzen*, ed. Wolfgang Brückner and Jürgen Lenssen, 40–54/99–131. Würzburg.

Bruzelius, Caroline A. 1992. "Hearing Is Believing: Clarissan Architecture, ca. 1213–1340." *Gesta* 31, no. 2:83–91.

Bücher, Carl. 1882. *Die Frauenfrage im Mittelalter: Vortrag gehalten am 28. März 1882 im Liebig'schen Hörsaale zu München*. Leipzig.

Buchwald, G. von. 1897. "Anna von Buchwald, Priörin des Klosters Preetz, 1494–1508." *Zeitschrift für Schleswig-Holsteinische Geschichte* 9:3–98.

Budny, Mildred and Dominic Tweddle. 1985. "The Early Medieval Textiles at Maaseik, Belgium." *Antiquaries Journal* 65, no. 2:353–389.

Bürkle, Susanne. 1999. *Literatur im Kloster: Historische Funktion und rhetorische Legitimation frauenmystischer Texte des 14. Jahrhunderts*. Bibliotheca Germanica 38. Tübingen.

Bynum, Caroline Walker. 1987. *Holy Feast and Holy Fast: The Religious Significance of Food to Medieval Women*. Berkeley.

——. 1995. "Why All the Fuss about the Body? A Medievalist's Perspective." *Critical Inquiry* 22:1–33.

——. 1996. "Warum das ganze Theater mit dem Körper? Die Sicht einer Mediävistin." *Historische Anthropologie: Kultur—Gesellschaft—Alltag* 4:1–33.

——. 2004a. "The Power in the Blood: Sacrifice, Satisfaction and Substitution in Late Medieval Soteriology." In *The Redemption: An Interdisciplinary Symposium on Christ as Redeemer*, ed. Stephen T. Davis, Daniel Kendall, and Gerald O'Collins, 177–204. Oxford.

——. 2004b. "Soul and Body." In *Dictionary of the Middle Ages: Supplement*, ed. William Jordan, 588–594. New York.

Caciola, Nancy. 2003. *Discerning Spirits: Divine and Demonic Possession in the Middle Ages*. Conjunctions of Religion and Power in the Medieval Past. Ithaca, N.Y.

Cannon, Joanna and Vauchez, André. 1999. *Margherita of Cortona and the Lorenzetti: Sienese Art and the Cult of a Holy Woman in Medieval Tuscany*. University Park, Pa.

Carr, Annemarie Weyl. 1976. "Women Artists in the Middle Ages." *Feminist Art Journal* 5:5–9, 26.

——. 1985. "Women and Monasticism: Introduction from an Art Historian." *Byzantinische Forschungen* 9:1–15.

——. 1997. "Women as Artists in the Middle Ages: 'The Dark Is Light Enough.'" In Gaze 1997:3–21.

Carroll, Jane L. 2003. "Woven Devotions: Reform and Piety in Tapestries by Dominican Nuns." in: Carroll and Stewart 2003:182–201.

Carroll, Jane L. and Alison G. Stewart, eds. 2003. *Saints, Sinners, and Sisters: Gender and Northern Art in Medieval and Early Modern Europe.* Aldershot.

Cat. Aachen 1980 = Kaspar Elm, Peter Joerissen, and Hermann-Josef Roth, eds. *Die Zisterzienser: Ordensleben zwischen Ideal und Wirklichkeit. Eine Ausstellung des Landschaftsverbandes Rheinland, Rheinisches Museumsamt, Brauweiler. Aachen, Krönungssaal des Rathauses 3. Juli–28. September 1980.* Cologne.

Cat. Bamberg 2002 = Josef Kirmeier and Bernd Schneidmüller, eds. 2002. *Kaiser Heinrich II: 1002–1024.* Exhibition catalog, Bayerische Landesausstellung Bamberg. Veröffentlichungen zur Bayerischen Geschichte und Kultur 44/2002. Augsburg.

Cat. Berlin 1992 = Dietrich Kötzsche, ed. 1992. *Der Quedlinburger Schatz wieder vereint.* Exhibition catalog, Kunstgewerbemuseum Berlin. Berlin.

Cat. Bonn/Essen 2005 = Kunst- und Ausstellungshalle der Bundesrepublik Deutschland, Bonn, and the Ruhrlandmuseum Essen, eds. 2005. *Krone und Schleier: Kunst aus mittelalterlichen Frauenklöstern.* Exhibition catalog. Munich.

Cat. Braunschweig 1983 = Elisabeth Schraut and Claudia Opitz, eds. 1983. *Frauen und Kunst im Mittelalter.* Exhibition catalog, Landesmuseum Braunschweig. Braunschweig.

Cat. Brescia 2000 = Carlo Bertelli and Gian Pietro Brogiolo, eds. 2000. *Il futuro dei Longobardi: L'Italia e la costruzione dell'Europa di Carlo Magno.* Exhibition catalog, Monastero di Santa Giulia Brescia. Geneva.

Cat. Brescia (Saggi) 2000 = Carlo Bertelli and Gian Pietro Brogiolo, eds. 2000. *Il futuro dei Longobardi: Saggi.* Milan.

Cat. Brussels 1994 = Paul Vandenbroek, ed. 1994. *Hooglied: De beeldwereld van religieuze vrouwen in de Zuidelijke Nederlanden, vanaf de 13de eeuw.* Exhibition catalog, Palais voor Schone Kunsten Brüssel. Brussels.

Cat. Colmar 2000–2001 = Madeleine Blondel, Jeffrey F. Hamburger and Catherine Leroy, eds. 2000, 2001. *Les dominicaines d'Unterlinden.* Exhibition catalog, Musée d'Unterlinden Colmar. 2 vols. Paris.

Cat. Frankfurt 2002 = Stephan Kemperdick. 2002. *Avantgarde 1350: Ein rekonstruierter Baldachinaltar aus Nürnberg.* Exhibition catalog, Städel Frankfurt. Frankfurt.

Cat. Freiburg 1978 = Hans Hofstätter, ed. 1978. *Mystik am Oberrhein und in benachbarten Gebieten.* Exhibition catalog, Augustinermuseum Freiburg i.Br. Freiburg.

Cat. Freiburg 1985 = Adelhausenstiftung Freiburg, ed. 1985. *750 Jahre Dominikanerinnenkloster Adelhausen Freiburg im Breisgau.* Texts by Günther Wolf and Detlef Zinke. Exhibition catalog, Augustinermuseum Freiburg i.Br. Freiburg.

Cat. Karlsruhe 1995 = Harald Siebenmorgen, ed. 1995. *Faszination eines Klosters: 750 Jahre Zisterzienserinnen-Abtei Lichtenthal.* Exhibition catalog, Badisches Landesmuseum Karlsruhe. Sigmaringen.

Cat. Mainz 1998 = Hans-Jürgen Kotzur, ed. 1998. *Hildegard von Bingen, 1098–1179.* Exhibition catalog, Bischöfliches Dom- und Diözesanmuseum Mainz. Mainz.

Cat. Münster 1982 = Géza Jászai, ed. 1982. *Monastisches Westfalen, Klöster und Stifte 800–1800.* Exhibition catalog, Westfaelisches Landesmuseum für Kunst und Kulturgeschichte Münster. Münster.

Cat. Munich/Regensburg 1987 = Florentine Müherich and Karl Dachs, eds. 1987. *Regensburger Buchmalerei: Von frühkarolingischer Zeit bis zum Ausgang des Mittelalters.* 1987. Exhibition catalog, Bayerische Staatsbibliothek Munich and Museen der Stadt Regensburg. Munich.

Cat. Nuremberg 1982 = Lotte Kurras and Franz Machilek, eds. 1982. *Caritas Pirckheimer, 1467–1532.* Exhibition catalog, Katholische Stadtkirche Nuremberg and Kaiserburg Nuremberg. Munich.

Cat. Nuremberg 1987 = Elisabeth Schraut. 1987. *Stifterinnen und Künstlerinnen im mittelalterlichen Nürnberg.* Exhibition catalog, Stadtarchiv Nuremberg. Nuremberg.

Cat. Regensburg 1983 = Paul Mai and Achim Hubel, eds. *750 Jahre Dominikanerinnenkloster Hl. Kreuz Regensburg.* 1983. Exhibition catalog, Diözesanmuseum Regensburg. Munich.

Cat. Schussenried 2003 = Volker Himmelein and Hans Ulrich Rudolf, eds. 2003. *Alte Klöster, neue Herren: Die Säkularisation im deutschen Südwesten 1803.* Exhibition catalog, Bad Schussenried. Ostfildern.

Cat. St. Gallen 2006 = Theres Fleury, Simone Mengis, Karl Schmucki, Ernst Tremp, and Kathrin Utz Tremp. *Frauen im Galluskloster.* 2006. Exhibition catalog, Stiftsbibliothek St. Gallen. St. Gallen.

Cat. St. Marienstern 1998 = Judith Oexle, Markus Bauer, and Marius Winzeler, eds. 1998. *Zeit und Ewigkeit: 128 Tage in St. Marienstern, Katalog der ersten sächsischen Landesausstellung im Kloster St. Marienstern.* Exhibition catalog, Kloster St. Marienstern. Halle.

Cat. Uden 1986 = *Birgitta van Zweden, 1303–1373: 600 jaar kunst en cultuur van haar klosterorde.* 1986. Exhibition catalog, Museum voor Religieuze Kunst Uden. Uden.

Cat. Ulm 2003 = Brigitte Reinhardt, ed. 2003. *Ulmer Bürgerinnen, Söflinger Klosterfrauen in reichsstädtischer Zeit.* Exhibition catalog, Museum Ulm. Ulm.

Caviness, Madeline H. 1996. "Anchoress, Abbess, and Queen: Donors and Patrons or Intercessors and Matrons?" In McCash 1996:105–153.

——. 1997a. "The Feminist Project: Pressuring the Medieval Object." *Frauen Kunst Wissenschaft* 24:13–21.

——. 1997b. "Gender Symbolism and Text Image Relationships: Hildegard of Bin-

gen's Scivias." In *Translation Theory and Practice in the Middle Ages*, ed. Jeanette Beer, 71–111. Studies in Medieval Culture 38. Kalamazoo.

——. 2001. *Visualizing Women in the Middle Ages: Sight, Spectacle, and Scopic Economy.* The Middle Ages Series. Philadelphia.

Césaire d'Arles. 1988. "Règle des vierges." In *Œuvres monastiques 1: Œuvres pour les moniales*, ed. Adalbert de Vogüé and Joël Courreau. Sources chrétiennes 345. Paris.

Cescutti, Eva. 1998. *Hrotsvit und die Männer: Konstruktionen von "Männlichkeit" und "Weiblichkeit" in der lateinischen Literatur im Umfeld der Ottonen. Eine Fallstudie.* Forschungen zur Geschichte der älteren deutschen Literatur 23. Munich.

——. 2000. "'Nicht nur den Rechtsgelehrten und Gebildeten, sondern auch dem schwachen Geschlecht': Caritas Pirckheimer über Hrotsvit von Gandersheim, weibliches Talent und männlichen Hochmut." Special supp., *Beiträge zur historischen Sozialkunde. Sondernummer: Geschlecht und Kultur*, 36–41.

——. 2004. "'Quia non convenit ea lingua foeminis'—und warum Charitas Pirckheimer dennoch lateinisch geschrieben hat." In *Nonne, Königin und Kurtisane: Wissen, Bildung und Gelehrsamkeit von Frauen in der Frühen Neuzeit*, ed. Michaela Hohkamp and Gabriele Jancke, 202–224. Königstein im Taunus.

Chance, Jane, ed. 1996. *Gender and Text in the Later Middle Ages.* Gainesville.

Chojnacki, Stanley. 1998. "Daughters and Oligarchs: Gender and the Early Renaissance State." In *Gender and Society in Renaissance Italy*, ed. Judith C. Brown and Robert C. Davis, 63–86. New York.

Clark, Anne L. 2000. "An Uneasy Triangle: Jesus, Mary and Gertrude of Helfta." *Maria: A Journal of Marian Studies* 1:37–56.

Coakley, John W. 2004. *Women, Men, and Spiritual Power: Female Saints and Their Collaborators.* New York.

*Le Codex Guta-Sintram: Faksimileausgabe mit Kommentarband.* 1983. Lucerne.

Coester, Ernst. 1984. *Die einschiffigen Cistercienserinnenklöster West- und Süddeutschlands von 1200–1350.* Quellen und Abhandlungen zur mittelrheinischen Kirchengeschichte 46. Mainz.

Cohen, Adam S. 2000. *The Uta Codex: Art, Philosophy, and Reform in the Eleventh-Century.* University Park, Pa.

Cramp, Rosemary J. 1976. "Monastic Sites." In *The Archaeology of Anglo-Saxon England*, ed. David M. Wilson, 201–252. London.

——. 1993. "A Reconsideration of the Monastic Site of Whitby." In *The Age of Migrating Ideas*, ed. John Higgitt and Michael Spearman, 64–73. Edinburgh.

Crusius, Irene. 2001a. "'Sanctimoniales quae se canonicas vocant': Das Kanonissenstift als Forschungsproblem." In Crusius 2001b, 9–38.

——, ed. 2001b. *Studien zum Kanonissenstift.* Veröffentlichungen des Max-Planck-Instituts für Geschichte 167; Studien zur Germania Sacra 24. Göttingen.

Curschmann, Michael. 1981. "Texte—Bilder—Strukturen: Der 'Hortus deliciarum'

und die frühmittelhochdeutsche Geistlichendichtung." *Deutsche Vierteljahrsschrift für Literaturwissenschaft und Geistesgeschichte* 55:379–418.

Daniels, Robin. 1999. "The Anglo-Saxon Monastery at Hartlepool, England." In *Northumbria's Golden Age*, ed. Jane Hawkes and Susan Mills, 105–112. Sutton.

De Kegel, Rolf. 2003. "Vom 'ordnungswidrigen Übelstand'? Zum Phänomen der Doppelklöster bei den Prämonstratensern und Benediktinern." *Rottenburger Jahrbuch für Kirchengeschichte* 22:47–63.

Decker, Otmar. 1935. *Die Stellung des Predigerordens zu den Dominikanerinnen*. Quellen und Forschungen zur Geschichte des Dominikanerordens in Deutschland 31. Vechta.

Degler-Spengler, Brigitte. 1985. "Zahlreich wie die Sterne des Himmels: Zisterzienser, Dominikaner und Franziskaner vor dem Problem der Inkorporation von Frauenklöstern." *Rottenburger Jahrbuch für Kirchengeschichte* 4:37–50.

Delahaye, Gilbert-Robert. 1993. "Jouarre: État de recherches sur les cryptes mérovingiennes." In *L'Île-de-France de Clovis à Hugues Capet du Ve siècle au Xe siècle*, 106–110. Musée de Guiry-en-Vexin.

Descoeudres, Georges. 1989. "Mittelalterliche Dominikanerinnenkirchen in der Zentral- und Nordostschweiz." *Mitteilungen des Historischen Vereins des Kanton Schwyz* 81:39–77.

Desmarchelier, Michel. 1982. "L'architecture des églises des moniales cisterciennes: Essai de classement des différents types de plans." In *Mélanges à la mémoire du Père Anselme Dimier*, ed. Benoît Chauvin, 3:part 5, 79–121. Arbois.

Dimier, Anselme. 1947. *Recueil de plans d'églises cisterciennes*. Grignan.

——. 1967. *Recueil de plans d'églises cisterciennes: Supplément*. Grignan.

——. 1974. "L'architecture des églises de moniales cisterciennes." *Cîteaux: Commentarii Cistercienses* 25:8–23.

Dinshaw, Carolyn and David Wallace, eds. 2003. *The Cambridge Companion to Medieval Women's Writing*. Cambridge Companions to Literature. Cambridge.

Dinzelbacher, Peter. 1988. "Zur Interpretation erlebnismystischer Texte des Mittelalters." *Zeitschrift für deutsches Altertum und deutsche Literatur* 117:1–23.

——. 1992. "Religiöses Erleben von bildender Kunst in autobiographischen und biographischen Zeugnissen des Hoch- und Spätmittelalters." In Schreiner and Schnitzler 1992:299–330.

Dinzelbacher, Peter and Dieter R. Bauer, eds. 1985. *Frauenmystik im Mittelalter*. Ostfildern.

——. 1988. *Religiöse Frauenbewegung und mystische Frömmigkeit im Mittelalter*. Beihefte zum Archiv für Kulturgeschichte 28. Cologne.

Doepner, Thomas. 1999. *Das Prämonstratenserinnenkloster Altenberg im Hoch- und Spätmittelalter*. Marburg.

Dor, Juliette, Lesley Johnson, and Jocelyn Wogan-Browne, eds. 1999. *New Trends in Feminine Spirituality: The Holy Women of Liège and Their Impact.* Medieval Women: Texts and Contexts 2. Turnhout.

Driver, Martha W. 1995. "Nuns as Patrons, Artists, Readers: Bridgettine Woodcuts in Printed Books Produced for the English Market." In *Art Into Life: Collected Papers from the Kresge Art Museum Medieval Symposium,* ed. Carol Garnett Fisher and Kathleen C. Scott, 237–267. East Lansing, Mich.

Dubler, Anne-Marie. 1968. *Die Klosterherrschaft Hermetschwil von den Anfängen bis 1798.* Argovia 80. Aarau.

Duval, Noel, ed. 1991. *Naissance des arts chrétiens: Atlas des monuments paléochrétiens de la France.* Paris.

Eberl, Immo. 1978. *Geschichte des Benediktinerinnenklosters Urspring bei Schelklingen, 1127–1806.* Schriften zur südwestdeutschen Landeskunde 13. Stuttgart

———. 2003. "Reformen und Baumaßnahmen in Klöstern: Sanierungen und Neubauten im Zusammenhang mit Reformbewegungen." In Moraht-Fromm 2003:85–100.

Ebner, Margaret. 1896/1993. *Major Works.* The Classics of Western Spirituality. New York.

Eckenstein, Lina. 1896/1963. *Woman Under Monasticism: Chapters on Saint-Lore and Convent Life between A.D. 500 and A.D. 1500.* New York/Neudruck.

Ehlers, Caspar. 2001. "Bad Gandersheim." In *Die deutschen Königspfalzen: Repertorium der Pfalzen und übrigen Aufenthaltsorte der Könige im deutschen Reich des Mittelalters,* ed. Max-Planck-Institut für Geschichte in Göttingen, vol. 4, *Niedersachsen,* 246–333. Göttingen 2001.

———. 2003. "Der helfende Herrscher: Immunität, Wahlrecht und Königsschutz für sächsische Frauenstifte bis 1024." In Gerchow and Schilp 2003:29–44.

Eisermann, Falk. 1996. *Die Inschriften auf den Textilien des Augustiner-Chorfrauenstifts Heiningen.* Nachrichten der Akademie der Wissenschaften in Göttingen. Philologisch-historische Klasse 1996, 6. Göttingen.

Eisermann, Falk, Eva Schlotheuber, and Volker Honemann, eds. 2004. *Studien und Texte zur literarischen und materiellen Kultur der Frauenklöster im späten Mittelalter: Ergebnisse eines Arbeitsgesprächs in der Herzog August Bibliothek Wolfenbüttel, 24.–26. März 1999.* Studies in Medieval and Reformation Thought 99. Leiden.

El-Kholi, Susann. 1997. *Lektüre in Frauenkonventen des ostfränkisch-deutschen Reiches vom 8. Jahrhundert bis zur Mitte des 13. Jahrhunderts.* Epistemata: Reihe Literaturwissenschaft 203. Würzburg.

Elkins, Sharon. 1997. "Gertrude the Great and the Virgin Mary." *Church History* 66, no. 4:720–734.

Ellger, Otfried 2003. "Das 'Raumkonzept' der Aachener Institutio sanctimonialium

von 816 und die Topographie sächsischer Frauenstifte im früheren Mittelalter." In Gerchow and Schilp 2003:129–159.

Elliott, Dyan. 2004. *Proving Women: Female Spirituality and Inquisitional Culture in the Later Middle Ages*. Princeton.

Elliott, Janis and Cordelia Warr, eds. 2004. *The Church of Santa Maria Donna Regina: Art, Iconography and Patronage in Fourteenth-Century Naples*. Aldershot.

Elm, Kaspar. 1980. "Verfall und Erneuerung des Ordenswesens im Spätmittelalter: Forschungen und Forschungsaufgaben." In Max-Planck-Institut 1980:188–238.

Elm, Kaspar and Michel Parisse. 1992. *Doppelklöster und andere Formen der Symbiose männlicher und weiblicher Religiosen im Mittelalter*. Berliner Historische Studien 18, Ordensstudien 8. Berlin.

Ennen, Edith. 1988. "Politische, kulturelle und karitative Wirksamkeit mittelalterlicher Frauen in Mission—Kloster—Stift—Konvent." In Dinzelbacher and Bauer 1988:59–82.

Erbstösser, Martin. 1970. *Sozialreligiöse Strömungen im späten Mittelalter: Geißler, Freigeister und Waldenser im 14. Jahrhundert*. Berlin.

Erler, Mary C. 1995. "Exchange of Books Between Nuns and Laywomen: Three Surviving Examples." In *New Science Out of Old Books: Studies in Manuscripts and Early Printed Books in Honour of A.I. Doyle*, ed. Richard Beadle and Anthony J. Piper, 360–373. Hants.

———. 2002. *Women, Reading, and Piety in Late Medieval England*. Cambridge 2002.

Eydoux, Henri-Paul. 1952. *L'architecture des églises cisterciennes d'Allemagne*. Travaux et mémoires des Instituts Français en Allemagne 1. Paris.

Fabri, Felix. 1999. *Felix Fabri: Die Sionpilger*. Ed. Wieland Carls. Texte des späten Mittelalters und der frühen Neuzeit. Berlin.

Faust, Ulrich, ed. 1984. *Die Frauenklöster in Niedersachsen, Schleswig-Holstein und Bremen*. Germania Benedictina 11, Norddeutschland. St. Ottilien.

———. 1994. *Die Männer- und Frauenklöster der Zisterzienser in Niedersachsen, Schleswig-Holstein und Hamburg*. Germania Benedictina 12, Norddeutschland. St. Ottilien.

Favreau, Robert. 1995. *La vie de sainte Radegonde par Fortunat: Poitiers, Bibliothèque Municipale Manuscrit 250 (136)*. Paris.

Fehrenbach, Frank. 1996. *Die Goldene Madonna: Der Körper der Königin*. Kunstort Ruhrgebiet 4. Ostfildern.

Fellerer, Karl Gustav. 1950. "Die Nottulner Osterfeier." *Westfalia Sacra* 2:215–249.

Felten, Franz J. 1984. "Norbert von Xanten: Vom Wanderprediger zum Kirchenfürsten." In *Norbert von Xanten: Adliger, Ordensstifter, Kirchenfürst*, ed. Kaspar Elm, 69–157. Cologne.

———. 1992. "Frauenklöster und -stifte im Rheinland im 12. Jahrhundert: Ein Beitrag zur Geschichte der Frauen in der religiösen Bewegung des hohen Mittelalters." In *Reformidee und Reformpolitik im spätsalisch-frühstaufischen Reich*, ed. Stefan Wein-

furter and Hubertus Seibert, 189–300. Quellen und Abhandlungen zur mittel-
rheinischen Kirchengeschichte 68. Mainz.

——. 2000a. "Der Zisterzienserorden und die Frauen." In *Weltverachtung und Dy-
namik*, ed. Harald Schwillus and Andreas Hölscher, 34–135. Berlin.

——. 2000b. "Zum Problem der sozialen Zusammensetzung von alten Benedik-
tinerklöstern und Konventen der neuen religiösen Bewegung." In Haverkamp
2000:189–235.

——. 2001. "Wie adelig waren Kanonissenstifte (und andere weibliche Konvente)
im (frühen und hohen) Mittelalter?" In Crusius 2001b, 39–128.

——. 2003. "Hildegard von Bingen, 1198–1998; oder, Was bringen Jubiläen für die
Wissenschaft" *Deutsches Archiv* 59:165–193.

Finke, Heinrich. 1891. *Ungedruckte Dominikanerbriefe des 13. Jahrhunderts*. Paderborn.

Finnegan, Mary Jeremy. 1991. *The Women of Helfta: Scholars and Mystics*. Athens, Ga.

Fleck, Beate Sophie, Friedel Helga Roolfs, and Gabriela Signori, eds. 2003. *Das Freck-
enhorster Legendar: Andacht, Geschichte und Legende in einem spätmittelalterlichen Kan-
onissenstift (Edition und Kommentar)*. Religion in der Geschichte 10. Bielefeld.

Forsyth, Ilene. 1972. *The Throne of Wisdom: Wood Sculptures of the Madonna in Roman-
esque France*. Princeton.

Frank, Karl Suso. 1980. *Das Klarissenkloster Söflingen*. Ulm.

Fremer, Torsten. 2002. *Äbtissin Theophanu und das Stift Essen: Gedächtnis und Individu-
alität in ottonisch-salischer Zeit*. Bottrop.

Frugoni, Chiara. 1983. "Le mistiche, le visioni e l'iconographia: Rapporti ed influssi."
In *Temi e problemi nella mistica femminile trecentesca: Convegni del Centro di Studi Sul-
la Spiritualità Medievale, Todi, 14–17 Ottobre, 1979*, 139–179. Università degli Studi
di Perugia 20. Todi.

——. 1984. "'Domine, in conspectu tuo omne desiderium meum':Visioni e immag-
ini in Chiara da Montefalco." In *S. Chiara e il suo tempo: Spoleto, 28–30 decembre,
1981*, ed. C. Leonardi and E. Menestò, 155–175. Perugia.

Fulton, Rachel. 1998. "'*Quae Est Ista Quae Ascendit Sicut Aurora Consurgens?*' The
Song of Songs as the 'Historia' for the Office of the Assumption." *Mediaeval Stud-
ies* 60:55–122.

Fürstenberg, Michael von. 1995. *"Ordinaria loci" oder "Monstrum Westphaliae"? Zur
kirchlichen Rechtsstellung der Äbtissin von Herford im europäischen Vergleich*. Studien
und Quellen zur westfälischen Geschichte 29. Paderborn.

Gäbe, Sabine. 1989. "Radegundis—sancta, regina, ancilla: Zum Heiligkeitsideal der
Radegundisviten von Fortunat und Baudonivia." *Francia* 16, no. 1:1–30.

Gand, Friedrich. 1973. *Maria-Reuthin: Dominikanerinnenkloster und Hohenberger Gra-
blege*. Göppinger Akademische Beiträge 82. Göppingen.

——. 1979. *Das verlorene Seelbuch des Klosters Maria-Reuthin*. Böblingen.

Garber, Rebecca L.R. 2003. *Feminine Figurae: Representations of Gender in Religious*

*Texts by Medieval German Women Writers, 1100–1375.* Studies in Medieval History and Culture 10. New York.

Gardill, Ingrid. 2005. *Sancta Benedicta—Missionarin, Märtyrerin, Patronin: Der Prachtcodex aus dem Frauenkloster Sainte-Benoîte in Origny.* Petersberg.

Gärtner, Magdalene. 2002. *Römische Basiliken in Augsburg: Nonnenfrömmigkeit und Malerei um 1500.* Schwäbische Geschichtsquellen und Forschungen 23. Augsburg.

Gaze, Delia, ed. 1997. *Dictionary of Women Artists.* London.

Geith, Karl-Ernst. 1980/1981. "Elisabeth Kempf (1415–1485): Priorin und Übersetzerin in Unterlinden zu Colmar." *Annuaire de Colmar* 29:47–73.

Gerchow, Jan. 2002. "Geistliche Damen und Herren: Die Benediktinerabtei Werden und das Frauenstift Essen (799–1803)." In *Essen: Geschichte einer Stadt,* ed. Ulrich Borsdorf, in collaboration with Hermann Burghard and Ulrich Bosdorf, 58–167. Bottrop.

———. 2003. "Der Schatz des Essener Frauenstifts bis zum 15. Jahrhundert: Zur Geschichte der Institution." *Das Münster am Hellweg* 56:79–110.

Gerchow, Jan and Thomas Schilp, eds. 2003. *Essen und die sächsischen Frauenstifte im Frühmittelalter.* Essener Forschungen zum Frauenstift 2. Essen.

Gerson, Johannes. 1987. *Johannes Gerson Opera Omnia.* Ed. Louis Ellies Du Pin. Hildesheim.

Gertrude d'Helfta. 1968–1986. *Œuvres spirituelles.* Vols. 2–5, *Le Héraut: Livres I–V.* Ed. Pierre Doyère. Sources chrétiennes 139, 143, 255, 331. Paris.

Geuenich, Dieter and Uwe Ludwig, with assistance from Arnold Angenendt, Gisela Muschiol, Karl Schmid, and Jean Vezin, eds. 2000. *Der Memorial- und Liturgiecodex von San Salvatore/Santa Giulia in Brescia.* Monumenta Germaniae Historica, Antiquitates, Libri memoriales et necrologia, n.s., 4. Hanover.

Gilchrist, Roberta. 1989. "The Archeology of Medieval English Nunneries: A Research Design." In *The Archeology of Rural Monasteries,* ed. Roberta Gilchrist and Harold Mytum, 251–260. BAR British Series 203. Oxford.

———. 1994. *Gender and Material Culture: The Archaeology of Religious Women.* London.

Gill, Katherine. 1996. "'Scandala': Controversies Concerning 'Clausura' and Women's Religious Communities in Late Medieval Italy." In *Christendom and its Discontents: Exclusion, Persecution, and Rebellion, 1000–1500,* ed. Scott L. Waugh and Peter D. Diehl, 177–203. Cambridge.

Gilomen-Schenkel, Elsanne. 1986. "Frühes Mönchtum und benediktinische Klöster des Mittelalters in der Schweiz." In *Helvetia Sacra III/1, Teil 1: Frühe Klöster: Die Benediktiner und Benediktinerinnen der Schweiz,* 33–93. Bern.

Glatz, Karl Jordan. 1881. *Chronik des Bickenklosters zu Villingen 1238 bis 1614.* Tübingen.

Gleba, Gudrun. 2000. *Reformpraxis und materielle Kultur: Westfälische Frauenklöster im späten Mittelalter.* Historische Studien 462. Husum.

———. 2002. *Klöster und Orden im Mittelalter*. Geschichte kompakt: Mittelalter. Darmstadt.

Gleich, Friederike. 1998. "Zisterzienserinnenkirchen als repräsentative Herrschaftsbauten." In *Spiritualität und Herrschaft: Konferenzband zu "Zisterzienser, Multimedia, Museen,"* ed. Oliver H. Schmidt, Heike Frenzel, and Dieter Pötschke, 100–118. Studien zur Geschichte, Kunst und Kultur der Zisterzienser 5. Berlin.

Goetting, Hans. 1973. *Das reichsunmittelbare Kanonissenstift Gandersheim*. Germania Sacra, n.s., 7: Die Bistümer der Kirchenprovinz Mainz, Das Bistum Hildesheim 1. Berlin.

Goetz, Hans-Werner. 1995. *Frauen im frühen Mittelalter: Frauenbild und Frauenleben im Frankenreich*. Weimar.

———, ed. 1999. *Moderne Mediävistik: Stand und Perspektiven der Mittelalterforschung*. Darmstadt.

Goll, Jürg. 1996. "Zisterzienserbauten in der Schweiz unter besonderer Berücksichtigung des Klosters St. Urban." *Beiträge zur Mittelalterarchäologie in Österreich* 12:217–226.

*Das Graduale von St. Katharinenthal: Kommentar zur Faksimile-Ausgabe des Graduale von St. Katharinenthal*. 1983. Introduction by A.A. Schmid and contributions by E.J. Beer, A. Knoepfli, P. Ladner, M. Lütolf, D. Schwarz, and L. Wüthrich. Lucerne.

*Das Graduale von St. Katharinenthal um 1312: Handschrift im gemeinsamen Besitz der Eidgenossenschaft und des Kantons Thurgau*. 1980. Facsimile ed. Lucerne.

Graf, Katrin. 2002. *Bildnisse schreibender Frauen im Mittelalter, 9. bis Anfang 13. Jahrhundert*. Basel.

Grange, Arthur de la. 1897. "Choix de testaments tournaisiens antérieurs au XVIe siècle." *Annales de la société historique et archéologique de Tournai*, n.s., 2:5–365.

Grassi, Liliana. 1964. "Iconologia delle chiese monastiche femminili dall'alto medioevo ai secc. XVI–XVII." *Arte Lombarda* 9:131–150.

Green, Rosalie B. 1951. "The Flabellum of Hohenbourg." *Art Bulletin* 33:153–155.

Green, Rosalie B., Michael Evans, Christine Bischoff, and Michael Curschmann, eds. 1979. *The Hortus Deliciarum of Herrad of Hohenbourg*. Vol. 1, *Reconstruction*; vol. 2, *Commentary*. Studies of the Warburg Institute 36. London.

Greenspan, Kate. 1996. "Autohagiography and Medieval Women's Spiritual Autobiography." In Chance 1996:216–236.

Greven, Joseph. 1912. *Die Anfänge der Beginen: Ein Beitrag zur Geschichte der Volksfrömmigkeit und des Ordenswesens im Hochmittelalter*. Vorreformationsgeschichtliche Forschungen 8. Münster.

Griesebner, Andrea and Christina Lutter. 2000. "Geschlecht und Kultur: Ein Definitionsversuch zweier umstrittener Kategorien" Special supp., *Beiträge zur historischen Sozialkunde. Sondernummer: Geschlecht und Kultur*, 58–64.

Griffiths, Fiona J. 2001. "Herrad of Hohenbourg: A Synthesis of Learning in 'The Garden of Delights.'" In Mews 2001:221–243.

———. 2003. "Brides and 'Dominae': Abelard's 'Cura monialium' at the Augustinian Monastery of Marbach." *Viator* 34:57–88.

———. 2004. "'Men's Duty to Provide for Men's Needs': Abelard, Heloise, and Their Negotiation of the 'Cura Monialium.'" *Journal of Medieval History* 30:1–24.

Grube, Karl. 1886. *Des Augustinerpropstes Iohannes Busch Chronicon Windeshemense und Liber de reformatione monasteriorum.* Geschichtsquellen der Provinz Sachsen und angrenzender Gebiete 19. Halle.

Grundmann, Herbert. 1935/1970. *Religiöse Bewegungen im Mittelalter: Untersuchungen über die geschichtlichen Zusammenhänge zwischen der Ketzerei, den Bettelorden und der religiösen Frauenbewegung im 12. und 13. Jahrhundert und über die geschichtlichen Grundlagen der deutschen Mystik.* Berlin/Darmstadt.

———. 1961. *Religiöse Bewegungen im Mittelalter: Untersuchungen über die geschichtlichen Zusammenhänge zwischen der Ketzerei, den Bettelorden und der religiösen Frauenbewegung im 12. und 13. Jahrhundert.* Rev. ed. Hildesheim.

Hahn, Cynthia. 1997. "The Voices of the Saints: Speaking Reliquaries." *Gesta* 36, no. 1:20–31.

Hale, Rosemary. 1990. "'Imitatio Mariae': Motherhood Motifs in Devotional Memoirs." *Mystics Quarterly* 16, no. 4:193–203.

Haller, Bertram. 2003. "Buchkunst in westfälischen Klöstern—ein Überblick." In Hengst 2003:3:625–682.

Hamann, Richard. 1926. *Die Holztür der Pfarrkirche St. Maria im Kapitol.* Marburg.

Hamburger, Jeffrey F. 1990. *The Rothschild Canticles: Art and Mysticism in Flanders and the Rhineland ca. 1300.* New Haven.

———. 1997a. *Nuns as Artists: The Visual Culture of a Medieval Convent.* California Studies in the History of Art 37. Berkeley.

———. 1997b. "'To Make Women Weep': Ugly Art as 'Feminine' and the Origins of Modern Aesthetics." *Res* 31 (Spring): 9–33.

———. 1998a. "The Liber miraculorum of Unterlinden: An Icon in Its Convent Setting." In *The Visual and the Visionary: Art and Female Spirituality in Late Medieval Germany,* 279–315. New York.

———. 1998b. *The Visual and the Visionary: Art and Female Spirituality in Late Medieval Germany.* New York.

———. 2000a. "La Bibliothèque d'Unterlinden et l'art de la formation spirituelle." In Cat. Colmar 2000–2001, 1:110–159.

———. 2000b. "Speculations on Speculation: Vision and Perception in the Theory and Practice of Mystical Devotions." In *Deutsche Mystik im abendländischen Zusammenhang: Neue erschlossene Texte, neue methodische Ansätze, neue theoretische Konzepte,*

*Kolloquium Kloster Fischingen*, ed. Walter Haug and Wolfram Schneider-Lastin, 353–408. Tübingen 2000.

———. 2002a. "Idol Curiosity." In *Curiositas: Welterfahrung und ästhetische Neugierde in Mittelalter und früher Neuzeit*, ed. Klaus Krüger, 19–58. Göttinger Gespräche zur Geschichtswissenschaft 15. Göttingen.

———. 2002b. *St. John the Divine: The Deified Evangelist in Medieval Art and Theology*. Berkeley.

———. 2004a. "Am Anfang war das Bild: Kunst und Frauenspiritualität im Spätmittelalter." In Eisermann, Schlotheuber, and Honemann 2004:1–43.

———. 2004b. "Der geistliche Rosengarten, Bibliothèque Nationale de France ms. all. 34." *Art de l'enluminure* 11:2–75.

———. 2004c. "'In the Image and Likeness of God': Pictorial Reflections on Images and the 'Imago Dei.'" In J.-Cl. Schmitt 2004:1–18.

———. 2004d. "The 'Various Writings of Humanity': Johannes Tauler on Hildegard of Bingen's Liber Scivias." In *Visual Culture and the German Middle Ages*, ed. Kathryn Starkey and Horst Wenzel, 161–205. London.

———. 2005. "'Johannes Scotus Eriugena deutsch redivivus': Translations of the 'Vox spiritualis' in Relation to Art and Mysticism at the Time of Eckhart." In *Meister Eckhart in Erfurt*, ed. Andreas Speer, 473–537. Miscellanea Mediaevalia 32. Berlin.

———. Forthcoming 1 (1989–). "Heinrich Seuse 'Exemplar.'" In *Katalog der deutschsprachigen illustrierten Handschriften des Mittelalters*, ed. Hella Frühmorgen-Voss and Norbert Ott. Munich.

———. Forthcoming 2. "'In gebeden vnd in bilden geschriben': Prints as Exemplars of Piety and the 'Culture of the Copy' in Fifteenth-Century Germany." In *The Woodcut in Fifteenth-Century Europe*, ed. Peter Parshall and Peter Schmidt. Washington, D.C.

Hanslik, Rudolph, ed. 1977. *Benedicti Regula*. Rev. ed. Corpus Scriptorum Ecclesiasticorum Latinorum 75. Vienna.

Harms, Bernhard, ed. 1909–1913. *Der Stadthaushalt Basels im ausgehenden Mittelalter*. 3 vols. Quellen und Studien zur Basler Finanzgeschichte. Tübingen.

Harrington, Christina. 2002. *Women in a Celtic Church: Ireland, 450–1150*. Oxford.

Härtel, Helmar. 1996. "Die Klosterbibliothek Ebstorf: Reform und Schulwirklichkeit am Ausgang des Mittelalters." In *Schule und Schüler im Mittelalter: Beiträge zur europäischen Bildungsgeschichte des 9. bis 15. Jahrhunderts*, ed. Martin Kintzinger, Sönke Lorenz, and Michael Walter, 245–258. Beihefte zum Archiv für Kulturgeschichte 42. Cologne.

Hartmann, Alfred, ed. 1942. *Die Amerbachkorrespondenz*. Vol. 1, *1481–1513*. Basel.

Hasse, Max. 1981. "Kleinbildwerke in deutschen und skandinavischen Testamenten des 14., 15. und frühen 16. Jahrhunderts." *Niederdeutsche Beiträge zur Kunstgeschichte* 20:60–72.

Hattenhauer, Hans. 1976. *Das Recht der Heiligen*. Schriften zur Rechtsgeschichte 12. Berlin.

Hauck, Albert. 1913. *Kirchengeschichte Deutschlands*. Part 4 (parts 2–4 published together). Leipzig.

Haug, Hans and Robert Will. 1965. *Alsace Romane*. Paris.

Haupt, Herman. 1897. "Beginen und Begarden." In *Realencyclopädie für protestantische Theologie und Kirche*, ed. Karl Hauck, 516–526. 3d ed. Berlin.

Haussherr, Reiner. 1975. "Über die Christus-Johannes-Gruppen: Zum Problem 'Andachtsbilder' und deutsche Mystik." In *Beiträge zur Kunst des Mittelalters: Festschrift für Hans Wentzel zum 60. Geburtstag*, 79–103. Berlin.

Haverkamp, Alfred. 1984. "Tenxwind von Andernach und Hildegard von Bingen: Zwei 'Weltanschauungen' in der Mitte des 12. Jahrhunderts." In *Institutionen, Kultur und Gesellschaft im Mittelalter: Festschrift für Josef Fleckenstein*, 515–548. Sigmaringen.

——, ed. 2000. *Hildegard von Bingen in ihrem historischen Umfeld: Internationaler wissenschaftlicher Kongress zum 900 jährigen Jubiläum, 13.–19. September 1998 Bingen am Rhein*. Mainz.

Hecht, Christian. 2003. "Das Schmerzensmannkreuz: Herkunft, Sinn und Missdeutung eines mittelalterlichen Bildthemas." *Jahrbuch fuer Volkskunde*, 7–30.

Heck, Christian. 1990. "Rapprochement, antagonisme ou confusion dans le culte des saints: Art et dévotion à Katharinenthal au quatorzième siècle." *Viator* 21:229–238.

Heerlein, Karin. 2000. "Hildegard von Bingen (1078–1179): Erträge des Jubiläumsjahres." *Kunstchronik* 53:549–560.

Hegner, Kristina. 1996. *Kleinbildwerke des Mittelalters in den Frauenklöstern des Bistums Schwerin, vornehmlich im Zisterzienserinnenkloster zum Heiligen Kreuz in Rostock und im Klarissenkloster Ribnitz*. Kunstgeschichte 46. Münster.

Heimann, Heinz-Dieter, ed. 1986. *Wie men wol eyn statt regyrn sol: Didaktische Literatur und berufliche Schreiben des Johann von Soest, gen. Steinwert*. Soester Beiträge 48. Soest.

Hengevoss-Dürkop, Kerstin. 1994. *Skulptur und Frauenkloster: Studien zu Bildwerken der Zeit um 1300 aus Frauenklöstern des ehemaligen Fürstentums Lüneburg*. Artefact 7. Berlin.

——. 1998. "Äbtissinnengräber als Repräsentationsbilder: Die romanischen Grabplatten in Quedlinburg." In *Die Repräsentation der Gruppen: Texte—Bilder—Objekte*, ed. Otto Gerhard Oexle and Andrea von Hülsen-Esch, 454–487. Göttingen.

Hengst, Karl, ed. 1992, 1994, 2003. *Westfälisches Klosterbuch: Lexikon der vor 1815 errichteten Stifte und Klöster von ihrer Gründung bis zur Aufklärung*. Veröffentlichungen der historischen Kommission für Westfalen 44; Quellen und Forschungen zur Kirchen- und Religionsgeschichte 2. 3 vols. Münster.

Herlihy, David. 1985. "Did Women Have a Renaissance? A Reconsideration." *Mediaevalia et Humanistica* 13:1–22.

Heusinger, Christian von. 1953. "Studien zur oberrheinischen Buchmalerei und Graphik im Spätmittelalter." Ph.D. diss., University of Freiburg.

———. 1959. "Spätmittelalterliche Buchmalerei in oberrheinischen Frauenklöstern." *Zeitschrift für die Geschichte des Oberrheins* 107; n.s., 68:136–160.

Hildebrandt, Hans. 1928. *Die Frau als Künstlerin.* Berlin.

Hildegard of Bingen. 1965. *Briefwechsel.* Trans. Adelgundis Führkötter. Salzburg.

———. 1978. *Scivias.* Ed. Adelgundis Führkötter and Angela Carlevaris. Corpus christianorum, Continuatio mediaevalis 43–43a. Turnhout.

——— (Hildegardis Bingensis). 1991. *Epistolarium.* Ed. Lieven van Acker. Corpus christianorum, Continuatio mediaevalis 91. Turnhout.

———. 1996. *Liber divinorum operum.* Ed. Albert Derolez and Peter Dronke. Corpus christianorum, Continuatio mediaevalis 92. Turnhout.

*Hildegard-Gebetbuch: Faksimile-Ausgabe des Codex Latinus Monacensis 935 der Bayerischen Staatsbibliothek.* 1982–1987. Wiesbaden.

Hilpisch, Stephanus. 1928. *Die Doppelklöster: Entstehung und Organisation.* Beiträge zur Geschichte des alten Mönchtums und des Benedictinerordens 15. Münster.

Hindsley, Leonard P. 1998. *The Mystics of Engelthal: Writings from a Medieval Monastery.* New York.

Hlawitschka, Eduard, Karl Schmid, and Gerd Tellenbach, eds. 1970. *Liber memorialis von Remiremont.* 2 vols. Monumenta Germaniae Historica Libri memoriales 1. Dublin.

Hochstetler, Donald. 1987. "The Meaning of Monastic Cloister for Women According to Caesarius of Arles." In *Religion, Culture, and Society in the Early Middle Ages: Studies in Honor of Richard E. Sullivan,* ed. Thomas F.X. Noble, 27–40. Studies in Medieval Culture 23. Kalamazoo.

Holladay, Joan A. 1997. "Relics, Reliquaries, and Religious Women: Visualizing the Holy Virgins of Cologne." *Studies in Iconography* 18:67–118.

Houts, Elisabeth M.C. van. 1999. *Memory and Gender in Medieval Europe, 900–1200.* Explorations in Medieval Culture and Society. Basingstoke.

Hutchison, Ann M. 1989. "Devotional Reading in the Monastery and the Late Medieval Household." In *"De Cella in Seculum": Religious and Secular Life and Devotion in Late Medieval England,* ed. Michael G. Sargent, 215–227. Cambridge.

"Institutio sanctimonialium Aquisgranensis." 1906/1979. In *Concilia aevi Karolini I, pars I,* ed. Albert Werminghoff, 421–456. Monumenta Germaniae Histroica, Leges: Concilia II. Hanover/Leipzig.

Jacobsen, Werner. 1992. *Der Klosterplan von St. Gallen und seine Stellung in der Geschichte der karolingischen Architektur: Entwicklung und Wandel von Form und Bedeutung im fränkischen Kirchenbau zwischen 751 und 840.* Berlin.

——. 2003. "Die Stiftskirche von Gernrode und ihre liturgische Ausstattung." In Gerchow and Schilp 2003:219–246.

Jaffé, Philipp, Samuel Loewenfeld, Friedrich Kaltenbrunner, and Paul Ewald, eds. 1885, 1888/1956. *Regesta Pontificum Romanorum*. Leipzig/Graz.

Jäggi, Carola, 2000. "Architecture et disposition liturgique des couvents féminins dans le Rhin supérieur aux XIIIe et XIVe siècles." In Cat. Colmar 2000–2001:1:89–105.

——. 2001. "Eastern Choir or Western Gallery? The Problem of the Place of the Nuns' Choir in Koenigsfelden and Other Early Mendicant Nunneries." *Gesta* 40, no. 1:79–93.

——. 2002. "Liturgie und Raum in franziskanischen Doppelklöstern: Königsfelden und Chiara/Neapel im Vergleich." In *Art, Cérémonial et Liturgie au Moyen Âge: Actes du Colloque de 3e Cycle Romand de Lettres (Lausanne-Fribourg 2000)*, ed. Nicolas Bock, 223–246. Rome.

——. 2004a. *Frauenklöster im Spätmittelalter: Lage und Ausstattung des Nonnenchors in den Klarissen- und Dominikanerinnenkirchen des 13. und 14. Jahrhunderts*. Studien zur internationalen Architektur- und Kunstgeschichte 34. Petersberg.

——. 2004b. "'Sy bettet och gewonlich vor únser frowen bild . . .': Überlegungen zur Funktion von Kunstwerken in spätmittelalterlichen Frauenklöstern." In J.-Cl. Schmitt 2004:63–86.

——. 2006. *Frauenklöster im Spätmittelalter: Die Kirchen der Klarissen und Dominikanerinnen im 13. und 14. Jahrhundert*. Studien zur internationalen Architektur- und Kunstgeschichte, 34. Petersberg.

James of Vitry. 1867. "Life of Mary of Oignies." In *Acta sanctorum . . . editio novissima*, ed. Jean Baptiste Carnandet et al., 5:551–552. Paris.

Janssen, Roman. 1993. "'Unsere Liebe Frau von Herrenberg' im Mittelalter." In *Die Stiftskirche in Herrenberg, 1293–1993*, ed. Roman Janssen and Harald Müller-Baur, 15–77. Herrenberger Historische Schriften 5. Herrenberg.

——. 1999. "Die Viheli—eine Patrizier- und Klerikerfamilie des 14. Jahrhunderts." In *Herrenberger Persönlichkeiten aus acht Jahrhunderten*, ed. Roman Janssen and Oliver Auge, 33–38. Herrenberger Historische Schriften 6. Herrenberg.

Jenal, Georg. 1994. "'Caput autem mulieris vir' (1 Kor. 11, 3): Praxis und Begründung des Doppelklosters im Briefkorpus Abaelard-Heloise." *Archiv für Kulturgeschichte* 76:285–304.

Johnson, Penelope D. 1989a. "Family Involvement in the Lives of Medieval Nuns and Monks." In *Monks, Nuns, and Friars in Medieval Society*, ed. Edward B King, Jacqueline T. Schaefer, and William B. Wadley, 83–92. Sewanee Mediaeval Studies 4. Sewanee, Tenn.

——. 1989b. "Mulier et Monialis: The Medieval Nun's Self-Image." *Thought* 64:242–253.

——. 1991. *Equal in Monastic Profession: Religious Women in Medieval Culture*. Chicago.

——. 1994. "La théorie de la clôture et l'activité réelle des moniales françaises du XIe au XIIIe siècle." In *Les religieuses* 1994, 491–505.

Jopek, Norbert. 1988. *Studien zur deutschen Alabasterplastik des 15. Jahrhunderts.* Manuskripte zur Kunstwissenschaft 21. Worms.

Kamann, Johannes Baptist. 1899, 1900. "Briefe aus dem Brigittenkloster Maihingen (Maria-Mai) im Ries 1516–1522." *Zeitschrift für Kulturgeschichte*, n.s., 6:249–287, 385–410; 7:170–199.

Kamerick, Kathleen. 2002. *Popular Piety and Art in the Late Middle Ages: Image Worship and Idolatry in England, 1350–1500.* 2002.

Kaufhold, Peter. 2002. *Das Wienhäuser Liederbuch.* Kloster Wienhausen 6. Wienhausen.

Keller, Hildegard Elisabeth. 1993. *Wort und Fleisch: Körperallegorien, mystische Spiritualität und Dichtung des St. Trudperter Hoheliedes im Horizont der Inkarnation.* Deutsche Literatur von den Anfängen bis 1700, 15. Bern.

——. 2000. *My Secret Is Mine: Studies on Religion and Eros in the German Middle Ages.* Studies in Spirituality Supplements 4. Louvain.

Kelly-Gadol, Joan. 1977/1984. "Did Women Have a Renaissance?" In *Becoming Visible: Women in European History*, ed. Renate Bridenthal and Claudia Koonz, 137–164. Boston. Reprinted in *Women, History, and Theory: The Essays of Joan Kelly*, 19–50. Chicago.

Kelm, Elfriede. 1974. "Das 'Buch im Chor' der Priörin Anna von Buchwald im Klosterarchiv Preetz." *Jahrbuch Plön*, 68–83.

——. 1974/1975. "Das Buch im Chore der Preetzer Klosterkirche: Nach dem Original dargestellt." *Schriften des Vereins für Schleswig-Holsteinische Kirchengeschichte* 30/31:15–35.

Kern-Stähler, Annette. 2002. *"A Room of One's Own": Reale und mentale Innenräume weiblicher Selbstbestimmung im spätmittelalterlichen England.* Frankfurt.

Kessler, Herbert. 2004. *Seeing Medieval Art.* Rethinking the Middle Ages 1. Peterborough, Ontario.

Kirchweger, Franz. 1999. "'Die Liebe zu Gott und zum nächsten': Überlegungen zum Ausstattungsprogramm der Michaelskapelle im ehemaligen Benediktinerinnenstift Göß." *Römische Historische Mitteilungen* 41:251–266.

Klaniczay, Gábor. 2000. *Holy Rulers and Blessed Princesses: Dynastic Cults in Medieval Central Europe.* Cambridge.

Klapisch-Zuber, Christiane. 1992. *Silences of the Middle Ages.* A History of Women in the West, ed. Georges Duby and Michelle Perrot, vol. 2. Cambridge, Mass.

Kleinberg, Aviad M. 1992. *Prophets in Their Own Country: Living Saints and the Making of Sainthood in the Later Middle Ages.* Chicago.

Klinger, Cornelia. 2000. "Die Kategorie Geschlecht in der Dimension der Kultur."

Special supp., *Beiträge zur historischen Sozialkunde. Sondernummer: Geschlecht und Kultur*, 3–8.

Klueting, Edeltraud. 1986. *Das Kanonissenstift und Benediktinerinnenkloster Herzebrock.* Germania Sacra, n.s., 21. Berlin.

———. 2001. "Damenstifte im nordwestdeutschen Raum am Vorabend der Reformation." In Crusius 2001b, 317–348.

———. 2004. "'Damenstifter sind zufluchtsorter, wo sich fräuleins von adel schicklich aufhalten können': Zur Säkularisation von Frauengemeinschaften in Westfalen und im Rheinland, 1773–1812." In *Reform—Reformation—Säkularisation: Frauenstifte in Krisenzeiten*, ed. Thomas Schilp, 177–200. Essener Forschungen zum Frauenstift 3. Essen.

Koch, Gottfried. 1962. *Frauenfrage und Ketzertum im Mittelalter: Die Frauenbewegung im Rahmen des Katharismus und des Waldensertums und ihre sozialen Wurzeln (12–14. Jahrhundert).* Berlin.

Köbele, Susanne. 1993. *Bilder der unbegriffenen Wahrheit: Zur Struktur mystischer Rede im Spannungsfeld von Latein und Volkssprache.* Bibliotheca germanica, 30. Tübingen.

Kohl, Wilhelm. 1975. *Das (freiweltliche) Damenstift Freckenhorst.* Germania Sacra, n.s., 10, Die Bistümer der Kirchenprovinz Köln, Das Bistum Münster 3. Berlin.

———. 1980. "Bemerkungen zur Typologie der Frauenklöster des 9. Jahrhunderts im westlichen Sachsen." In Max-Planck-Institut 1980, 112–139.

———. 2003a. "Die frühe Klosterlandschaft Westfalens (um 800–1100). In Hengst 2003:3:133–154.

———. 2003b. "Der westfälische Adel und seine Klöster." In Hengst 2003:3:457–474.

Kohnle, Antje. 2002. *Hildegard von Bingen Liber Scivias: Farbmikrofiche-Edition der Handschrift Heidelberg, Universitätsbibliothek, Cod. Sal. X 16.* Codices illuminati medii aevi 50. Munich.

König, Joseph, ed. 1880. "Die Chronik der Anna von Munzingen: Nach der ältesten Abschrift mit Einleitung und Beilagen." *Freiburger Diöcesan-Archiv* 13:129–236.

Konrad, Michaela, Arno Rettner, and Eleonore Wintergerst. 2003. "Die Grabungen von Klaus Schwarz unter dem Niedermünster in Regensburg." In Sennhauser 2003:2:651–663.

Kosch, Clemens. 2000. *Kölns romanische Kirchen: Architektur und Liturgie im Hochmittelalter.* Regensburg.

———. 2001. "Organisation spatiale des monastères de Cisterciennes et de Prémontrées en Allemagne et dans les pays germanophones au Moyen Âge: Églises conventuelles et bâtiments claustraux." In Barrière and Henneau 2001:19–39.

Kötzsche, Dietrich. 1994. "Der sog. Kamm Heinrichs I. in Quedlinburg." *Aachener Kunstblätter* 60:97–104.

Krenig, Ernst Günther. 1954. *Mittelalterliche Frauenklöster nach den Constitutionen von*

*Cîteaux unter besonderer Berücksichtigung fränkischer Nonnenkonvente*. Analecta sacri ordinis Cisterciensis 10, fasc. 1–2. Rome.

Kroos, Renate. 1970. *Niedersächsische Bildstickereien des Mittelalters*. Ed. Deutscher Verein für Kunstwissenschaft. Berlin.

———. 1978. "Sächsische Buchmalerei, 1200–1250: Ein Forschungsbericht." *Zeitschrift für Kunstgeschichte* 41:283–316.

Kruse, Britta-Juliana. 2002. "Eine Witwe als Mäzenin: Briefe und Urkunden zum Aufenthalt der Nürnberger Patrizierin Katharina Lemlin im Brigittenkloster Maria Mai (Maihingen)." In *Literarische Leben: Rollenentwürfe in der Literatur des Hoch- und Spätmittelalters. Festschrift für Volker Mertens zum 65. Geburtstag*, ed. Matthias Meyer and Hans-Jochen Schiewer, 465–506. Tübingen.

Kubach, Hans Erich and Albert Verbeek. 1976, 1989. *Romanische Baukunst an Rhein und Maas*. Vols. 1–3 and vol. 4. Berlin.

Kuchenbuch, Ludolf. 1991. "Opus feminile: Das Geschlechterverhältnis im Spiegel von Frauenarbeiten im früheren Mittelalter." In *Weibliche Lebensgestaltung im Frühmittelalter*, ed. Hans-Werner Goetz, 139–175. Cologne.

Kugler, Hartmut, ed. 1991. *Ein Weltbild vor Kolumbus: Die Ebstorfer Weltkarte*. Weinheim.

Kuhn, Annette. 2002. "Frauenbewegungen." In *Wörterbuch der Feministischen Theologie*, ed. Elisabeth Gößmann, 179–182. Rev. ed. Guetersloh.

Kuhn-Rehfus, Maren. 1980. "Zisterzienserinnen in Deutschland." In Cat. Aachen 1980, 125–147.

———. 1992. *Das Zisterzienserinnenkloster Wald*. Germania Sacra, n.s., 30. Berlin.

Knoepfli, Albert. 1989. *Das Kloster St. Katharinental*. Die Kunstdenkmäler des Kantons Thurgau, vol. 4. Basel.

Küppers-Braun, Ute. 1997. *Frauen des hohen Adels im kaiserlich-freiweltlichen Damenstift Essen (1605–1803): Eine verfassungs- und sozialgeschichtliche Studie. Zugleich ein Beitrag zur Geschichte der Stifte Thorn, Elten, Vreden und St. Ursula in Köln.* Quellen und Studien: Veröffentlichungen des Instituts für kirchengeschichtliche Forschung des Bistums Essen 8. Münster.

———. 2002. *Macht in Frauenhand: 1000 Jahre Herrschaft adeliger Frauen in Essen.* Essen.

Küsters, Urban. 1985. *Der verschlossene Garten: Volkssprachliche Hoheliedauslegung und monastische Lebensform im 12. Jahrhundert.* Studia humaniora 2. Düsseldorf.

———. 1991. "Formen und Modelle religiöser Frauengemeinschaften im Umkreis der Hirsauer Reform des 11. und 12. Jahrhunderts." In *Hirsau St. Peter und Paul, 1091–1991.* Vol. 2, *Geschichte, Lebens- und Verfassungsformen eines Reformklosters*, ed. Klaus Schreiner, 194–220. Stuttgart.

Lange, Klaus. 2001. *Der Westbau des Essener Doms.* Quellen und Studien: Veröffentlichungen des Instituts für kirchengeschichtliche Forschung des Bistums Essen 9. Münster.

Lauwers, Michel and Walter Simons. 1988. *Béguins et béguines à Tournai au bas Moyen Age.* Tornacum 3. Tournai.

Laven, Mary. 2002. *Virgins of Venice: Enclosed Lives and Broken Vows in the Renaissance Convent.* London.

Leclercq, Jean. 1981. "Eucharistic Celebrations Without Priests in the Middle Ages." *Worship* 55:160–168.

Lentes, Thomas. 1992. "Inneres Auge, äußerer Blick und heilige Schau: Ein Diskussionsbeitrag zur visuellen Praxis in Frömmigkeit und Moraldidaxe des späten Mittelalters." In Schreiner and Schnitzler 1992:179–220.

———. 1994. "Bild, Reform und 'Cura Monialum': Bildverständnis und Bildgebrauch im Buch der Reformacio Predigerordens des Johannes Meyer (1485)." In *Dominicains et dominicaines en Alsace XIIIe s.*, ed. Jean-Luc Eichenlaub, 177–195. Colmar.

———. 1996. *Gebetbuch und Gebärde: Religiöses Ausdrucksverhalten in Gebetbüchern aus dem Dominikanerinnen-Kloster St. Nikolaus in undis zu Straßburg (1359–1550).* Ph.D. diss., University of Münster.

Lerner, Gerda. 1993. *Die Entstehung des feministischen Bewußtseins: Vom Mittelalter bis zur ersten Frauenbewegung.* Frankfurt.

Lewis, Gertrud Jaron. 1996. *By Women, for Women, about Women: The Sister-Books of Fourteenth-Century Germany.* Studies and Texts 125. Toronto.

Lewis, Suzanne. 1995. *Reading Images: Narrative Discourse and Reception in the Thirteenth-Century Illuminated Apocalypse.* Cambridge.

*Lexikon des Mittelalters.* 1980–1999. 10 vols. Munich.

Leyser, Karl. 1984. *Herrschaft und Konflikt: König und Adel im ottonischen Sachsen.* Veröffentlichungen des Max-Planck-Instituts für Geschichte 76. Göttingen. English edition: *Rule and Conflict in an Early Medieval Society: Ottonian Saxony* (Oxford: Blackwell, 1989).

Lindgren, M. 1991. "Altars and Apostles: St. Birgitta's Provisions for the Altars in the Abbey Church at Vadstea and Their Reflection of Birgittine Spirituality." In *In Quest of the Kingdom: Ten Papers on Medieval Monastic Spirituality*, ed. Alf Härdelin, 245–282. Stockholm.

Lindner, Ines, Sigrid Schade, Silke Wenk, and Gabriele Werner, eds. 1989. *Blick-Wechsel: Konstruktionen von Männlichkeit und Weiblichkeit in Kunst und Kunstgeschichte.* Berlin.

Lipsmeyer, Elizabeth. 1988. "The Imperial Abbey and the Town of Zurich: The Benedictine Nuns and the Price of Ritual in Thirteenth, Fourteenth, and Fifteenth Century Switzerland." *Vox Benedictina* 5:175–189.

Lobbedey, Uwe. 1996. "Wohnbauten bei frühen Bischofs-, Kloster- und Stiftskirchen in Westfalen nach den Ausgrabungsergebnissen." In *Wohn- und Wirtschaftsbauten frühmittelalterlicher Klöster: Acta*, ed. Hans Rudolf Sennhauser, 91–105. Schriften des Instituts für Denkmalpflege der ETH Zürich 17. Zurich.

———. 2000. *Romanik in Westfalen*. Regensburg.

———. 2003. "Die Frauenstiftskirche zu Vreden: Bemerkungen zur Architektur und Liturgie." In Gerchow and Schilp 2003:185–218.

Lorenz, Sönke and Thomas Zotz, eds. 2005. *Frühformen von Stiftskirchen in Europa: Funktion und Wandel religiöser Gemeinschaften vom 6. bis zum Ende des 11. Jahrhunderts: Festgabe für Dieter Mertens zum 65. Geburtstag. Vorträge der Wissenschaftlichen Tagung des Südtiroler Kulturinstituts in Zusammenarbeit mit dem Institut für Geschichtliche Landeskunde und Historische Hilfswissenschaften der Universität Tübingen und der Abteilung Landesgeschichte des Historischen Seminars der Universität Freiburg im Breisgau im Bildungshaus Schloß Goldrain/Südtirol, 13.–16. Juni 2002*. Schriften zur südwestdeutschen Landeskunde 54. Leinfeld-Echterdingen.

Löther, Andrea and Birgit Tramsen. 1998. "'Du liebst mich mehr, als Du von mir geliebt wirst': Jordan von Sachsen und Diana von Andalo." In *Meine in Gott geliebte Freundin: Freundschaftsdokumente aus klösterlichen und humanistischen Schreibstuben*, ed. Gabriela Signori, 91–99. Religion in der Geschichte 4. Rev. ed. Bielefeld.

Louis, Pierre, ed. 2004. *Epreuves du temps: 200 ans de la bibliothèque de Metz (1804–2004)*. Metz.

Ludwig-Jansen, Katherine. 2000. *The Making of the Magdalen: Preaching and Popular Devotion in the Later Middle Ages*. Princeton.

Lundt, Bea. 2003. "Mediävistische Genderforschung: Fragestellungen—Forschungsergebnisse—Geschichtsdidaktische Überlegungen." In *Zwischen Politik und Kultur: Perspektiven einer kulturwissenschaftlichen Erweiterung der Mittelalter-Didaktik*, ed. Wolfgang Hasberg and Manfred Seidenfuß, 71–108. Neuried.

Luther, Martin. 1962. *An den christlichen Adel deutscher Nation*. Stuttgart.

Lutterbach, Hubertus. 2004. "Peter Abaelards Lebensregel für Klosterfrauen: Zum korrigierenden Umgang mit dem fundierenden Text." In *Normieren, Tradieren, Inszenieren: Das Christentum als Buchreligion*, ed. Andreas Holzem, 127–139. Darmstadt.

McCallum Chibnal, Marjorie. 2005. "Eileen Edna Le Poer Power (1889–1940)." In *Women Medievalists and the Academy*, ed. Jane Chance, 311–321. Madison.

McCash, June Hall, ed. 1996. *The Cultural Patronage of Medieval Women*. Athens Ga.

McGinn, Bernard. 1977. Introduction to *Three Treatises on Man: A Cistercian Anthropology*. Cistercian Fathers Series 24. Kalamazoo.

Machilek, Franz. 1986. "Dorothea Markgräfin von Brandenburg (1471–1520)." In *Fränkische Lebensbilder*, 72–90. Veröffentlichungen der Gesellschaft für fränkische Geschichte, Reihe VII A, vol. 12. Neustadt a. d. Aisch.

McKitterick, Rosamond. 1992. "Nuns' Scriptoria in England and Francia in the Eighth Century." *Francia* 19, no. 1:1–35.

———. 1994/2004. "Women and Literacy in the Early Middle Ages." In *Books, Scribes and Learning in the Frankish Kingdoms, 6th–9th Centuries*, 1–43. Aldershot.

McLaughlin, Mary Martin. 1975. "Peter Abelard and the Dignity of Women: Twelfth

Century 'Feminism' in Theory and Practice," 287–333. In *Pierre Abélard, Pierre le Vénérable: Les courants philosophiques, littéraires et artistiques en occident au milieu du XIIe siècle*, 287–333. Paris.

McLaughlin, T.P., C.S.B., ed. 1956. "Abelard's Rule for Religious Women." *Medieval Studies* 18:241–292.

McNamara, Jo Ann. 1991. "The Need to Give: Suffering and Female Sanctity in the Middle Ages." In *Images of Sainthood in Medieval Europe*, ed. R. Blumenfeld-Kosinski et al., 199–221. Ithaca, N.Y.

McNamara, Jo Ann Kay. 1996. *Sisters in Arms: Catholic Nuns through Two Millennia*. Cambridge.

Makowski, Elizabeth. 1997. *Canon Law and Cloistered Women: "Periculoso" and Its Commentators, 1298–1545*. Studies in Medieval and Early Modern Canon Law 5. Washington.

Margaret of Oingt. 1990. *The Writings of Margaret of Oingt: Medieval Prioress and Mystic*. Trans. Renate Blumenfeldt-Kosinski. Focus Library of Medieval Women. Newburyport, Mass.

Marsolais, Miriam. 2001. "'God's Land Is My Land': The Territorial-Political Context of Hildegard of Bingen's Rupertsberg Calling." Ph.D. diss., University of California, Berkeley.

Marti, Susan. 1996. "Königin Agnes und ihre Geschenke: Zeugnisse, Zuschreibungen und Legenden." *Kunst + Architektur in der Schweiz* 47:169–180.

———. 2002. *Malen, Schreiben und Beten: Die spätmittelalterliche Handschriftenproduktion im Doppelkloster Engelberg*. Zürcher Schriften zur Kunst-, Architektur- und Kulturgeschichte 3. Zurich.

Märtl, Claudia. 1995. "'Pos verstockt weyber'? Der Streit um die Lebensform der Regensburger Damenstifte im ausgehenden 15. Jahrhundert." In *Regensburg, Bayern und Europa: Festschrift für Kurt Reindel zum 70. Geburtstag*, ed. Lothar Kolmer and Peter Segl, 365–405. Regensburg.

Matter, E. Ann and John Coakley, eds. 1994. *Creative Women in Medieval and Early Modern Italy: A Religious and Artistic Renaissance*. Philadelphia.

Mattick, Renate. 1998. "Drei Chorbücher aus dem Kölner Klarissenkloster im Besitz von Sulpiz Boisserée." *Wallraf-Richartz-Jahrbuch* 59:59–101.

Max-Planck-Institut für Geschichte, ed. 1980. *Untersuchungen zu Kloster und Stift*. Veröffentlichungen des Max-Planck-Instituts für Geschichte 68; Studien zur Germania Sacra 14. Göttingen.

Mecham, June L. 2003. "Reading Between the Lines: Compilation, Variation and the Recovery of an Authentic Female Voice in the 'Dornenkron' Prayer Books from Wienhausen." *Journal of Medieval History* 29:109–128.

Mechthild of Hackeborn. 1877. *Revelationes Gertrudianae ac Mechtildianae*. Ed. monks of Solesmes. Vol. 2, *Sanctae Mechtildis Liber Specialis gratiae*. Paris.

Mechthild von Magdeburg. 2003. *Das fließende Licht der Gottheit.* Ed. Gisela Vollmann-Profe. Frankfurt.

Meer, Haye van der. 1965. *Priestertum der Frau? Eine theologiegeschichtliche Untersuchung.* Quaestiones disputatae 42. Freiburg.

Meier, Christel. 1979. "Zum Verhältnis von Text und Illustration im aüberlieferten Werk Hildegards von Bingen." In *Hildegard von Bingen, 1179–1979: Festschrift zum 800. Todestag der Heiligen,* ed. Anton P.H. Brück, 159–169. Quellen und Abhandlungen zur mittelrheinischen Kirchengeschichte 33. Mainz.

Mersch, Margit. 2004. "Gehäuse der Frömmigkeit—Zuhause der Nonnen: Zur Geschichte der Klausurgebäude zisterziensischer Frauenklöster im 13. Jahrhundert." In Eisermann, Schlotheuber, and Honemann 2004:45–102.

Metz, René. 1985. *La femme et l'enfant dans le droit canonique médiéval.* London.

*Metz enluminée: Autour de la Bible de Charles le Chauve. Trésors manuscrits des églises messines.* 1989. Metz.

Mews, Constant J. 2000. "Hildegard, the Speculum Virginum and Religious Reform in the Twelfth Century." In Haverkamp 2000:237–267.

——, ed. 2001. *Listen Daughter: The Speculum Virginum and the Formation of Religious Women in the Middle Ages.* New York.

Meyer, Ruth. 1995. *Das "St. Katharinentaler Schwesternbuch": Untersuchung, Edition, Kommentar.* Münchener Texte und Untersuchungen zur deutschen Literatur des Mittelalters 104. Tübingen.

Michael, Eckhard. 1985. "Bildstickereien aus Kloster Lüne als Ausdruck der Reform des 15. Jahrhunderts." *Die Diözese Hildesheim in Vergangenheit und Gegenwart: Jahrbuch des Vereins für Heimatkunde im Bistum Hildesheim* 53:63–78.

Michler, Wiebke. 1968. *Kloster Wienhausen: Die Wandmalereien im Nonnenchor.* Wienhausen.

Miller, Max. 1940. "Die Söflinger Briefe und das Klarissenkloster Söflingen." Ph.D. diss., University of Tübingen, Würzburg.

Miner, Dorothy. 1974. *Anastaise and Her Sisters: Woman Artists of the Middle Ages.* Baltimore.

Mischlewski, Adalbert. 1994. "Idéal monastique et intérêt de la bourgeoisie: La clôture du couvent des Augustines de la ville libre et impériale de Memmingen." In *Les religieuses* 1994, 539–547.

Mittermaier, Paul. 1965, 1966. "Lebensbeschreibung der sel: Christina von Retters." *Archiv für mittelrheinische Kirchengeschichte* 17:209–251; 18:203–238.

Młynarczyk, Gertrud. 1987. *Ein Franziskanerinnenkloster im 15. Jahrhundert: Edition und Analyse von Besitzinventaren aus der Abtei Longchamp.* Pariser Historische Studien 23. Bonn.

Mohn, Claudia. 2004. "Mittelalterliche Klosteranlagen der Zisterzienserinnen: Ein

Beitrag zur Architektur der Frauenklöster im mitteldeutschen Raum." Ph.D. diss., Technical University, Berlin.

——. 2006. *Mittelalterliche Klosteranlagen der Zisterzienserinnen: Architektur der Frauenklöster im mitteldeutschen Raum.* Berliner Beiträge zu Bauforschung und Denkmalpflege 4. Petersberg.

Mooney, Catherine M., ed. 1999. *Gendered Voices: Medieval Saints and Their Interpreters.* Middle Ages Series. Philadelphia.

Moraht-Fromm, Anna, ed. 2003. *Kunst und Liturgie: Choranlagen des Spätmittelalters. Ihre Architektur, Ausstattung und Nutzung.* Ostfildern.

Moraw, Peter. 1980. "Über Typologie, Chronologie und Geographie des Stifts im deutschen Mittelalter." In Max-Planck-Institut 1980, 9–37.

Muckle, Joseph T., C.S.B. 1955. "The Letter of Heloise on Religious Life and Abelard's First Reply." *Medieval Studies* 17:240–281.

Müntz, Marc. 1998. "Freundschaften und Feindschaften in einem spätmittelalterlichen Frauenkloster: Die sogenannten Söflinger Briefe." In *Meine in Gott geliebte Freundin: Freundschaftsdokumente aus klösterlichen und humanistischen Schreibstuben,* ed. Gabriela Signori, 111–120. Religion in der Geschichte 4. Rev. ed. Bielefeld.

Muschiol, Gisela. 1990. "'Psallere et legere': Zur Beteiligung der Nonnen an der Liturgie nach den frühen gallischen Regulae ad Virgines." In *Liturgie und Frauenfrage: Ein Beitrag zur Frauenforschung aus liturgiewissenschaftlicher Sicht,* ed. Teresa Berger and Albert Gerhards, 77–125. St. Ottilien.

——. 1994. *Famula Dei: Zur Liturgie in merowingischen Frauenklöstern.* Beiträge zur Geschichte des alten Mönchtums und des Benediktinertums 41. Münster.

——. 1999–2000. *Klausurkonzepte: Mönche und Nonnen im 12. Jahrhundert.* Habilitationsschrift, Universität Münster, Katholisch-theologische Fakultät.

——. 2000a. "Das 'gebrechlichere Geschlecht' und der Gottesdienst: Zum religiösen Alltag in Frauengemeinschaften des Mittelalters." In Berghaus, Schilp, and Schlagheck 2000:19–28.

——. 2000b. "Liturgische Texte (Edition)." In Geuenich and Ludwig 2000:199–228.

——. 2001. "Liturgie und Klausur: Zu den liturgischen Voraussetzungen von Nonnenchören." In Crusius 2001b:129–148.

——. 2003a. "Architektur, Funktion und Geschlecht: Westfälische Klosterkirchen des Mittelalters." In Hengst 2003:3:791–811.

——. 2003b. "Die Gleichheit und die Differenz: Klösterliche Lebensformen für Frauen im Hoch- und Spätmittelalter." In Zimmermann and Priesching 2003:65–76.

Neidiger, Bernhard. 2003a. "Die Reformbewegungen der Bettelorden im 15. Jahrhundert." In Zimmermann and Priesching 2003:77–90.

——. 2003b. "Standesgemäßes Leben oder frommes Gebet? Die Haltung der weltli-

chen Gewalt zur Reform von Frauenklöstern." In *Altes Herkommen—neue Fröm-migkeit: Reform in Frauenklöstern des 15. Jahrhunderts, Sektion auf dem 44. deutschen Historikertag in Halle an der Saale 2002 "Traditionen—Visionen,"* ed. Andreas Ranft and Markus Meumann, 54. Munich.

Newman, Barbara. 1995. "On the Threshold of the Dead: Purgatory, Hell, and Religious Women." In From Virile Woman to WomanChrist: Studies in Medieval Religion and Literature, 108–136. Middle Ages Series. Philadelphia.

———. 1998a. *Voice of the Living Light: Hildegard of Bingen and Her World.* Berkeley.

———. 1998b. "Possessed by the Spirit: Devout Women, Demoniacs, and the Apostolic Life in the Thirteenth Century." *Speculum* 73:733–770.

———. 2003. *God and the Goddesses: Vision, Poetry, and Belief in the Middle Ages.* Middle Ages Series. Philadelphia.

———. 2005. "What Did It Mean to Say 'I Saw'? The Clash Between Theory and Practice in Medieval Visionary Culture." *Speculum* 80:1–43.

Niehr, Klaus. 2000. Review of Lieselotte Saurma-Jeltsch, *Die Miniaturen im "Liber Scivias" der Hildegard von Bingen* (Wiesbaden, 1998), and Keiko Suzuki, *Bildgewordene Visionen oder Visionserzählungen* (Bern, 1998). *Zeitschrift für deutsches Altertum* 129:215–222.

Nobs-Greter, Ruth. 1984. *Die Künstlerin und ihr Werk in der deutschsprachigen Kunstgeschichtsschreibung.* Zurich.

Nolte, Cordula. 1986. "Klosterleben von Frauen in der frühen Merowingerzeit: Überlegungen zur Regula ad virgines des Caesarius von Arles." In *Frauen in der Geschichte,* ed. Werner Affeldt and Annette Kuhn, 7:257–271. Düsseldorf.

Nordenfalk, Carl. 1961. "St. Bridget of Sweden as Represented in Illuminated Manuscripts." In *De artibus opuscula XL: Essays in Honor of Erwin Panofsky,* 2 vols., ed. Millard Meiss, 371–393. New York.

Nyberg, Tore. 1965. *Birgittinische Klostergründungen des Mittelalters.* Leiden.

———. 1983. "Birgittiner, Birgittinerinnen." *Lexikon des Mittelalters* 2:218–219.

Oberste, Jörg. 1996. *Visitation und Ordensorganisation: Formen sozialer Normierung, Kontrolle und Kommunikation bei Cisterziensern, Prämonstratensern und Cluniazensern (12.-frühes 14. Jahrhundert).* Vita Regularis 2. Münster.

O'Cróinín, Daíbhí. 1995. "The Salaberga Psalter." In *From the Isles of the North: Early Medieval Art in England and Britain. Proceedings of the Third International Conference on Insular Art Held in the Ulster Museum Belfast, 7–11 April 1994,* ed. Es. Cormac Bourke, 127–135. Belfast.

———, ed. 1994. *Psalterium Salabergae: Staatsbibliothek zu Berlin—Preussischer Kulturbesitz, Ms. Hamilt. 553.* Codices illuminati medii aevi 30. Munich.

Ohly, Friedrich, with assistance from Nikola Kleine, ed. 1998. *Das St. Trudperter Hohelied: Eine Lehre der liebenden Gotteserkenntnis.* Bibliothek des Mittelalters 2. Frankfurt.

Oliva, Marilyn. 1998. *The Convent and the Community in Late Medieval England: Female Monasteries in the Diocese of Norvich, 1350–1540.* Woodbridge.

Oliver, Judith. 1995. "The Herkenrode Indulgence, Avignon, and Pre-Eyckian Painting of the Mid-Fourteenth-Century Low Countries." In *Flanders in a European Perspective: Manuscript Illumination Around 1400 in Flanders and Abroad*, ed. Maurits Smeyers and Bert Cardon, 187–206. Löwen.

——. 1996. "The Walters Homilary and Westphalian Manuscripts." *Journal of the Walters Art Gallery* 54:69–85.

——. 1997. "Worship of the Word: Some Gothic Nonnenbücher in their Devotional Context." In *Women and the Book: Assessing the Visual Evidence*, ed. Lesley Smith and Jane H.M. Taylor, 106–122, London.

——. 1999. "Image et dévotion: Le rôle de l'art dans l'institution de la Fête-Dieu." In *Fête-Dieu (1246–1996), I. Actes du Colloque de Liège, 12–14 septembre 1996*, ed. André Haquin, 153–172. Publications de l'Institut d'Études Médiévales. Textes, Études, Congrès, 19/1. Louvain-la-Neuve.

——. 2004a. "A Primer of Thirteenth-Century German Convent Life: The Psalter as Office and Mass Book." In *The Illuminated Psalter: Iconography, Function of Images and Decorative Context*, ed. Frank Büttner, 153–164. Turnhout.

——. 2004b. "Singing a Blue Note on a Red-Letter Day: The Art of Easter in Some North German Convents." In J.-Cl. Schmitt 2004.

——. 2007. *Singing with Angels: Liturgy, Music, and Art in the Gradual of Gisela von Kersenbroeck.* Turnhout.

Osthues, Gabriele. 1989. "Die Macht edler Herzen und gewaltiger Weiblichkeit: Zwei frühe Beiträge zur Situation der Frau im Mittelalter. Karl Weinhold und Carl Bücher." In *Der frauwen buoch: Versuche zu einer feministischen Mediävistik*, ed. Ingrid Bennewitz, 399–431. Göppingen.

Ostrowitzki, Anja. 1999. "Der 'Liber dictaminum' des Abtes von Himmerod als Zeugnis für die 'cura monialium' im spätmittelalterlichen Zisterzienserorden." *Deutsches Archiv* 55:157–181.

Pächt, Otto. 1956. "The Illustrations of St. Anselm's Prayers and Meditations." *Journal of the Warburg and Courtauld Institutes* 19:68–83.

Parisse, Michel. 1983a. "Deux testaments de nobles comtoises, chanoinesses de Remiremont, Mathilde et Guie de Granges (1301–1379)." *Mémoires de la Société pour l'histoire du droit et des institutions des anciens pays bourguignons, comtois et romands* 39:119–131.

——. 1983b. *Les nonnes au Moyen Age.* Le Puy.

——. 1988. "Der Anteil der lothringischen Benediktinerinnen an der monastischen Bewegung des 10. und 11. Jahrhunderts." In Dinzelbacher and Bauer 1988:83–97.

——. 1991. "Die Frauenstifte und Frauenklöster in Sachsen vom 10. bis zur Mitte

des 12. Jahrhunderts." In *Die Salier und das Reich*, vol. 2, *Die Reichskirche in der Salierzeit*, ed. Stefan Weinfurter, 465–501. Sigmaringen.

——. 1992. "Fontevraud, monastère double." In Elm and Parisse 1992:135–148.

Peers, Charles and C. A. Ralegh Radford. 1943. "The Saxon Monastery of Whitby." *Archaeologia* 89:27–88.

Peters, Ursula. 1988. *Religiöse Erfahrung als literarisches Faktum: Zur Vorgeschichte und Genese frauenmystischer Texte des 13. und 14. Jahrhunderts*. Hermaea, n.s., 56. Tübingen.

Petroff, Elizabeth A. 1994. *Body and Soul: Essays on Medieval Women and Mysticism*. New York.

Pleij, Herman. 1989. "Zwischen Selbsterniedrigung und Selbstvergottung: Bilderwelt und Selbstbild religiöser Frauen in den südlichen Niederlanden. Eine erste Erkundigung." *De zeventiende eeuw* 5, no. 1:67–88.

Poeschke, Joachim, ed. 2004. *Das Soester Antependium und die frühe mittelalterliche Tafelmalerei: Kunsttechnische und kunsthistorische Beiträge. Kolloquium Westfälisches Landesmuseum für Kunst und Kulturgeschichte 5.–7. 12. 2002*. Münster.

Poor, Sara S. 2001. "Mechtild von Magdeburg: Gender and the 'Unlearned Tongue.'" *Journal of Medieval and Early Modern Studies* 31, no. 2:213–250.

——. 2004. *Mechtild of Magdeburg and Her Book: Gender and the Making of Textual Authority*. Middle Ages Series. Philadelphia.

Power, Eileen. 1922. *Medieval English Nunneries, c. 1275 to 1535*. Cambridge.

Preysing, Gräfin Marietheres. 1981. "Über Kleidung und Schmuck von Brabanter Christkindfiguren." In *Documenta Textilia: Festschrift für Sigrid Müller-Christensen*, ed. Mechthild Flury-Lemberg, 349–356. Munich.

Raming, Ida. 1973. *Der Ausschluß der Frau vom priesterlichen Amt: Gottgewollte Tradition oder Diskriminierung?* Cologne.

——. 2002. *Priesteramt der Frau: Geschenk Gottes für eine erneuerte Kirche*. Rev. ed. of Raming 1973. Münster.

*Reallexikon zur deutschen Kunstgeschichte*. 1937–. Begun by Otto Schmidt. Stuttgart.

Reichenmiller, Margareta. 1964. *Das ehemalige Reichsstift und Zisterziensernonnenkloster Rottenmünster*. Stuttgart.

Reichert, Benedictus Maria, ed. 1908–1909. *Iohannes Meyer Ord. Praed.: Buch der Reformacio Predigerordens*. Quellen und Forschungen zur Geschichte des Dominikanerordens in Deutschland 2/3. Leipzig.

Reinhardt, Uta, ed. 1996. *Lüneburger Testamente des Mittelalters 1323 bis 1500*. Veröffentlichungen der historischen Kommission für Niedersachsen und Bremen 37; Quellen und Untersuchungen zur Geschichte Niedersachsens im Mittelalter 22. Hanover.

*Les religieuses dans le cloître et dans le monde des origines à nos jours: Actes du Deuxième Colloque International du C.E.R.C.O.R., Poitiers, 29 septembre–2 octobre 1988*. 1994. St. Etienne.

Reudenbach, Bruno. 1996. "Individuum ohne Bildnis? Zum Problem künstlerischer Ausdrucksformen von Individualität im Mittelalter." In *Individuum und Individualität im Mittelalter*, ed. Jan A. Aertsen and Andreas Speer, 807–818. Miscellanea Mediaevalia, 24. Berlin.

Riemer, M. 1924. "Berichte über Visitationen von Nonnenklöstern des Bistums Halberstadt und des Erzbistums Magdeburg aus den Jahren 1496–1498." *Zeitschrift des Vereins für Kirchengeschichte der Provinz Sachsen* 20:92–107.

Rigaux, Dominique. 1992. "Dire la foi avec des images, une affaire de femmes?" In *La religion de ma mère: Les femmes et la transmission de la foi*, ed. J. Delumeau, 71–90. Paris.

——. 1994. "La donna, la fede, l'immagine negli ultimi secoli del medioevo." In *Donne e fede: Santità e vita religiosa in Italia*, ed. L. Scaraffia and G. Zarri, 157–176. Storia Della Donne in Italia. Florence.

Riggert, Ida-Christine. 1996. *Die Lüneburger Frauenklöster*. Veröffentlichungen der historischen Kommission für Niedersachsen und Bremen 37; Quellen und Untersuchungen zur Geschichte Niedersachsens im Mittelalter 19. Hanover.

Ringler, Siegfried. 1980. *Viten- und Offenbarungsliteratur in Frauenklöstern des Mittelalters: Quellen und Studien*. Münchner Texte und Untersuchungen 72. Munich.

Ritzinger, Edme and Heribert C. Scheeben. 1941. "Beiträge zur Geschichte der Teutonia in der zweiten Hälfte des 13. Jahrhunderts." *Archiv der Deutschen Dominikaner* 3:11–95.

Röckelein, Hedwig. 1992. "Historische Frauenforschung: Ein Literaturbericht zur Geschichte des Mittelalters." *Historische Zeitschrift* 255:377–409.

——. 1995. "Frauenbewegung, religiöse." In *Lexikon für Theologie und Kirche*, 3d ed., ed. Walter Kasper, 4:cols. 76–77. Freiburg.

——. 2000. "Leben im Schutz der Heiligen: Reliquientranslationen nach Essen von 9. bis 11. Jahrhundert." In Berghaus, Schilp, and Schlagheck 2000:87–100.

——. 2002. "Entre société et religion: L'histoire des genres au Moyen Age en Allemagne." In *Les tendances actuelles de l'histoire du Moyen Age en France et en Allemagne*, ed. Jean-Claude Schmitt and Otto Gerhard Oexle, 583–594. Histoire ancienne et médiévale 66. Paris.

Rode, Herbert. 1974. *Die mittelalterlichen Glasmalereien des Kölner Domes*. Corpus Vitrearum Medii Aevi, Deutschland 4/1. Berlin.

Rohrbach, Bernhard. 1884. "Liber gestorum." In *Frankfurter Chroniken und annalistische Aufzeichnungen des Mittelalters*, ed. Richard Froning, 181–223. Frankfurt.

Roisin, Simone. 1947. *L'hagiographie cistercienne dans le diocèse de Liège au XIIIe siècle*. Recueil de travaux d'histoire et de philologie sér. 3, fasc. 27. Louvain.

Rösener, Werner. 1974. *Reichsabtei Salem*. Sigmaringen.

——. 1980. "Strukturformen der älteren Agrarverfassung im sächsischen Raum." *Niedersächsisches Jahrbuch für Landesgeschichte* 52:107–143.

———. 1983. "Spiritualität und Ökonomie im Spannungsfeld der zisterziensischen Lebensform." *Citeaux* 34:245–274.

———. 1991. *Grundherrschaft im Wandel: Untersuchungen zur Entwicklung geistlicher Grundherrschaften im südwestdeutschen Raum vom 9. bis 14. Jh.* Veröffentlichungen des Max-Planck-Instituts für Geschichte 102. Göttingen.

Rublack, Ulinka. 1996. "Female Spirituality and the Infant Jesus in Late Medieval Dominican Convents." In *Popular Religion in Germany and Central Europe, 1400–1800*, ed. Bob Scribner and Trevor Johnson, 16–37. Themes in Focus. New York.

Rudy, Kathryn M. 2000. "'Den aflaet der heiliger stat Jherusalem ende des berchs van Calvarien': Indulgenced Prayers for Mental Holy Land Pilgrimage in Manuscripts from the St. Agnes Convent in Maaseik." *Ons geestelijk Erf* 74:211–254.

Ruh, Kurt. 1985. *Meister Eckhart: Theologe, Prediger, Mystiker.* Munich.

———. 1996. *Geschichte der abendländischen Mystik.* Vol. 3, *Die Mystik des deutschen Predigerordens und ihre Grundlegung durch die Hochscholastik.* Munich.

———, ed. 1978–. *Die deutsche Literatur des Mittelalters: Verfasserlexikon.* Rev. ed. Vols. 1–. Berlin.

Salzburger Äbtekonferenz, ed. 1992. *Regula Benedicti: Die Benediktusregel lateinisch/deutsch.* Beuron.

Sapin, Christian. 2002. "Archéologie de l'architecture carolingienne en France: État de la question." *Hortus Artium Medievalium* 8:57–70.

Saurma-Jeltsch, Lieselotte E. 1998. *Die Miniaturen im "Liber scivias" der Hildegard von Bingen: Die Wucht der Vision und die Ordnung der Bilder.* Wiesbaden.

Schade, Sigrid and Silke Wenk. 1995. "Inszenierungen des Sehens: Kunst, Geschichte und Geschlechterdifferenz." In *Genus: Zur Geschlechterdifferenz in den Kulturwissenschaften*, ed. Hadumod Bußmann and Renate Hof, 341–407. Kröners Taschenbuch 492. Stuttgart.

Schäfer, Karl Heinrich. 1907. *Die Kanonissenstifter im deutschen Mittelalter: Ihre Entwicklung und innere Einrichtung im Zusammenhang mit dem altchristlichen Sanktimonialentum.* Kirchenrechtliche Abhandlungen 43/44. Stuttgart.

Scheible, J., ed. 1860. *Die Klöster der Christenheit: Historisch-romantische Schilderungen des Lebens- und Treibens in Mönchs- und Frauenklöstern von Lurine, Brot und Anderen.* Bruenn.

Schellhorn, Maurus. 1925. "Die Petersfrauen: Geschichte des ehemaligen Frauenkonventes bei St. Peter in Salzburg (c. 1130–1583)." *Mitteilungen der Gesellschaft für Salzburger Landeskunde* 65:114–207.

"Das Schenkbuch einer Nürnberger Patricierfrau von 1416 bis 1438." *Anzeiger für Kunde der deutschen Vorzeit*, n.s., 23:cols. 37–42 and 70–74.

Schieber, Martin. 1993. "Die Geschichte des Klosters Pillenreuth." *Mitteilungen des Vereins für Geschichte der Stadt Nürnberg* 80:1–115.

Schiewer, Regina D. 1998. "Sermons for Nuns of the Dominican Observance Movement." In *Medieval Monastic Preaching*, ed. Carolyn Muessig, 75–92. Brill's Studies in Intellectual History 90. Leiden.

Schilling, Albert. 1887. "Die religiösen und kirchlichen Zustände der ehemaligen Reichsstadt unmittelbar vor der Einführung der Reformation, geschildert von einem Zeitgenossen." *Freiburger Diözesan-Archiv* 19:1–191.

Schilp, Thomas. 1998. *Norm und Wirklichkeit religiöser Frauengemeinschaften im Frühmittelalter: Die Institutio sanctimonialium Aquisgranensis des Jahres 816 und die Problematik der Verfassung von Frauenkommunitäten.* Veröffentlichungen des Max-Planck-Instituts für Geschichte 137; Studien zur Germania Sacra 20. Göttingen.

———. 2000. "Gründung und Anfänge der Frauengemeinschaft Essen." *Beiträge zur Geschichte von Stadt und Stift Essen* 112:30–63.

———. 2005. "Die Wirkung der Aachener 'Institutio sanctimonialium' des Jahres 816." In Lorenz and Zotz 2005:163–184.

Schlecht, Joseph. 1886. "Stiftungsbrief des Klosters St. Walburg." *Sammelblatt des historischen Vereins Eichstätt* 1:29–37.

Schleusener-Eichholz, Gudrun. 1984. *Das Auge im Mittelalter.* Vol. 1. Münstersche Mittelalter-Schriften 35. Munich.

Schlotheuber, Eva. 2004. *Klostereintritt und Bildung: Die Lebenswelt der Nonnen im späten Mittelalter, mit einer Edition des "Konventstagebuchs" einer Zisterzienserin von Heilig-Kreuz bei Braunschweig (1484–1507).* Spätmittelalter und Reformation, N.R. 24. Tübingen.

Schmid, Wolfgang. 1991. *Kölner Renaissancekultur im Spiegel der Aufzeichnungen des Hermann Weinsberg (1518–1597).* Veröffentlichungen des Kölnischen Stadtmuseums 8. Cologne.

Schmidt, Peter. 2003a. *Gedruckte Bilder in handgeschriebenen Büchern: Zum Gebrauch von Druckgraphik im 15. Jahrhundert.* Pictura et Poesis 16. Cologne.

———. 2003b. "The Use of Prints in German Convents of the Fifteenth Century: The Example of Nuremberg." *Studies in Iconography* 24:43–69.

Schmitt, Jean-Claude. 2002. *Le corps des images: Essais sur la culture visuelle au Moyen Age.* Paris.

———, ed. 2004. *Femmes, art et religion au Moyen Age: Colloque international, Colmar, Musée d'Unterlinden, 3–5 mai.* Strasbourg.

Schmitt, Sigrid. 2002. "'Wilde, unzucht- und ungaistlich swestern': Straßburger Frauenkonvente im Spätmittelalter." In *Frauen und Kirche*, ed. Sigrid Schmitt, 71–94. Mainzer Vorträge 6. Stuttgart.

Schneider, Karin. 1983. "Die Bibliothek des Katharinenklosters in Nürnberg und die städtische Gesellschaft." In *Studien zum städtischen Bildungswesen des späten Mittelalters und der frühen Neuzeit: Bericht über Kolloquien der Kommission zur Erforschung der Kultur des Spätmittelalters 1978 bis 1981*, ed. Bernd Moeller, Hans Patze,

and Karl Stackmann, 70–82. Abhandlungen der Akademie der Wissenschaften in Göttingen, Philologisch-historische Klasse, Dritte Folge, 137. Göttingen.

Schomer, Josef. 1937. *Die Illustrationen zu den Visionen der heiligen Hildegard als künstlerische Neuschöpfung: Das Verhältnis der Illustrationen zueinander und zum Texte.* Bonn.

Schönbach, Anton Emanuel. 1909/1976. "Mitteilungen aus altdeutschen Handschriften 10: Die Regensburger Klarissenregel." *Wiener Sitzungsberichte der Phil.-Hist. Classe der kaiserlichen Akademie der Wissenschaften,* no. 160, part 6, 1–68. Vienna/Hildesheim.

Schraut, Elisabeth. 1991. "Kunst im Frauenkloster: Überlegungen zu den Möglichkeiten der Frauen im mittelalterlichen Kunstbetrieb am Beispiel Nürnberg." In *Auf der Suche nach der Frau im Mittelalter: Fragen, Quellen, Antworten,* ed. Bea Lundt, 81–114. Munich.

Schreiner, Klaus. 1964. *Sozial- und standesgeschichtliche Untersuchungen zu den Benediktinerkonventen im östlichen Schwarzwald.* Stuttgart.

———. 1982. "Mönchtum zwischen asketischem Anspruch und gesellschaftlicher Wirklichkeit: Spiritualität, Sozialverhalten und Sozialverfassung schwäbischer Reformmönche im Spiegel ihrer Geschichtsschreibung." In *Speculum Sueviae: Beiträge zu den historischen Hilfswissenschaften und zur geschichtlichen Landeskunde Südwestdeutschlands. Festschrift für Hansmartin Decker-Hauff,* 2:250–307. Stuttgart.

Schreiner, Klaus and Norbert Schnitzler. 1992. *Gepeinigt, begehrt vergessen: Symbolik und Sozialbezug des Körpers im späten Mittelalter und in der frühen Neuzeit.* Munich.

Schuchhardt, Wolfgang. 1941. *Weibliche Handwerkskunst im deutschen Mittelalter.* Berlin.

Schuette, Marie. 1927, 1930. *Gestickte Bildteppiche und Decken des Mittelalters.* Vol. 1, *Die Klöster Wienhausen und Lüne: Das Lüneburgische Museum;* vol. 2, *Braunschweig: Die Klöster Ebstorf und Isenhagen, Wernigerode, Kloster Drübeck, Halberstadt.* Leipzig.

Schulenburg, Jane Tibbets. 1998. *Forgetful of Their Sex: Female Sanctity and Society, c. 500–1100.* Chicago.

Schulte, Aloys. 1910. *Der Adel und die deutsche Kirche im Mittelalter: Studien zur Sozial-, Rechts- und Kirchengeschichte.* Stuttgart.

"Schwester Katrei." 1981. In *Der Freiheitbegriff der deutschen Mystik: Seine Beziehung zur Ketzerei der "Brüder und Schwestern vom Freien Geist," mit besonderer Rücksicht auf den pseudoeckartischen Traktat "Schwester Katrei,"* ed. Franz-Josef Schweitzer, 303–455, 667–684. Arbeiten zur mittleren deutschen Literatur und Sprache 10. Frankfurt.

Seeberg, Stefanie. 2002. *Die Illustrationen im Admonter Nonnenbrevier von 1180, Marienkrönung und Nonnenfrömmigkeit: Die Rolle der Brevierillustration in der Entwicklung von Bildthemen im 12. Jahrhundert.* Wiesbaden.

Selmer, Carl, ed. 1933. *Middle High German Translations of the Regula Benedicti: The Eight Oldest Versions.* Medieval Academy of America Publications 17. Cambridge, Mass.

Sennhauser, Hans Rudolf. 1990. "Kirchen und Klöster der Zisterzienserinnen in der Schweiz." In *Zisterzienserbauten in der Schweiz: Neue Forschungsergebnisse zur Archäologie und Kunstgeschichte, Teil 1, Frauenklöster,* ed. Hans Rudolf Sennhauser. Veröffentlichungen des Instituts für Denkmalpflege an der ETH Zürich 10. Zurich.

———. 2002. "St. Gallen: Zum Verhältnis von Klosterplan und Gozbertbau." *Hortus artium medievalium* 8:49–55.

———, ed. 2003. *Frühe Kirchen im östlichen Alpengebiet.* 2 vols. Munich.

Seyfarth, Jutta, ed. 1990. *Speculum virginum, Editio princeps.* Corpus christianorum, Continuatio mediaevalis 5. Turnhout.

———. 2001. *Speculum virginum—Jungfrauenspiegel: Text und Übersetzung.* 4 vols. Fontes Christiani 20. Freiburg.

Shepard, Dorothy M. 1988. "Conventual Use of St. Anselm's Prayers and Meditations." *Rutgers Art Review* 9:1–16.

Sickel, Theodor, ed. 1893/1997. *Die Urkunden Ottos des III. (Ottonis III. Diplomata).* Monumenta Germaniae Historica, Die Urkunden der deutschen Könige und Kaiser 2, 2. Hanover.

Signori, Gabriela. 1995. *Maria zwischen Kathedrale, Kloster und Welt: Hagiographische und historische Annäherungen an eine hochmittelalterliche Wunderpredigt.* Sigmaringen.

———. 1997a. "Frauengeschichte/Geschlechtergeschichte/Sozialgeschichte: Forschungsfelder—Forschungslücken. Eine bibliographische Annäherung an das späte Mittelalter." In *Lustgarten und Dämonenpein: Konzepte von Weiblichkeit in Mittelalter und Früher Neuzeit,* ed. Annette Kuhn and Bea Lundt, 29–53. Dortmund.

———. 1997b. "Ritual und Ereignis: Die Straßburger Bittgänge zur Zeit der Burgunderkriege (1474–1477)." *Historische Zeitschrift* 264:281–328.

———. 2000. "Leere Seiten: Zur Memorialkultur eines nicht regulierten Augustiner-Chorfrauenstifts im ausgehenden 15. Jahrhundert." In *Lesen, Schreiben, Sticken und Erinnern: Beiträge zur Kultur- und Sozialgeschichte mittelalterlicher Frauenklöster,* ed. Gabriela Signori, 151–186. Religion in der Geschichte 7. Bielefeld.

Simmons, Loraine N. 1992. "The Abbey Church at Fontevraud in the Late Twelfth Century: Anxiety, Authority and Architecture in the Female Spiritual Life." *Gesta* 31, no. 2:99–107.

Simons, Walter. 2001a. "Architecture of Semi-Religiosity: The Beguinages of the Southern Low Countries, Thirteenth to Sixteenth Centuries." In *Shaping Community: The Art and Archaeology of Monasticism. Papers from a Symposium Held at the Frederick R. Weisman Museum, University of Minnesota, March 10–12, 2000,* ed. Sheila McNally, 117–128. British Archaeological Reports International Series 941. Oxford 2001.

———. 2001b. *Cities of Ladies: Beguine Communities in the Medieval Low Countries, 1200–1565.* Middle Ages Series. Philadelphia.

Smith, Lesley and Jane H. M. Taylor, eds. 1995a. *Women, the Book and the Godly*. Selected Proceedings of the St. Hilda's Conference 1993, 1. Cambridge.

———. 1995b. *Women, the Book and the Worldly*. Selected Proceedings of the St. Hilda's Conference 1993, 2. Cambridge.

Smith, Susan L. 1990. "The Power of Women Topos on a Fourteenth-Century Embroidery." *Viator. Medieval and Renaissance Studies* 21:203–228.

Spamer, Adolf. 1930. *Das kleine Andachtsbild vom XIV. bis zum XX. Jahrhundert*. Munich.

Stange, Alfred. 1934. *Deutsche Malerei der Gotik*. Vol. 1, *Die Zeit von 1250 bis 1350*. Berlin.

Steinhausen, Georg. 1894. "Sechzehn deutsche Frauenbriefe aus dem endenden Mittelalter." *Zeitschrift für Kulturgeschichte*, n.s., 1:93–111.

———. 1907. *Deutsche Privatbriefe des Mittelalters*. Vol. 2, *Geistliche—Bürger*. Berlin.

Stievermann, Dieter. 1989. *Landesherrschaft und Klosterwesen im spätmittelalterlichen Württemberg*. Sigmaringen.

Stofferahn, Steven A. 1999. "Changing View of Carolingian Women's Literary Culture: The Evidence from Essen." *Early Medieval Europe* 8:69–97.

Stoudt, Debra Lynn. 1991. "The Production and Presentation of Letters by Fourteenth-Century Dominican Nuns." *Mediaeval Studies* 53:309–326.

Strauch, Philipp. 1882/1966. *Margaretha Ebner und Heinrich von Nördlingen: Ein Beitrag zur Geschichte der deutschen Mystik*. Freiburg/Amsterdam.

Studer, Gottlieb. 1871. "Die Ordensregeln der Dominikaner-Frauenklöster nach einer Bernerhandschrift." *Archiv des Historischen Vereins des Kantons Bern* 7:466–521.

Suckale, Robert. 2002. "Die Weltgerichtstafel aus dem römischen Frauenkonvent Maria in Campo Marzio als programmatisches Bild der einsetzenden Gregorianischen Kirchenreform." In *Das mittelalterliche Bild als Zeitzeuge: Sechs Studien*, 12–122. Berlin.

———. 2004. "Der Kruzifix in St. Maria im Kapitol—Versuch einer Annäherung." In J.-Cl. Schmitt 2004:87–101.

Suckale-Redlefsen, Gude. 1987. *Mauritius: Der heilige Mohr. The Black Saint Maurice*. Menil Foundation. Munich.

Sweetman, Robert. 1997. "Thomas of Cantimpré, Mulieres Religiosae, and Purgatorial Piety: Hagiographical Vitae and the Beguine 'Voice.'" In *A Distinct Voice: Medieval Studies in Honor of Leonard E. Boyle, O.P.*, ed. Jacqueline Brown and William P. Stoneman, 606–628. Notre Dame.

Taddey, Gerhard. 1966. *Das Kloster Heiningen von der Gründung bis zur Aufhebung*. Veröffentlichungen des Max-Planck-Instituts für Geschichte 14; Studien zur Germania Sacra 4. Göttingen.

Taylor, Jane H. M. and Lesley Smith, eds. 1996. *Women and the Book: Assessing the Visual Evidence*. London.

Testoni Volonté, Giuseppina. 2001. "La chiesa monastica femminile nei Decreta Generalia di Giovan Francesco Bonomi (1579)." *Kunst + Architektur in der Schweiz* 52, part 1:27–35.

Theil, Bernhard. 1994. *Das (freiweltliche) Damenstift Buchau am Federsee.* Germania Sacra, n.s., 32. Berlin.

Thomas, Anabel. 2003. *Art and Piety in the Female Religious Communities of Renaissance Italy: Iconography, Space, and the Religious Woman's Perspective.* Cambridge.

Thompson, Sally. 1978. "The Problem of the Cistercian Nuns in the Twelfth and Early Thirteenth Centuries." In *Medieval Women,* ed. Derek Baker, 227–252. Oxford.

——. 1991. *Women Religious: The Founding of English Nunneries After the Norman Conquest.* Oxford.

Thümmler, Hans. 1970. *Weserbaukunst im Mittelalter.* Hameln.

Thunø, Erik and Gerhard Wolf, eds. 2004. *The Miraculous Image in the Late Middle Ages and Renaissance.* Analecta Romana Instituti Danici 35. Rome.

Toepfer, Michael. 1983. *Die Konversen der Zisterzienser.* Berliner Historische Studien 10; Ordensstudien 4. Berlin.

Tomkinson, Diane. 2004. "'In the Midst of the Trinity': Angela of Foligno's Trinitarian Theology of Communion." Ph.D. diss., Fordham University, New York.

Toussaint, Gia. 2003. *Das Passional der Kunigunde von Böhmen: Bildrhetorik und Spiritualität.* Paderborn.

Triest, Monika. 2000. *Het Besloten Hof: Begijnen in de Zuidelijke Nederlanden.* Leuven.

Tripps, Johannes. 1998. *Das handelnde Bildwerk in der Gotik: Forschungen zu den Bedeutungsschichten und der Funktion des Kirchengebäudes und seiner Ausstattung in der Hoch- und Spätgotik.* Berlin.

Uffmann, Heike. 2000. "Innen und außen: Raum und Klausur in reformierten Nonnenklöstern des späten Mittelalters." In Signori 2000:185–212.

Uhlhorn, Gerhard. 1884/1895. *Die christliche Liebesthätigkeit im Mittelalter.* vol. 2, 1st and 2d eds. Stuttgart.

Urbanski, Silke. 1993. "'Der begevenen kinder frunde': Soziale und politische Gründe für das Scheitern eines Reformversuchs am Kloster Harvestehude 1482." In *Recht und Alltag im Hanseraum: Gerhard Theuerkauf zum 60. Geburtstag,* ed. Silke Urbanski, Christian Lamschus, and Jürgen Ellermeyer, 411–428. De Sulte 4. Lüneburg.

Vandenbroeck, Paul, ed. 1994. *Le jardin clos de l'âme: L'imaginaire des religieuses dans les Pays-Bas du Sud depuis le 13e siècle.* Société des Expositions Palais des Beaux-Arts de Bruxelles 1994. Ghent.

Vassilevitch, Daria. 2000. "'Schrei der Seele' oder didaktische Stilisierung? Schwesternbücher aus Dominikanerinnenklöstern." In Signori 2000:213–229.

Venarde, Bruce L. 1997. *Women's Monasticism and Medieval Society: Nunneries in France and England, 890–1215.* Ithaca, N.Y.

Veronese, Alessandra. 1987. "Monasteri femminili in Italia settentrionale nell'alto medioevo: Confronto con i monasteri maschili attraverso un tentativo di analisi statistica." *Benedictina* 34:355–416.

Vetter, Ewald M. 1972. *Die Kupferstiche zur Psalmodia Eucharistica des Melchior Prieto von 1622.* Spanische Forschungen der Görres-Gesellschaft 2, no. 15. Münster 1972.

Veyssière, Laurent. 2001. "Cîteaux et tart, fondations parallèles." In Barrière and Henneau 2001:179–191.

Voaden, Rosalynn. 1999. *God's Words, Women's Voices: The Discernment of Spirits in the Writing of Late-Medieval Women Visionaries.* York.

von der Osten, Gert. 1967. "Der umarmende Kruzifix in Helmstedt." *Niederdeutsche Beiträge zur Kunstgeschichte* 6:111–116.

von Euw, Anton and Peter Schreiner. 1993. *Kunst im Zeitalter der Kaiserin Theophanu: Akten des Internationalen Colloquiums veranstaltet vom Schnütgen-Museum, Köln, 13.– 15. Juni 1991.* Cologne.

von Stülpnagel, Karl-Heinrich. 2000. *Die gotischen Truhen der Lüneburger Heideklöster: Entstehen–Konstruktion–Gestalt.* Cloppenburg.

von Wilckens, Leonie. 1977. "Das goldgestickte Antependium aus Kloster Rupertsberg." *Pantheon* 35:3–10.

———. 1991. *Die textilen Künste: Von der Spätantike bis um 1500.* Munich.

von Zahn, Joseph. 1884. "Chronik des Stiftes Göss." *Steiermärkische Geschichtsblätter* 5:1–218.

*Vorromanische Kirchenbauten: Katalog der Denkmäler bis zum Ausgang der Ottonen.* 1966–1971. Ed. Friedrich Oswald, Leo Schaefer, and Hans Rudolf Sennhauser. Munich.

———. 1991. Supp. vol. Ed. Werner Jacobsen, Leo Schaefer, and Hans Rudolf Sennhauser. Munich.

Watson, Nicholas. 1997. "Visions of Inclusion: Universal Salvation and Vernacular Theology in Pre-Reformation England." *Journal of Medieval and Early Modern Studies* 27, no. 2:145–187.

———. 2003. "Julian of Norwich." In Dinshaw and Wallace 2003:210–221.

Wegener, Gertrud. 1969. "Der Ordinarius des Stiftes St. Ursula in Köln." In *Aus kölnischer und rheinischer Geschichte: Festgabe für Arnold Güttsches,* ed. Hans Blum, 115–132. Veröffentlichungen des Kölner Geschichtsvereins 29. Cologne.

Wegener, Hans. 1927. *Beschreibendes Verzeichnis der deutschen Bilderhandschriften des späten Mittelalters in der Heidelberger Universitäts-Bibliothek.* Leipzig.

———. 1928. *Beschreibendes Verzeichnis der Miniaturen-Handschriften der preußischen Staatsbibliothek Berlin.* Vol. 5, *Die deutschen Handschriften.* Leipzig.

Wehrli-Johns, Martina. 1992/1998. "Das mittelalterliche Beginentum—religiöse Frauenbewegung als Sozialidee der Scholastik? Ein Beitrag zur Revision des

Begriffes 'religiöse Frauenbewegungen.'" In *"Zahlreich wie die Sterne des Himmels": Beginen am Niederrhein zwischen Mythos und Wirklichkeit*, 9–40. Bensberger Protokolle 70. Bergisch-Gladbach. Reprinted in *Fromme Frauen oder Ketzerinnen? Leben und Verfolgung der Beginen im Mittelalter*, ed. Martina Wehrli-Johns and Claudia Opitz, 25–52. Freiburg.

——. 1996. "Voraussetzungen and Perspektiven mittelalterlicher Laienfrömmigkeit seit Innozenz III: Eine Auseinandersetzung mit Herbert Grundmanns 'Religiösen Bewegungen.'" *Mitteilungen des Instituts für Österreichische Geschichtsschreibung* 104:286–309.

Weigel, Helmut. 1960. "Die Grundherrschaft des Frauenstiftes Essen." *Beiträge zur Geschichte von Stadt und Stift Essen* 76:4–312.

Weilandt, Gerhard. 1987. "Wer stiftete den Hitda-Codex? Ein Beitrag zur Entwicklung der ottonischen Kölner Buchmalerei." *Annalen des historischen Vereins für den Niederrhein* 190:49–83.

——. 2003. "Alltag einer Küsterin: Die Ausstattung und liturgische Nutzung von Chor und Nonnenempore der Nürnberger Dominikanerinnenkirche nach dem unbekannten 'Notel der Küsterin' (1436)." In Moraht-Fromm 2003:159–187.

Weinhold, Karl. 1851. *Die deutschen Frauen in dem Mittelalter: Ein Beitrag zu den Hausalterthümern der Germanen*. Vienna.

Weinmann, Ute. 1990. *Mittelalterliche Frauenbewegungen: Ihre Beziehungen zur Orthodoxie und Häresie*. Pfaffenweiler.

Weis-Müller, René. 1956. *Die Reform des Klosters Klingenthal und ihr Personenkreis*. Basel.

Welti, Friedrich Emil, ed. 1925. *Die Pilgerfahrt des Hans von Waltheym im Jahre 1474*. Bern.

Wemhoff, Matthias. 1993. *Das Damenstift Herford: Die archäologischen Ergebnisse zur Geschichte der Profan- und Sakralbauten seit dem späten 8. Jahrhundert*. Denkmalpflege und Forschung in Westfalen 24. Bonn.

Wemple, Suzanne F. 1981. *Women in Frankish Society: Marriage and the Cloister, 500 to 900*. Philadelphia.

Wentzel, Gunnel. 1948. "Birgittiner." In *Reallexikon* 1937–, 2:cols. 750–767.

Werner, Ernst. 1956. "Pauperes Christi." In *Studien zu sozial-religiösen Bewegungen im Zeitalter des Reformpapsttums*. Leipzig.

Westra, M. Salvina, O.P., ed. 1950. *A Talkyng of the Love of God: Edited from Ms. Vernon (Bodleian 3938)*. The Hague.

Wiberg Pedersen, Else Marie. 1999. "The In-carnation of Beatrice of Nazareth's Theology." In Dor et al. 1999:61–80.

Wilke, Jürgen. 2001. *Die Ebstorfer Weltkarte*. 2 vols. Veröffentlichungen des Instituts für Historische Landesforschung der Universität Göttingen 39. Göttingen.

Williams, Ulla and Werner Williams-Krapp, eds. 1998. *Die "Offenbarungen der Katharina Tucher."* Untersuchungen zur deutschen Literaturgeschichte 98. Tübingen.

Williams-Krapp, Werner. 1985. "Bilderbogen-Mystik: Zu 'Christus und die minnende Seele.' Mit Edition der Mainzer Überlieferung." In *Überlieferungsgeschichtliche Editionen und Studien zur deutschen Literatur des Mittelalters: Kurt Ruh zum 75. Geburtstag*, ed. Konrad Kunze, Johannes G. Mayer, and Bernhard Schnell, 350–364. Texte und Textgeschichte: Würzburger Forschungen 31. Tübingen.

———. 1990. "'Dise ding sint dennoch nit ware zeichen der heiligeit': Zur Bewertung mystischer Erfahrung im 15. Jahrhundert." In *Zeitschrift für Literaturwissenschaften und Linguistik* 80: *Frömmigkeitsstile im Mittelalter*, ed. Wolfgang Haubrichs, 61–71. Göttingen.

———. 1993. "Frauenmystik und Ordensreform." In *Literarische Interessenbildung im Mittelalter. DFG-Symposium 1991*, ed. Joachim Heinzle, 301–313. Stuttgart.

Wilmart, André. 1944. *Le "Jubilus" dit de Saint Bernard (Étude avec textes).* Rome.

Winston-Allen, Anne. 2004. *Convent Chronicles: Women Writing About Women and Reform in the Later Middle Ages.* University Park, Pa.

Witte, Hans, ed. 1900. *Urkundenbuch der Stadt Straßburg.* Vol. 7. Strasbourg.

Wolf, Norbert. 2002. *Deutsche Schnitzretabel des 14. Jahrhunderts.* Berlin.

Wollasch, Joachim. 1961. "Muri und St. Blasien." *Deutsches Archiv* 17:420–446.

———. 1992. "Frauen in der Cluniacensis ecclesia." In Elm and Parisse 1992:97–113.

Wood, Jeryldene M. 1996. *Women, Art, and Spirituality: The Poor Clares of Early Modern Italy.* Cambridge.

Wormstall, Albert. 1895. "Eine westfälische Briefsammlung des ausgehenden Mittelalters (1470–1495)." *Westfälische Zeitschrift* 53:149–181.

Wunder, Heike. 1994. "'Gewirkte Geschichte': Gedenken und 'Handarbeit.' Überlegungen zum Tradieren von Geschichte im Mittelalter und zu seinem Wandel am Beginn der Neuzeit." In *Modernes Mittelalter: Neue Bilder einer populären Epoche*, ed. Joachim Heinzle, 324–354. Frankfurt.

Zarri, Gabriella. 2000. "Christian Good Manners: Spiritual and Monastic Rules in the Quattro- and Cinquecento." In *Women in the Italian Renaissance: Culture and Society*, ed. Letizia Panizza, 76–91. Oxford.

Ziegler, Joanna E. 1987. "The Curtis Beguinages in the Southern Low Countries and Art Patronage: Historiography and Interpretation." *Bulletin de l'Institut Historique Belge de Rome* 57:31–70.

———. 1992. *Sculpture of Compassion: The Pietà and the Beguines in the Southern Low Countries, c. 1300–c. 1600.* Brussels.

Zimmer, Petra. 1990. "Die Funktion und Ausstattung des Altares auf der Nonnenempore: Beispiele zum Bildgebrauch in Frauenklöstern aus dem 13. bis 16. Jahrhundert." Ph.D. diss., University of Cologne.

Zimmermann, Wolfgang and Nicole Priesching, eds. 2003. *Württembergisches Klosterbuch: Klöster, Stifte und Ordensgemeinschaften von den Anfängen bis in die Gegenwart*. Ostfildern.

Zomer, Hiltije F.H. 1995. "The So-Called Women's Gallery in the Medieval Church: An Import from Byzantium." In *The Empress Theophano: Byzantium and the West*, ed. A. Davids, 290–306. Cambridge.

# Picture Credits

Aarau, Aargauische Denkmalpflege (Foto JAE 1986): fig. 3.6

Antwerp, Museum Mayer van den Bergh, Collectie beleid: fig. 2.4

Bamberg, Diözesanmuseum: fig. 2.6

Berlin, Bildarchiv Preußischer Kulturbesitz: fig. 1.7

Berlin, Staatliche Museen Preußischer Kulturbesitz, Kupferstichkabinett: figs. 6.4, 7.1; Jörg P. Anders: fig. 2.1

Bern, Historisches Museum (Stefan Rebsam): fig. 2.9

Braunschweig, Herzog Anton Ulrich Museum (Bernd Peter Keiser): fig. 1.8

Braunschweig, Jutta Brüdern: figs. 2.10, 2.11, 2.12, 2.13, 2.15, 4.4, 7.4

Brescia, rapuzzi, fotostudio: fig. 1.1

Chelles, Musée municipale Alfred Bonno: fig. 9.1

Città del Vaticano, Musei Vatican: figs. 6.7, 8.2

Colmar, Bibliothèque de la Ville: fig. 2.7

Darmstadt, Universitäts- und Landesbibliothek: fig. 3.1

Dößel, Janos Stekovics: fig. 4.1

Eibingen, Abtei St. Hildegard: fig. 6.2

Eichstätt, Abtei St. Walburg: fig. 3.10

Engelberg, Kloster (René Perret): fig. 6.6

Erlangen, Universität, Lehrstuhl für Christliche Archäologie, Lehrgrabung Pfullingen: fig. 4.5

Essen, Domschatz (Anne Gold): fig. 9.7

Essen, Ruhrlandmuseum (Foto: Jens Nober): figs. 1.2, 1.4, 3.2, 3.3, 4.2, 12.1

Freiburg, Stiftsverwaltung, Fotoarchiv: figs. 2.8, 6.1

Fröndenberg, Gerhard Nolte: figs. 2.2

Göttingen, Universität, Lehrstuhl Prof. H. Röckelein: fig. 9.4–6

Halle, Landesamt für Denkmalpflege und Archäologie Sachsen-Anhalt (Gunar Preuß.): fig. 3.9

Helmstedt, Paramentenwerkstatt der von-Veltheim-Stiftung: fig. 9.2

Innes, Hector: fig. 2.14

Karlsruhe, Badisches Landesmuseum: fig. 2.5

Köln, Rheinisches Bildarchiv: figs. 3.4, 3.8

London, The British Library: figs. 5.1, 8.1

London, Victoria and Albert Museum: fig. 1.9

Lucca, Biblioteca Statale: fig. 6.3

Mainz, Landesamt für Denkmalpflege Rheinland-Pfalz (Sigmar Fitting): fig. 4.3

Munich, Bayerische Staatsbibliothek: fig. 3.5

Munich, Bayerisches Hauptstaatsarchiv: fig. 3.6

Münster, Westfälisches Landesmuseum für Kunst und Kulturgeschichte: fig. 9.3

New Haven, Beinecke Rare Book and Manuscript Library, Yale University (Thor Moser): fig. 3.13

New York, The Metropolitan Museum of Art (1917 [17.190.724]): fig. 2.3

Osnabrück, Bischöfliches Generalvikariat, Diözesanarchiv: fig. 5.2

Oxford, Keble College: fig. 3.14

Paris, Bibliothèque nationale de France: fig. 7.2

Poitiers, Bibliothèque municipale/La médiathèque François Mitterand (C.O. Neuillé): fig. 1.5

Prag, Národní knihovna: fig. 3.15

Pulheim, Rheinisches Amt für Denkmalpflege: fig. 3.12

Schwerin, Kunstsammlungen, Staatliches Museum: figs. 6.5, 7.5

Sint-Truiden, Provinciaal Museum voor religieuze Kunst: fig. 8.3

Strasbourg, Bibliothèque nationale et universitaire: fig. 1.3

Strasbourg, Cliché J.-Cl. Stamm, copyright Inventaire général/ADAGP: fig. 10.1

Strasbourg, Musée de Strasbourg, Service photos: fig. 7.3

Wolfenbüttel, Niedersächsisches Staatsarchiv: fig. 1.6

Printed in the USA
CPSIA information can be obtained
at www.ICGtesting.com
JSHW021942291123
52960JS00012B/30/J